GOD'S
CHOICE

GOD'S CHOICE

Pope Benedict XVI and
the Future of the Catholic Church

GEORGE WEIGEL

HarperCollins*Publishers*

HarperCollins books may be purchased for educational, business, or sales promotional use. For information, please write: Special Markets Department, HarperCollins Publishers, 10 East 53rd Street, New York, NY 10022.

FIRST EDITION
Designed by Joseph Rutt
Printed on acid-free paper

Library of Congress Cataloging-in-Publication Data
Weigel, George.
God's choice : Pope Benedict XVI and the future of the Catholic Church /
George Weigel.—1st ed.
p. cm.
Includes bibliographical references and index.
ISBN-10: 0-06-621331-2
ISBN-13: 978-0-06-621331-6
1. Benedict XVI, Pope, 1927–. 2. Catholic Church. I. Title.
BX1378.6.W45 2005
282.092—dc22 2005052687
[B]

05 06 07 08 09 NMSG/RRD 10 9 8 7 6 5 4 3 2 1

For my NBC and MSNBC colleagues

Contents

GOD'S
CHOICE

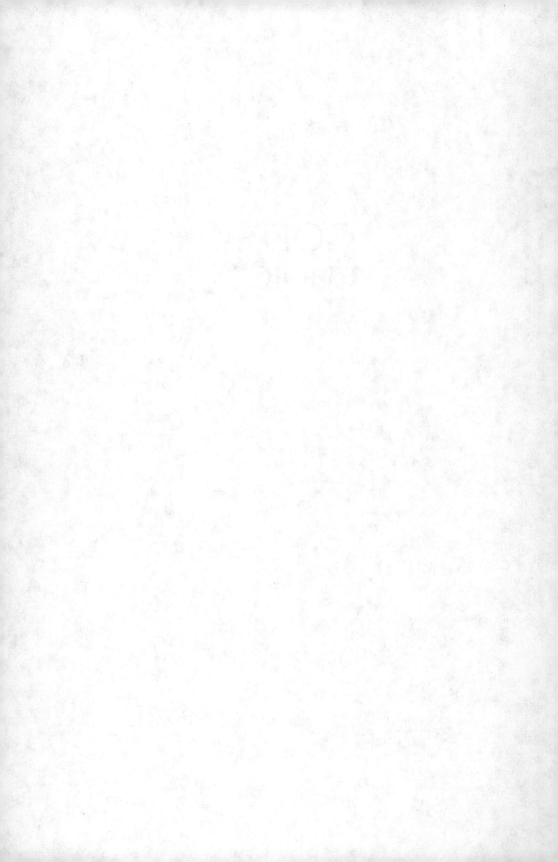

Prologue

T HE BAVARIAN CARDINAL sometimes admitted that more than two
decades in Rome had "Italianized" him; few traditions are more
deeply ingrained in Italian culture than the custom of the *riposo*, the
mid-afternoon, post-luncheon rest. Yet it is very doubtful that Joseph
Ratzinger got much, if any, sleep on the afternoon of April 19, 2005.

Tutored for almost seven decades by the theological realism of St.
Augustine, and with more than twenty years experience at the highest
levels of the Catholic Church, he was a man accustomed to facing
facts. And the facts of the previous eighteen hours suggested that, by
sundown, more than two-thirds of his brother-cardinals would cast
their votes for him as the next Bishop of Rome. So this was not a time
for napping, but for thinking and praying.

The questions can be imagined: What was God asking of him?
Should he accept an office for which he felt himself unsuited, by reason
of age and temperament? What should he make of the note he had just
received from another cardinal, reminding him of his duty to accept
election, were it to come to that? If he accepted, by what papal name
should he be known? What would he say to the men who had been his
brothers but would now be his subordinates, as they paid him their
homage in the Sistine Chapel? And what should he say to the tens of
thousands of people who were sure to be standing outside in St. Peter's
Square, awaiting the first public words of the new universal pastor of
the Church?

In the hours immediately after lunch on April 19, 2005, Joseph Ratzinger may also have thought, at least a bit, about the man who had brought him to Rome and to his present circumstances—Karol Wojtyła, the Polish pope, with whom he had had his first serious conversation at another conclave, in August 1978. Then, he had recognized in Wojtyła what he once called a "passion for man," a passion that expressed itself in the kind of large public personality of which he knew himself incapable. The Pole, who had read some of Ratzinger's books, admired the younger German's theological intelligence, which he recognized as deeper and broader than his own. Each knew the other to be a man of intellectual and moral courage, someone who would not bend with the winds of fashion or pressure, someone to be relied upon when things got difficult.

By 2005, they had worked in close harness for more than twenty-three years. Because of their association, and because of the work John Paul II had asked him to take on, Joseph Ratzinger had become a world figure in his own right—often, to his discomfort. Three times he had asked his Polish superior to allow him to retire, so that he might return to his theological work; three times the Pope had asked him to stay; three times he had agreed to put his own intellectual aspirations on hold yet again. Now, in no small part because John Paul had confirmed him in his current position of leadership within the College of Cardinals, it seemed as if Joseph Ratzinger's personal plans were about to be derailed once more—this time, definitively.

So the story of Pope Benedict XVI, and the impact he may have on the Catholic Church and the world in the early 21st century, begins with the final chapter in the story of Pope John Paul II: two different personalities, two different intellectual sensibilities, two different styles, yet both Christian radicals—unshakably convinced of the truth of the Gospel of Jesus Christ; willing to speak truth to power; determined to challenge the Church and the world to a nobler, more bracing understanding of the human adventure.

The Death of a Priest

ON EASTER SUNDAY 2005, one of Pope John Paul II's oldest friends said, in a voice tinged with both gratitude and sadness, "I think they are finally beginning to understand him." It was an acute observation, and a telling one.

For twenty-six and a half years, ever since he had burst onto the world stage as the first Slavic pope in history and the first non-Italian pontiff in four hundred fifty-five years. "they"—the world and, indeed, many Catholics—had understood John Paul II from the outside: as a dynamic statesman, a media superstar, an implacable foe of communism, a resolute defender of human rights, a compelling public intellectual, a voice for the voiceless; a man of dialogue, reason, and tolerance in a season of religious passions and terrorist violence. All of which he was. But understanding Karol Józef Wojtyła from the outside—through his public roles—never really got you to the core of the man.

Now, the center of Karol Wojtyła's life—the quality that made him distinctively himself—was coming into clearer focus. John Paul II lived the last nine weeks of his earthly pilgrimage as he had lived the fifty-eight years since his ordination: as a Catholic priest, leading others more deeply into the mystery of Jesus Christ, crucified and risen. "Mystery," in the Pope's Christian vocabulary, did not mean an intellectual puzzle to be solved; in the realm of the spirit, a mystery is a truth that can only be grasped in its essence by love. The mystery of the crucified God contained within itself, John Paul believed, the truth of the world: the world's origins, its redemption, its eternal destiny—"For God so

loved the world that he gave his only Son, that whoever believes in him should not perish but have eternal life" [John 3.16]. That was the truth on which he had staked his life. That was the truth by which he had bent history in a more humane direction. And that was the truth in which he would die.

It was often said during those nine weeks (and, in fact, for years before) that John Paul II had become an icon of suffering; and that was true, too. This was not suffering borne stoically, however. This was suffering transformed from absurdity into witness and grace by being offered to God in union with Christ. He had gotten his first glimpses into the mystery of redemptive suffering through his father, a widower who had taken him to the Polish Holy Land shrine of Kalwaria Zebrzydowska when he was nine years old, some months after his mother's death. There, he had watched an enormous throng re-enact the passion and death of Jesus Christ; and there, he had experienced with that throng the astonishing joy of the Lord's resurrection. Easter, he saw, was always preceded by Good Friday. It was a lesson he never forgot.

His pontificate had reminded more than one observer of a biblical epic—as the French journalist André Frossard had written after John Paul II's installation Mass, "This is not a pope from Poland; this is a pope from Galilee." And in the dignity with which he bore his suffering, John Paul taught the 21st century the same lesson St. Paul had tried to teach the people of Corinth in the 1st century: "As we share abundantly in Christ's sufferings, so through Christ we share abundantly in comfort, too" [2 Corinthians 1.5]. For centuries, preachers and biblical scholars had tried to unpack the meaning of that mysterious phrase in the Letter to the Colossians, in which the apostle writes, "Now I rejoice in my sufferings for your sake, and in my flesh I complete what is lacking in Christ's afflictions for the sake of his body, that is the Church . . ." [Colossians 1.24]. The debates over the meaning of that text would continue, but through John Paul II, millions around the world caught a glimpse of what it meant to fill up what is lacking in the suffering of Christ, for the good of the Church and the world.

Karol Józef Wojtyła—son of Poland and son of the Catholic Church, a poet who had once written the mystery play *Radiation of Fatherhood* and who had come to embody paternity for millions—died a very public death over a period spanning the penitential days of Lent

and the beginnings of the Easter season. It was his last, great paternal lesson.

The response was beyond anyone's imagining.

SUFFERING SERVANT

Although Karol Wojtyła had lived a robust life before assuming the papacy—and then did things as pope that had been previously inconceivable, like skiing in the Italian Alps and hiking in the Rocky Mountains outside Denver—he had also known physical suffering from the inside, and early. During the Nazi occupation of Kraków in World War II, he had done months of backbreaking manual labor in a stone quarry. In 1944, while he was a clandestine seminarian surreptitiously studying theology after slogging buckets of lime around a chemical factory, he had been run over by a German truck and left unconscious in a roadside ditch with a concussion and a broken shoulder; his characteristic stoop was a lifelong souvenir of that experience. In 1981, it had taken the better part of four months for him to recover, first from the gunshot wounds that had come within a few millimeters of costing him his life and then from the viral infection he had contracted from a tainted pint of donated blood given him during his emergency surgery. That period aside, however, John Paul set a pace of physical activity during the first fourteen years of his pontificate that often left those around him gasping in the dust. (He could, and did, tease others about their stamina, or lack thereof. When the papal plane crossed the international date line on its circumnavigation of the globe, during a grueling two-week pilgrimage to the Philippines, Guam, Japan, and Alaska in February 1981, the Pope, mischief in his eyes, cracked to an exhausted papal entourage and press corps, "Now we must decide what to do with the extra day we've been given."[1])

Things began to change in 1992; on July 15 of that year, the Pope had surgery to remove a benign intestinal tumor and some stones from his gallbladder. Sixteen months later, at an audience in the Hall of Benedictions atop the atrium of St. Peter's Basilica, he slipped on a piece of newly installed carpet while coming down from the dais, fell,

and broke his shoulder; as he walked out, holding his arm, he tried an Italian pun: *"Sono caduto ma non sono scaduto"* [I fell, but I haven't been demoted.] Five months after that, in April 1994, John Paul fell in his bath, broke his femur, and had an artificial hip implanted, not altogether successfully. For the rest of his life, the prosthesis would cause him pain, and the Pope began using a cane (which he quickly turned into a stage prop, twirling it to the delight of millions at World Youth Day in Manila in 1995). In 1994, he was diagnosed with a form of Parkinson's disease. Its immediate manifestations were a tremor in his left hand and arm, but as the years unfolded, his neurological problems would cause the Pope far worse difficulties. In 1996, he had to have his appendix removed, just a month before celebrating the fiftieth anniversary of his ordination to the priesthood.

Yet he pressed ahead, his focus fixed on the Great Jubilee of 2000, which he frequently described as the key to his entire pontificate. On the night of December 24–25, 1999, and despite his neurological and orthopedic difficulties, he knelt at the Holy Door of St. Peter's before opening it with a gentle push; then he processed through the opened door, a symbol of God's openness to humanity, and symbolically led the universal Church up the center aisle of the basilica for the celebration of Christmas Midnight Mass and the beginning of the jubilee year. During the Great Jubilee he maintained a physically punishing schedule, going to Mt. Sinai in February, the Holy Land in March, and the shrine of Our Lady of Fatima in Portugal in May; during that remarkable year, he was also present to millions of pilgrims in Rome at beatifications, canonizations, and other public ceremonies. Still, when the Great Jubilee of 2000 was formally closed on the Solemnity of the Epiphany, January 6, 2001, more than a few observers asked whether John Paul II might not lay down, now, the burden of the papacy.

The thought may have occurred to him, as it would have occurred to anyone; but the idea of a papal abdication never seems to have been under serious consideration. John Paul believed that the papacy was a form of paternity and that fatherhood was not something one resigned; he had promised his service to Christ and the Church "to the end," when he accepted his election on October 16, 1978. Moreover, he was acutely aware of the practical problems an abdicated pope would present: as he said on one occasion, there wasn't room in the Church for

two popes. Vocational conviction and practical wisdom, not stubbornness and certainly not ego, led him to continue.

In 2002, John Paul's physical condition had gotten sufficiently worse that there was widespread concern in Canada that he might not be able to attend the World Youth Day events scheduled for Toronto in August—despite the fact that the Pope had insisted, on numerous occasions, that he would be there. On July 23, he walked down the gangway of his Alitalia jet at Toronto's Pearson International Airport and pounded his cane three times on the runway when he reached the bottom—as if to say, "Look, I *told* you I'd be here." Over the following weekend, John Paul II inspired and personally led the greatest religious gatherings in Canada's national history.

Yet there was no denying that things were inexorably getting more difficult. No pope had ever invested as much time as John Paul II in meeting with the world's bishops on their quinquennial *ad limina* visits to Rome (which are made in regional groups). In the first two decades of the pontificate, John Paul would meet each visiting bishop individually, for as long as a half hour, while also hosting a lunch or dinner for the group, concelebrating Mass with the group, and reading each group a specially prepared message. By 2003, the program had been cut back sharply, with the Pope meeting each bishop individually for a few minutes and the message being given to the bishops in an envelope. Some bishops came home and told friends that John Paul was in bad shape, while others, who had seen him at a different moment, were struck by how robust he seemed, as least by comparison with the gloomier reports; like anyone being medicated for a serious neurological disease, the Pope had good days and bad days, and good hours and bad hours within the good days. Severe arthritis in his knees was another constant source of pain, and further compounded his difficulties in walking—to the point where arrangements were finally made to wheel him into audiences and liturgies on a rolling version of the *sedia gestatoria*—a sort of sedan chair on which popes had once been carried into public events, high on the shoulders of Italian nobles. Now, John Paul would sit at the papal altar of St. Peter's to preside at Mass. No one seemed to mind.

He had long treated his infirmities with the medicine of humor. Asked how he felt in 1994, shortly after the hip-replacement surgery,

he shot back, wryly, "Neck down, not so good." When a cross-section of the world's bishops watched him walk with difficulty toward the dais at a Synod later that year, the Pope turned to the assembled prelates and wise-cracked, *"Eppur' si muove..."* [Nonetheless, it moves . . .]— Galileo's sotto voce comment to his accusers at the end of his trial. In the years after the Great Jubilee, he took to referring to the Gemelli hospital as "Vatican III" ("Vatican I" being the apostolic palace and "Vatican II" the papal summer residence at Castel Gandolfo). At the same time, John Paul II remained the man who had discovered St. John of the Cross, St. Teresa of Avila, and the cross-centered mysticism of the Carmelites during the brutal Nazi occupation of Poland. He had always been a Carmelite, spiritually, and throughout his life he had experienced those dark nights of the soul that are an unavoidable aspect of living the spirituality of Carmel. One such dark night came in the summer of 2003. It was infernally hot in Italy, so the Pope, who still tried to use the swimming pool he had had installed at Castel Gandolfo shortly after his election, couldn't even avail himself of that modest form of exercise. Castel Gandolfo itself was not air-conditioned in those days. To make matters even worse, the doctors had to tell John Paul that the orthopedic surgery they had planned in order to relieve his intense knee pain could not be done, presumably for fear of complications that might be caused by anesthetizing someone who already had serious neurological problems. It was another, unexpected blow; the Pope's physical and spiritual suffering visibly intensified as the twenty-fifth anniversary of his pontificate approached.

Four days before that celebration, John Paul was wheeled down to the Sala Clementina of the apostolic palace from his third-floor apartment; he wanted to thank those who were about to participate in a two-hour Polish television special being anchored from Rome. More than one of those whom the Pope asked to greet personally on that occasion came away fighting back tears. He was slumped over in his portable throne, his face a frozen mask; only his eyes conveyed his greetings, his blessing, his physical pain, and his frustration at being unable to do more than take a friend's hand, briefly. Yet by October 16, John Paul had rallied. He led the concelebrated Mass of thanksgiving for his twenty-five years of service as pope. Three days later, he led the Mass for the beatification of an old friend, Mother Teresa of Calcutta.

And forty-eight hours after that, he created thirty-one new cardinals in a consistory in St. Peter's Square. Rather than imposing the distinctive red biretta on each new member of the College of Cardinals, he handed the biretta to the candidate—but he could also be seen exchanging small words of greeting and smiles with newcomers to the College he knew particularly well. Still, some of those who had lived through mid-October 2003 with John Paul II in Rome came away convinced that they would be back before Christmas—for a papal funeral and the conclave to elect the new pope. They were, of course, wrong. By Christmas 2003, John Paul had rallied again, his face no longer stiffened with pain, and his characteristic curiosity and good spirits intact; he joked with dinner guests and his secretary about the possibility of writing more poems, beyond the *Roman Triptych* he had published a few months earlier.

John Paul II managed only three trips in 2004: to Bern, Switzerland, on June 5–6; to the Italian Marian shrine at Loreto on September 5; and, most movingly, to the shrine of Our Lady of Lourdes in France on August 14–15. There, surrounded by the ill and the disabled at Catholicism's greatest center of healing, John Paul proclaimed himself "a sick man among the sick," and knelt in prayer at the rock grotto of Masabielle where Bernadette Soubirous had met the Virgin Mary in 1858. Yet while his travels were few, John Paul continued to lead, now from a wheelchair and a rolling throne. He proclaimed a Year of the Eucharist to be celebrated between October 2004 and October 2005. He returned the famous icon of Our Lady of Kazan to the Orthodox patriarch of Moscow, Aleksy II (who had persistently impeded John Paul's efforts to visit Russia). He received Ecumenical Patriarch Bartholomew I of Constantinople in Rome in November; John Paul and Bartholomew jointly presided over an ecumenical service in St. Peter's, during which relics of St. Gregory Nazianzen and St. John Chrysostom, two of the great Fathers of eastern Christianity, were returned to the Orthodox patriarchate.

Over the course of 2004, John Paul also received some thirty heads of state or government, including U.S. President George W. Bush, President Pervez Musharraf of Pakistan, President Aleksander Kwaśniewski of Poland, and Prime Minister José Luis Rodríguez Zapatero of Spain. Yet his arguments and pleas were ignored when the

drafters of Europe's new constitutional treaty obstinately refused to acknowledge Christianity's contributions to the formation of contemporary Europe in the preamble to the document intended to govern the expanded European Union. He had always loved the Christmas season and was in good spirits at the end of the year. But guests at dinner just before Christmas noticed that, for all his clarity of mind, it took him the better part of two minutes to write a brief Christmas greeting by hand. The intellect and will were as strong as ever; the machinery was clearly breaking down.

Yet, as 2004 gave way to 2005, the underlying situation remained the same: John Paul suffered from no immediately life-threatening condition. Talk of a consistory for the creation of new cardinals was in the air in early 2005, and, given the circumstances, didn't seem bizarre or inappropriate. It was not to be, however.

LAST CRISIS

On January 30, 2005, Pope John Paul II appeared at the window of his study in the apostolic palace, just as he had done for more than twenty-six years, to lead the noontime recitation of the Angelus and to offer a few words of greeting to pilgrims gathered in St. Peter's Square and those watching on television. It was the end of a month dedicated to peace by the children of Italian Catholic Action, and two representatives of the group, a young boy and a young girl, had been invited to share the window with the Pope and to release two symbolic doves. One of the doves got away and tried to fly back into the papal apartment; John Paul, in a reminder of how things once were, ducked, laughed, and tried to bat the recalcitrant dove back on course. In a weak but understandable voice, the Pope asked the pilgrims, and especially the children present, "to defeat injustice with justice, falsehood with truth, vengeance with forgiveness, hate with love."[2]

Those would be some of his last words from the window from which he had addressed the world for more than a quarter-century, changing history in the process.

That night, it was announced that, due to the flu, the Pope's sched-

ule the next day had been canceled. The Tuesday and Wednesday schedules were subsequently canceled on Monday evening. Nothing serious seemed at hand, though, and papal spokesman Joaquín Navarro-Valls (himself a trained physician) joked about the papal prognosis: "A flu given proper treatment lasts seven days, whereas the flu without care runs seven days."[3] Yet, after dinner Tuesday night, February 1, John Paul began to have a hard time breathing (due to what Navarro-Valls subsequently called "acute laryngeal tracheitis"). His personal physician, Dr. Renato Buzzonetti, made the sensible decision to take an eighty-four-year-old man with a serious neurological disorder, other health problems, and the flu to the hospital, and John Paul was driven in an ambulance to the Policlinico Agostino Gemelli, where he had been hospitalized on previous occasions and where a suite was always reserved for him.

A media frenzy immediately ensued. Keith Miller of NBC News remarked that "the level of speculation, rumor, and innuendo . . . was amazing," and said that he couldn't recall anything quite like it in more than twenty-five years of covering wars, natural disasters, and political upheavals of various sorts. One U.S. network's Rome bureau chief urged the network's Vatican commentator to come to Rome immediately, because the Pope was dying. Others, like Miller and NBC, took a calmer, more measured approach. Several factors conspired to create the almost inevitable frenzy, however. The fact that the world press had been holding a papal death watch for the better part of a decade (the phrase "the frail and failing Pope" had been ubiquitous since 1994), plus the insatiable demand of 24/7 cable TV news for something different and attention-grabbing, had many journalists on a hair trigger. Long-standing prejudices about Vatican dissembling and spin were also in play. So were the vulnerabilities of American reporters, unfamiliar with the Italian media culture, to a journalistic environment in which the border between truth and fiction is often permeable—to the point of being non-existent.

Things had calmed down by Thursday, and on Friday, February 4, Navarro-Valls announced that there would be no more press briefings until Monday (setting off a round of aggrieved protests in some journalistic quarters). On Sunday, February 6, the Pope appeared at a window of the Gemelli hospital, with his Angelus message being read for

him by Archbishop Leonardo Sandri, the deputy secretary of state, or *sostituto*. Despite his flu, John Paul managed to say a few words of the Angelus and to give the final blessing. In his message, as read by Archbishop Sandri, John Paul thanked those who were praying for him and said that he "continued to serve the Church and the whole of humanity, even here in the hospital among other sick persons, of whom I am thinking with affection."[4] A subsequent mini-controversy over whether the Pope had actually spoken or a tape recording had been played turned out to be a tempest in an espresso cup—although one that illustrated yet again how suspicion of the Vatican's communications operation dominated some journalistic minds.

Lent began early in 2005, with Ash Wednesday, the beginning of the Church's penitential season, being observed on February 9. John Paul received ashes at the Gemelli, while Cardinal James Francis Stafford, the former archbishop of Denver and head of the Vatican office dealing with penitential matters and questions of conscience, presided in the Pope's stead over the solemn opening of Lent at St. Peter's Basilica. The next day, February 10, John Paul returned to the apostolic palace via a motorcade that came down to the Vatican along the Via Gregorio VII, which was lined with cheering crowds. Italian television covered the Pope's return; John Paul waved to the crowds and seemed pleased with the Romans' response to his release from the hospital. It seemed as if business as usual—or "as usual" given the Pope's ongoing difficulties—was about to recommence.

John Paul sent greetings to the Thirteenth World Day of the Sick, being held in Yaoundé, Cameroon, on February 11 (the annual commemoration of Our Lady of Lourdes on the Catholic liturgical calendar); the papal message centered on "Jesus, the man who knows suffering."[5] Two days later, on the evening of the First Sunday of Lent, John Paul began his annual week-long retreat, along with the senior members of the Roman Curia; the retreat master was an Italian bishop, Renato Corti of Novara, who took as his theme "The Church in Service to the New and Everlasting Covenant." That same day, ninety-seven-year-old Sister Lucia dos Santos, last surviving child-seer of the apparitions of the Blessed Virgin Mary at Fatima in 1917, died in her Portuguese convent in Coimbra. John Paul sent Cardinal Tarcisio Bertone, S.D.B., the archbishop of Genoa, as a special envoy to her February 15 funeral. There,

Cardinal Bertone read a message from the Pope, in which John Paul said that he liked "to think that it was the Blessed Virgin, the same one whom Sister Lucia saw at Fatima so many years ago, who welcomed her on her pious departure from earth to Heaven."[6] Many would soon think similar thoughts of another spiritual voyager.

With the Pope home from the hospital, speculations about a possible abdication might have been expected to die down. Yet they were re-ignited by an imprudent statement from the second-ranking Vatican official, Cardinal Angelo Sodano, the secretary of state. Asked by a reporter whether the Pope might abdicate, Sodano, rather than saying that the Pope had made clear on numerous occasions his intention to complete the service he had promised the Church in 1978, got into a more rambling conversational mode: "If there is a man who loves the Church more than anybody else, who is guided by the Holy Spirit, if there is a man who has marvelous wisdom, that's him. We must have great faith in the Pope. He knows what to do." This was taken to mean that abdication was under consideration, even if the final choice was the Pope's. But that was already obvious under Church law, as no one can compel a papal abdication, and any abdication offered under pressure or duress would lack effective force.[7] It was not the first time, alas, that clumsy statements from senior churchmen had fueled groundless speculations, either about the Pope's health or his plans. But coming from the cardinal secretary of state, this round of baseless prognostication had a longer half-life than its predecessors.

Speculations collapsed before facts, however, when John Paul II was taken to the Gemelli once again, on February 24, for what Dr. Navarro-Valls later described as an "elective tracheotomy." The Pope had experienced further difficulties breathing as the Parkinson's disease weakened his chest muscles, and it was decided to do the tracheotomy—an incision in the windpipe—to "favor the resolution of the larynx pathology." The operation had been conducted under anesthesia, and, according to Navarro-Valls, "the post-operative situation" was "regular." The Pope, who had jokingly called his 1981 medical team "the Sanhedrin" and had constantly asked, "What did the Sanhedrin decide on my behalf?," retained his sense of humor, slipping Navarro-Valls a note after the operation: "What did they do to me now?"[8] For all his legendary resilience, however, the need for the tracheotomy, which eased the Pope's breath-

ing problems somewhat but further impaired his ability to speak, marked an obvious and significant decline in his condition.

Less than a week after the operation, John Paul met at the Gemelli on March 1 with Cardinal Joseph Ratzinger, prefect of the Congregation for the Doctrine of the Faith (CDF), for a working session; the two spoke German and Italian, as was their usual custom, although John Paul could manage only a few sentences. Physical therapy to cope with the effects of the tracheotomy and the "larynx pathology," and to help him regain the capacity to speak, was under way; John Paul was being briefed daily on Vatican business, and spending time in a chair and in the small chapel near his room. On March 9, he received copies of the Polish edition of his new book, *Memory and Identity*, from Henryk Woźniakowski, president of the Kraków-based Znak publishing company and the son of an old friend. The bishops of Tanzania were in Rome for their *ad limina* visit on those days; on March 11, John Paul concelebrated Mass in his Gemelli chapel with Cardinal Polycarp Pengo of Dar-es-Salaam and Bishop Severine Niwemugizi of Rulenge, president of the Tanzanian bishops' conference. One of those present remembers the Pope's pain, his continuing difficulties breathing, his determination, and his composure, all of which combined to cause tears in his visitors. Even in his dramatically diminished circumstances, though, John Paul II remained himself: during this period of painful convalescence, according to Dr. Navarro-Valls, the Pope wrote on some notepaper, "I am always *Totus Tuus*" [Entirely Yours]—his papal motto, an expression of his dedication to the Virgin Mary and his willingness to put his life and his future in her hands.[9]

The Pope returned to the Vatican on the evening of Sunday, March 13, in another televised motorcade. He had managed a few words from the Gemelli window at the noontime Angelus that day, and the message read for him by Archbishop Sandri went out of its way to thank "so many people who work in the mass media . . . [for their] appreciated service, thanks to which the faithful in every part of the world can feel that I am closer . . ."[10] A camera mounted behind John Paul in the van that drove him home allowed the television audience to see what the Pope saw—crowds even larger than on his previous trip back from the Gemelli.

To some, it seemed that John Paul might defy the odds-makers yet

again. Hanna Suchocka, the Polish ambassador to the Holy See and a former Polish prime minister, saw things more clearly. Four days before the Pope's last return to the Vatican, she said to a friend, after the Lenten stational Mass at the Basilica of St. Paul Outside the Walls, "He is living his *via crucis*" [way of the cross]. The implication was unmistakable: those who loved him, indeed the entire Church, should walk the road to Calvary with him.

VIA CRUCIS

Back in his apartment on the top floor of the apostolic palace, the Pope's breathing difficulties continued; his voice was weak, and the physical struggle to breathe, to eat, and to speak was wearing down even this toughest of pilgrims. So, for the first time in his pontificate, John Paul II was unable to lead the Holy Week ceremonies in St. Peter's. On Palm Sunday, March 20, the outdoor Mass commemorating Jesus' triumphal entry into Jerusalem was celebrated by Cardinal Camillo Ruini, the Pope's vicar for the Diocese of Rome. John Paul appeared at the window of his study to bless the pilgrims below with an olive branch. His message, read by Archbishop Sandri, recalled the first World Youth Day, twenty years before, and asked the youth of the world to gather in Cologne in August for the Twentieth World Youth Day; the Magi, whose relics are venerated in Cologne Cathedral, would be "your guides on the way to that event."[11]

The next day, a rumor swept Rome that the Pope had died, fueled in part by what was now becoming painfully obvious: the Pope was fading. On Holy Thursday, the Chrism Mass for the blessing of the next year's holy oils was celebrated by Cardinal Giovanni Battista Re, prefect of the Congregation for Bishops; at the Holy Thursday evening Mass of the Lord's Supper, Cardinal Alfonso López Trujillo, president of the Pontifical Council for the Family, presided in place of John Paul and read a message from the Pope. The Good Friday liturgical service in the basilica was led by Cardinal James Francis Stafford. That evening, the traditional Way of the Cross was celebrated at the Roman Colosseum using meditations prepared by Cardinal Joseph Ratzinger; John Paul sat in his

chapel in the papal apartment, holding a large crucifix. A television camera had been placed in the rear of the chapel, so that he could be seen participating in the ceremony by TV. Some asked why the camera never showed the Pope's face; as had been the case for decades, John Paul was saying, in this distinctive way, "Don't look at me; look at Christ."

Cardinal Ratzinger was principal celebrant at the Easter Vigil Mass at St. Peter's; the Pope, who was watching the ceremony on television, sent a message that spoke of "this truly extraordinary night, in which the blazing light of the risen Christ definitively defeats the dark power of evil and death, and rekindles hope and joy in the hearts of believers." Through the Resurrection, John Paul wrote, "what was destroyed is rebuilt, what was aging is renewed and completely restored, more beautiful than ever, to its original wholeness"[12]—words with a particular poignancy in the circumstances.

On Easter Sunday, March 7, Cardinal Angelo Sodano celebrated the great Mass of Easter in St. Peter's Square. John Paul II appeared at the window of his study for the Regina Coeli blessing at noon, but, despite heroic efforts, was unable to speak. He blessed the crowd time and again, as if to communicate by gesture what he could not say in words. Just before the Pope's appearance, Cardinal Sodano read the traditional *urbi et orbi* Easter Message [to the city and the world]. Written in a kind of free verse with italicized emphases, as had become John Paul's custom, it was a lyrical profession of Easter faith and human solidarity by a pastor who remained, in his heart, a poet:

> 1. *Mane nobiscum, Domine!*
> Stay with us, Lord! [cf. Luke 24.29]
> With these words, the disciples on the road to
> Emmaus invited the mysterious Wayfarer
> to stay with them, as the sun was setting
> on that first day of the week
> when the incredible had occurred.
> According to his promise, *Christ had risen;*
> but they did not yet know this.
> Nevertheless, the words spoken by the Wayfarer
> along the road made their hearts *burn within them.*
> So they said to him: "Stay with us."

Seated around the supper table,
they recognized him in the "breaking of bread"
—and suddenly he *vanished.*
There remained in front of them *the broken bread,*
There echoed in their hearts the
gentle sound of *his words.*

2. Dear brothers and sisters,
the *Word* and the *Bread* of the Eucharist,
the mystery and the gift of Easter,
remain down the centuries as a constant memorial
of the Passion, Death and Resurrection of Christ!
On this Easter Day,
together with all Christians throughout the world,
we, too, repeat those words:
Jesus, crucified and risen, *stay with us!*
Stay with us, faithful friend and
sure support for humanity
on its journey through history!
Living Word of the Father,
give hope and trust to all who are searching
for the true meaning of their lives.
Bread of Life, nourish those who hunger
for truth, freedom, justice and peace.

3. Stay with us, *Living Word of the Father,*
and teach us words and deeds of peace:
peace for our world consecrated by your Blood
and drenched in the blood of
so many innocent victims:
peace for the countries of the
Middle East and Africa
where so much blood continues to be shed;
peace for all humanity,
still threatened by fratricidal wars.
Stay with us, *Bread of eternal life,*
broken and distributed to those at table:
give us also the strength to show
generous solidarity

> towards the multitudes who are even today
> suffering and dying from poverty and hunger,
> decimated by fatal epidemics
> or devastated by immense natural disasters.
> By the power of your resurrection,
> may they too become sharers in new life.
> 4. We, the men and women of the
> third millennium,
> we too need you, Risen Lord!
> Stay with us now and until the end of time.
> Grant that the material progress of peoples
> may never obscure the spiritual values
> which are the soul of their civilization.
> Sustain us, we pray, on our journey.
> In you do we believe, in you do we hope;
> for you alone have the
> words of eternal life [cf. John 6.68].
> *Mane nobiscum, Domine!* Alleluia![13]

Three days later, on Wednesday, March 30, the drumbeat along John Paul's personal *via crucis* grew louder; he was fitted with a nasal feeding tube, as swallowing food had become almost impossible. The following evening, Dr. Navarro-Valls's press statement said that the Pope was running a high fever caused by a urinary tract infection, and was being treated in his apartment with antibiotics; perhaps sensing the end coming, the Pope had decided to stay home rather than return to the Gemelli, and had received the sacrament of the anointing of the sick. As crowds began to gather to hold vigil in St. Peter's Square, the 11:30 a.m. press briefing on April 1 described the Pope's condition as "very grave"; John Paul had suffered "septic shock" (a poisoning of the circulatory system), which had caused a dramatic collapse in his blood pressure. That morning, the Pope, fully aware of his circumstances, had concelebrated Mass while remaining in bed; he had then asked that the Stations of the Cross, the Church's traditional fourteen meditations on the passion of Christ, be read to him. Every Friday, since his youth, Karol Wojtyła had prayed the stations; now, on what seemed likely to be the last Friday of his earthly life, he prayed them again as best he

could, making the sign of the cross on his sickbed as each station was announced. The Pope remained, as Navarro-Valls put it, "extraordinarily serene."

Around the world, as a kind of global prayer vigil spontaneously unfolded, the thought occurred to more than one person who knew Karol Wojtyła well: "He's going to die on Divine Mercy Sunday." The Divine Mercy devotion began in Poland through the visions of a young nun, Sister Faustina Kowalska, in the 1930s; in her mystical experiences, she came to understand that mercy was the face that God was turning toward the world at a moment of particular cruelty and wickedness. As archbishop of Kraków, Karol Wojtyła had championed the cause of Sister Faustina, clearing up misunderstandings about her writings in Rome; as pope, he had fostered the Divine Mercy devotion throughout the world. And on April 30, 2000, he had canonized Sister Faustina Kowalska as the first saint of the Church's third millennium, underscoring his own conviction that the face of the merciful Father was the dimension of God's infinite goodness most urgently sought by a 21st-century world of prodigal sons and daughters. At the canonization, John Paul had declared that the Second Sunday or Octave of Easter would be observed throughout the world as Divine Mercy Sunday. If, as the Book of Ecclesiastes suggests, there is "a time to be born and a time to die" [Ecclesiastes 3.2], no day could have been more appropriate for Karol Wojtyła to die than Divine Mercy Sunday.

On the night of April 1, Cardinal Camillo Ruini, the vicar of Rome, celebrated a Mass for the Pope at the Basilica of St. John Lateran, John Paul's cathedral as Bishop of Rome, and indicated that the end was near: "The Holy Father," he suggested, "can already touch and see the Lord."[14]

John Paul had one more message, though, this time for the young people who had been his special care and special love—and who were now gathered in prayer outside his apartment window in St. Peter's Square. As his life slowly ebbed away on April 2, he tried over and over to say something, according to Navarro-Valls. Those present, the papal spokesman said, had finally understood: John Paul was saying to the young who were praying for him a few hundred yards away, "I have sought you out. Now, you have come to me. I thank you."

At about three-thirty that afternoon, a desperately weakened John

Paul said, in Polish, "Let me go to the house of the Father." The Pope lapsed into a coma at about five p.m., and according to Polish custom, a small candle was lit in the twilight of the papal bedroom, a beacon for the final journey. At eight p.m., Archbishop Stanisław Dziwisz, the Pope's secretary and confidant who had been in his service for almost forty years, celebrated the Vigil Mass for the Octave of Easter at the foot of the Pope's deathbed. In Catholic custom, following Jewish tradition, a liturgical day begins in the evening of the previous calendrical day, so it was, in liturgical fact, Divine Mercy Sunday—the last day of the week-long continuation of Easter Sunday through its "octave." The Pope died shortly after the Mass had ended, on the day given to meditation on God's paternal mercy, as he might have wished. Stories circulated that John Paul II's last word, as the Mass concluded, had been "Amen." Those who had lived through this final drama in the dramatic life of Karol Józef Wojtyła knew that, spoken or unspoken, he had died an "Amen" as he had lived an "Amen" for the twenty-six years, five months, and seventeen days of one of the most remarkable pontificates in two millennia.[15]

As the news cascaded around the world, millions felt orphaned. In a world bereft of paternity and its unique combination of strength and mercy, John Paul II had become a father to countless men and women living in an almost infinite variety of human circumstances and cultures. That radiation of fatherhood, which was rooted in the Pope's singular capacity to preach and embody the Christian Gospel, would lead history to know him as "John Paul the Great," according to the Australian cardinal George Pell.[16] Yet as millions of those whose lives he had touched made hurried plans to come to Rome to mourn him, the question inevitably posed itself: What kind of Church had John Paul II left behind?

The Church That
John Paul II Left Behind

TRADITION—AND THE *Annuario Pontificio*, the Vatican yearbook—
make no judgment on the length of St. Peter's pontificate (which, in
Peter's case, is an anachronistic notion anyhow). The longest papacy on
the historical record was that of Blessed Pius IX, who reigned for almost
thirty-two years, dying in 1878. Thus John Paul II's was the second
longest pontificate for which there is reliable historical data. In the days
after his death, some analysts calculated that, of the more than one bil-
lion Catholics on the planet, at last half had known no other pope.

The statistical summary of the pontificate, released by the Vatican,
was nothing less than staggering. More than 17.6 million pilgrims had
participated in John Paul's Wednesday general audiences (of which
there had been more than 1,160). Eight million pilgrims had come to
Rome during the Great Jubilee of 2000 alone. The number of people
who had seen John Paul II around the world was, literally, uncountable;
he had, among other spectaculars, gathered two of the largest crowds
in human history, at least 5 million in Manila in 1995 and perhaps 10
million or more in Mexico City in 2002. Whatever the aggregate fig-
ure might be, there was no doubt that Karol Wojtyła had been seen
live by more human beings than any man in the history of the world.

One reason for that was, of course, his travels, which he insisted on
calling "pilgrimages." They had become so familiar, as had the idea of
an itinerant pope, that their novelty may have been forgotten. In the
late 1950s, it had been thought marvelous that John XXIII had left the

Vatican to visit a Roman prison a few blocks away, and virtually mirac-
ulous that he had traveled by train to the shrine of Loreto. Pope
Paul VI had been bolder, going to the United Nations, Uganda, the
Philippines, Australia, and the Holy Land. John Paul II's global evange-
lism, which took the Pope out of Rome for more than a tenth of his
pontificate, was different by several orders of magnitude: 104 pastoral
visits outside Italy, 146 within Italy. In twenty-six years, he traveled
more than 720,000 miles, the equivalent of thirty circuits of the globe
or three times the distance from Earth to the moon. His travels were
not simply global or national, however; John Paul insisted on visiting
his flock when he was *in* Rome. For decades, a map of the Diocese of
Rome was mounted on the back wall of the Pope's bedroom, with pins
to mark each parish the Bishop of Rome had visited. By the end, there
were 317 pins on the map; John Paul, who invited parishes into the
Vatican for Sunday Mass when his infirmities made it impossible for
him to go to them, had fallen sixteen short of his goal of visiting every
parish in his diocese.

His travels would remain in the memories of tens of millions of
human beings for decades, the stories being passed down from genera-
tion to generation of "the day I saw the Pope" or "the day I met the
Pope." Even as those memories faded with the passing of generations,
John Paul II's magisterium—the body of authoritative teaching he
crafted—would continue to shape Catholic thought for centuries. He
wrote fourteen encyclicals, eleven apostolic constitutions, fifteen apos-
tolic exhortations, and forty-five apostolic letters.[1] His magisterium
also included a myriad of messages, addresses, and letters, not to men-
tion thousands of homilies, *ad limina* addresses to bishops, and formal
remarks to heads of state or ambassadors (during the pontificate, he
held 738 audiences for heads of state and 246 with prime ministers or
other heads of government). The authoritative collection of his teach-
ing, the *Insegnamenti Giovanni Paolo II* [Teachings of John Paul II], covers
more than thirty linear feet of shelf space. Yet the multi-volume *Inseg-
namenti* do not exhaust the literary output of John Paul II. For, breaking
new papal ground (and causing no little consternation among the tradi-
tional keepers of popes), he had retained a kind of personal right of lit-
erary initiative, publishing the international bestseller *Crossing the
Threshold of Hope* in 1994, and two volumes of memoirs—*Gift and Mys-
tery: On the Fiftieth Anniversary of My Priestly Ordination* in 1996 and "Rise,

Let Us Be on Our Way," a reflection on his life as a bishop, in 2004. *Memory and Identity*, a philosophical dialogue with two Polish colleagues, was edited over several years and published in 2005, shortly before the Pope's death. *Roman Triptych*, a three-paneled set of poems, had been published the year before.

That every Christian is called to be a saint was a recurring theme of his preaching and teaching. John Paul II gave effect to his conviction that God was wonderfully profligate in making saints in fifty-one canonization ceremonies (during which 482 new saints were proclaimed) and 147 beatification ceremonies (often outside Rome), during which 1,338 men and women were brought to the last stage before sainthood. These canonizations and beatifications often coincided with pastoral pilgrimages abroad, or major meetings in Rome, of which there were more than plenty: John Paul presided over fifteen Synods of Bishops (eight involving regional or national episcopates, the other seven involving representatives of all the bishops of the world). He was also the greatest creator of cardinals in Church history (231 named, with one reserved *in pectore*: the name withheld, presumably out of concern for governmental reprisal). Far more than his predecessors, John Paul used the College of Cardinals as a kind of ecclesiastical senate, summoning them to six plenary meetings. He also expanded the custom of honoring with the red hat older Catholic theologians of great accomplishment (e.g., Henri de Lubac, S.J.; Yves Congar, O.P.; and Avery Dulles, S.J.) and other distinguished churchmen in their golden years. Of perhaps more consequence for the long-term life of the Church were the 3,995 bishops John Paul II appointed—in effect, a complete remaking of the Catholic hierarchy in the course of the pontificate.

The numbers are impressive, even stunning. Beneath and beyond the numbers, however, it was not unreasonable, only respectful, to ask, at the Pope's death: What had happened? What was the John Paul II difference?

CHRISTIAN FEARLESSNESS

It was a pontificate of singular . . . well, single-mindedness. From the beginning, John Paul II had made clear that the great theme of his pa-

pacy would be Christian humanism. In answer to the crisis of confidence that had beset various worldly humanisms throughout the 20th century—crises of confidence that had often had spectacularly lethal consequences—the Church would propose Christ, the image of true humanity.

Karol Wojtyła had been thinking about those crises for a long time, when he formally inaugurated his Petrine ministry on October 22, 1978. He had known the effects of one deformed, ultramundane humanism—Nazism—in his bones and in his spirit. He had fought tenaciously and deftly against communism, another failed humanism worshiping a false god. Before Vatican II, in answer to a Vatican request (sent to all the world's bishops) for agenda items for the forthcoming Council, he had sent a meditation on the spiritual cul-de-sac in which humanity found itself, six decades into the 20th century. It was a century that had begun with high hopes of great civilizational achievement; yet within sixty years, the 20th century had produced two world wars, three totalitarian systems, mountains of corpses, oceans of blood, the greatest persecution of the Church in history—and now, a Cold War that threatened global annihilation. What had happened?

What had happened, Wojtyła suggested, was a crisis in the order of ideas: the *idea* of the human, the idea of the human person, had gone off the rails. Married to modern technology, defective ideas of the human person had produced a chamber of horrors whose emblematic ghouls were Lenin, Stalin, Hitler, and Mao Zedong—the most accomplished mass murderers in human history. History had demonstrated that anthropology without God—humanity without God—meant the end of humanism, and just possibly the end of humanity. What should be done? The answer to the crisis of ultramundane humanism, Wojtyła proposed, was Christian humanism: a rediscovery of the inalienable dignity and infinite value of the human person, which the Church saw in the face of Christ, the incarnate Son of God who reveals the truth about the human and our capacities, under grace, for glory.

That was the conviction that carried Karol Wojtyła through the Second Vatican Council and inspired his leadership in shaping several of its texts; that was the conviction he sought to buttress philosophically in his major (if unfinished) intellectual work, *Person and Act*; and that was the conviction that both launched his papacy and gave it di-

rection for more than a quarter-century.[2] That Christ revealed both the face of the merciful Father *and* the truth about our humanity was the conviction that led John Paul to cry out, at his installation Mass, "Be not afraid! Open the doors to Christ!" It was the challenge of Christ to his disciples; and it was the challenge that the 264th Vicar of Christ put before the Church and the world at the very outset of his public ministry:

> Be not afraid to welcome Christ and accept his power. Help the Pope and all those who wish to serve Christ and with Christ's power to serve the human person and the whole of mankind.
>
> Be not afraid! Open wide the doors for Christ. To his saving power open the boundaries of states, economies, and political systems, the vast fields of culture, civilization, and development.
>
> Be not afraid! Christ knows "what is in man." He alone knows it . . . I ask you . . . I beg you, let Christ speak to [you]. He alone has words of life, yes, eternal life.[3]

To carry this message of Christian fearlessness to the world, the Church had to reimagine itself: not only as a religious institution (although its institutional forms were important), but also as an evangelical movement, living the new Pentecost that John XXIII had hoped the Second Vatican Council would inspire. Somehow, the Council had triggered a seemingly endless debate about the institutional dimension of the Church, and particularly about power within the institution; yet the purpose of the Council, as John Paul II understood it, was to give the Church a new burst of evangelical and missionary energy on the cusp of the third millennium of Christian history. Mission is not one of the Church's functions, beside sundry other functions; the Church does not *have* a mission, the Church *is* a mission—a mission to be served by its institutional structures. That was why the structures were important: not because they provided career opportunities, but because they made the Church's mission—converting the world and healing its wounds— possible.

If the Church was to reimagine itself, according to the teaching of Vatican II, as an evangelical movement engaging the world in order to propose to it the good news of Jesus Christ, then the papacy, the cen-

ter of the Church's unity, also had to be renewed. But how? In renovating the papacy in order to provide the entire Church with an example of evangelical energy and outreach, John Paul II reached back into the New Testament, to the Last Supper scene in Luke's gospel account. There, Jesus turns to Peter, the all-too-human "rock" who is usually making a muddle of things, and says, ". . . I have prayed for you that your faith may not fail; and when you have turned again, strengthen your brethren" [Luke 22.32]. For John Paul, this was not merely an injunction of Jesus to Peter, erstwhile Galilean fisherman; to strengthen the brethren was, as Karol Wojtyła understood it, a dominical command to every one of Peter's successors. That was why he took the papacy on the road—in order to strengthen the brethren, Peter had to be present to the brethren in the myriad circumstances of their lives, not only as a fixed reference-point in Rome.

For twenty-six and a half years, the proclamation of Christian fearlessness and the summons to renew cultures, societies, polities, and economies on the basis of Christian humanism had been John Paul II's program. It took as its focal point (or "key," a favorite John Paul II image) the Great Jubilee of 2000. For John Paul, the Jubilee was not to be understood as a kind of global birthday party for the Church's Lord, although deepening the Church's understanding of the mystery of the Incarnation was surely at the center of the Jubilee celebrations. The strategic purpose of the Great Jubilee of 2000 was to launch the Church "into the deep" of a new evangelization, as the Pope put it in his apostolic letter closing the Great Jubilee, *Novo Millennio Ineunte* [Entering the New Millennium]. If the Church stayed in the shallows, minding the institutional shop, it wouldn't be or do much; more grievously, it would fail its Lord. Having reminded itself on the two thousandth anniversary of the Incarnation that all things are indeed possible with God, the Church had to get out of the shallows and put out into the deep of the modern world and the post-modern world and whatever other worlds humanity found itself in. Why? Not so much to argue as to propose. "The Church proposes, she imposes nothing," John Paul had written in one of his major encyclicals.[4] And to propose what? To propose Jesus Christ as the answer to the question that is every human life. That was the proposal the Pope was convinced the world was waiting for, out there in the deep of individual lives, as well as in cultures and societies.

That was the proposal a renovated papacy had to make, to inspire a Church renewed in evangelical energy to do the same.

John Paul's colossal effort at global evangelism will be assessed for centuries. It is not without interest that the Rev. Billy Graham, the only other plausible contender for the title, said, on John Paul II's death, that Karol Wojtyła had been *the* great Christian witness of the century. Beyond his personal witness, though, was the question of his impact on the Church. John Paul's had been a pontificate of epic accomplishments; it was also marked by troubling frustrations and ambiguities. Together, the accomplishments, the frustrations, and the ambiguities cast light on the Church that John Paul II left behind—as well as on the work that this most energetic of popes left the rest of the Church, and his successor in the See of Peter, to do.

EPIC ACCOMPLISHMENT

An unprecedented magisterium

Ideas have consequences—especially in the Church. John Paul II was a man of consequential ideas. As suggested above, the late Pope left behind a vast body of teaching, which the Church and the world will be digesting for centuries. Virtually no great issue on the agenda of either the Church or the world went unaddressed in John Paul's encyclicals, apostolic letters, apostolic exhortations, and public addresses. Choosing the highlights in such a staggering mass of material is, inevitably, an exercise in idiosyncrasy; but perhaps most analysts would agree on the following as the teaching texts of John Paul II likely to have the most enduring impact, pastorally or intellectually:

His inaugural encyclical in 1979, *Redemptor Hominis* [The Redeemer of Man], was the first papal encyclical ever devoted to Christian anthropology—to unpacking the Christian view of the human person. As the late Cardinal James Hickey of Washington, D.C., often remarked, *Redemptor Hominis* provided the "program notes" for the entire pontificate. As such, and in its own right as an exploration of what it means to be a human being in full, it will be read with interest long into the future.

Dives in Misericordia [Rich in Mercy], the 1980 encyclical on God the Father inspired in part by Sister Faustina Kowalska and her visions of the divine mercy, was the second panel of John Paul's trinitarian trip-tych of encyclicals, which he completed with the dense and challeng-ing 1986 letter, *Dominum et Vivificantem* [Lord and Giver of Life], on the Holy Spirit.

John Paul's inaugural social encyclical, *Laborem Exercens* [On Human Work], was the first encyclical in the tradition of papal social teaching to reflect its author's own experiences of manual labor, and the first to look to a poet, Cyprian Kamil Norwid, as a theological inspiration. Together, the Pope's experiences and the poet's reflections led to a rich portrait of the working person, in which work was understood not so much as a punishment for original sin but as a human participation in God's ongo-ing creativity. The third social encyclical, *Centesimus Annus* [The Hun-dredth Year], was written in 1991 for the centenary of Leo XIII's groundbreaking *Rerum Novarum* [New Things], which began modern Catholic social teaching. *Centesimus Annus* offered a penetrating analysis of the free and virtuous society in its three component parts—democratic political community, free economy, vibrant public moral culture—and emphasized the centrality of culture to democracy and the market. At the level of analysis and prescription, the encyclical also took the Catholic Church far beyond quests for a third way that was somehow neither socialist nor capitalist. *Evangelium Vitae*, the 1995 encyclical on "The Gospel of Life," is not usually understood as a social encyclical, but could well be taken that way; its insistence on the inviolability of inno-cent human life, and its authoritative rejection of abortion and euthana-sia, identify crucial moral issues in themselves, and for the free and virtuous society.

Redemptoris Missio [The Mission of the Redeemer] was largely ig-nored at its 1991 publication because *Centesimus Annus*, which dealt with topics of greater interest to the world media (like politics and economics), was issued shortly after. That is a shame, for *Redemptoris Missio* may be one of John Paul's most consequential documents, with its description of the Church *as* a mission and its identification of the Areopagi, the Mars Hills, of contemporary culture as fertile fields for evangelization.

Ut Unum Sint [That They May Be One], the 1995 encyclical on

Christian unity (and the first encyclical ever devoted to that topic), could help invigorate the ecumenical movement in the 21st century. In any event, it was notable for calling ecumenism back to its original focus on a common creed, baptism, Eucharist, and ministry, a goal that was getting lost in the late 20th century.

Then there were John Paul's two encyclicals on the intellectual life. *Veritatis Splendor* [The Splendor of Truth], was the Pope's 1993 effort to reform Catholic moral theology. Its insistence that there are certain things that are always and everywhere wrong, regardless of intentions or circumstances, seems likely to provide an ever-more-welcome reference point in a world given more and more to moral judgments based on mere utility, or even the abdication of moral judgment in radical moral relativism. In that sense, *Veritatis Splendor* was John Paul II's last commentary on (and condemnation of) the totalitarian systems of the 20th century, which had demonstrated that if there is no such thing as *the* truth (especially about the human person), then anything goes—and what goes, literally, are the weak, the vulnerable, the "other." Similarly, *Fides et Ratio* [Faith and Reason], issued in 1998, will be read long into the future as a robust defense of the human capacity to know the truth of things, even if we can never know the truth of things completely. Two and a half centuries after the French Enlightenment dismissed the Church in the name of reason, it was the Catholic Church that defended the capacities and prerogatives of reason. Voltaire must have been spinning in his grave; but then Voltaire (despite his friendly correspondence with the 18th-century humanist pope Benedict XIV) never imagined a pope quite like John Paul II.

If John Paul's encyclicals frequently addressed issues on the world's agenda (and created vigorous public debates in the process), the apostolic exhortations he wrote to complete the work of several world Synods of bishops were aimed at completing the Second Vatican Council's reform of the internal life of the Church. Thus *Christifideles Laici* [Christ's Faithful Lay People, issued in 1988] was a charter for the lay apostolate in the world, as *Pastores Dabo Vobis* [I Will Give You Shepherds, 1992] established patterns for the reform of Catholic seminaries, and *Vita Consecrata* [The Consecrated Life, 1996] set standards for the reform of religious orders. *Familiaris Consortio* [The Community of the Family, 1981] defended the centrality of family life in human civilization, a

matter of concern to both the Church and the world and a core theme of John Paul II's preaching around the globe.

The Pope's personality—his theological and philosophical personality, and his pastoral personality—shone readily through his apostolic letters. *Salvifici Doloris* [Redemptive Suffering] was issued in 1984, six weeks after the Pope met his would-be assassin, Mehmet Ali Agca, in Agca's Roman prison cell. Suffering, the Pope taught, summoned forth aspects of our humanity that would otherwise remain dormant; suffering built communities of friendship and solidarity that might otherwise remain unbuilt; above all, suffering conformed the Christian to Christ in a special way. Coming from a man who knew what it was to suffer, physically and spiritually, it was a powerful message to a world that often regarded suffering as an absurdity or a problem to be solved technologically—even by euthanizing the suffering. *Mulieris Dignitatem* [The Dignity of Women, 1988] was the first formal exercise in John Paul II's papal feminism, and is sure to be discussed and debated for a very long time. Perhaps the most lyrical of John Paul's teaching documents were the two apostolic letters that served as bookends for the Great Jubilee of 2000. *Tertio Millennio Adveniente* [The Coming Third Millennium, 1994] proposed that the Incarnation was the revelation of true humanism and thus an axial moment of universal significance: here, in the Son of God, eternity entered into time, and the truth about time came into focus—time is not tedious chronology, but adventure and drama. Those who grasped that could prepare a new springtime of the human spirit. *Novo Millennio Ineunte*, issued in 2001, has been mentioned previously, with its biblically charged challenge to the Church to "put out into the deep" of a new evangelization. In one of the most revealing personal passages in his magisterium, John Paul wrote in "Entering the Third Millennium" of standing at the window of the papal apartment, watching the endless lines of crowds queued up to walk through the Holy Door during the Great Jubilee; every one of those faces, the Pope noted, reflected some aspect of the face of Christ, who had died so that each of those pilgrims might have eternal life.

John Paul II made his most original contribution to Catholic thought, and perhaps to world culture, in a series of general audience addresses between September 1979 and November 1984. Together,

these 129 texts are the most coherent and compelling Christian response to the sexual revolution ever articulated. Known now as John Paul's theology of the body, their rereading of the great themes of Christian life (including the nature of God himself) through a deep reflection on human embodiedness as male and female is already reshaping Catholic pastoral practice, in marriage-preparation and counseling. It also seems likely to help give Catholic theology as a whole a more sacramental cast of mind in the decades ahead, with nuptial giving and receptivity reminding the Church of the many other ordinary realities of life that become extraordinary vehicles of grace. Taken with the seriousness it deserves, the theology of the body can also be read in an ecumenical and inter-religious light, as yet another facet of John Paul's comprehensive response to the crisis of ultramundane humanism.

Thus, in the second volume of the theology of the body, *Blessed Are the Pure of Heart*, the Pope proposed that the self-giving and receptivity of male and female in sexual love makes visible the built-in moral structure of the human person: the law of the gift, or self-giving, as the path to human flourishing. Ultramundane humanisms imagine human beings to be endlessly plastic and malleable; yet that leads, ultimately, to the manipulation of the human for purposes of power. A truer humanism, the Pope argued, recognizes that certain truths are built into the human condition; that those truths are unveiled by a serious reflection on what it means to be sexual beings, created male and female; and that human flourishing, and genuine freedom, requires us to live out those truths, rather than ignore them as impositions from some outsider authority.

At the beginning of the pontificate, the world—and a lot of Catholics—thought the Church had nothing of interest to say about human sexuality. The Pope's teaching that sexual love within the bond of faithful and fruitful marriage is an icon of the interior life of God reversed the polarities. Now, the Catholic Church could say to the promoters of the sexual revolution, "You think of sex as another contact sport. We think of sex as a revelation of the deepest truths about the human and the divine. Who takes sex more seriously?"

Because the Church and the world will be wrestling with the thought of John Paul II for centuries, his magisterium constitutes what may be the most consequential and influential body of papal teaching since the Reformation—and perhaps in the entire second millennium of Christian

history. His thought was not without its tensions and ambiguities, however, and the debate over John Paul II's way of doing theology will continue. John Paul's distinctive philosophical personalism—his intense focus on the human person as the starting point for serious reflection on just about any topic—cast new light on ancient questions ranging from sexual morality to the nature of our encounter with Christ the Lord. Christian personalism also shaped the Pope's approach to ecumenism and to the Catholic-Jewish dialogue, as it bent his thinking about politics, economics, culture, and education in a distinctive direction that gave new energy to perennial truths and led to fresh intellectual discoveries. Even during the pontificate, though, questions were raised about the suitability of the personalist approach to issues involving state power (like the just war tradition or the death penalty) and the last things (including the question of the Last Judgment and the possibility of eternal damnation).[5] The debate seems likely to be a vigorous one, which will itself extend the intellectual legacy of John Paul II far into the future.

Keys to the Second Vatican Council

When John Paul II was elected in 1978, the bright promise of the Second Vatican Council (which had only been concluded thirteen years before) had dissipated into an acrimonious set of dispiriting and de-energizing squabbles, largely involving the exercise of authority within the Church. A Council intended to be a new Pentecost preparing the Church for a springtime of 21st-century evangelization and service—a Council, to use the conventional trope, that opened the Church's windows to the modern world—had, paradoxically, turned Catholic energies inward in a kind of ecclesiastical civil war. In part, this was a function of the times, the late Sixties not being the calmest of cultural moments in the West—especially for reflecting on the relationship between traditional authority and personal freedom. But the rugged reception of Vatican II was also a function of the Council itself.

Previous ecumenical councils had provided keys to their interpretation by writing creeds (like the Nicene-Constantinopolitan Creed Catholics recite at Mass every Sunday), by legislating canon laws, or by condemning heresies. Vatican II offered no such keys to its sixteen

documents: it wrote no creed, condemned no one, and added nothing to the Code of Canon Law.[6] The question of the authoritative interpretation of the Second Vatican Council was thus left open—and, given the temper of the times, that openness inevitably led to controversy, and sometimes to bitter acrimony.

One way to think of the extraordinarily wide-ranging magisterium of John Paul II is to imagine John Paul's teaching as a set of keys for unlocking and understanding the teaching of Vatican II. Every item on the Council's agenda—the nature of the Church and of divine revelation; the renewal of the office of bishop; the reform of the priesthood, seminaries, and consecrated religious life; the lay vocation; ecumenism and inter-religious dialogue; Catholic education; religious freedom and related questions of the nature of the just state; the Church's missionary activity; the renewal of moral theology—received an authoritative interpretation in one or another document of John Paul II's extensive magisterium, just as the encyclical *Redemptor Hominis* helped clarify the crucial anthropological issues in the modern world the Council intended to engage. Thus the encyclical *Redemptoris Missio* offered a key to understanding and interpreting the Council's text on missions, *Ad Gentes Divinitus* [To the Nations], as the encyclical *Veritatis Splendor* offered a key to the otherwise unexplicated call in the Council's Decree on the Training of Priests for a renewal of Catholic moral theology. Similarly, the apostolic exhortations *Christifideles Laici* and *Vita Consecrata* were keys to the authoritative interpretation of the Council's teaching on the lay vocation [*Apostolicam Actuositatem*, Apostolic Activity] and the consecrated life of poverty, chastity, and obedience [*Perfectae Caritatis*, Perfect Charity]. The list could be multiplied, but the point is clear: coming to the papacy as a young and vigorous man of fifty-eight—and, perhaps more important, as a bishop who had played a significant role at the Council and who had led a thoughtful and successful implementation of Vatican II in Kraków—John Paul II systematically set about the task of creating keys to the entire corpus of the Council's teaching, which he believed had not been sufficiently learned by the Church. In doing so, he helped rescue the genuine teaching of Vatican II from the slippery hermeneutic of the "spirit of Vatican II" and from the crossfire of the ecclesiastical tong-wars.

Some might argue that the one exception to this pattern of pro-
viding keys to Vatican II was in the liturgy, the most neuralgic aspect
of the Council's implementation, at least in the English-speaking
world. Evidence to the contrary can be found in the 1980 apostolic
letter *Dominicae Cenae* [The Lord's Supper] and the 2004 encyclical *Ec-
clesia de Eucharistia* [The Church from the Eucharist]. Both documents
stressed the Eucharist as sacrifice and sacred meal; both underscored
the Catholic belief in the Real Presence of the living Christ in the
consecrated bread and wine of the Eucharist; both reiterated the
Church's belief that the priest celebrating the Eucharist does so *in per-
sona Christi*—in the person of Christ, not simply as the overseer of a
worshiping congregation; both urged that the Mass be celebrated in
a dignified manner, as an appropriate witness to Christ's presence in
the worshiping community, the priest, and the Eucharistic bread and
wine; and both urged Eucharistic adoration outside Mass as a means
of strengthening the Church's sacramental piety. These were the core
theological issues involved in the controversies over implementing the
liturgical renewal mandated by Vatican II. John Paul may have judged
that establishing these basic principles set a secure foundation on
which, at the practical level (translations, music, art and architecture,
liturgical style, etc.), the "reform of the reform" of the liturgy could
proceed apace.

Throughout the Church's history, ecumenical councils have been
held amid controversy and followed by controversy; in that sense, Vat-
ican II was no exception. But the nature of the controversy after Vati-
can II, centering as it did on the question of authority, threatened to
unravel the Council's achievement. With the keys provided by the
magisterium of John Paul II, the full and authoritative implementation
of Vatican II has a better chance of success in the early 21st century
than it did when Karol Wojtyła was elected to the Chair of Peter in
1978.

In play in the world

During World War I, Pope Benedict XV—the Genoese patrician in
whose pontificate Karol Wojtyła was born—tried unsuccessfully to

offer the Holy See's services as a mediator in the conflict that was tearing Europe apart. The powers of the day weren't interested; the papacy remained on the sidelines; and, as Aleksandr Solzhenitsyn and others have remarked, Europe proceeded to commit civilizational suicide.[7]

Slightly more than a half-century later, the papacy was in play in world politics to the point where a reigning pope had a greater impact on the unfolding of world events than popes had had in centuries. By the testimony of no less an observer than Mikhail Gorbachev, last president of the late Soviet Union, John Paul II was the crucial figure in what the world has come to know as the Revolution of 1989 in east central Europe—a revolution that reached its logical conclusion with the crack-up of the Soviet Union itself in 1991. By igniting a revolution of conscience in Poland during his epic first pilgrimage home in June 1979, John Paul created the cultural, moral, and psychological conditions for the possibility of a nonviolent overthrow of communist power—something the realist school of international relations theory couldn't have imagined possible. Yet John Paul's world-historical effects were felt not only in his native part of Europe. He helped inspire—and certainly encouraged—the People Power Revolution of 1985–86 that replaced the Marcos dictatorship in the Philippines. He encouraged the democratic transformation of South Korea. And by challenging both entrenched mercantilist and militarist oligarchies and *Marxisant* revolutionary clergy in Latin America, he helped create the circumstances in which Central and South America made their own transitions to democracy.[8]

John Paul II made another significant and successful intervention in world politics in the run-up to the Cairo World Conference on Population and Development in 1994. The United Nations bureaucracy, aided and abetted by the Clinton administration in the United States, was determined to see abortion-on-demand declared a fundamental human right at Cairo; the Pope was just as determined that no such moral atrocity, as he understood it, take place. Throughout the summer of 1994, the Pope mounted a global public relations campaign—through his weekly general audience addresses and his Sunday Angelus addresses—that challenged the Cairo draft document's view of the family, women, children, and the relationship of population to economic development. In March 2004, John Paul had sent a personal letter to all the world's heads

of state, as well as to the U.N. secretary-general, deploring the draft document's radical individualism, its contempt for the family, its diminished sense of human possibility, and its support for an unrestricted abortion right that trumped all other rights. But the Pope did not limit himself to appeals at this level. By going above and around governments in a direct appeal to the peoples of the world, John Paul helped create pressures that presidents, prime ministers, and legislators could not ignore. As a result, abortion was not declared a basic human right at Cairo, much to the annoyance of some.

John Paul had less success rallying Europe's leaders to do something about the genocide in southeastern Europe, as the former Yugoslavia fell apart in the early 1990s. Deeply concerned about the fate of minority Christian communities in a Middle East increasingly marked by Islamist extremism, he tried to forestall the Iraq Wars of 1991 and 2003, without success. And, as noted above, his interventions in Europe's constitutional debates in 2003–04 did not succeed in preventing the draft Euro-constitution from ignoring the Christian roots of European civilization and attempting to establish secularism, de facto if not de iure, as the official ideology of the European Union. Still, his diplomatic record remains impressive. The papacy had long claimed a universal reach, and several of the popes of the 20th century thought of themselves as providing a kind of universal moral reference point for reflection on world affairs. John Paul II gave that claim and that self-image real traction in history.

He also put the papacy back in play in international affairs at the level of ideas. His first address to the U.N. General Assembly, in October 1979, insisted that all politics, including world politics, was under moral scrutiny, and boldly challenged totalitarian power on the terrain of human rights, particularly the right of religious freedom—which he defended, not as the head of a religious institution but as a moral philosopher determined to nail down a crucial point about just governance. That address established beyond doubt that the Catholic Church had embraced the cause of human freedom, and that the Church's primary goal in world affairs was the defense and promotion of fundamental human rights.[9] The second U.N. address, in October 1995, defended the universality of human rights at a time when the very idea of "human rights" was being dismissed as a cultural peculiarity

of the West by east Asian autocrats, Islamist extremists, the world's remaining communists—and some post-modern French, German, and American intellectuals. The address concluded with a ringing and profoundly moving declaration of John Paul's faith in the human future:

We must not be afraid of the future. We must not be afraid of man. It is no accident that we are here. Each and every human person has been created in the "image and likeness" of the One who is the origin of all that is. We have within us the capacities for wisdom and virtue. With these gifts, and with the help of God's grace, we can build in the next century and the next millennium a civilization worthy of the human person, a true culture of freedom . . . And in doing so, we shall see that the tears of this century have prepared the ground for a new springtime of the human spirit.[10]

And with that, it might be said, the transition from Pope Pius IX and the last item in his Syllabus of Errors—which condemned the proposition that "the Roman Pontiff can and should reconcile himself to and agree with progress, liberalism, and modern civilization"—was complete. The Church would not be an uncritical celebrant of modernity; John Paul II's social doctrine had made that clear. Now, however, the papacy was in play in the appropriate way—as a voice of moral reason, proposing a moral grammar and vocabulary through which the world could sort out the basic question of all politics: How *should* we live together?

A youthful Church

If anything seemed clear in 1978, it was that young people around the world, and particularly in the West, simply weren't interested in what Catholicism had to offer. That wasn't clear to Karol Wojtyła, however. He had been a pied piper for the young for thirty years when he assumed the papacy; the young people he had first met when they were students in Stalinist-era Poland and he was a newly ordained university chaplain—the students who called him *Wujek* [Uncle] and whom he came to call "my *Środowisko*" [milieu]—were not different in kind from

the young people of the late 20th century, he was convinced. The yearnings, aspirations, fears, and muddles of adolescence and young adulthood remained the same. He had always thought of this as a privileged period of life, a time when a genuine human personality begins to be formed; he thought the Church should be present to young lives at those crucial moments of maturation and vocational discernment; the questions "Who am I?" and "What am I supposed to be?" were God-touched, and the Church should be engaged with those raising such fundamental questions of identity and purpose. The traditional managers of popes—and, it seems likely, most of the world's bishops—told him not to waste his time, that it was impossible. He disagreed, and by launching the World Youth Days that drew millions of young men and women from all over the world for an encounter with Christ, each other, and the Pope, he created one of the signature innovations of his pontificate.

His magnetism for the young didn't fade with time, and the question was raised time and again: How did he do it? The world-weary, the cynical, or those who simply couldn't imagine any other answer chalked it up to the celebrity-fascination of the young. But as the years went on and the Pope got older, slower, more bent, and more difficult to understand, he certainly didn't seem like any other celebrity on offer. The truth lay elsewhere. John Paul II remained immensely attractive to young people, until the day he died, for two reasons. He was a man of transparent integrity, which is itself compelling for young men and women who have acute noses for hypocrisy. John Paul never asked a young person to do anything he hadn't done, or to struggle with any spiritual dilemma with which he hadn't wrestled; young people understood that, and appreciated it. Then there was his challenge. He knew, from his work with students in Poland, that adolescence and young adulthood are naturally times to dream large dreams, including dreams of the heroic and dramatic. That was the challenge he laid out in World Youth Days in Rome, Buenos Aires, Compostela, Częstochowa, Denver, Manila, Paris, and Toronto: never settle for less that the spiritual and moral grandeur of which, with God's grace, you're capable. Don't sell yourself short. You will fail. That's no reason to lower the bar of expectation. Get up, dust yourself off, seek forgiveness and reconciliation— and try again. That's the drama of the spiritual life. Live it.

And they came.

The results are likely to be crucial to the Catholic future. Thanks to the Internet and other innovations in communications technology, the young people who came to John Paul's World Youth Days form a potentially powerful network of cultural renewal all over the world. They know how to find each other, and they can stay in touch with each other relatively easily—no small thing in a developed world that tends to treat religious-serious young adults as curiosities (at best), and no small thing in a Third World that often feels cut off from the First World action. One impressive example of World Youth Day–inspired international networking is the World Youth Alliance, a global pro-life lobby involving more than a million young people in over one hundred countries. The Alliance was founded by Anna Halpine, a young Canadian music student, offended by the U.N.'s practice of flying in "representative" young people from all over the world to lobby in New York and other U.N. venues for U.N. bureaucracy–approved positions on population control, "reproductive rights," and so forth. Asked more than once why she and her co-workers were living on subsistence salaries in New York while taking on an entrenched international clerisy with seemingly unlimited resources, Anna Halpine would always respond, "The Holy Father has told us to build a culture of life. We're just following orders." WYA's remarkable growth in North America, Europe, Africa, Latin America, and Asia suggests that others are eager to "follow orders," too.

Making room for the Holy Spirit

The intense focus on the Church-as-institution in the post–Vatican II period, with all the attendant arguments over authority and power, tended to obscure another post-conciliar phenomenon: the rapid development of the Church's charismatic element in a host of renewal movements and new Catholic communities throughout the world. "Charismatic," in this context, does not mean simply the charismatic renewal with its characteristic (and sometimes dramatic) forms of prayer—although the charismatic renewal, in this narrow sense of the term, was one of the striking features of post–Vatican II Catholic life,

especially in North America. "Charismatic" in the wider sense refers to those renewal movements and communities—often built around a dynamic and inspiring leader with a fresh vision of Catholic life—that bring Catholics together in gatherings outside the normal parish and diocesan structures of the Church, form them in a particular spirituality, and (typically) send them out for a distinctive service to the world. Some of the renewal movements and new communities that flourished in the years after Vatican II were in fact pre–Vatican II in origin: Communion and Liberation, an Italian renewal movement founded and led for decades by Don Luigi Giussani, a penetrating writer on the spiritual yearnings of modernity; Focolare, founded after World War II by the Italian mystic and spiritual writer Chiara Lubich; L'Arche, a community in service to the radically handicapped, founded by the Canadian Jean Vanier in 1964; Opus Dei, created in 1928 by a Spaniard, Father Josemaría Escrivá, to promote the sanctification of daily life, including the workplace; and Regnum Christi, the lay renewal movement affiliated with the Legionaries of Christ (a relatively new religious congregation of priests), which, like Opus Dei, took the renewal of Catholic education as one of its missions.[11] The Neo-Catechumenal Way, founded in the slums of Madrid in 1962 by Kiko Argüello, takes up the challenge of re-evangelizing poorly educated Catholics through a distinctive catechetical, liturgical, and community life.

Other lively Catholic renewal movements and communities were born from the post–Vatican II Church. The Emmanuel Community, founded by Pierre Goursat, a layman, in 1976, is a French-based effort, now active in almost four dozen countries, to build intentional Catholic life and realize the call to holiness implicit in every Christian's baptism; its members include single and married lay men and women, lay men and women committed to celibacy, and priests. The Sant'Egidio Community, based in Rome's Trastevere district, was launched by Italian student activists who wanted to combine the intense social involvement of the late Sixties with a vigorously orthodox Catholicism. The Sodalitium Christianae Vitae [Sodality of Christian Life] was born in Peru in 1971; founded by a layman, Luis Fernando Figari, it includes laity consecrated to poverty, chastity, and obedience, as well as priests, and works in both schools and the mass media. The list could be multiplied exponentially. For all its secularity (indeed, perhaps

because of its secularity, and the inability of some Church institutions to respond to that effectively), the 20th century saw one of the greatest outpourings of charismatic energy in the history of the Catholic Church.

Unlike other senior prelates, who often worry about how to fit these renewal movements and untraditional communities into the normal structures and governance of the Church, Karol Wojtyła had always been remarkably open to this kind of Catholic spiritual entrepreneurship. He had supported and defended the Oasis movement in Poland, a pioneering effort to rescue Catholic youth ministry at a time when official Catholic youth work was frowned upon, even forbidden, by the communist regime; he had come to know Opus Dei during his years at the Second Vatican Council, and was impressed by its work with university students. As pope, he continued to encourage renewal movements and new Catholic communities while bringing them more closely into the orbit of the Church's normal administrative structures (a particularly challenging task with the Neo-Catechumenal Way, for example). Despite the inevitable difficulties in balancing the institutional and charismatic elements in the Church, there was no doubt that John Paul saw in these movements and communities a Spirit-led revitalization of Catholic life throughout the world. To celebrate what he saw as their emerging maturity, he invited members of Catholic renewal movements and new communities to Rome for Pentecost 1998, the great feast of the Holy Spirit; half a million people accepted the invitation, spilling out of St. Peter's Square, down the Via della Conciliazione to the Tiber, and into the maze of streets surrounding the Vatican. It was the largest gathering, and celebration, of the Church's charismatic element in Catholic history.

Many of these movements and communities were genuine novelties—lay-led communities and celibate laity working in the world were not previously prominent in Catholic life—and they could be unsettling in a Church whose institutional leadership is understandably chary of innovations that stretch tried-and-true institutional boundaries. John Paul II wasn't afraid of the novelty, seeing in it the revitalizing action of the Holy Spirit. His own fearlessness was a tremendous encouragement to Catholic renewal movements; his enthusiastic endorsement of their work created space within the Church for these movements and communities to find a

place at the table of Catholic life—from there, to be deployed for the conversion of the world.

Saints everywhere

If World Youth Days were one of the signature events of the pontificate, so were the unprecedented number of beatifications and canonizations John Paul II conducted. The numbers have already been noted: 482 new saints, 1,338 new *beati* [blesseds]. The saints he canonized became some of the most memorable personalities of his papacy: Maximilian Kolbe, the Franciscan martyr of charity in Auschwitz; Edith Stein, Sister Teresa Benedicta of the Cross, the brilliant German philosopher and Jewish convert, martyred at Auschwitz-Birkenau; Sister Faustina Kowalska, apostle of divine mercy; Albert Chmielowski, quondam-avant-garde-artist-turned-servant-of-the-poor in Kraków (about whom Karol Wojtyła had written a play, *Our God's Brother*); Jadwiga, queen of Poland and co-founder of the Polish-Lithuanian Commonwealth, for centuries the largest political unit in Europe; Gianna Beretta Molla, the Italian physician, wife, and mother who gave her life in 1962 to save her un-born child; Katherine Drexel, the Philadelphia heiress who founded a religious order to serve African-Americans and Native Americans; Padre Pio, the Italian stigmatic whose intercession was sought throughout the world; martyrs slain during the evangelization of China, Japan, and Korea; and martyrs of the Reformation. Unlike some of his papal pre-decessors, who were concerned about the possible political fallout from acknowledging modern martyrs, John Paul II beatified and canonized martyrs of the *Cristero* uprising in Mexico in the 1920s, martyrs of the Spanish Civil War of the 1930s, and martyrs of mid-20th-century Nazi and communist persecutions. John Paul's blesseds included two of the most beloved personalities of modern Catholicism—Pope John XXIII and Mother Teresa of Calcutta—as well as the first married couple ever beatified together, Luigi and Maria Beltrame-Quattrocchi.

All of this canonizing and beatifying bore witness to the Pope's con-victions that sanctity was everywhere, that sanctity wasn't a matter of the church sanctuary only, and that the 21st century should be re-minded of the virtual infinity of forms that heroic virtue—the Church's

traditional definition of the sanctity necessary for beatification and canonization—could take. There were critics. Some were unhappy with the new, scholarly-historical process for saint-making that John Paul substituted in 1983 for the traditional adversarial-legal process. Others thought that, whatever the merits of the new process, it was being abused so that the Pope could "take a new blessed in his pocket" when he traveled to a given country. Still others suggested, if quietly, that all these beatifications and canonizations were debasing the coinage of sainthood, so to speak.

Yet the enthusiasm that John Paul's beatifications and canonizations aroused, in Roman ceremonies but also throughout the world, suggested that he had struck a chord in the Catholic soul. Veneration of the saints had fallen fallow in the post–Vatican II period. John Paul's revival of the cult of the saints could be another way of fostering the new evangelization he saw as a central thrust of his pontificate, and indeed of 21st-century Catholic life. That was indisputably his intention.

Giving an account

The opening of the Holy Door on December 24–25, 1999; the flood of pilgrims to Rome during the Great Jubilee of 2000; the Pope's epic pilgrimage to the Holy Land in March 2000—all of these made the Jubilee great Catholic theater and underscored the turn into the third millennium of Christian history as a singular key to John Paul's pontificate. This was, in a sense, a tremendous personal accomplishment, as senior churchmen were noticeably unenthusiastic about the Pope's plans for the Great Jubilee in the early 1990s. John Paul decided to forge ahead, and the popular response testified to the truth of his intuition (shaped by the traditional Polish emphasis on anniversaries as moments of grace) that the Church *had* to mark the two thousandth anniversary of the Incarnation in a spectacular way, in order to bear public witness to its credal conviction that the Incarnation was, in fact, *the* turning point of human history.

That witness, John Paul believed, had to be intellectually serious as well as emotionally charged. And that, in turn, explains why he so enthusiastically supported the proposal, first made at the Extraordinary

Synod of 1985 (summoned to mark the twentieth anniversary of Vatican II), for the first comprehensive catechism of Catholic doctrine to be written for the universal Church since the 16th century. Catholicism had to show that it could give an account of the faith, the love, and the "living hope" [1 Peter 1.3] that were the basis of its life. Produced in a short span of seven years, the *Catechism of the Catholic Church* was an international bestseller and provided a ready reference point for Catholic education in the 21st century.

The *Catechism* was also one of the most important cultural accomplishments of the pontificate. Contemporary high culture held that the men and women of our time could not retrieve, much less make their own, the origins of their religious and moral traditions; the *Catechism* taught that, whatever problems modern historical scholarship posed for a retrieval of Christian origins, the Church was always in touch with *the* source of its life, the Risen Christ, who continued to live in the Church which is his mystical body in the world. Contemporary culture argued that human beings couldn't put the world together in a coherent way, that everything was plurality and difference; the *Catechism* bears witness to the unity of the Church's convictions over time, and further suggests that every human being—whatever their cultural location—can hear a saving word of grace from the living God. Contemporary culture is exceedingly nervous about any assertion of *the* truth; the *Catechism* insists that human beings cannot live without truth, and that the truth is food for the soul. At a time when the high culture of the West lived in a miasma of skeptical doubt about the nature of the human person, human origins, and human destiny, the *Catechism of the Catholic Church* joyfully, humbly, but confidently proposes a comprehensive, coherent, and, to many, compelling account of how things are, how the world came to be, and how the story of humanity will ultimately be brought to fulfillment.

No other Christian community attempted such a comprehensive explication of its faith and hope at the turning point between the second and third millennia of Christian history. By focusing the Church's attention on the importance of the Great Jubilee of 2000, and by supporting the development of the *Catechism* as an essential reference point for the Jubilee year, John Paul II not only provided the Catholic Church with an instrument of education and evangelization; he gave

the post-modern world an example of the human capacity to give an account of the truth of the human condition. It was a gift that seems likely to keep giving itself away in the decades and centuries ahead.

The unity of the Church and the unity of the world

The ecumenical movement—the organized quest for Christian unity—had long been a Protestant enterprise, beginning as it did with the Edinburgh conference on world mission in 1910. By the end of the 20th century, however, liberal Protestantism seemed to have lost interest in the classic ecumenical movement's goals of a Christianity re-composed in unity around a common creed, baptism, Eucharist, and ministry. Indeed, in 1995, the general secretary of the World Council of Churches, the premier institutional embodiment of classic ecu-menism, said in a Rome lecture that the classic quest was over; the frac-tured communities of the Christian world were never going to agree on matters of doctrine—which, in any case, wasn't all that important, the important things being issues of global poverty, environmental degra-dation, and peace, on which the various Christian communities ought to focus their attention.

Shortly thereafter, John Paul II issued the encyclical *Ut Unum Sint* [That They May Be One], revived the classic ecumenical agenda, and thereby put the Catholic Church—long the tardy child at the ecu-menical table—at the center of the global quest for Christian unity. The concrete results were not immediate. Although 1998 saw a joint declaration of doctrinal agreement by the Catholic Church and the Lutheran World Federation on the issue of justification by faith, the theological opening-wedge of the Reformation, the Catholic Church and the communities of the Reformation were not measurably closer to a common Eucharist by the end of John Paul's pontificate than they had been when he took office. Still, it was not without significance that the classic goals of the ecumenical movement—a Christian unity recom-posed on the basis of the truth that Christ had promised the Church as a lasting gift—had been reaffirmed, and by the world's largest Christian body.

For John Paul II, ecumenism was neither an optional post–Vatican II

nicety, nor was it simply a matter of Christianity's internal life, important as that was. It was also a matter of the Church's witness to the world. A world increasingly fractured and fractious—not least along religious axes of conflict—needed the witness of a global Christian community working to recompose the unity that had been formally broken in the 11th century (between Christian West and Christian East) and in the 16th century (within the Christian West). The disunity of the one Church of Christ was an obstacle to the spread of the Gospel, the evangelization of the world, and the building of a global civilization of genuine freedom. The Church owed the world a witness in unity; the Church owed its Lord unity in the truth of Christ. By insisting on the ecumenical imperative, in and out of season, John Paul II kept alive one of the great hopes of the Christian 20th century and underscored one of the Christian Church's premier 21st-century obligations.[12]

Catholics and Jews

John Paul II received steady praise for his numerous initiatives in Catholic-Jewish relations—without, perhaps, his radical intent being fully understood by either Catholics or Jews.

Karol Wojtyła, who grew up in a town that was 20 percent Jewish and who lost friends in the Holocaust, had a singular appreciation of the Jewish pain of the 20th century. His unprecedented visit to the Synagogue of Rome in 1986; his completion of formal diplomatic relations between the Holy See and the State of Israel in 1992; his Holy Land pilgrimage in 2000, including his unforgettably poignant remarks at the Yad Vashem Holocaust memorial and his prayer at the Western Wall of the Temple—these were all goods in themselves. They were also intended to help clear away the rubble built up over more than nineteen hundred years of a tortured relationship that had begun when what became Christianity and what became rabbinic Judaism came to the parting of the ways during the First Jewish War in A.D. 70—and that had done grave damage to both parties ever since. The rubble being largely cleared away, however, the question became: Now what? Some imagined that, with Catholic liturgical, catechetical, and homiletic materials cleansed of formulations offensive to Jewish ears, and with Catholics

and Jews working together in the West to build open, tolerant, and civil societies, the agenda of Catholic-Jewish dialogue had just about been completed.

John Paul disagreed. His goal was to reconvene the real dialogue: the religious and theological dialogue that had broken off in A.D. 70. The point was not proselytization; the point was a mutual exploration, between the peoples who took Abraham as their father in faith and the Ten Commandments as their fundamental moral code, of what it meant, in the 21st century, to be chosen people, lights to the nations, and witnesses to the truth of the one true God—the God of Abraham, Moses, and Jesus of Nazareth. It was, understandably, a difficult point for many of the Catholic Church's Jewish interlocutors to grasp—as it was for professional Catholic dialogue participants who were more comfortable in the established grooves than with charting new, and potentially explosive, religious and theological terrain. The Pope's initiative was not without effect, however. Some 170 Jewish scholars in North America took up John Paul's challenge in the remarkable document *Dabru Emet* [Speak the Truth], which tried to fit Christianity and Christians into an orthodox Jewish understanding of God's abiding covenant with the Chosen People. Among its other affirmations, *Dabru Emet* affirmed that "a new religious dialogue with Christians will not weaken Jewish practice or accelerate Jewish assimilation"—revolutionary statements in a Jewish context, and, it seems reasonable to conclude, a direct response to the openness and challenge of John Paul II.

Dabru Emet was not without its Jewish critics. The fact of its existence, though, suggested that, once again, John Paul II had been correct in following both his personal intuitions and the teaching of the Second Vatican Council in taking the Catholic Church into uncharted waters—a feat of papal navigation that compelled others to do the same.[13]

The free and virtuous society

John Paul's world-historical impact on politics among nations—his pivotal role in the collapse of European communism, his roles in the

democratic transitions in Latin America and east Asia—have already been noted, as have his contributions to democratic theory in his two addresses to the U.N. General Assembly, his 1991 encyclical *Centesimus Annus*, and his 1995 encyclical *Evangelium Vitae*. To these might be added his reflections on the relationship between democracy and secure moral truths in the 1993 encyclical *Veritatis Splendor*, as well as his homilies in New York, Brooklyn, and Baltimore during his 1995 pastoral visit to the United States, all of which took up important questions of the relationship of public virtue to democratic self-governance. Parallel questions were explored with particular eloquence in several homilies during John Paul's 1997 Polish pilgrimage.

One idea linking these disparate texts—and the Pope's challenge to the new democracies of east central Europe in the 1990s, which was often misconstrued as the scolding of a disappointed old man— is that democracy is not a machine that can run by itself. Neither, he insisted, is the free economy. Both democracy and the market unleash tremendous human energies; those energies must be disciplined and directed by the virtues, if free politics and free economics are to lead to genuine human flourishing, rather than to exploitation and degradation. These were inevitably controversial claims in a cultural climate increasingly dominated by the pleasure principle in personal (especially sexual) life, and by a utilitarian approach to public policy in which the question "Will it work?" often trumped the deeper question "Is it right?" As the West began to grapple with the promise and the peril of the biotechnology revolution in the last years of John Paul's pontificate, the questions of virtue he kept pressing into the public debate seemed, to some at least, ever more urgent.

The world was not accustomed to taking moral instruction from a pope; and some were puzzled by hearing such challenging, even critical, counsel from a pope in whom they recognized a champion of human freedom. John Paul II, however, was quite sure that bearing witness to the truth that freedom is not a matter of doing what we like but of freely choosing the good, which we can know by reason, is one of the things that popes must do at this or any moment in human history. His credentials as a champion of human rights gave him a unique platform from which to teach that human rights are not matters of personal willfulness, but rather moral truths built into the very structure of

human being. In doing so, he fulfilled an important public dimension of his evangelical mission. At the same time, he helped strengthen the intellectual foundations of the human rights movement, which had enjoyed remarkable success in the last quarter of the 20th century, but which, absent strong philosophical foundations, risked degenerating into an ideology or another shallow form of political correctness.

Giving Africa a chance

With the end of the Cold War, in which various of its countries had played proxy roles, Africa seemed ready to fall off the edge of history into an abyss of tribal brutality, rancid government, poverty, disease, and general chaos. Virtually alone among world leaders, John Paul II refused to write Africa off. As the Nigerian archbishop John Onaiyekan put it in 2001, "He's the only one who's bothered to understand what we mean when we say 'We're dying.' "[14]

Karol Wojtyła had first been fascinated by Africa and Africans at the Second Vatican Council; here, he thought, was a fresh experience of the joy and hope of Christian faith, unencumbered by the burdens of history and the cynicism that too often accompanies age and experience. In the young African prelates he met at Vatican II (some of whom were first-generation Christians), he discovered, as he wrote in a poem, "thoughts which glitter in your eyes and mine in a different way / although they / have the same content."[15] Africa, he was convinced, had great resources of faith within itself; Africa's vibrant new faith also had something to offer the world Church.

He brought those convictions to Rome (where they were not universally shared) in 1978, and then began to put them into action. John Paul went to Africa in 1980, 1982, 1985, 1988, 1989, 1990, 1992, 1993, 1995, and 1998, visiting some thirty-nine countries. He canonized a former African slave, Josephine Bakhita, in 2000, and beatified the first Nigerian so honored, Father Cyprian Michael Tansi, the former mentor of Cardinal Francis Arinze, whom John Paul brought to Rome to run the Church's dialogue with world religions and, later, the Curia's liturgy office. In accord with the wishes of the African bishops, the Pope held a continental Synod for Africa in Rome in 1994, thus

compelling the Roman Curia to spend the better part of a month lis-
tening to African concerns and meeting the two hundred African bish-
ops who attended. John Paul then honored Africa by signing his 1995
post-Synod apostolic exhortation, *Ecclesia in Africa* [The Church in
Africa], in Africa, during a week-long transcontinental celebration that
took him to Yaoundé in Cameroon, Johannesburg in South Africa, and
Nairobi, Kenya—the first time in two millennia of Catholic history
that a teaching document of the papal magisterium had been "given"
from Africa.

John Paul's encouragement of Africa's evangelical energy paid rich
dividends. There were 55 million Catholics in Africa in 1978. Their
numbers had almost tripled, to 144 million, by the end of 2003, and
seemed likely to reach 230 million by 2025, at which point Africans
would comprise one-sixth of the world Church.[16] By the mid-21st cen-
tury, it seemed virtually certain that Africa would be home to more
Catholics than Europe.[17] Some, in fact, talked of a re-evangelization of
Europe by African missionaries, in a kind of great reversal of the mis-
sionary path of the 19th and early 20th centuries. Religious vocations
boomed in Africa, with new communities of priests and nuns growing
rapidly; the diocesan seminary in Enugu, Nigeria, has more than one
thousand seminarians, and by some accounts is the largest in the world.
Throughout Africa, millions of people, including non-Catholics, spoke
with unfeigned affection of the Polish Bishop of Rome whom they
called "Baba"—the "Old Man."[18]

Africa also produced impressive Church leaders during John Paul's
pontificate. The Pope entrusted Cardinal Bernardin Gantin from Benin
with the crucial position of prefect of the Congregation for Bishops
(which prepares nominations to the episcopate for two-thirds of the
world) for sixteen years, until the cardinal's retirement. Cardinal Ar-
inze's work as president of the Pontifical Council for Interreligious Dia-
logue and later as prefect of the Congregation for Divine Worship
made him one of the most important members of John Paul's curial
team—and led some to think of the Nigerian as a future pope. Cardinal
Polycarp Pengo of Tanzania was appointed as a member of two crucial
curial congregations—the Congregation for the Doctrine of the Faith
and the Congregation for the Evangelization of Peoples (the office that
supervises world missions); some also imagined Pengo as a future pope,

if later in the 21st century. Archbishop Pius Ncube of Bulawayo, appointed by John Paul II in 1998, was an outspoken critic of the maniacal Zimbabwean regime of Robert Mugabe, and could have laid claim to the title of world's bravest Catholic bishop. Archbishop John Onaiyekan of Abuja, appointed to the national capital of Nigeria in 1994, was a courageous defender of pluralism and democracy in a country threatened by militant Islamism and the imposition of *sharia* law. By appointing the first cardinals from Angola, Cameroon, Ivory Coast, Madagascar, Mozambique, and Sudan, John Paul ensured that African voices would have a significant say in senior Church councils; Africans would, in fact, make up 10 percent of the electorate that would choose John Paul's successor.

The Church had long taken up the cause of Africa's lepers, and by 2002 was running 339 leprosaria across the continent. Catholic relief efforts were invaluable in dealing with the carnage caused by AIDS, and Church leaders supported the Ugandan government's abstinence-and-fidelity-based AIDS prevention program, the only successful such effort on the continent.[19] The African Church's accomplishments in evangelism, health care, and education, however, did not exhaust the picture; throughout the John Paul II years, the Church in Africa was under pressure from external enemies and from its own incapacities and weaknesses. Externally, Catholics found themselves in conflict with militant Muslims along a jagged band of confrontation that ran from Senegal through Nigeria and on to the killing grounds of southern Sudan. Internally, African Catholicism was not immune to the tribal passions and governmental corruption that racked the continent; the point was graphically illustrated in Rwanda, where a few African churchmen stood against the homicidal impulses that drove the slaughter of hundreds of thousands—but others, including priests and nuns, did not. (In the Democratic Republic of Congo in 2003, priests who resisted militia-led mass murder were themselves martyred.) Leading African bishops like John Onaiyekan admitted that the Church had done a poor job of instilling the idea of the "common good" in African societies, which was a prerequisite to dealing with the widespread corruption that eroded African economies and polities.[20] There were incidents of clergy sexual abuse and other forms of unchaste behavior by priests and some bishops in Africa; African

priests who came to work in the First World were sometimes guilty of financial improprieties.[21]

The failures of African Catholicism underscored its challenges for the immediate future. No one who looked seriously at the missionary statistics and the demographics could doubt that the fate of the Church in Africa would play a large role in determining the fate and character of the world Church in the 21st century.[22] John Paul II, the pope who refused to write Africans off, had given Africa a chance to influence Catholic life as it had not done since the Greco-Roman-Christian civilization of North Africa was destroyed by the armies of Islam in the 7th century.

The greatest vocations director in history

The word "crisis" was, and is, frequently overused in describing aspects of post-conciliar Catholicism, but there is little doubt that the priesthood was truly in crisis when John Paul II assumed the Chair of Peter in 1978. Some forty-six thousand priests had left the active ministry, in the largest incidence of priestly defections since the Reformation. Seminaries in North America, bursting at the seams in the 1950s and early 1960s, emptied. The priests and seminarians who remained were often demoralized, unsure of the future, uncertain about the Church's understanding of, and commitment to, a celibate priesthood in which the priest was understood as an icon of the eternal priesthood of Jesus Christ, not simply as an ecclesiastical functionary. That those uncertainties, compounded by other pathologies, led to a breakdown of clerical and seminary discipline with disastrous results in priestly sexual misconduct and abuse is now beyond reasonable dispute.[23]

John Paul II immediately set about changing the dynamics of the situation, putting a stop to automatic dispensations from priestly vows (which had been the pattern in the latter years of Pope Paul VI) and issuing a personal "Letter to Priests" on Holy Thursday 1979, the first in an annual series. Meetings with priests and seminarians became a staple of his pastoral pilgrimages around the world. A 1990 Synod devoted to the reform of priestly education turned into a month-long seminar on

the renewal of the priesthood itself, and was completed by one of the crucial documents of the pontificate, the 1992 apostolic exhortation, *Pastores Dabo Vobis.* In 1996, to mark the fiftieth anniversary of his own priestly ordination, John Paul II published a vocational memoir, *Gift and Mystery*, that encouraged both seminarians and priests throughout the world. He also invited priestly golden jubilarians from all over the world to join him on their common anniversary; sixteen hundred priests joined him on November 10, 1996, in the largest concelebration of Mass in history.

Over the course of the pontificate, things began to change in North America, and by the mid-1990s at the latest, most seminarians in most seminaries throughout the United States and Canada would readily tell visitors that one of the prime reasons they had discerned a vocation to the priesthood was Pope John Paul II. His own love for the priesthood, the manliness with which he lived his priestly life, his sense of priestly adventure—all of these qualities had made the priesthood, again, an attractive prospect for a serious young Catholic. Once, an intact Catholic culture in North America had made the offer; now, the Pope and the bishops who followed his lead were making the offer, by example or by explicit invitation. The results were generous. As a former American seminary rector, Archbishop Edwin O'Brien, once put it, John Paul had become the greatest vocations director—the greatest recruiter of seminarians—in Church history. Moreover, Archbishop O'Brien thought he knew the reason why: the Pope had clarified just what a Catholic priest was, and just what was expected of him. That identity and those expectations were, to be sure, countercultural; as the archbishop put it, however, "A man will give his life for a mystery, but not for a question mark."[24] John Paul II had removed the question mark, and the situation had improved, in North America at least.

(The same could not be said of Great Britain and Ireland. English seminaries had a significant number of Scandinavian students, filling places once taken by Englishmen and Scots. The Irish bishops closed seminaries; fewer than a dozen priests were ordained in all of Ireland in 2004, a catastrophic decline from 193 ordinations in 1990.)

The world picture was mixed, but encouraging in aggregate terms. According to Vatican statistics, there were some 421,000 priests in the

world in 1978, the year of John Paul's election; there was a 3.8 percent decline in the total number of priests (to some 405,000) during the first twenty-four years of the pontificate, as the actuarial tables completed the meltdown begun by the defections of the 1960s and 1970s. (The number of diocesan priests actually increased between 1978 and 2002 by 1.9 percent, but the number of priests belonging to religious orders dropped by a precipitous 13 percent.) The overall decline in priestly numbers was primarily because of Europe and North America. Significant increases over the forty-year period between 1961 and 2001 were recorded in Latin America, Africa, and Asia.

On the future side of the ledger, the number of seminarians preparing for ordination had dramatically expanded during the pontificate, in both diocesan seminaries and seminaries for religious orders. There were some 64,000 seminarians worldwide in 1978, and 113,200 in 2002, a gain of more than 70 percent. Those numbers were particularly encouraging in light of the fact that the Church's need for priests was never greater than in the 21st century, for the world Catholic population had grown by 40 percent during John Paul's pontificate, from 757 million to more than 1.1 billion.

In 1978, more than one analyst thought that the Catholic priesthood, as the Church and the world had known it in the second millennium, had no future. That the priesthood manifestly has a future in the 21st century has to rank as one of the signal accomplishments of John Paul II, who gave new heart to priests and proved a vocations-magnet of the sort the Church had never seen before.

FRUSTRATIONS AND AMBIGUITIES

All pontificates experience frustrations, ambiguities, even failures. The pontificate of John Paul II, for all its greatness, was no exception. If the accomplishments of the pontificate illuminate both the bright prospects and the challenges of the Catholic Church in the early 21st century, the frustrations and ambiguities of John Paul's papacy underscore those challenges and suggest at least part of the work that the late Pope left for his successor, his brother-bishops and priests, and the

people of the Church. Those frustrations and ambiguities touched both the Church's mission to the world, and its internal life.

The apostasy of Europe and its consequences

No pope in history was a more thoroughgoing European than John Paul II. He came from the heart of the continent (for Poles insist, correctly, that they live in central Europe, not "eastern Europe," a phrase of Stalinist provenance). He spoke most European languages and was deeply familiar with Europe's cultures, especially European philosophy and literature. Over the course of twenty-six years, he invested months of time in pastoral visits to every part of Europe he was permitted to visit. Time after time, on those pilgrimages and in two special Synods he held for Europe, he called Europe back to the promises of its baptism, to its civilizational roots in Christianity and in biblical morality.

Yet Europe, after twenty-six years of John Paul II, seemed even more deeply stuck in the cultural quicksand of a crisis of civilizational morale. Its economies could not, in the main, keep pace with the United States and Asia. Its politics were becoming sclerotic, with major decisions being taken by bureaucrats or judges in Brussels, Strasbourg, and The Hague, rather than by legislatures. One French political theorist, Pierre Manent, went so far as to say that Europe was suffering from "depoliticization," a democracy-deficit in which the people of Europe appeared to acquiesce.[25] European high culture, deep into its postmodern phase, seemed incapable of calling anything *the* truth, and in the aftermath of 9/11 and the Madrid bombings, seemed disinclined to call radical evil by its name, either.

Most depressingly, and most urgently, Europe continued to depopulate itself in a historically unprecedented way, thanks to generations of below-replacement-level birth rates that seemed perilously close to a form of demographic suicide. When the better part of an entire continent—wealthier, healthier, and more secure than ever before—declines to create the human future in the most elemental sense, by creating the next generation, something is wrong. That "something" has, obviously, many dimensions, but to deny its spiritual dimension is to miss the heart of the matter. Europe, it seems, had become spiritually bored,

its horizon of aspiration desperately lowered. And, as the numbers made unmistakably plain, Europe was boring itself to death.

John Paul II tried to raise yet another warning flag about Europe's malaise—and offer a positive program for Europe's cultural revival—in one of the most impressive documents of the latter years of the pontificate: *Ecclesia in Europa* [The Church in Europe], which was issued on June 28, 2003, to complete the work of the second special Synod for Europe, held to help mark the Great Jubilee of 2000. In *Ecclesia in Europa*, the Pope suggested that Europe's greatest need was not for a common currency or a new constitution but for hope: "the most urgent matter Europe faces, in both East and West, is a growing need for hope, a hope that will enable us to give meaning to life and history . . ." How did Europe's loss of hope display itself? In "a kind of practical agnosticism and religious indifference whereby many Europeans give the impression of living without spiritual roots . . . somewhat like heirs who have squandered a patrimony . . . ;" in a "fear of the future"; in the "inner emptiness that grips many people"; in a "selfishness that closes individuals and groups in upon themselves"; and, of course, in "the diminished number of births."

Europe was also suffering from self-inflicted historical amnesia, in which Christianity's contributions to the formation of a Europe of tolerance, civility, human rights, and democracy were being denied. Yet, as John Paul insisted, it was from "the biblical conception of man [that] Europe drew the best of its humanistic culture, found inspiration for its artistic and intellectual creations, created systems of law and, not least, advanced the dignity of the person as the subject of inalienable rights." A Europe seizing its opportunities rather than squandering them would have to reclaim its roots. For the denial of those roots had created a false story about Europe's past and present, and that false story was threatening Europe's future.[26]

John Paul's attempt to re-evangelize Europe met with at least some success. His encouragement of renewal movements and new Catholic communities invigorated local churches that had not been energized through sluggish parish and diocesan structures. His successful appeal to the young adults of Europe at World Youth Days in Compostela, Częstochowa, and Rome suggested the possibility of a generational shift in European self-consciousness—as, from a different angle, did the

Pope's difficulties in turning around the graying children of 1968 (who happened to be the parents of the young men and women flocking to him). In that sense, John Paul's impact on Europe can only be measured in the mid-21st century, when the younger generation he inspired has had an opportunity to turn Europe around, culturally, politically, and economically.

But the clock is running. Christianity is dying in Christianity's historic heartland. The abandonment of the God of the Bible in Europe has led to a widespread ignoring of the biblical God's first commandment: "Be fruitful and multiply" [Genesis 1.28]. Europe's depopulation is, in turn, leading it into fiscal and social crisis, as its decreasing numbers of workers will find it difficult, and then impossible, to sustain its retirement and health care systems. That same depopulation is also leading to grave security issues, as the population vacuum in western Europe is filled by immigrants, often from the Arab Islamic world, who not infrequently become radicalized in the process. Islamists make no secret of the fact that they regard the defeat of the Turks at Vienna in 1683 as a temporary setback on the road to control of Europe. Europe's depopulation, and the consequent immigration from the Islamic world, have opened up the possibility that that control will be achieved not by conquest but by the ballot box.

No pope since the Middle Ages had tried harder to arouse Europe's Christian spirit. The response, to be charitable, was tepid.

The difficult Chinese

The most traveled pope in history was acutely aware that he had been unable to speak in person to one-sixth of humanity: the people in the oxymoronically named People's Republic of China. It was not for lack of effort on his part.

In 1983, he had sent a letter to Chinese leader Deng Xiaoping, requesting a new conversation between the PRC government and the Holy See; the letter remained unanswered at Deng's death in 1997, and was still unanswered when John Paul II died. The Pope broadcast by radio to China from South Korea in 1983 and from the Philippines in 1995. In 1993, one of John Paul's personal diplomatic troubleshooters,

Cardinal Roger Etchegaray, made a private visit to China on the Pope's behalf. His report, plus reports from Taiwan, Hong Kong, and the mainland itself, convinced John Paul and senior officials of the Roman Curia that the situation was a complex and delicate one: while the Church remained formally divided between underground Catholics, who had never broken with Rome, and the members of the regime-approved Patriotic Catholic Association, numerous "patriotic" bishops had made written submissions of obedience to Rome, and in some parts of the country, the previously estranged wings of the Catholic Church were working together. The regime continued to persecute the underground Church, sometimes with the connivance of "patriotic" bishops. But the road to reconciliation within the Church seemed more open than had been thought possible in the late 1970s.

Still, it was a considerable frustration for John Paul not to be able to go to China in person, to express his esteem for China's great civilizational accomplishments (as he had in his unrequited letter to Deng Xiaoping), and to advance the reconciliation of China's Catholics. With his penetrating insight into the future, John Paul may have intuited that China, when it finally opened itself completely to the world, would become the greatest field of Christian mission since the European evangelization of the Americas. He wanted to do his part, in person, to help create the conditions for the possibility of that great missionary thrust. He was denied the opportunity to do that by a regime that was, evidently, afraid of him. They had seen what he had done to the comrades in central and eastern Europe; they had seen what he had helped inspire in the neighborhood, in the Philippines and South Korea. And they wanted none of it.

Ecumenical logjams

Judging from his remarks at the Ecumenical Patriarchate in Istanbul in 1979, in which he spoke of his hope that Catholics and Orthodox Christians would soon concelebrate the Eucharist together, John Paul II really seems to have believed that the breach between Rome and the Christian East—formally ratified in 1054, at the beginning of the second millennium—could be closed by the end of the second millen-

nium. It was not to be. Perhaps the hope of real ecclesial reconciliation between West and East was itself somewhat misplaced, however noble.

In his ecumenical encyclical *Ut Unum Sint*, John Paul had broadly hinted that the Catholic Church could accept a return to the status quo ante 1054 in its relationship to Orthodoxy: Rome would make no jurisdictional claims in the East, the Orthodox would acknowledge the form of Petrine primacy that had prevailed in the first millennium, and the Pope and the ecumenical patriarch of Constantinople would find themselves, once again, at the Eucharistic table, concelebrating the divine liturgy. The difficulty with that suggestion was that it may have taken too benign a view of what had happened prior to 1054, and too optimistic a view of Orthodoxy's capabilities at the end of the 20th century.

The mutual excommunications of 1054 were not events in a historical vacuum. In one sense, 1054 ratified a breach that had been widening over the previous centuries. To return to the status quo ante 1054 was not, in other words, to return to a status quo of tranquil unity; it meant revisiting the theological tensions that had made 1054 possible in the first place. Even those might have been overcome, however, if Orthodoxy had been in any position to accept John Paul II's 1995 invitation. But it wasn't. For as Ecumenical Patriarch Bartholomew I had said in a lecture at Georgetown University in 1997, Catholicism and Orthodoxy had spent more than a millennium living an "ontologically different" experience of the Church—a difference, the Ecumenical Patriarch seemed to suggest, of kind, not degree, and a difference that, as he put it, "continually increases."[27]

The Orthodox world is luxuriously fissiparous. No one speaks for Orthodoxy in the way that the Bishop of Rome speaks for the Catholic Church. John Paul's excellent personal relationships with the two ecumenical patriarchs whose terms overlapped his own, Dimitrios I and Bartholomew I, could not compensate for the fact that neither Dimitrios nor Bartholomew could, so to speak, deliver Orthodoxy—particularly given the ambitions and obstreperousness of the Patriarch of Moscow, Aleksy II, who not only impeded John Paul's efforts to reach a modus vivendi between Russian Catholics and the Russian Orthodox Church but who persistently blocked the Pope from visiting Russia. Aleksy's own rivalry with Bartholomew—the Russian patriarch (who was, in fact,

born in Estonia and has German ethnic roots) led the largest Orthodox community in the world and was not averse to the idea of Moscow as the "Third Rome"—made matters even more difficult.

Beyond these questions of personality and history, however, was the realm of ideas. Proposals to return to the status quo ante 1054, with full communion between Rome and the East re-established on the basis of the arrangements of the first millennium, assumed that no serious Church-dividing issues had arisen between Catholicism and Orthodoxy in the second millennium. That was not at all clear, however. Although Orthodoxy shares Catholicism's profound Marian piety, the Orthodox were not persuaded that the dogmatic definitions of Mary's immaculate conception (by Pius IX in 1854) and assumption (by Pius XII in 1950) had been legitimate developments of doctrine; at least they could not be considered as such until they had been affirmed by a pan-Orthodox consensus—and as veteran ecumenists sometimes observed, a pan-Orthodox consensus, expressed by a pan-Orthodox council, was an eschatological concept, a matter for the Kingdom of God. More gravely, many Orthodox had internalized a profound anti-Roman bias into their own self-understanding as Orthodox Christians: to these defenders of Orthodoxy, to "be Orthodox" meant, by definition, "not to be in communion with the Bishop of Rome." The Orthodox theology of marriage, of the priesthood, and of ecclesial headship offered three other examples of what Ecumenical Patriarch Bartholomew had called, at Georgetown, increasing differences between Orthodoxy and Catholicism.[28]

Then there was the weight of more recent history. Orthodoxy had had a very difficult 20th century. Its largest Church, in Russia, had been decimated by persecution and then used by the communist regime as a propaganda tool, more than a few of its bishops being agents of the KGB. Even after the collapse of communism and the Soviet Union, the degree to which some Russian Orthodox leaders remained in thrall to the Kremlin was an open question. The Moscow Patriarchate's fierce opposition to establishing normal Catholic structures to serve Catholics in Russia, and its even fiercer opposition to the rebirth of the Greek Catholic Church in Ukraine, compounded the difficulties; what Rome insisted was normal pastoral care and the restoration of ecclesiastical structures and offices suppressed by communism was proselytism and sheep-stealing to Moscow. As Cardinal Walter Kasper put it in 2002,

Russian Orthodoxy's understanding of "Church" risked becoming "ideology, not theology."[29] Orthodoxy's 20th-century difficulties were not limited to Russia, however. The Greek Orthodox Church flirted, and sometimes more-than-flirted, with the heresy of nationalism, seeming to insist that to be Greek was to be Orthodox, period (a temptation often encountered in Russian Orthodox circles, too). The ecumenical patriarchate itself was a ward of the secular Turkish government, which set the qualifications for those eligible to be elected Ecumenical Patriarch. Orthodoxy's historic difficulties in sorting out the relationship between the Church and the civil authority were, thus, once again in play.

John Paul began to work his way around the outer boundaries of the Orthodox world in the late 1990s, as if to demonstrate on the periphery that his intentions were fraternal, not aggressive. A successful pastoral visit to Romania in May 1999 was an important first step, made possible by the courage of Romanian Orthodoxy's patriarch, Teoctist. Another probe along the outer boundaries of the Orthodox world took the Pope to Georgia in November 1999. John Paul had to wait until May 2001 to complete his Great Jubilee biblical pilgrimage by walking in the footsteps of St. Paul—in this instance, to Athens and the Areopagus, where Paul had preached the "unknown God" (a biblical scene the Pope had often cited as a metaphor for the Church in the modern world). Despite some chippiness from certain Greek Orthodox authorities (two bishops declined to recite the Lord's Prayer in public with John Paul II), the visit was considered a success in itself and another small step on the road to reconciliation. A month later, in Lviv and Kiev, John Paul navigated brilliantly through the contentions that had divided Ukrainian Orthodoxy into three competing jurisdictions, while keeping faith with the Ukrainian Greek Catholic faithful.

But that was as far as he got. To the end, Aleksy refused to have him in Russia.

John Paul's personal decency and radiant faith helped heal some of the wounds of the heart and the mind that kept Catholics and Orthodox apart. That kind of healing was, surely, an important prerequisite to any possible future reconciliation in full. So was the grassroots cooperation between Catholics and Orthodox Christians in educational and charitable endeavors throughout the post-communist world, cooperation that John Paul II's example helped inspire and support; as a

Latin-rite Romanian archbishop, Ioan Robu, put it in 2001, "We move toward unity by living the teaching of Christ together, not by [going to ecumenical] meetings."[30] John Paul's dream of 1979, however, seemed as far off into the unforeseeable future in 2005 as it did when he first visited Ecumenical Patriarch Dimitrios and expressed his deep wish to be able to concelebrate the Eucharist with his Orthodox brethren. The conditions—theological, historical, psychological— were not only not right, they were not close to being right.

Frustration also marked John Paul's efforts with the Christian communities of the Reformation. The once-promising Anglican-Catholic dialogue foundered in the mid-1980s when the Church of England broke what Rome regarded as an unalterable apostolic tradition by calling women to priestly ordination (a decision that also estranged the Church of England from Orthodoxy). The subsequent difficulties of an Anglican Communion rent by disagreements over sexual morality and biblical authority confirmed what some had intuited from the Anglican-Catholic difficulties over the question of ordination and the even more fundamental question of the authority by which the ordination issue would be resolved: in many respects, Anglicanism was another Protestant grouping rather than a third branch on a tree that included Catholicism and Orthodoxy.

Similar frustrations beset the Lutheran-Catholic dialogue. If the doctrine of justification by faith was *the* Church-dividing issue between Rome and Wittenberg in the 16th century, then agreement on the truths of the doctrine (reached by Catholics and Lutherans in 1998–99) ought to have resolved the division. That it manifestly didn't—that Catholics and Lutherans were not measurably closer to ecclesial reconciliation and full communion on the day after the *Joint Declaration on Justification by Faith* was signed than they had been the day before—suggested that other Church-dividing issues had entered the scene; or that, as some ecumenical wags put it, the "goal posts have been moved." Here, too, questions of ordained ministry, sexual morality, apostolic authority, and biblical interpretation loomed large, and seemed likely to loom ever larger in the years ahead. It was another frustration for the Pope, who had invested enormous energies into breaking down historic barriers of distrust with Protestant Christians.

John Paul's unapologetic global witness to the Gospel and his robust defense of the fundamental right to life did have one, perhaps unex-

pected, ecumenical effect: it reconciled large numbers of evangelical and fundamentalist Christians to the idea that Catholics were, in fact, brothers and sisters in Christ. Evangelical pastors and theologians whose parents unblushingly referred to the Bishop of Rome as the "Whore of Babylon" came to regard John Paul II as the great Christian witness of the late 20th century. At a time when Catholic-evangelical relations were often conflicted in Latin America and Africa, the warm appreciation shown John Paul II by the leading figures of North American evangelicalism suggested the possibility of a better future—and indeed of a new axis of ecumenical dialogue, as the liberal Protestant communities that had been Catholicism's post–Vatican II dialogue partners continued to fade demographically.

Bishops

Karol Wojtyła was a bishop of the Catholic Church for almost forty-seven years. In Kraków, he was one of the most innovative and successful diocesan bishops of his time. From Rome, his pontificate exuded episcopal paternity and energy. Some 40 percent of the entire public schedule of his pontificate was devoted to meeting with the world's bishops. He also attended virtually every session of every one of the fifteen Synods of bishops he summoned over the course of twenty-six years. Why, then, did this most dynamic Bishop of Rome not inspire a similar evangelical confidence and episcopal dynamism in many of his brother-bishops—particularly in the developed world, but not only there?

Once again, different understandings of the Second Vatican Council, its teachings and its artifacts, were likely in play.

In an important historical and theological sense, Vatican II was necessary in order to complete the work of Vatican I, which had been suspended in 1870 because of the Franco-Prussian War and never reconvened. Vatican I had defined the infallibility of the pope when teaching *ex cathedra* on matters of faith and morals; it was then supposed to have gone on to explore the ministry and authority of bishops themselves, and in their relationship to the Bishop of Rome. Because that didn't happen at Vatican I, a certain imbalance entered into Catholic

ecclesiology, the theology of the Church. So, the ministry and author-
ity of bishops was necessarily one of the most prominent agenda items
at Vatican II.

Two of the Council's documents dealt with the nature of the episco-
pal office and its exercise in the modern world: *Lumen Gentium* [Light of
the Nations], the Council's foundational Dogmatic Constitution on the
Church, and *Christus Dominus* [Christ the Lord], the Decree on the Pas-
toral Office of Bishops in the Church. Both documents identified three
episcopal roles—teaching, sanctifying, and governing—while placing
primary stress on teaching and sanctifying. Administration, the Coun-
cil taught, was a necessary and indispensable part of the bishop's task;
episkopos, after all, meant "overseer" in Greek. But when administration
trumped teaching and sanctifying in the way the bishop conducted his
ministry, something was out of joint.

At Vatican II, bishops rightly insisted that they were not junior
branch-managers, merely executing the instructions of the ecclesiasti-
cal C.E.O., the pope. Yet in the years after the Council, that is what
many bishops in the developed world became—managers, frequently
enmeshed in the toils and snares of large ecclesiastical bureaucracies
(another by-product of Vatican II in the developed world). In one of
the oddities of the post–Vatican II period, those bishops most vocal in
their criticism of Roman "centralism" were often the same bishops who
had mortgaged a considerable part of their own authority to their local
Church bureaucrats.

The same diminishment of episcopal authority and energy was an
unforeseen consequence of another mandate of Vatican II—that every
country have a national bishops' conference. While intended to facili-
tate joint pastoral action, on the one hand, and episcopal fraternity, on
the other, bishops' conferences in the developed world quickly became
highly bureaucratic, with large staffs of priests, sisters, and laity work-
ing for the bishops, but, in more than one instance, tying the bishops
up in knots—or forwarding, through the bishops, agendas of their
own. John Paul II was a great believer in bishops' conferences, in no
small part because of his Polish experience. Long before the Second
Vatican Council, the Polish bishops had had a tradition of collegial
consultation and decision-making, which they continued after Vati-
can II. But the Polish episcopate had virtually no staff, its discussions

were held behind closed doors, the bishops were in charge of their own agenda; and when the debates were over and decisions made, the bishops closed ranks against any attempts by the communist government to drive wedges among them. None of this, admirable as it was, had much to do with the way the U.S., Canadian, British, or German bishops' conferences functioned after Vatican II. So when the Pope, as he frequently did, advised a troubled diocesan bishop to "take the problem to the conference," he may have been thinking of a form of episcopal consultation and collegiality that didn't exist, especially in the American case.

There were other ways in which episcopal conferences tended to impede both episcopal initiative and the evangelical renewal of the Church a renewed episcopate was intended to foster. Several national episcopal conference staffs—notably in North America—quickly took on an ideological coloration that was not necessarily friendly to the pontificate of John Paul II. Thus staff members of the U.S. conference were deeply skeptical about (and, in some cases, hostile to) the Pope holding World Youth Day in Denver in 1993; similar (indeed, worse) skepticism and hostility could be found in the Canadian bishops' conference staff prior to World Youth Day 2002 in Toronto. Somehow, the bishops in question did not seem to understand that if the staffers in question were skeptical to the point of hostility about one of the most successful Catholic initiatives of the 20th century, new staff should be found.

In addition to clarifying an important theological point in its description of the world episcopate as a college of equal members under the headship of the Bishop of Rome, the Council intended to promote episcopal fraternity. One aspect of that fraternity and mutual support was what the Church refers to as "fraternal correction": bishops calling other bishops to account when necessary, as Cyprian, Augustine, and others had done in the Church's formative patristic era. Unfortunately, the functioning of episcopal conferences in the developed world tended to accentuate their men's club atmosphere, and in the atmosphere of the episcopal club (or, as one American cardinal called it, "the brotherhood"), fraternal correction does not come easily. In many cases, it never came at all. In France, in Britain, in Canada, in the United States, and in South Africa, it was Rome, not the local conference, which was forced to discipline malfeasant bishops; even in extreme cases, the local "broth-

erhood" couldn't bring itself to act. Post–Vatican II bishops in the developed world like to think that they've professionalized the Catholic episcopate, and in some respects, they have. But one distinguishing hallmark of a true profession is that it's self-regulating; bar and medical associations that could not bring themselves to discipline malfeasant members would not be true professional associations. It is a point that does not seem to have been grasped by various bishops' conferences.

These matters, and others relating to the effective exercise of the episcopate in a Church that relies on vigorous leadership from its bishops, might have been thrashed out in the Synod of Bishops. But during John Paul's pontificate, the Synod was at least as much part of the problem of fostering true episcopal leadership as it was part of the solution. Whatever else might be said about it, its modus operandi, especially under the leadership of Cardinal Jan Schotte, C.I.C.M., did not promote free and frank debate. Rather, bishops from all over the world (and John Paul himself) were subjected to endless gusts of episcopal rhetoric, as week after week, one bishop after another gave a five- or ten-minute speech in a Synod Hall whose design was itself ill-suited for real conversation. Good things happened at Synods, often on the fringe: at lunches and dinners, or in other informal settings. But the formal Synod process itself did little to advance the cause of episcopal vitality, and in some instances sapped those energies further.

Still, the frustrations with their bishops felt by many Catholics enthusiastic about John Paul II's pontificate were not the result of sclerotic diocesan and conference bureaucracies or the Synod of Bishops alone; they also had to do with episcopal appointments. Some of John Paul's appointments were bold and defied the conventions of the Vatican or the local hierarchical club (and sometimes both): Jean-Marie Lustiger to Paris; John J. O'Connor to New York; Camillo Ruini as vicar for Rome; Norberto Rivera Carrera to Mexico City; Ivan Dias to Bombay/Mumbai; Francis E. George, O.M.I., to Chicago; Jorge Mario Bergoglio, S.J., to Buenos Aires; Péter Erdő to Esztergom-Budapest; Marc Ouellet, P.S.S., to Québec; and George Pell to Melbourne and then Sydney would be some of the notable examples in major sees. Other John Paul II appointments were far more conventional; still others seemed inexplicable, as the bishop involved clearly did not share the Pope's vision of what the

full implementation of Vatican II meant. In the last years of the pontificate, more than one of the Pope's supporters took the view that the system of episcopal appointments was, if not completely broken, then at least seriously dysfunctional.

The effects of a dysfunctional process of episcopal vetting and nomination—combined with the various disempowerments of bishops previously discussed—could be devastating. As many Catholics in the United States came to understand by the end of 2002, a scandal of priestly sexual misconduct had become a true crisis because of failed leadership by bishops: bishops who had relied on the bishops' conference to solve these problems; bishops who had been overly influenced by psychologists and psychiatrists; bishops who showed terrible judgment in choosing subordinates.[31] These failures were not widely understood in Rome, which made coping with them even more difficult.

The Catholic Church believes its form—including the episcopate—was given to it by Christ. Genuine reform of the Church always means a return to form—in this case, to the will of Christ for the office of bishop. Vatican II laid the theological ground for reforming and renewing the office. John Paul II demonstrated, in action, how the Council's vision of the bishop-as-apostle could be lived effectively. One of the large questions for the Church that John Paul II left behind was the question of how to expand, exponentially, the percentage of bishops who understand the Council's vision and the practical implications of John Paul II's example. It was a question that touched both ideas and process.

The unreformed consecrated life

John Paul II came to the papacy with a deep respect for consecrated life: Christian life lived according to perpetual vows of poverty, chastity, and obedience. He was notably successful in encouraging new forms of consecrated life, in the renewal movements and new Catholic communities where different forms of the life of the vows—say, as lived by lay people in the world—were being explored, often with impressive evangelical results. He was notably less successful in reforming established religious orders, the traditional home of the consecrated life in the Church.

On one occasion he tried, very hard. The situation in the Society of Jesus—since the Counter-Reformation, the Catholic Church's most prestigious religious order of men—had been a deep concern to Pope Paul VI in the last years of his life; the Jesuits were a concern to John Paul II as he took office. Theological adventurousness that seemed at times to breach the boundaries of orthodoxy, or to deny the very possibility of the Church's capacity to teach authoritatively; lifestyle innovations and peculiarities that made it difficult to recognize the presence of the vows in Jesuit houses; politicization of the priesthood and flirtations with Marxism—all of these were prominent features of Jesuit life in the early 1980s. The Pope's effort to get the Jesuits to think again took the form of an unprecedented papal intervention in the Society's internal governance: in October 1981, the Pope appointed a personal representative to govern the Jesuits, rather than permitting the election of a new General to replace Father Pedro Arrupe, S.J., who had suffered a stroke. The Pope's representative, Father Paolo Dezza, S.J., and his assistant, Father Giuseppe Pittau, S.J., were in nominal charge of the Jesuits until September 1983, when the Pope permitted a General Congregation of the Society to convene and elect a new General.[32]

The papal intervention in the governance of the Society had some successes, and the Society continues to provide a true intellectual and spiritual service to the Church in some instances. But if the intention of John Paul's shock therapy was to impel a thoroughgoing, indeed radical, reform of Jesuit life, it cannot be counted a success. Throughout the pontificate, Jesuit institutions of higher education continued to describe themselves as being "in the Jesuit and Catholic traditions," but the latter was sometimes more difficult to discern than the former. At one such school, Boston College, a Jesuit moral theologian, John Paris, S.J., was a prominent proponent of denying food and water to (and thus effectively euthanizing) Terri Schiavo during the Pope's own last illness. Jesuits in positions of authority continued to persecute their more assertively orthodox brethren inside the Society; in some provinces, candidates for the Society were still screened for what the Jesuit vocation bureaucracy regarded as excessive fidelity to Catholic doctrine (usually described as "rigidity" or "judgmentalism"). That orthodoxy, in both moral theology and lifestyle, was being very broadly defined in some Jesuit quarters was made clear when the Web site of

the California province posted, in 2001, a photo gallery of novices featuring kinky Mardi Gras pictures of "Pretty Boy and Jabba the Slut" in drag. Of far more concern than such sleaziness, however, is the condition of the Society in India, now one of the largest communities of Jesuits in the world—many of whom, according to knowledgeable observers, are unpersuaded of, or are unprepared to defend, the uniqueness of Jesus Christ as savior of the world, and who are thus committed to downplaying the Church's missionary mandate.[33]

After the less than complete success of the Jesuit intervention, John Paul II seemed to adopt a two-track strategy vis-à-vis religious orders: encourage living, vibrant communities, and let those who had fallen into various theological and moral corruptions die of their own ultimate implausibility. The first half of the approach had some important successes; one of them was the Polish Dominican province, whose numbers, evangelical effectiveness, and public outreach increased dramatically under the leadership of a brilliant young provincial, Fr. Maciej Zięba, O.P., a former Solidarity activist and favorite of John Paul II's. And in North America, observers noted that the fastest growing religious orders of women in the United States were those most attuned to the consecrated life in its classic form, including wearing the religious habit. The triage strategy of letting irrecoverably wounded communities die was less defensible, however—particularly when it meant permitting high schools, colleges, and universities that were manifestly not thinking with the Church or teaching what the Church believed to maintain the charade of their nominal Catholicism.

The leadership of the Vatican's Congregation for Religious was generally weak throughout John Paul's pontificate. In Rome, as in the United States, it was often thought that the problems of religious orders, which were not unknown, were a kind of untouchable third rail in Catholic life. Here, too, there was important, reforming work to be done in the post–John Paul II Church.

The traditional managers of popes

Throughout the pontificate, it was frequently said that John Paul II was not a man of administration or, as they say in the Vatican, a "man of

governo." Karol Wojtyła came to Rome knowing that his strengths were intellectual and pastoral, not managerial, and, in the main, he was content to leave the structures of the Roman Curia as he found them. His 1988 apostolic constitution, *Pastor Bonus* [The Good Shepherd], did make a significant re-arrangement of the curial flowchart; these were changes quite in line with the new curial structure created by Paul VI in 1967, however, and in some cases involved alterations that were anticipated in 1967 but couldn't be done then for reasons of entrenched bureaucratic opposition. There was no systematic re-examination of the curial system and process created by Paul VI after Vatican II, though, and like similar bureaucracies around the world, the Roman Curia grew larger during the last quarter of the 20th century (although by contemporary organizational standards, it remains a remarkably lean operation—a central bureaucracy of 2,700 in a Church of 1.1 billion members).

This failure to re-examine the basic design of the Curia, plus its expansion, led to what some observers (and the occasional curialist) regarded as serious difficulties. Parts of the new Curia did significant work: the Pontifical Council for the Laity, for example, did yeoman service in arranging World Youth Days and undertook, successfully, the often-delicate task of bringing renewal movements and new Catholic communities into a more normal canonical relationship with the instruments of the Church's governance. The Pontifical Council for Promoting Christian Unity did serious theological work, if at times in (natural) tension with the Congregation for the Doctrine of the Faith. The Pontifical Council for the Interpretation of Legislative Texts played an important role in securing the revised Code of Canon Law in the life of the Church. In other instances, however, a pontifical council originally intended as a kind of think tank for the rest of the Curia (and, beyond that, for the world Church) became, in effect, an international non-governmental organization, issuing reams of statements and studies that went largely unheard or unread. This seemingly irresistible bureaucratic imperative could make for serious difficulties when it intersected with the poor coordination of the Vatican's message (another bureaucratic flaw in the curial system) on controverted issues; the variegated signals coming from "the Vatican" during the controversy over the doctrinal document *Dominus Iesus* [The

Lord Jesus] in 2000, and during the 2002–03 debate over Saddam Hussein and Iraq, were prominent cases in point.

If he was disinclined to tinker with structure, John Paul II did try to change the Curia's ingrained culture and habits by example. His own vibrant priesthood demonstrated to the priest-officials of Vatican offices that there was no contradiction between necessary desk work and a deep spiritual life. His openness—to visitors, guests, pilgrims—could not help but inspire a similar opening, however slowly, of the offices of others. On at least one occasion, he tried to accelerate a process of fresh thinking in the Curia; the result, alas, was his least impressive social encyclical, *Sollicitudo Rei Socialis* [On Social Concern], which emerged from a tortuous process of consultation between the papal apartment, the Pontifical Council for Justice and Peace, and other curial offices (or "dicasteries," as they're known in the Vatican). He remained committed to internationalizing the senior posts in the Curia until the last few years. Then, with Cardinal Angelo Sodano, the secretary of state, exerting more influence (by default if not by design), the old ways reasserted themselves; by the end of the pontificate, all six senior posts in the Curia were held once again by Italians (or, to be absolutely precise, five native Italians and a thoroughly Italianate Argentine). It was a clear signal that, for all John Paul II's innovations in the conduct and style of the papacy, habits of mind and heart had not changed decisively throughout the Vatican bureaucracy. Its default positions remained, in many instances, precisely where they had been when the *lo straniero*, the "foreigner," had been elected pope in 1978.

THE AMERICAN EXAMPLE

The epic accomplishments, the frustrations, the ambiguities, and even the failures of the pontificate of Pope John Paul II come into particularly clear focus when examined through the prism of the Catholic Church's life in the United States between 1978 and 2005.

In 1978, it was not clear that Catholicism in America would remain the most vibrant local church in the developed world. By 2005, and de-

spite the greatest crisis in its history, the skeptics and the Cassandras had been confounded. Expectations among some of its gloomier (or less courageous) bishops notwithstanding, Catholicism in the United States had not gone down the road pioneered by similarly situated local churches in Europe, Canada, and Australia. The Catholic Church in the United States, for all its problems, remained the premier laboratory for testing, with considerable success, how to be the Church in the modern world.

Its parishes displayed a vibrancy unimaginable in parts of Europe; visitors could find more people at Mass on a Lenten weekday morning in a typical suburban Washington, D.C., parish than could be found at the vigil Mass on Saturday evening in the cathedral of Munich. The Catholic Church in the United States supported the largest independent education system in the country and made its schools readily available, often without charge, to at-risk children in inner-urban areas. The Church continued to operate the largest independent health care system in the world, sometimes under considerable pressure from legislators determined to impose practices contrary to Catholic doctrine on Catholic hospitals. Catholic social service agencies were among the most cost-effective in the United States. And the Church (with its evangelical Christian allies) maintained a large nationwide network of centers to serve women in crisis pregnancies, thus demonstrating that it did not just inveigh against abortion, it provided alternatives to abortion. Catholic bishops, priests, intellectuals, and activists were in play in American public life far more than their counterparts in Europe. The vitality of Catholic life in the United States, and the generosity of U.S. Catholics, had led to the establishment of the world's largest Catholic telecommunications empire, the EWTN network founded by a redoubtable dumpling of a nun, Mother Angelica, who was devoted to John Paul II and enjoyed his support.[34]

From the mid-1990s on, a generational shift could be detected among younger Catholic intellectuals: some were directly inspired by the Pope, others were simply bored by the dissent of their elders. By the end of the pontificate, it was becoming increasingly clear that the generation of dissent among U.S. Catholic theologians was not reproducing itself; its hegemony in Catholic colleges and universities, it seemed, could not be indefinitely sustained. This trend was already

having an effect on Catholic campuses; the flagship University of Notre Dame, for example, was far more robustly Catholic in 2005 than it had been in 1978. Catholicism in the United States had also proven to be fertile ground for renewal movements and new Catholic communities. World Youth Day in Denver in 1993 had re-energized Catholic youth ministry, at least in some dioceses. Seminary life had been largely reformed, and if priests were feeling the pressure of fewer colleagues, many of them were also reaffirmed and reinvigorated in their priestly service.

Measured against the situation in Canada or western Europe, then, U.S. Catholicism under John Paul II was a considerable, even striking, success. Measured by the standard of what might have been, though, there were serious disappointments.

The Church continued to suffer from too many weak, ineffective, or, in a few instances, arguably heterodox bishops. The American priesthood was aging, and seemed headed for a difficult ten- to twenty-year patch until the vocation stream inspired by John Paul II came on line. Too much of Catholic higher education remained unreformed; Boston College, a pulsing center of theological dissent and lifestyle curiosity, seemed poised to become the de facto center of Catholic life in eastern Massachusetts as the Archdiocese of Boston crumbled under the impact of priestly scandal, episcopal misgovernance, and a poisonous media atmosphere. At every level of Church life, from the parish to the bishops' conference, Catholics found themselves enmeshed in bureaucracy, spending untold hours in meetings— which did not seem to be exactly what John Paul II had in mind by the new evangelization.

Yet there was a tremendous sense of possibility in the Church in the United States: *if* the bishops would lead and *if* the bureaucracies would stop choking off initiatives. John Paul II had been taken seriously in America—more seriously, in intellectual and political terms, than in any other part of the developed world. By the same token, the Pope had given Catholics in America a new sense of pride in their Catholicism, and had inspired a new Catholic presence in public life that the Church's opponents (and some Catholic politicians) may have found uncomfortable—but which was in no danger of fading away.

"The Church that John Paul II left behind" in the United States was, like the Church in every time and place, an earthen vessel containing miracles of grace. Whatever its frustrations, Catholicism in America, as throughout the world, had ample reasons to thank God for the leadership, the witness, and the teaching of a pope whom most of its people had come to revere.

The Tears of Rome

IN THE EARLY SECOND CENTURY, about A.D. 110 or so, Ignatius, the bishop of Antioch in Syria, sent a letter to the Church in Rome. He was on his way there to be martyred, and he didn't want his fellow Christians in the imperial capital to do anything about it. "I am in the throes of being born again," Ignatius wrote; "I desire to belong to God . . . Let me see the pure light; when I am there, I shall truly be a man at last." Eighteen and a half centuries later, Karol Wojtyła, in his preaching and his intellectual work, would weave extensive variations on Ignatius's theme: to be in communion with God was to live the fullest possible human life. That the ultimate form of that communion meant passing over the door of death concerned the 264th Bishop of Rome as little as it had the second-century bishop of Antioch.

Thus, when death came for him at 9:37 p.m., Rome time, on April 2, 2005, those who shared Pope John Paul II's faith could only see that moment as a beginning, not an end. Karol Wojtyła, the man from a far country who had lived the last twenty-six and a half years of his life in obedient exile from his homeland, was now where he had always wanted to be. The man who had spent himself out defending the dignity of the human was, as the patristic theologian Ignatius had put it, "truly a man at last."

The announcement was made in St. Peter's Square to the tens of thousands keeping vigil there by the late Pope's chief-of-staff, Archbishop Leonardo Sandri, the *sostituto* or deputy secretary of state: "The Holy Father has returned to the house of the Father." Archbishop San-

dri then led the crowd—or, perhaps better, congregation—in singing the *Salve, Regina* [Hail, Holy Queen]: a plaintively beautiful Gregorian chant in honor of the Virgin Mary, which Karol Wojtyła had sung tens of thousands of times in his life. Its two familiar stanzas include an appeal that aptly caught some of the emotion of the moment: *Ad te clamamus, exsules filii Evae / Ad te suspiramus, gementes et flentes in hac lacrimarun valle* [To thee do we cry, poor banished children of Eve / To thee do we send up our sighs, mourning and weeping in this valley of tears].

Sir John Gielgud, the great British star of stage and screen, once said that John Paul II, the former Rhapsodic Theater actor, had the "most perfect" sense of timing he had ever encountered—which turned out to be as true of the Pope's death as it was of his public life. He died after participating in the Vigil Mass for Divine Mercy Sunday, an annual feast he had given the Church, bringing a particular gift of Polish Catholicism to Catholics throughout the world. According to the secular calendar, his last day on earth was the first Saturday of the month; in traditional Catholic piety, first Saturdays are devoted to the Blessed Virgin, to whom Karol Wojtyła had dedicated his life in his episcopal motto *Totus Tuus* [Entirely Yours]. The congregation outside his window in St. Peter's Square, praying him through the Passover of death, was filled with young people, to whom he had devoted so great a part of his priestly ministry for more than fifty-eight years. It was all, somehow, as it should have been—as it was meant to be.

He had kept in touch with people and places he cherished until the very end. On March 29, he had written a letter to an old friend, Maria Tarnowska, whom he had first known when he was a student chaplain in the early 1950s. Signed, as always, *Wujek* [Uncle], the letter arrived the day seventy other longtime friends of *Wujek*, members of his *Środowisko*, left for Rome and the papal funeral; many were clad in the hiking gear reminiscent of their excursions with *Wujek* through Poland's mountains. On the day he died, a telegram the Pope had dictated on March 31 was delivered and read at the Divine Mercy basilica in Łagiewniki, on the outskirts of Kraków.

So it was fitting that a man who had worked hard to keep his friendships green and who had drawn the intense loyalty of his friends and associates should have died with some of those closest to him surrounding his deathbed: Archbishop Stanisław Dziwisz, his longtime

secretary, who had made Karol Wojtyła's life work for almost four decades; Monsignor Mieczysław Mokrzycki, a young Ukrainian who had been his second secretary since the late 1990s; Father Tadeusz Styczeń, S.D.S., his first philosophical protégé and his successor in the Chair of Ethics at the Catholic University of Lublin; Archbishop Stanisław Ryłko, a Kraków priest who had served in Rome for years, most recently as president of the Pontifical Council for the Laity; Cardinal Marian Jaworski, the Latin-rite archbishop of Lviv in Ukraine, his old housemate at St. Florian's parish and later on Kanonicza Street in Kraków, when both were aspiring young philosophers; and the Polish sisters who had taken care of his household since his first days as archbishop of Kraków. These closest of the Pope's associates reportedly marked the moment of his death by singing the *Te Deum*, the Church's classic hymn of praise and thanksgiving.[1]

Outside, and indeed around the world, more than one person, receiving the news, spontaneously thought of one of the most famous lines in St. Augustine's *Confessions*: "Thou hast made us for Thee, and our hearts are restless until they rest in Thee."

The great heart of John Paul II was now, finally, beyond restlessness.

A MOST SINGULAR MAN

Because the Pope's death had been expected for several days, the great and the good of the world had ample time to think what they might say on his passing, which is one reason why the immediate tributes on Saturday, April 2, were so impressive. Henry Kissinger told NBC that it would be hard to imagine a figure who had had a greater impact on the 20th century—a striking judgment from a diplomat and historian with no religious or ideological investment in the life of Karol Józef Wojtyła. Zbigniew Brzezinski took the immediate postmortem conversation in an important, if slightly different, direction. Brzezinski had first met Wojtyła in 1976, when the Polish cardinal had lectured at the Harvard Summer School and had struck the Columbia University international affairs theorist as a man of "intel-

ligence and calm strength." Later, when the Polish émigré scholar was national security advisor to the president of the United States and Karol Wojtyła was pope, they had spoken in Polish by telephone about ways to forestall a Soviet invasion of Poland to crush the nascent Solidarity movement.[2] In his comments on NBC, Brzezinski, a man not noted publicly for his piety, reminded the audience that John Paul II's most impressive accomplishments were in the realm of the spirit: this was the man who had come to embody the global yearning for spiritual truth at a time when so much of Western high culture was feeding the world stones.

Timothy Garton Ash, the historian and journalist who had chronicled the rise, struggle, and final triumph of Solidarity, wrote in the British *Guardian* that he didn't feel competent to judge the Pope's impact on the Catholic Church; but from the point of view of "an agnostic liberal," John Paul II was "the first world leader" and "the greatest political actor of the last quarter-century"—and by "actor," Garton Ash meant both a man with the rhetorical skills to summon others to freedom's colors, and a man who had actually made things "happen in the world."[3] (The *Guardian* itself didn't hesitate to pass judgment on John Paul's theology and papal ministry: he had been "a doctrinaire, authoritarian pontiff."[4])

One of America's most widely read columnists, Charles Krauthammer, brought Kissinger's, Brzezinski's, and Garton Ash's points together in an op-ed reflection on a famous—or infamous—question:

It was Stalin who gave us the most famous formulation of that cynical (and today quite fashionable) philosophy known as "realism"—the idea that all that ultimately matters in the relations among nations is power. "The pope? How many divisions does he have?"

Stalin could only have said that because he never met John Paul II. We have just lost the man whose life was the ultimate refutation of "realism." Within ten years of his elevation to the papacy, John Paul II had given his answer to Stalin and to the ages: More than you have. More than you can imagine. . . .

Under the benign and deeply humane vision of this pope, the power of faith led to the liberation of half a continent . . . We

mourn him for restoring strength to the Western idea of the free human spirit at a moment of deepest doubt and despair. And for seeing us through to today's great moment of possibility for both faith and freedom.[5]

In a lengthy *New York Times* obituary, Robert McFadden summarized the chief accomplishments of an "extraordinary papacy," one that fulfilled the promise, nascent in its beginning, of a pope who would "captivate much of humanity by sheer force of personality and reshape the Church with a heroic vision of a combative, disciplined Catholicism."[6] The *Times*'s editorial comment was less generous, indeed less intelligent. After suggesting that John Paul's decision to die at home had somehow vindicated the euthanizing of Terri Schiavo, the *Times* depicted the late Pope as a man "who used the tools of modernity to struggle against the modern world," a man who had shaped our times "even as he railed against them."[7] As in the previous twenty-six years, the *Times*'s editors evidently found it impossible to consider an alternative reading of Karol Wojtyła's life: that he was a thoroughly modern man with an alternative reading of modernity's achievements, aspirations, temptations, and difficulties. (Saturday afternoon, as the Pope was dying, the *Times* embarrassed itself by posting on its Web site an unedited piece of copy that spoke volumes about its approach to covering John Paul II; the posted copy read as follows: "Even as his own voice faded away, his views on the sanctity of all human life echoed unambiguously among Catholics and Christian evangelicals in the United States on issues from abortion to the end of life. **Need quote from supporter.** John Paul II's admirers were as passionate as his detractors, for whom his long illness served as a symbol for what they said was a decrepit, tradition-bound papacy in need of rejuvenation and a bolder connection with modern life. 'The situation in the Catholic Church is serious,' said Hans Küng, the eminent Swiss theologian who was barred from teaching in Catholic schools because of his liberal views."[8])

In contrast to the *Times*, the *Washington Post*, while editorially recalling its disagreements with the late Pope on questions like population policy, proposed that John Paul "will be seen by most . . . as a remarkable witness, to use a favorite term of his—witness to a vision charac-

terized by humaneness, honesty, and integrity throughout his reign
and his life."[9] Britain's *Telegraph* ran an obituary which began with the
frank assertion that John Paul II, "a master of modern communications,"
had "raised the papacy to a political and social influence it had not en-
joyed since the Middle Ages."[10] In his comments to *Newsweek*, evangelist
Billy Graham focused on John Paul II as "unquestionably the most in-
fluential voice for morality and peace in the world over the last 100
years," while *Time's* Nancy Gibbs wrote movingly in her magazine's on-
line edition of the feelings of those in St. Peter's Square when the Pope
was dying: "You feel smaller when your father dies because he was
strong and lifted you, carried you and taught you, and when he's gone
the room feels too big without him. So it was in St. Peter's Square,
where pilgrims kept vigil, their faces traced in low light by candles,
murmuring, 'Don't leave us.' Among the believers [there] was almost
disbelief that death still comes even to a man this strong—the Holy Fa-
ther who had carried people so far, lifted them so high, taught them so
much . . ."[11]

The *Washington Post's* Daniel Williams fell prey to a confusion that
had bedeviled many others throughout the twenty-six-plus years of
John Paul II's papacy: the confusion of Catholic doctrine with personal
papal opinion. Thus, the day after the Pope's death, Williams specu-
lated as to whether the cardinals then traveling to Rome would want to
affirm "strict continuity with John Paul II's thinking"—as if the *Catechism
of the Catholic Church* taught the idiosyncracies of the man who had just
died, rather than the settled convictions of a two-thousand-year-old re-
ligious community. Predictably, Catholic commentators from the port
side of the Barque of Peter took a similar line, more harshly in several
cases. Psychologist and commentator Eugene Kennedy described John
Paul to the *Boston Globe* in somewhat schizophrenic terms: "This was a
papacy characterized by irony . . . he helped free the peoples of Europe
from communism, but as a master figure in the Church, he invested his
own Church with authoritarianism."[12] James Carroll, a former Paulist
priest and regular *Boston Globe* columnist, continued the assault on the
late Pope's putative authoritarianism, telling ABC News that John Paul
had "faithfully tried to preserve this medieval, absolutist notion of
pope-centered Catholicism with everything going out from the Vati-
can."[13] Marco Politi, the *Vaticanista* of *La Repubblica* (and co-author, with

Carl Bernstein, of a strange biography of the late Pope), argued in *The Tablet* that the "intransigent" John Paul "had always had a problem with modernity," which was manifest in his "systematic demonization of the twentieth century" and his suggestion (evidently incomprehensible to Politi) that Nietzsche, Marx, and Freud had not been altogether positively disposed toward Christianity.[14] Thomas Cahill, the popular historian and cradle Catholic, took the indictment to what might have seemed its outer limits when, in an April 5 op-ed column, he suggested that John Paul "may, in time, be credited with destroying his Church."[15] Veteran British journalist and Catholic convert Clifford Longley pushed the boundaries out even farther, however: "So the reign of Karol Wojtyła is ending. It was magnificent, but was it Christianity? It is a little too early to say."[16]

Meanwhile, after the Pope's death, the French government found itself in an uproar when secularists and socialists protested lowering the *tricolour* to half-staff in honor of the late Pope, while Ireland, which had abandoned its traditional Catholic practice at an astonishing rate during John Paul's pontificate, debated whether the prime minister, Bertie Ahern, should have declared the day of the Pope's funeral a national holiday.[17]

Whether positive, negative, or critically balanced, the sheer volume of the news coverage and commentary that flooded the world's newspapers, magazines, televisions, radios, Web sites, and blogs buttressed the argument for the case that Karol Wojtyła of Wadowice, Kraków, and Rome had been the singular figure of the late 20th century and the early 21st. The onetime student actor had lived a most dramatic life, and the drama of his life somehow seemed to embody the aspirations of our times, for an extraordinary number of the earth's inhabitants. At the United Nations in 1995, John Paul II had described the "quest for freedom" as "one of the great dynamics of human history."[18] By harnessing that quest to a passionate defense of the dignity of the human person, John Paul had changed the times by changing lives. His old friend Father Józef Tischner, the Polish philosopher, had once described Solidarity as a "huge forest planted by awakened consciences."[19] Karol Wojtyła had planted forests of conscience all over the world. In the days after his death, an astonishingly large number of people would thank him for doing so.

THE GATHERING OF THE FAMILY

Father Jay Scott Newman, pastor of St. Mary's Catholic Church in Greenville, South Carolina, had left his rectory and the television coverage of the Pope's death to go over to his church and hear Saturday afternoon confessions. Some time later, he called a friend and reported that he'd just had "the most remarkable three hours of my priesthood." Six people who hadn't been to confession in between thirty and forty years had come to St. Mary's to receive the sacrament of reconciliation. After welcoming them home, Father Newman asked each penitent why they had picked that moment to return. In each case, it was the death of the Pope. As Father Newman put it, "it's only been four hours since he died, and the grace is already pouring out."

Elizabeth Doerr, a twenty-five-year-old Catholic from the Indianapolis area, was one of the founders in the United States of the Pier Giorgio Frassati Society, an organization of young adult Catholics named in honor of one of Pope John Paul's favorite *beati;* a Milanese bon vivant and mountain climber of the Roaring Twenties who had worked extensively with the local poor, and who had died at age twenty-four, victim of the polio he had contracted from an invalid he was visiting. The day after the Pope's death, she e-mailed a friend in Rome: "You may think I'm crazy, but I'm on the train from Paris to Rome. I don't know whether I'll see anything. But I have to be there."

Elizabeth Doerr, it turned out, wasn't alone. By early Tuesday morning, April 5, the Borgo Pio—which runs from the Vatican's Sant'Anna Gate down toward the grassy moat surrounding the Castel Sant' Angelo, hard by the Tiber River—was completely filled with tens of thousands of pilgrims, as were the surrounding streets in the Borgo district. Those streets and alleys would stay filled for the next four days, as some three million people descended on the Eternal City, effectively doubling its population. Early in the week, sensing what was coming, the Italian government contacted the Polish episcopate and the Polish government, pleading with them to organize large public events in Warsaw, Kraków, Częstochowa, and elsewhere in order to keep people in Poland; similar requests were made to the French bishops and the Spanish bishops. Thus the enormous throngs that did come to Rome

represented what might be called, in American election jargon, a "suppressed turnout." (The Italian authorities did far more than worry, however. By Tuesday afternoon, portable toilets and stations where pilgrims could get free bottles of water had been set up all over the Borgo district and around the Vatican.)

Poland itself was "an entire nation on retreat," as Dominican provincial Father Maciej Zięba put it. All advertising on all Polish television channels was canceled until after the Pope's funeral. Memorial Masses were celebrated before congregations of hundreds of thousands of Poles all over the country. The recording angel, flying over Poland at night, would have been dazzled by the hundreds of illuminated crosses, hearts, and papal coats-of-arms the Polish people were creating out of tens of thousands of vigil candles, laid reverently in patterns on the soil Karol Wojtyła had so often kissed.

On April 4, students using cell phones and text-messaging organized a "white march" in Kraków; hundreds of thousands, perhaps a million, people walked silently through the city's streets Monday evening, wearing white and holding vigil candles. (Earlier that day, a "Mass of Reconciliation" was held at Cracovia Stadium for fans of two soccer clubs, Cracovia and Wisła, long known for riotous behavior toward each other; the principal celebrants were Fathers Henryk Surma and Bronisław Fidelus, the team chaplains. After Mass, fans of both clubs, in tears, came to the platform, embraced, and swore publicly that they would never fight again.) On April 7, an enormous "white Mass" (reminiscent of the Mass held in the Old Town Square for hundreds of thousands of Cracovians, all dressed in white, on the day after John Paul II was shot) was celebrated on the vast greensward of the Blonia Krakowskie, the city commons. John Paul II had celebrated some of his most memorable Masses in Poland there, including the last Mass of his epic 1979 pilgrimage and the Mass for the canonization of Queen Jadwiga in 1997, both of which drew more than a million congregants. Now, one more time, and on the day before the late Pope's funeral, more than a million Poles gathered again to pay homage to the man who, on that spot in 1979, had begged them, "Never lose your trust, do not be defeated, do not be discouraged . . . never lose your spiritual freedom." Even Cardinal Franciszek Macharski, the late Pope's old friend and successor as archbishop, was stunned at the size of the

turnout. After the Mass, few went home; children came to the stage to read the late Pope's "Letter to Children" aloud to the crowd; old people read John Paul's "Letter to the Elderly."

By the night after the Pope's death, the memorial flowers were piled high in front of Karol Wojtyła's archiepiscopal residence at Franciszkańska, 3. On Sunday, the people of Kraków came to their former archbishop's home to pray, by the thousands. Some were there all night, kneeling on the street, holding vigil candles. The next day, Franciszkańska Street had to be closed; there was so much candle wax on it that neither people nor cars could navigate the surface. It was later announced that the *hejnał*, the broken trumpeter's call that sounds every hour of every day from the tower of the Mariacki, the Basilica of St. Mary's on the Old Town square, would be supplemented at 9:37 p.m. on the first Saturday of each month by a Marian melody loved by the late Pope.

On Sunday, April 3, Cardinal Angelo Sodano—no longer the secretary of state, because he, like almost every other senior Vatican official, had lost his office at the moment of the Pope's death[20]—celebrated a Mass for the public in St. Peter's Square. In the official text of his homily, released to the press, Sodano referred to "John Paul the Great." For reasons known only to him, though, he omitted this phrase when delivering the sermon. Whatever Cardinal Sodano's hesitancies may have been, the people of Rome were making their own feelings unmistakably clear, and not only by their presence in and around the Vatican. Rome is a city of posters, primarily political, one being pasted over another with bewildering rapidity. By Monday night, Rome was covered with posters from various groups, all saying, in one form or another, *Grazie, Santo Padre* [Thank you, Holy Father].

On the evening of April 3, Pope John Paul II, dressed in red and gold pontifical vestments, was laid out on a bier in the Sala Clementina, one of the audience halls in the apostolic palace. Cardinal Eduardo Martínez Somalo, the *camerlengo* [chamberlain] of the Holy Roman Church, led the brief ceremony, *De recognitione mortis* [On the reception of the dead], which was attended by officials of the Italian government as well as senior churchmen. The prayers included a hymn familiar to anyone who had ever attended a Catholic wake or funeral: "Come, saints of God, hasten, angels of the Lord; receive his soul and

present it at the throne of the Most High. May Christ who called you, receive you, and may the angels lead you to Abraham in paradise. Receive his soul and present it at the throne of the Most High. Eternal rest grant unto him, O Lord, and let perpetual light shine upon him; receive his soul, and present it at the throne of the Most High."

The following morning, on Monday, April 4, members of the Roman Curia, journalists regularly present at the Vatican, and friends of the late pontiff were invited to pay their respects. For the first time in a long time, the late Pope's face seemed in natural repose; the distortions and frozenness caused by his Parkinson's disease were things of the past. Nor was he stooped and bent as he had been in recent years, thanks to the Parkinson's and his arthritis. Seeing him on the bier, his back straight and his face at peace, the mind's eye turned to images of the youthful John Paul II, taking steps two at a time and tossing babies in the air, even as the imagination led back even further, to Karol Wojtyła, daredevil sportsman, careening through the Tatras on skis or racing a kayak through the Dunajec Gorge. In his left arm, he cradled the crozier—the pastoral staff topped with a modernistic silver crucifix that he had held up to the crowds at his papal installation Mass in 1978 as if it were a great sword of the spirit; the cross that he had waved to the faithful Catholics of Nicaragua in 1983, over the heads of chanting and disruptive Sandinistas. Yet for all the splendor of his silver staff, his gold miter, and his red vestments, he remained, lying in state, unmistakably himself: on his feet were the battered red-brown loafers that he preferred to the typical embroidered papal slippers, much to the discomfort of the traditional managers of popes.

(The papal crozier produced the first journalistic howler of the interregnum. On the front page of the April 4 *International Herald Tribune*, reporter Ian Fisher wrote that "tucked under his left arm was the silver staff, called the crow's ear, that he had carried in public." Fisher, having been told by John Thavis of Catholic News Service that the Pope's "crozier" was nestled in his left arm, heard, and wrote, "crow's ear," which evidently passed muster with *IHT* editors.[21])

At five p.m. on the evening of April 4, the Pope's body was carried through the apostolic palace into St. Peter's Square, and thence into the basilica, where it would lay in state until the funeral. For the first time, arrangements had been made to televise this impressive proces-

sion, led again by Cardinal Martínez Somalo, who was now joined by several dozen cardinals. The translation to St. Peter's began in the Sala Clementina with a chanted antiphon taken from Christ's assuring words to Martha at the death of her brother Lazarus: "I am the resurrection and the life. Whoever believes in me, even though he die, will live; and whoever lives and believes in me, will not die forever." After blessing the late Pope's body with holy water, Cardinal Martínez then invited those present to accompany the remains to the basilica, "where John Paul had, many times, exercised his ministry as bishop of the Church that is in Rome, and as pastor of the universal Church." As the procession formed, the Pope's body was taken up by the "Gentlemen of the Papal Family," the *Gentiluomini di Sua Santità*, so often seen directing the human traffic at major papal events. The procession came down the Scala Nobile to the *prima loggia* of the apostolic palace before passing through Bernini's Sala Ducale and the Sala Regia, painted by Vasari, then descending to the Square via the Scala Regia and the Portone di Bronzo, the famous "Bronze Doors." As the procession passed through these audience rooms and hallways frescoed by Renaissance masters, psalms were sung: the comforting Psalm 23 ("The Lord is my shepherd . . ."); the penitential Psalm 51 ("Have mercy on me, O God, in your kindness; in your compassion blot out my offense . . ."); the plaintively pleading Psalm 63 ("O God, you are my God, at dawn I seek you; my soul thirsts for you, my flesh yearns for you, like a dry desert, without water . . ."); the prayer of the dying, Psalm 130 ("Out of the depths I cry to you, O Lord; Lord, hear my voice . . ."). The psalms were followed by the three great New Testament canticles: the Canticle of Zechariah ("Blessed be the Lord, the God of Israel, who has come to his people and set them free . . ."), the Canticle of Mary ("My soul magnifies the Lord and my spirit rejoices in God, my savior . . ."), and the Canticle of Simeon ("Now, Lord, you may dismiss your servant, in peace, according to your word . . ."). The canticles led into the Litany of the Saints—the Church on earth asking the Church in glory to come to its aid in its mourning, and to welcome the soul of Karol Józef Wojtyła into heaven. The typical response within the Litany, after each invocation of a saint, is "pray for us"; on this occasion, it was "pray for him." (Curiously, among the ninety-four saints invoked by name, there were none canonized by John Paul II. The Litany did in-

clude the late Pope's model and predecessor as archbishop of Kraków, ⟋
St. Stanislaus, and Sts. Cyril and Methodius, the apostles of the Slavs
whom he had named co-patrons of Europe in 1980.)

After John Paul's body had been placed on a bier in front of the high
altar of St. Peter's, just above the tomb of Peter himself, the chant
"Come to his aid, saints of God" was sung again; then a passage from
the high priestly prayer of Christ at the Last Supper was read from the
Gospel of John. Prayers for the Church throughout the world fol-
lowed; then the Lord's Prayer; and, finally, the familiar closing plea:
"Eternal rest grant unto him, O Lord. Let perpetual light shine upon
him. May he rest in peace. Amen."

It was a deeply moving ceremony, a ritual passing-over from the
Pope's longtime home, the apostolic palace, to the place where he
would be buried. The fact that the Vatican agreed to televise it—and
did so brilliantly—suggested that at least some lessons had been
learned from the great papal communicator. He had died as pastor of
the universal Church, and the universal Church ought to be present,
even by television, at his obsequies.

Outside the basilica, the crowds were already queuing in a series of
lines that wove through the Borgo area beyond the Vatican walls. "Pa-
tient waiting" and "effective crowd control" are not phrases that readily
occur to anyone familiar with the Italian temperament, but something
dramatic was happening here. The vast throng, numbering in the hun-
dreds of thousands at any given moment over the next several days,
was marked by a spirit of prayerfulness and calm—even as some pil-
grims waited as long as twenty hours for a brief ten or twenty seconds
of prayer before the bier inside St. Peter's. (One veteran observer of the
Roman scene waggishly had it that "John Paul has performed his first
miracle: the locals are behaving themselves in line." A skeptic asked
about the Roman nuns, famous for piously pushing their way through
crowds to get into a pontifical ceremony. "The nuns, too," came the
reply. At which point, the skeptic's skepticism abated considerably.)
On Tuesday evening, the Borgo Pio remained completely jammed from
the Vatican to the Tiber. And the crowds were dominated by young
people. One group carried a large handmade banner that read *SANTO
SUBITO*—"Make him a saint now!" It was a sentiment that, as events
unfolded, would be widely shared.

The vast crowds on Tuesday, Wednesday, and Thursday—the Catholic family gathering from all over the world—were powerful testimony to how John Paul II had changed the Church's experience of the papacy. Traditionally, all Vatican stamps and coins printed or minted during an interregnum bear the Latin motto *Sede Vacante* [While the See Is Vacant]. In 1978, this was simply another Vatican ritual, interesting but hardly something to stir the emotions; Paul VI had been ready to die, and most everyone in Rome was ready to turn the page to a new pontificate after the struggles and contention of the previous fifteen years. This was different. In the crowds, among Roman seminarians and other university students, even among veteran curialists, there was a profound sense of emptiness: the See really *was* vacant, empty, and the emptiness was palpable. At every Mass, every day and everywhere, the Pope and the local bishop are remembered by name during the Eucharistic prayer or Canon: "We pray for John Paul, our Pope, and James (or William, or Edward, or whatever the local prelate's name might be), our bishop." In Rome, that prayer has a special resonance, as the priest-celebrant prays for "John Paul, our pope and bishop." Now, as there was no pope, there was no local bishop in Rome—and just about everyone at Mass in Rome in those days felt the difference.

Which, in part, explains the crowds: in the absence of a beloved father, the Catholic family was gathering to share a measure of solidarity amid a widespread sense of having just been orphaned. Yet the crowds were not somber or melancholy. The streets around the Vatican were filled with a sense of gratitude for a Christian life well-lived, and a sense of faith that the man to whom millions had come to bid farewell was, indeed, in "the house of the Father."

As the cardinals of the Catholic Church streamed into Rome after John Paul's death, they were spared the lines and the waiting, the Portosans, water bottles, and first aid stations. But they could not have been unaware of the significance of what they could see all around them. This had truly been a pope for the world. This had been a pope who, controversies notwithstanding, had touched the Church in all its variety and plurality. Whatever their previous thoughts on the succession, the members of the College of Cardinals who would enter the conclave as electors knew, by the middle of the week, that they were going to have to find a pope capable of a similar breadth of outreach

and impact. They were going to have to find a pope for all those, Catholic and non-Catholic alike, who were waiting in line for hours to see John Paul II for the last time.

Just before John Paul's death, Father Hans Küng, the premier example of the dissident theologian as world media star, had published a biting essay in the leading Italian daily, *Corriere della Sera*, criticizing numerous aspects of the pontificate. But, as Cardinal Julian Herranz, a veteran curial figure not given to displays of enthusiasm, told the *National Catholic Reporter*'s John Allen, the crowds jamming the precincts of the Vatican were "a sort of popular rebuttal to Hans Küng's criticism." "The Church is alive," the cardinal insisted. "Look at these young people, and you can see it in their faces . . . the Church lives."[22]

"WHAT IS GOD ASKING OF ME NOW?"

The College of Cardinals had been meeting in daily General Congregations since the Pope's death, to attend to practical details (such as setting the date of John Paul's funeral—which they decided to celebrate on Friday, April 8), and to begin planning the conclave that would elect the 265th Bishop of Rome. One of the practicalities involved reading the late Pope's spiritual testament, which was released to the public in an Italian translation from the Polish original on Thursday, April 7, the day before the funeral Mass. It was a remarkable document, indeed.

There was very little in it that one would normally associate with a will. As John Paul put it at the outset, "I leave no property behind of which it is necessary to dispose." Whatever "items of daily use" remained were to be "distributed as appears opportune." His "personal notes" were "to be burned," a task the Pope consigned to "Don Stanisław" [Dziwisz].[23]

One intriguing aspect of the Pope's testament was that it was a document he had elaborated over time, always during his annual Lenten retreat. The first part of the testament was written on March 6, 1979, less than five months after his election. It began with a quotation from the Gospels: "Watch, therefore, for you do not know on what day your

Lord is coming" [Matthew 24.42]—the pious and prudent sentiment of
a Christian radical, to be sure; but perhaps also the intuition of a man
who knew that his recent elevation to the See of Peter had put him in
the crosshairs of worldly power. As always, whatever was to come he
placed "in the hands of the Mother of my Master: *Totus Tuus*"—yet an-
other commitment of his life to the Blessed Virgin Mary. During the
1979 retreat, he wrote, he had been reading the spiritual testament of
Paul VI, and he now requested that he be buried "like the Holy Father
Paul VI." A marginal note to this request, dated March 13, 1992, speci-
fied the instructions further: John Paul wished to be "buried in the bare
earth, not in a tomb," which in Vatican parlance meant burial in the
Vatican grottoes, without a funerary monument. It seemed a simple re-
quest; yet it, too, spoke volumes about the man and his convictions.
Paul VI was the pope who had ordered the forensic investigation that
determined that bones found under the high altar of St. Peter's were, as
far as these things can be known, the bones of Peter, son of John, fish-
erman of Galilee—the man to whom Christ had entrusted "the keys of
the kingdom of heaven" and the awesome power of binding and loos-
ing sins [Matthew 16.19]. Peter's bones had been mixed with the earth
of the Vatican Hill, on which the basilica stands; Paul VI had wanted to
mix his dust with the same earth; and so, evidently, did John Paul II.

The next entry to the testament was undated; it, too, offered a
glance into the distinctive faith of a man who, since the harsh years of
World War II, had lived his life as if God, not he, were in charge: "I
confess the most profound faith that, in spite of my weakness, the Lord
will grant me every grace necessary to face, according to His will,
whatever task, trial, or suffering may be asked of His servant through-
out the course of life . . ." What is God asking of me now?—that was
the question that had guided his life since the war years; that was the
question he kept posing to himself throughout the pontificate.

He came back to this theme during the Lenten retreat in 1980,
adding further notes to his testament from February 24 to March 1,
1980. After reflecting on the 20th-century persecution of the Church
"which is not less, in some cases, than in the first centuries," he wrote
again of his own death, whenever it should come: "I hope that Christ
will give me the grace for the final crossing, which is [my] Easter," so
that his death might be "useful" in aiding the great causes "I am trying

to serve—the salvation of men, the safeguarding of the human family and all the nations and peoples (among these I refer in a particular way to my earthly Fatherland), useful for those who have been entrusted to me in a special way in the Church, for the glory of God himself."

The next installment in the testament was written on March 5, 1982—ten months after Mehmet Ali Agca had shot the Pope down in his front yard, St. Peter's Square. The assassination attempt, he wrote, had confirmed the hopes for the gift of final grace he had expressed in 1980; now, "I feel myself ever more profoundly in the Hands of God— and I remain continually at the disposition of my Lord, entrusting myself to Him and His Immaculate Mother (*Totus Tuus*)."

Another brief entry, on March 1, 1985, tried to clarify a question that had evidently arisen from the Pope's earlier request that the College of Cardinals consult the Polish bishops' conference and particularly the archbishop of Kraków about the possibility (which some had apparently raised) of John Paul's being buried in Poland; now, he made clear that the College should take its own decision in this matter unless it decided, for its own reasons, to consult the Poles.

The final, and longest, section of John Paul II's testament was written during his Lenten retreat in the jubilee year of 2000, between March 12 and 18. In the first paragraph, the Pope recounts a story he had told many times before: that during the second conclave of 1978, Cardinal Stefan Wyszyński, the Primate of Poland, had come to him immediately after his election and had told his former subordinate, "The new pope's task will be to lead the Church into the Third Millennium." The 20th century was now closing, "day by day," while the 21st century was opening. He was now approaching his eightieth birthday (and couldn't resist a Latin pun, parenthetically writing *octogesima adveniens* [the coming eightieth anniversary]—the title of one of Paul VI's apostolic letters). In light of the fact that he had indeed brought the Church into the new millennium, and given his own age, a question had to be posed: "It is necessary to ask myself if it is not time to repeat with the biblical Simeon, '*Nunc dimittis*' [Now, Lord, you may dismiss your servant . . .]." Yet Providence had saved him "in a miraculous way" on May 13, 1981, when Christ had "extended this life, and in a sense given it to me anew." Therefore, "from this moment it belongs to Him all the more." John Paul prayed that the Lord would "help me recog-

nize how long I must continue this service" and asked Christ "to call me
when He wants." Whenever that might be, however long he might be
Peter in the Church, may "the Mercy of God give me the strength nec-
essary for this service."

After thanking God that the Cold War had ended without nuclear
holocaust, John Paul then wrote of his gratitude for the Second Vatican
Council and its "great patrimony," which he hoped would be received
and implemented by future generations. Then, perhaps thinking that
this might indeed be the last installment in his testament, he thanked
the cardinals, bishops, priests, religious, and laity who had supported
him in his papal service; the chief rabbi of Rome and other leaders of
other religions; the men and women of science, culture, politics, and the
media whom he had met. Then his mind turned to those nearest and
dearest to him: his parents, his brother, the sister he never met because
she had died before his birth; his home parish and his boyhood friends;
his friends from secondary school and the Jagiellonian University; the
parishes he had served; the former Cracovian students, most now mar-
ried professionals, who had become his *Środowisko*, the network of his
closest lay friends; the city of Kraków and the city of Rome—to all of
these, "I want to say one thing only: 'May God reward you.' "[24]

And then he finished, as his Master had finished: *"In manus Tuas,
Domine, commendo spiritum meum"* [Into your hands, O Lord, I commend
my spirit].

Catholics still think of the word "vocation" as referring, typically, to
the special roles of priest and nuns in the Church. Karol Wojtyła, and
the Second Vatican Council, had a different view. Every Catholic—
every Christian—has a vocation: a specific, unique role in the divine
scheme of things. The great question of life is to discern God's purpose
for our lives, to embrace that, and to live it, with the help of God's
grace. And the question keeps repeating itself, even after one's primary
vocation—marriage, a profession or trade, the priesthood, the conse-
crated life of poverty, chastity, and obedience—had been clarified.
Even within those vocations, the question still had to be raised: What
is God asking of me *now?*

Pope John Paul II's last testament breathes the spirit of a man who
had constantly asked himself that question since his early adult years,
and continued asking it until the end. Others may have thought that

the path to the future *must* be clear, especially for popes; John Paul knew that he had to keep pressing the question, what is being asked of me *now?* The notion of a pilgrim Church has become a little stale since the phrase emerged from Vatican II. Even given its fragmentary quality, John Paul II's testament was the expression, in this distinctive literary form, of his self-understanding as a pilgrim, journeying toward the Easter that would be his death.

Alas, it wasn't immediately understood that way, as the Associated Press quickly published a story that led with a dramatic suggestion: the testament indicated that the Pope had seriously considered abdicating. A.P.'s claim was based, evidently, on John Paul's evocation of the *Nunc dimittis* during the Great Jubilee of 2000. Virtually every other media source ran with that interpretation for hours—and as the cable-TV news cycle, with its demand for something ever more dramatic, took over, the story went from the late Pope having considered abdication to the "troubled" Pope to the "tormented" Pope. Yet the story really wasn't what the A.P. and others suggested it was. Catholics who pray the Liturgy of the Hours say the *Nunc dimittis* every night at the conclusion of Compline, the last prayer of the day. To evoke the *Nunc dimittis* in 2000 did not suggest that the Pope was seriously pondering abdication; it simply meant that, once again, John Paul was confessing his faith in Providence and his willingness to subordinate his will to God's will. He was telling God that he was ready to go, whenever and however God willed; and he asked God for the strength to carry out his Petrine service to the Church. To read a tormented interior struggle over the possibility of abdication into this was to miss the meaning of the *Nunc dimittis*—and the character of Karol Wojtyła.

THE FIRST SPONTANEOUS WORLD YOUTH DAY

Public Masses were said for John Paul II during the week between his death and his funeral—the traditional *Novemdiales*. In a sad indication that the old default positions were reasserting themselves, the lay members of the Roman Curia were not invited to sit in a special section reserved for curialists during one such celebration. Yet in a very real

sense, the people of the Church had assumed a form of ownership of the mourning for the late Pope.

Pilgrims continued to pour into the city by every conceivable means of transportation. The decision was made to keep St. Peter's open virtually all day and night, except for a brief three-hour period in the early morning hours, during which essential cleaning and maintenance were done in the basilica. President George W. Bush, his wife, Laura, Secretary of State Condoleezza Rice, and former presidents George H. W. Bush and Bill Clinton—the official party representing the United States—arrived in Rome on Wednesday, April 6, and were escorted into St. Peter's shortly after their arrival. The presidential party knelt in prayer beside the late Pope's bier for some time. The next evening, at the U.S. Embassy to Italy, the president hosted a reception for the U.S. cardinals and distinguished Americans in Rome at the time. The basilica was finally closed late Thursday evening in preparation for the next day's funeral Mass. By that point, some two million people had been able to pay their last respects to John Paul in person; tens of thousands of others would have liked to do so, and were waiting in line when time finally ran out.

Outside St. Peter's, and indeed throughout Rome, what some came to call "the first spontaneous World Youth Day" continued to unfold. No one knows what percentage of the millions who had come to Rome were young people, but it seemed as if they were in the majority. On Thursday night, as the crowds were being directed into the streets fanning out from the bottom of the Via della Conciliazione, where they would await the next day's events, Polish flags and banners were prominently displayed.

Perhaps the most moving sight that evening was along the Conciliazione itself. Built by the Italian government for the Jubilee Year of 1950, this broad avenue is home to a potpourri of bookstores, currency exchange shops, souvenir stands specializing in various bits of ecclesiastical bric-a-brac, pharmacies, the Columbus Hotel, and one noble church, Santa Maria in Traspontina. On Thursday night, on virtually every doorstep on either side of the Conciliazione, there was a priest wearing the stole of his office, sitting on the steps and hearing confessions. Long lines formed outside these makeshift outdoor confessionals as pilgrims from literally all over the world prepared themselves sacramentally for John Paul II's funeral.

The reception of the sacrament of reconciliation—"confession," as most Catholics still call it—had decreased, in many cases dramatically, in the years after Vatican II. John Paul, who had confessed his sins every week of his life, had worked hard to revive the practice, devoting one synod of bishops to the topic in the fall of 1983, and issuing the apostolic exhortation *Reconciliatio et Paenitentia* [Reconciliation and Penance] in December 1984. To John Paul's mind, the spiritual life was a drama—a drama lived in the gap between the person one is today and the person one ought to be. There could be no drama without dialogue; confessing one's sins, discussing the temper of one's spiritual and moral life and its inevitable challenges with a discerning and sympathetic confessor—this, for John Paul II, was the dialogue in the drama, and to avoid it or ignore it was to deprive oneself of a chosen moment of grace. Christ had given the Church the sacrament of reconciliation because Christ, who knew the human from the inside, knew the importance of the dialogue in the drama. So, John Paul believed, should his followers.

That the drama of Karol Wojtyła's own life and death should have inspired such a spontaneous flood of confessions on the night before his funeral was not only appropriate. It was further evidence that, as Father Scott Newman had observed the night the Pope died, the grace was already pouring out, thanks to his intercession. That grace was tangible on the Via della Conciliazione on the night of April 7, 2005.

REQUIEM

NBC News anchor Brian Williams opened his network's coverage of the funeral Mass of Pope John Paul II by welcoming viewers to "the human event of a generation." Somewhere between eight hundred thousand and a million people had gathered around the Vatican: some three hundred thousand in St. Peter's Square and spilling down the Via della Conciliazione to the Tiber, and more than half a million more in the streets and alleys of the Borgo district. Literally countless others had gathered throughout Rome in a number of open-air venues where large television screens had been erected: at the Circus Maximus and the Colosseum, at Tor Vergata (where World Youth Day 2000 had

been held), at the Piazza del Popolo and the Piazza Risorgimento, and
at the great basilicas of St. John Lateran, St. Paul Outside the Walls,
and St. Mary Major. The Square and the streets were filled with flags—
Polish, Croatian, Brazilian, Portuguese, Lebanese, Spanish, American,
and many others. It was a clear morning, bright with early sunshine,
and, as veteran Associated Press bureau chief Victor Simpson wrote,
"turbans, fezzes, yarmulkes, black lace veils or mantillas joined the 'zuc-
chettos,' or skullcaps, of Catholic prelates on the steps of St. Peter's in
an extraordinary mix of religious and government leaders from around
the world"—four queens, five kings, seventy prime ministers or heads
of government, and more than a hundred other officially recognized
dignitaries. Prince Charles represented his mother, Queen Elizabeth II,
having had to postpone his wedding for a day; Prime Minister Tony
Blair and his wife, Cherie, a Catholic, joined Dr. Rowan Williams,
archbishop of Canterbury, among an ecumenical delegation of Britons
that would have been unimaginable a generation before. President and
Mrs. Bush were seated next to French president Jacques Chirac and
Mme. Chirac. The King of Spain, Juan Carlos, and his devoutly
Catholic queen, Sophia, came; so did the anti-clerical Spanish prime
minister, José Luis Rodríguez Zapatero. Two recent heroes of the strug-
gle for freedom were present, Afghan president Hamid Karzai and
Ukrainian president Victor Yushchenko. The politically unreconciled
were also on hand: Israeli president Moshe Katzav and Syrian president
Bashar Assad were seated near each other. Each of the dignitaries was
greeted on their arrival by Archbishop James M. Harvey, the Milwau-
kee native who had served since 1998 as prefect of the papal house-
hold, the manager of the Pope's public schedule.

Ecumenical Patriarch Bartholomew of Constantinople was in atten-
dance, in the first row among religious leaders. The Orthodox patriar-
chate of Moscow was represented by its chief ecumenical officer,
Metropolitan Kirill of Smolensk and Kaliningrad; Patriarch Aleksy II
had decided, perhaps appropriately, not to attend the funeral of the
man whose burning desire to visit Russia he had blocked for years.
More than forty other Orthodox leaders were present, including Teoc-
tist, the patriarch of Romania who had welcomed John Paul to his
country, and Christodoúlos, archbishop of Athens, with whom John
Paul had prayed atop the Areopagus. Karekin II, supreme patriarch of

the Armenian Apostolic Church, was present to pay tribute to the pope who had regarded his predecessor, Karekin I, as a spiritual brother. Mar Dinkha IV, patriarch of the Assyrian Church of the East, came; in 1996, John Paul II had concluded a historic "Common Christological Declaration" with this ancient Christian community of the Fertile Crescent, healing the doctrinal breach with Rome that had taken place at the Council of Ephesus in 431. The Lutheran World Federation was represented by its president, Dr. Ishmael Noko; Dr. George Freeman, secretary general of the World Methodist Council, and Dr. Geoffrey Wainwright of Duke University represented the Wesleyan traditions. Baptist, Mennonite, Reformed, and Disciples of Christ leaders, plus twenty-two specially invited guests of the Pontifical Council for Promoting Christian Unity, filled out the Christian representation, which also included Dr. Samuel Kobia, secretary general of the World Council of Churches.[25] The chief rabbi of Rome, Dr. Riccardo Di Segni, was present, as was his predecessor, Rabbi Elio Toaff, who had welcomed John Paul to the Synagogue of Rome in 1986 and had become a friend.

Out of sight of the dignitaries, the massive crowds, and the ten thousand security officers brought in to keep order and prevent a terrorist incident, the last rites for Pope John Paul II began quietly, inside the basilica and in private. His body was placed in a wooden casket of cypress—the wood ordinarily used for coffins in Italy. Cardinal Martínez Somalo, the *camerlengo*, led a small group of senior churchmen in prayer, inviting them to "complete several acts of human piety, before the funeral Mass of the Roman Pontiff, John Paul II." Those present signed the *rogito*, a legal document summarizing the life and pontificate of Karol Wojtyła, while an antiphon was sung: "My soul is thirsting for God, the living God; when shall I enter and see the face of God?" The *rogito* concluded with this fitting sentence: "John Paul II has left to all an admirable testimony of piety, of a holy life, and of universal fatherhood."[26]

After the *camerlengo* led a brief prayer that the face of the deceased might be "ever illuminated by the true light of which You are the inexhaustible source," Archbishop Dziwisz, John Paul's secretary, and Archbishop Piero Marini, the pontifical master of ceremonies, covered the Pope's face with a white silk cloth, reminiscent of the white cloth given the baptized at their christening. A bag of coins minted during John

Paul's pontificate was placed inside the coffin, along with the *rogito*, now locked in a metal tube. As the coffin was closed and sealed, Psalm 42 was sung: "Like the deer that yearns for running streams, so my soul is yearning for you, O God. My soul is thirsting for God, the living God; when shall I enter and see the face of God?"

The coffin was then lifted to the shoulders of the *Gentiluomini di Sua Santità*, dressed in white tie and tails with white gloves, and carried through the great doors of the basilica out into the Square. There, it was placed flat on the ground, on a rug; the Book of the Gospels was opened on it. Throughout the service to follow, the breeze blew through the pages, one after another, before the Book of the Gospels was blown closed; it seemed an apt metaphor for the life of a man who had always been turning the page, asking what he should be doing next—and who had come to the end of a lifelong, steady search for the will of God.

The entire College of Cardinals—those who would elect John Paul's successor, and the cardinals over eighty years old who would not enter the conclave—concelebrated the funeral Mass, with Cardinal Joseph Ratzinger, dean of the College, as principal celebrant. The cardinals wore red chasubles, the traditional liturgical color of apostles. As they approached the altar to venerate it, and as Cardinal Ratzinger incensed the late Pope's coffin, a Gregorian antiphon familiar to generations of Catholics, *Requiem aeternam dona ei, Domine: et lux perpetua luceat ei* [Eternal rest grant unto him, O Lord: and let perpetual light shine upon him], was intoned, followed by the verses of Psalm 65: "To you, O God, praise is due in Zion; to you must vows be fulfilled in Jerusalem . . ."; between the verses, the choir and the vast congregation repeated the antiphon, *Requiem aeternam, dona ei, Domine.* The confession of sins was followed by the chanted *Kyrie, eleison; Christe, eleison; Kyrie, eleison* [Lord, have mercy; Christ, have mercy; Lord, have mercy]. Cardinal Ratzinger then offered the opening prayer, or Collect, in Latin, asking God that John Paul, "who presided over your Church in the love of Christ," might enjoy, "with the flock entrusted to him, the reward promised to faithful ministers of the Gospel."

The first Scripture reading of the Mass was proclaimed in Spanish: Acts 10.34–43, in which Peter, having been touched by the faith of the pagan centurion Cornelius, confesses his own faith that "God shows no

partiality . . . in every nation any one who fears him and does what is right is acceptable to him"—a faith that had been made possible by the Jesus "to [whom] all the prophets bear witness, that every one who believes in him receives forgiveness of sins through his name." Psalm 23—"My shepherd is the Lord"—followed, and then the second reading, from Paul's Letter to the Philippians, was proclaimed in English: the apostle's meditation on "our citizenship in heaven," where Christ "will give a new form to this lowly body of ours and remake it according to the pattern of his glorified body, by his power to subject everything to himself" [Philippians 3.20–4.1]. The Gospel reading, chanted by a deacon in Latin, was perfectly chosen: the scene in John 21 where the Risen Christ asks Peter, do you love me, do you love me, do you love me more than the rest of my friends? Karol Wojtyła had preached an extraordinary sermon on this text at the Church of St. Stanislaus in Rome on October 8, 1978, eight days before his own election as pope—a possibility with which he was, evidently, struggling in his soul. Then, he had spoken of the terrifying quality of Christ's question: Peter was being called to a more radical love, to a more complete emptying of himself, than any of the other apostles. In the Lord's response to Peter's answers—"Come follow me"—there was. Cardinal Wojtyła concluded, "a summons to live, and a summons to die." Now, as the pages of the Book of the Gospels lying on Karol Wojtyła's coffin were gently turned by the wind, the thought occurred that his entire pontificate had been, from beginning to end, a form of dying to self for the sake of the flock.

Cardinal Ratzinger's homily, preached in Italian immediately following the Gospel, was a masterpiece of ecclesiastical rhetoric: biblically grounded yet very personal; theologically strong yet accessible to all. He centered his reflections on John Paul's lifelong awe at the gift of his priesthood. It was a gift that John Paul had explained through three of his favorite gospel texts: "You did not choose me, but I chose you. And I appointed you to go and bear fruit, fruit that will last" [John 15.16]; "The good shepherd lays down his life for the sheep" [John 10.11]; "As the Father has loved me, so I have loved you: abide in my love" [John 15.9]. Here, Ratzinger said, one found "the heart and soul of our Holy Father," a tireless worker in the vineyard of the Lord, "a priest to the last . . . [who] in this way . . . became one with Christ, the Good Shep-

herd who loves his sheep." He was "the Pope who tried to meet every-
one, who had an ability to forgive them and open his heart to all"; and
in doing so, he had taught us that "by abiding in the love of Christ we
learn, in the school of Christ, the art of true love."

This was a life given in order to be given away: John Paul "never
wanted to make his own life secure, to keep it for himself; he wanted to
give of himself unreservedly, to the very last moment, for Christ and
thus also for us." That was how the law of the gift he had analyzed
philosophically was confirmed by his own life's experience: "Everything
which he had given over to the Lord's hands came back to him in a new
way." And thus he could deploy his God-given gifts in his service as
priest and bishop: "His love of words, of poetry, of language, became
an essential part of his pastoral mission and gave new vitality, new ur-
gency, new attractiveness to the preaching of the Gospel, even when it
is a sign of contradiction."

There was another dialogue between Jesus and Peter worth recalling
today, Cardinal Ratzinger suggested—the dialogue during the Last
Supper:

There, Jesus said, "Where I am going, you cannot come." Peter
said to him, "Lord, where are you going?" Jesus replied, "Where I
am going, you cannot follow me now, but you will follow me af-
terward" [John 13.33, 36]. Jesus from the Supper went towards
the Cross, went towards his resurrection—he entered into the
paschal mystery; and Peter could not yet follow him. Now—after
the resurrection—comes the time, comes this "afterward." By
shepherding the flock of Christ, Peter enters into the paschal
mystery, he goes toward the cross and resurrection. The Lord
says this in these words: " . . . when you were younger, you used
to fasten your own belt and go wherever you wished. But when
you grow old, you will stretch out your hands, and someone else
will fasten a belt around you and take you where you do not wish
to go" [John 21.18]. In the very first years of his pontificate, still
young and full of energy, the Holy Father went to the very ends
of the earth, guided by Christ. But afterwards, he increasingly en-
tered into the communion of Christ's sufferings; increasingly, he
understood the truth of the words: "Someone else will fasten a

belt around you." And in this very communion with the suffering Lord, tirelessly and with renewed intensity, he proclaimed the Gospel, the mystery of that love which goes to the end . . .

John Paul's suffering had confirmed his faith in the mystery of Christ's cross and resurrection "as a mystery of divine mercy," the "purest reflection" of which he found in the Mother of God, Mary, to whom he had made his *"Totus Tuus."* Like the apostle John, Ratzinger reflected, Karol Wojtyła had taken Mary into his home: "And from the mother he learned to conform himself to Christ."

Then, the German cardinal who had given more than twenty years of his life to the Polish pope, brought his homily to a fitting, eloquent conclusion:

None of us can ever forget how, in that last Easter Sunday of his life, the Holy Father, marked by suffering, came once more to the window of the apostolic palace and one last time gave his blessing *urbi et orbi*. We can be sure that our beloved Pope is standing today at the window of the Father's house, that he sees us and blesses us. Yes, bless us, Holy Father. We entrust your dear soul to the Mother of God, your Mother, who guided you each day and who will guide you now to the glory of her Son, our Lord Jesus Christ. Amen.

After the congregation chanted, antiphonally, the Apostles' Creed, the ancient baptismal creed of the Roman Church, prayers for the needs of the Church throughout the world were offered in French, Swahili, Tagalog, Polish, German, and Portuguese, with the congregation responding to each intercession in Latin, *Te rogamus, audi nos* [We beg you, hear us]. The Liturgy of the Eucharist followed, with the concelebrants using the Roman Canon; the senior members of each order of cardinals—Cardinal Sodano for the cardinal bishops, Cardinal Stephen Kim Sou-hwan of South Korea for the cardinal priests, and Cardinal Jorge Arturo Medina Estévez of Chile for the cardinal deacons, joined by Lebanese Cardinal Nasrallah Pierre Sfeir, the senior eastern-rite cardinal—led the recitation of the Canon with Cardinal Ratzinger.[27] The Lord's Prayer was chanted in Latin, after which the

concelebrants and the congregation exchanged the Sign of Peace; it
was later reported that, at this juncture, while the dignitaries present
were shaking hands, President Katzav of Israel and President Assad of
Syria exchanged a greeting. The distribution of holy communion was
accompanied by the chanting of Psalm 120: "Out of the depths I cry to
you, Lord; Lord, hear my voice."

And then, as the communion rite ended, but before Cardinal
Ratzinger could intone the final prayer and begin that part of the rite
known as the "final commendation and commitment," something took
place that had not happened in 1,401 years, since the funeral of Pope St.
Gregory I. Saints, in those days, were designated by popular acclama-
tion; on March 12, 604, the crowd took matters a step further, sponta-
neously erupting in chants of *Magnus, Magnus!* [Great, Great!]—after
which Gregory was known, as he is today, as "Gregory the Great," a title
usually applied to only one other pontiff, Pope St. Leo I (440–461).[28]
Now, spontaneously, cries of *Magnus, Magno, Il Grande,* and *Santo Subito*
erupted in St. Peter's Square, in the surrounding area, and down the Via
della Conciliazione—at a volume that could be heard atop the Janicu-
lum Hill, overlooking the Vatican. The chants lasted for what seemed to
be three, four, even five minutes, the vast congregation declaring its
conviction that John Paul II was, in fact, a saint—that he was, as Cardi-
nal Ratzinger had said, "in the house of the Father," and that he should
be known, in the future, as "John Paul the Great." The peculiar acoustics
of the Bernini colonnade made it hard for those on the *sagrato*—the
raised platform in front of St. Peter's where the altar stood and the dig-
nitaries were seated—to hear precisely what the crowd was crying out.
But Cardinal Ratzinger could see that something dramatic—a final emo-
tional tribute to John Paul—was under way, and he calmly let the cries
spend themselves out before beginning the concluding rites.

After the post-communion prayer of the Mass, the Prayer of the
Church of Rome unfolded in the form of the Litany of the Saints—
which, this time, included saints canonized by John Paul II: Maximilian
Kolbe and Faustina Kowalska—followed by an intercessory prayer read
by the late Pope's vicar for Rome, Cardinal Camillo Ruini. The Roman
Church's prayer was then followed by the Prayer of the Oriental
Churches: the eastern-rite Catholic patriarchs, major archbishops, and
metropolitans among the concelebrants came forward, around the late
Pope's coffin, and led a lengthy series of intercessory prayers chanted in

Greek, to which a Greek choir responded. Finally, Cardinal Ratzinger blessed the coffin with holy water and incensed it one last time, while the congregation sang the Latin antiphon *Et in carne mea videbo Deum, Salvatorem meum* [And in my flesh I shall see God, my Savior]. Then, at the very end, concelebrants and congregation sang the ancient farewell hymn, in Latin: "May the angels lead you to Paradise, may the martyrs welcome you at your arrival, and may they lead you into holy Jerusalem. May the choirs of angels welcome you, and like Lazarus, who was a poor man on earth, may you enjoy eternal rest in heaven."

The pallbearers—the *Gentiluomini*—then lifted the coffin from the ground and carried it toward the basilica. As they reached the topmost step of St. Peter's, they turned it toward the crowd one last time—and yet another gust of cries of *Magnus* and *Santo subito* broke out, followed by a flood of tears.

To the strains of a chanted *Magnificat* and Psalms 114, 118, and 42, the coffin was carried into the basilica, through the Door of Saint Martha to the left of the high altar, and down into the grottoes of St. Peter's, where the final burial rites were conducted by Cardinal Martínez Somalo and a small group of senior churchmen. The cypress coffin was bound with red bands, on which were impressed the wax seals of the Apostolic Camera, of the Prefecture of the Papal Household, of the Chapter of St. Peter's, and of the Office of Pontifical Liturgical Ceremonies.[29] This coffin was then placed inside a zinc casket, which was soldered shut. Then the double-casket was placed inside a walnut casket, to which the coat of arms of the late Pope, a cross, and a plate carrying his name and dates were affixed. The triple-casket was then lowered into the tomb that had been prepared in the space previously occupied by the tomb of Blessed John XXIII, who had been moved up into the basilica after his beatification. One of those present said later that he hadn't wept so much since he was a boy. A large marble slab was placed atop the tomb. It would soon bear a simple inscription:

IOANNES PAULUS PP. II
16–X–1978 * 2–IV–2005

Below was the Chi-Ro, ancient symbol of the Christ who had called him to a greater love.

AFTERWARDS

Brian Williams's fine phrase—"the human event of a generation"—was, if anything, an understatement. It was estimated that two billion people had watched television coverage of John Paul II's funeral—the greatest broadcast audience ever. The funeral Mass was also one of the largest gatherings of statesmen in history, and almost certainly the largest at a religious service. Six thousand journalists from the print and electronic media generated what must have been billions of words and images. It was a very sheltered (or oppressed) part of Planet Earth that was not aware of the funeral Mass of Pope John Paul II on April 8, 2005.

The crowds dispersed quietly, and an hour or so after John Paul's triple-casket had been lowered into the tomb, the Via della Concili-azione was beginning to resemble a reasonably normal thoroughfare. Then, at about five p.m., the rains came. They continued, on and off, for days. As some three million people took their leave of La Città Eterna to return to the far corners of the world, the dark skies and daily rains suggested that Rome was crying: crying for *lo straniero, il Polacco*, the Polish foreigner who had introduced himself on October 16, 1978, as a "man from a far country" but who had proudly claimed at his in-stallation Mass that he was "now a Roman"; crying for the bishop who had personally visited more than three hundred of the city's parishes; crying for the pope who had brought the world to Rome during the Great Jubilee of 2000; crying for a dead father who had become, liter-ally, Il Papa; and, perhaps, crying in some fear.

For what, and who, was coming next?

God's Choice—
The Conclave of 2005

FEBRUARY 22 IS A particularly good day to be in Rome. What Americans once knew as Washington's Birthday is the feast of the Chair of St. Peter on the Catholic liturgical calendar, the annual commemoration of Peter's apostolic service in Rome and thus the only day of the year on which Bernini's massive bronze *Altar of the Chair* in the apse of St. Peter's Basilica is illuminated as the sculptor intended—by more than a hundred colossal tapers, some of them measuring five feet or more in length. The *Altar of the Chair* is a drama in bronze under any circumstances; lit by a forest of candles, it is simply stunning. Thus it was appropriate that Pope John Paul II chose the feast of Peter's Chair, February 22, 1996, to sign the apostolic constitution, *Universi Dominici Gregis* [The Pastor of the Lord's Whole Flock], which would shape the drama of the next conclave. In addition to making several changes in the electoral process by which popes are chosen, the constitution set out the specific procedures that would govern the interregnum between John Paul's death and the conclave to elect his successor.

An apostolic constitution is a legislative text with legal effects; the premium in such documents is on precision, not eloquence. Yet a close reading of *Universi Dominici Gregis* offers some insight into John Paul II's idea of the spiritual dynamics of a conclave. Historians and commentators had, for years, thought of the cardinal-electors as the principal actors in this particular drama. *Universi Dominici Gregis* hints at a deeper theological reading of the conclave. This, after all, was an apostolic

constitution written by the pope who had said, at the shrine of Our Lady of Fatima in 1982, "In the designs of Providence, there are no mere coincidences." So it should not have been surprising to find, in *Universi Dominici Gregis*, unmistakable traces of John Paul's conviction that the Holy Spirit is, in fact, the chief protagonist of a conclave.

The Pope underscored that belief in his last published poems, *Roman Triptych*. The second of this three-paneled set of free-verse reflections is a lengthy poem entitled "Meditations on the Book of Genesis at the Threshold of the Sistine Chapel." The Sistine Chapel meant a lot to John Paul II. It was the site of the most dramatic moment in his exceptionally dramatic life: his own election to Peter's Chair. He had taken the risk of authorizing the cleaning of Michelangelo's Sistine frescoes—to dazzling effect. In a memorable sermon to mark the completed restoration of the ceiling frescoes, he had preached on the Creation story depicted there, calling the *Sistina* "the sanctuary of the theology of the human body." Now, several years before he would die, John Paul was obviously thinking about what would happen in the Sistine Chapel after his death. The cardinals would not be alone, the poet-pope suggested: "The colors of the Sistine will then speak the word of the Lord: *Tu es Petrus* [You are Peter]—once heard by Simon, son of John . . .You who see all, point to him! He will point him out!"[1]

After the death of John Paul II, Cardinal Ennio Antonelli of Florence was widely quoted to the effect that God had already chosen the next pope; the cardinals' task was to discern the man who was God's choice. Other cardinal-electors made similar comments, which seemed to reflect something of John Paul II's convictions. Still, to take such a high view of the Holy Spirit's role in the conclave was not to deny its human dynamics. According to settled Catholic belief and doctrine, God works through human instruments—in this case, the College of Cardinals and, in some extended sense, those with whom the cardinals are in conversation. Cardinals, for all their eminence, are men with human aspirations, foibles, passions, prejudices, convictions, and crotchets. It is no offense to the Holy Spirit—nor to the cardinals—to suggest that those aspirations, foibles, passions, prejudices, convictions, and crotchets are at work in a conclave and in what leads up to it. No one who was in Rome in April 2005 and in contact with members of the College would suggest otherwise.

On the other hand, to wrestle with the human dynamics of a con-

clave is not to reduce it to the level of precinct politics—or, to stoop much lower, academic politics. For the human dynamics to be conjured with here include the conclave's spiritual dimension. The cardinals of the Catholic Church, while not angels, are men of faith and prayer. And it would be a very cynical and hardened heart indeed that did not sense the tremendous spiritual, evangelical, and moral energy flowing through Rome in April 2005.

In the weeks before the conclave, many cardinals showed in their faces the weight of the responsibility that was now theirs. They were the most diverse electoral college in the history of this form of papal election. They hadn't been together as a group since October 2003, when new members were added to their number. On that occasion—John Paul II's twenty-fifth anniversary, the beatification of Mother Teresa of Calcutta, and John Paul's last consistory—it was not difficult to imagine that at least some of the cardinal-electors (and even some of those who had lost their vote on their eightieth birthday) were measuring others among them for the shoes of the fisherman. Yet that was an exercise in the realm of the imagination. This was the real thing.

Now, they had to choose—to choose a successor to the man who had just been afforded one of the most stunning funerals in human history; a man who had just been popularly acclaimed a saint.

A RUGGED HISTORY

Visitors to the great Roman basilica of St. Paul Outside the Walls cannot help but notice the mosaic portraits of 264 popes, in chronological order of accession, which adorn the frieze along the basilica's arcade, high above the marble pavement. (Those looking for clues to the future will be struck by the fact that there are only seven spaces left for future pontiffs.) The neatness of this sequence of portraits in St. Paul's is a decorative parallel to the stately list of Roman pontiffs at the very beginning of the *Annuario Pontificio*, the Vatican yearbook. The actual story of the papacy (which includes rival claimants to Peter's Chair on several occasions) and the tales that have accumulated about papal elections (which have been stormy, more than once) suggest a more rugged, and perhaps more intriguing, history.

According to Catholic belief, the pontifical line begins with Peter, chosen by Christ himself. Peter's immediate successors were likely chosen by the priests, deacons, and people of Rome. Interestingly enough, no one who was already a bishop could be elected Bishop of Rome in the first centuries of the papacy; a Roman deacon was customarily chosen and then ordained bishop by the bishops of the surrounding region, with the bishop of Ostia usually being the chief consecrator. Roman emperors had their say, at least in terms of confirming a choice, from the 4th century to the early 8th century. So did the Roman aristocracy, which played an important role in choosing popes in the early Middle Ages. The Holy Roman Emperors Otto III and Henry III took a more direct hand in the process; Otto personally appointed Popes Gregory V (the first German pope) and Silvester II (the emperor's former tutor)—who were then formally elected by the appropriate Church authorities.

As the College of Cardinals evolved in the Middle Ages, the right of election gradually devolved on this body, which elected a pope by itself for the first time in 1130—Pope Innocent II. Twelfth-century schisms led Pope Alexander III to confirm a decree of the Third Lateran Council (1179), which gave the College of Cardinals the exclusive right to elect popes and specified that the election must be by a two-thirds majority. The first "conclave," properly speaking—the first time the cardinals were locked up to do the job (thus "conclave"—from the Latin "with the key"), took place in 1241. A Roman official, Matteo Rosso Orsini, got tired of the cardinals' dithering (all ten of them!) and locked them up in dreadful conditions in a crumbling Roman palace, the Septizonium, until they produced a pope. Some thirty years later, Pope Gregory X gave the conclave something of its modern form by decreeing that the cardinal-electors must meet within ten days of the pope's death; must remain together without contact with the outside world during the election; and must, as historian J. N. D. Kelly primly put it, "be subjected to progressively austerer conditions the longer the process took." Gregory's decision may have been influenced by the circumstances of his own election, which took place in the Italian city of Viterbo, northwest of Rome. There, the public authorities, aggravated by the cardinals' delay—it had been three years since the previous pope's death—first locked them into Viterbo's papal palace; then took

the roof off; and finally threatened them with starvation. That seemed to do the trick, as they got down to business and elected Teobaldo Visconti, who, during his student days in Paris, had known Thomas Aquinas and Bonaventure (two future saints and doctors of the Church), but who hadn't even been ordained a priest yet. That detail, as well as his ordination as bishop, was taken care of in Rome (in which the two previous popes, Urban IV and Clement IV, had never resided, and in fact hadn't even visited).

In 1621, Pope Gregory XV reformed the conclave process again, specifying three ways by which a pope could be elected: on a two-thirds vote by oral or written ballot (*per scrutinium*); by a delegated commission of cardinals (*per compromissum*); or unanimously by acclamation (*quasi ex inspiratione*). This remained the prescribed pattern for centuries, but there were other issues to be settled before the conclave would reach the form known to the 20th century.[2]

State power continued to be an obstacle to orderly papal successions conducted by the Church within its own rules and according to its own criteria. Pope Pius VI was kidnapped by Napoleon's forces in 1798; when he died in French captivity in 1799, it was widely thought that the papacy was finished. Pius VI had made secret provisions for an emergency conclave, however; it was held in Venice and elected Pius VII on March 14, 1800 (after a fourteen-week deadlock). The collapse of the Papal States in 1870 during the Italian *Risorgimento*, and Pius IX's self-exile for eight years as a "prisoner of the Vatican," raised questions about whether a conclave could be held without Italian governmental interference when Pius died in 1878; Cardinal Henry Edward Manning, the archbishop of Westminster and a former Anglican, proposed holding the conclave in Malta, under the protective guns of the Royal Navy. As things turned out, though, the conclave of 1878 was the first to be held in the Vatican in a century (the conclaves of 1823, 1829, 1830–31, and 1846 had all been held in the Palazzo Quirinale in Rome)—and there, in the Vatican, the conclave has remained.

A recurring problem of state interference involved the great power veto, or *ius exclusivae* [right of exclusion], first claimed in the 16th century by Philip II of Spain, who would informally let cardinal-electors know which candidates he did not like. Acquiescence in this by some cardinals set a dangerous precedent, which Spain's Philip IV revived in 1644

by opposing the election of Cardinal Giulio Cesare Sacchetti (whom the Spaniards also vetoed in 1655). The eventual choice in 1644, Giambattista Pamfil, who reigned as Innocent X, was also opposed by the French government, but the veto to be cast by Cardinal Mazarin arrived too late. By the end of the 17th century, then, France and Austria had joined Spain as Catholic great powers claiming the *ius exclusivae*.

The veto was never formally acknowledged by the Church, but it played an important role nonetheless. In the conclave of 1721, Austria cast a veto, as did Spain in 1730 and France in 1758. Austria vetoed candidates in 1800 and 1823, as Spain did in the conclave of 1830–31. A veto was threatened but not cast in 1878. And in 1903, Cardinal Jan Puzyna of Kraków announced the Emperor Franz Josef's opposition to one of the leading candidates, Cardinal Mariano Rampolla del Tindaro, Leo XIII's secretary of state. Several cardinals protested, but Rampolla's candidacy was shattered and the conclave proceeded to elect Giuseppe Sarto of Venice—who, as Pius X, promptly issued an apostolic constitution absolutely forbidding the use of the *ius exclusivae*, which was finally given a well-deserved internment. Thus the great power veto shaped eight of the fourteen conclaves between 1721 and 1903, being cast seven times and threatened once.

Twentieth-century conclaves were not without their difficulties, the elimination of the *ius exclusivae* notwithstanding. In 1914, at the first General Congregation of Cardinals after the death of Piux X, none of the aged prelates present was strong enough to break the deceased's "Fisherman's Ring" (used to seal the most important papal documents); they settled for rendering it useless by scratching its surface. The beds and other furniture used during the 1914 conclave had to be rented from a local hotel, their 1903 predecessors having been given to the poor of Rome; but that was the least of the 1914 conclave's problems. When Cardinal Giacomo della Chiesa seemed to have been elected on the tenth ballot, one of his principal rivals, Cardinal Rafael Merry del Val, challenged the validity of the election, charging that della Chiesa had voted for himself. The seemingly newly elected pope had to sit there while every ballot was re-opened and it was determined that he had not, in fact, cast a vote for himself.[3] Eight years later, in 1922, the conclave had to borrow beds from Catholic hospitals and schools in Rome, as Benedict XV had exhausted the Church's financial resources

aiding prisoners and refugees during World War I.[4] The conclave of 1963 was reputedly a stormy one, with Cardinal Gustavo Testa, an old friend of the recently deceased John XXIII, blowing his stack at one point and demanding that some cardinals stop the "squalid maneuvering" that was blocking the candidacy of Cardinal Giovanni Battista Montini—who would eventually be elected as Pope Paul VI. The August 1978 conclave to choose Pope Paul's successor was notorious for its stifling heat, which may have been one human factor in its brevity; the cardinals elected Albino Luciani as John Paul I on four ballots.

A NEW CAST OF CHARACTERS

The pope is the Bishop of Rome. Rome is a diocese in Italy. Thus it stands to reason that Italian concerns should play a role in selecting a pope. At the same time, the Bishop of Rome is, according to the *Annuario Pontificio*, the "supreme pontiff of the universal Church [and] the patriarch of the West"—which suggests that concerns beyond the local must also shape the choice of a pope. The 455-year Italian hegemony of the papacy—from 1623 until 1978—saw the Church led by many saintly Italians; indeed, the Italian popes of the 19th and 20th centuries were, with rare exceptions, men of outstanding ability and deep faith. During their pontificates, however, and thanks in part to their missionary initiatives, the Church's presence throughout the world multiplied exponentially. A cardinal-elector from North America or Latin America was inconceivable in, say, 1846, and the representation from the New World remained virtually token for quite a while. Cardinal James Gibbons of Baltimore, the first American to cast a vote for a pope, in 1903, did not make the subsequent conclave of 1914 because of travel delays. The only Latin American at the conclave of 1914 was Cardinal Joaquim Arcoverde de Albuquerque Cavalcanti of Rio de Janeiro, who didn't make it to the conclave of 1922.[5] In 1978, a conclave *without* significant participation from the western hemisphere would have been inconceivable. The tremendous growth of Catholicism around the world made a broadening of the College of Cardinals inevitable.

The internationalization of the papal electorate began with Pius IX,

generally portrayed as a stern traditionalist. Elected in 1846 by a con-
clave in which fifty-three of the sixty-two electors were Italians, Pius
made slow but steady changes in the College of Cardinals during his
thirty-two-year-long pontificate, such that the conclave that elected his
successor, Leo XIII, in 1878 included twenty-five non-Italians out of
sixty-four electors. The process of internationalization was accelerated
by Pius XII and got a decisive boost when John XXIII expanded the
membership of the College beyond the seventy decreed by Sixtus V in
1586—thus creating room for more non-Italian members.

By the death of John Paul II, the College was at its most diverse in
history. Of the 115 electors who would enter the conclave on April 18,
2005, barely half were Europeans (58 Europeans to 57 non-Europeans),
and of the Europeans, only 20, or 17 percent of the total electorate,
were Italian. Nineteen percent of the cardinal-electors of 2005 came
from Latin America, and a further 11 percent from North America, thus
bringing the western hemisphere's count up to 30 percent of the elec-
torate. Asian electors were 11 percent of the total, and African electors
were 10 percent. (Added to the Latin American voters, the Asian and
African electors brought the number of Third World electors to 40 per-
cent of the total.) Seventeen percent of the electors of 2005 were mem-
bers of religious orders: four Franciscans, three Jesuits, three Salesians,
two Redemptorists, and one member each of the Claretians, the Do-
minicans, the Missionhurst Fathers, the Oblates of Mary Immaculate,
the Priests of the Sacred Heart, the Schönstatt Fathers, the Studites,
and the Sulpicians. The 2005 conclave also included, for the first time,
two cardinals who were priests of Opus Dei.

In conclave, the members of the College of Cardinals do not repre-
sent distinct parts of the world Church in the sense that a member of
the U.S. House of Representatives "represents" a congressional district.
The electorate is charged with responsibility for the world Church,
and every cardinal-elector, in that sense, is required to think globally.
In the nature of things human, though, all such global thinking is
shaped by local experiences, and in that not unimportant sense, the
conclave of 2005 would be the most representative in conclave history.
More of the experience of more of the people of the Church would
shape more of the cardinal-electors' reflections and decisions than ever
before.

WHAT *UNIVERSI DOMINICI GREGIS* DID

Years before John Paul II's death, it was already being suggested that he had virtually guaranteed a succession to his liking by nominating the overwhelming majority of the cardinals who would choose the next pope. Yet over the course of a twenty-five-year reign, Pope Leo XIII had appointed all but one of the cardinals who would elect his successor—and the conclave of 1903 chose a pope, Pius X, whose approach to the various tangled questions of Catholicism and modernity was very, very different than Leo's. Then there was 1958: the College of Cardinals had been depleted during the last years of Pius XII, but he had appointed a large majority of the electors, who proceeded to choose a pope, John XXIII, who was stylistically the polar opposite of Pius—and who took risks that Pius XII may have imagined but could never bring himself to take. No, the real John Paul II difference in the conclave of 2005 lay in the unprecedented diversity of the electorate and in the new election rules and procedures, which the Pope had laid down in *Universi Dominici Gregis*.

If *Universi Dominici Gregis* bore the marks of John Paul's faith in the Holy Spirit as the great protagonist of conclaves, it also reflected the insistence of this accomplished moral philosopher on the exercise of responsibility—in this case, the *personal* responsibility of the cardinal-electors. Thus the first major change legislated by John Paul II in 1996 was to suppress the methods of election-by-commission (*per compromissum*) and election-by-acclamation (*quasi ex inspiratione*). The latter only happened in Morris West novels, and the former method hadn't been used in centuries; but in any case, John Paul saw fit to proscribe them. Election-by-acclamation, he wrote, was "no longer an apt way of interpreting the thoughts of an electoral college so great in number and so diverse in origin." Election by a specially chosen commission of cardinals had to be eliminated, "not only because of the difficulty of the procedure, evident from the unwieldy accumulation of rules issued in the past, but also because by its very nature it tends to lessen the responsibility of the individual electors who, in this case, would not be required to express their choice personally."[6]

"Would not be required to express their choice personally"—this was the voice

of the author of *Person and Act*, the philosopher who had spent decades reflecting on the dynamics of human moral agency and what those dynamics revealed about the nature of the human person. It was also the voice of the confessor who, according to his former penitents, would help clarify a situation but would always say, at the end, "You must decide." The capacity to make good spiritual and moral decisions was, for Karol Wojtyła, one of the defining characteristics of a human being, one of the things that made the human person unique in nature. That truth should be reflected in the conclave, he believed, and that was why he suppressed election-by-acclamation and election-by-commission.

Universi Dominici Gregis also decreed that, although the balloting itself would continue to be held in the Sistine Chapel (". . . where everything is conducive to an awareness of the presence of God, in whose sight each person will one day be judged"),[7] the cardinals would no longer live in jury-rigged cubicles in the offices and apartments of the apostolic palace, but in the new Domus Sanctae Marthae [St. Martha's House], the guest residence he had built in the Vatican and opened in 1996. This was not simply an act of papal charity toward elderly cardinal-electors, who would now live in comfortable three-room suites rather than in un-air-conditioned cells equipped with chamber pots. It was also an expression of the Pope's convictions about the human drama of the conclave. Drama, as always, required dialogue. And real conversation, he seemed to think, would be more likely if the cardinal-electors were comfortable rather than miserable.[8]

Universi Dominici Gregis was also concerned that the responsibility of the electors not be compromised by state power, other forms of international political manipulation, or the press. Thus the apostolic constitution strictly forbade the electors, while in conclave, to have any contact with the outside world in any form (including cell phones and BlackBerrys, much less newspapers, magazines, radio, and television). It also provided for debugging the Sistine Chapel and otherwise making certain that what went on inside the chapel during the balloting was beyond the reach of eavesdroppers.[9] (The cardinals observed this provision of the constitution in April 2005 by, inter alia, creating a false floor in the Sistine Chapel, on which their desks and chairs were placed; the space between this wooden floor and the chapel's pavement was filled with debugging and electronic jamming equipment.)

There was one further, and dramatic, change legislated by *Universi Dominici Gregis*. If, after fourteen days and thirty-four ballots punctuated by three pauses (for prescribed sermons and consultations among the electors on the fifth, eight, and eleventh days), the cardinals had still failed to achieve an election by a two-thirds majority (or two-thirds-plus-one, if the number of electors was not evenly divisible by three), then things could be changed: then, by a majority vote, the cardinals could agree to elect a pope by a simple majority—either through an open vote, or by narrowing the candidates to those who had received the highest number of votes on the previous (i.e., thirty-fourth) ballot.[10] This was a historic innovation, and some didn't like it, claiming that it would allow a bare majority to hang on until it could enforce its will on the entire body of cardinal-electors.[11] But that seemed implausible, given what history teaches about the fragility of intra-conclave coalitions. The more likely explanation of the change was that John Paul wanted to prevent an intransigent minority from blocking the election of someone who was the manifest choice of almost two-thirds of the electorate. However one reads its intentions, though, the simple-majority option was, in itself, another element in the John Paul II difference in the conclave of 2005.

The diversity of the electorate; their relative unfamiliarity with each other; their lack of a common language; their comfortable living quarters; their acute awareness of the fact that they were electing a successor to one of the giant figures of Christian history—all these factors, taken together, suggested a new situation in which the old rules of the road didn't necessarily apply: "rules" such as nationality, or age, or previous experience. In that sense, the conclave of 2005—thanks to John Paul II's pontificate, his reconfiguration of the College of Cardinals, and the provisions of *Universi Dominici Gregis*—bid fair to be the most open in history: open to the work of the Holy Spirit, open to new possibilities, and indeed open to surprise.

But there was one old rule that did apply—a rule that reflects both the human dynamics of this unique election process and what Catholics like to think of as the work of the Holy Spirit. It would be fair to call it the Bermudez Rule, in honor of Alejandro Bermudez, the polyglot Peruvian journalist who formulated it in an interview with the *New York Times*: "Do not underestimate the power of the microculture

that is generated among the cardinals when they are together. The kind of reflections that end up influencing them are completely unpredictable."[12]

MAKING *PAPABILI*

To vary the Book of Ecclesiastes: of the making of lists of *papabili*—men who are, literally, "popeable," or, more elegantly, "men with the makings of a pope"—there is no end. The phenomenon is partially market-driven, at least in Italy. Every major Italian newspaper has a *Vaticanista*; the *Vaticanista* has to file something regularly, perhaps every day; and when all else fails, speculating on whether Cardinal X or Cardinal Y is *papabile* will usually keep editors and readers happy. Yet journalists are not the only professionals whose craft involves the endless making of lists of *papabili*. Senior churchmen are also thinking of the future—although one of the striking things about the last years of John Paul II's life was how little speculation and list-making went on among the cardinals. At the 2001 Synod, for example, there was little discussion of *papabili*; even the last consistory of the pontificate, in October 2003, was relatively free of a too-overt weighing of candidates. It was, in retrospect, another tribute to the greatness of John Paul II—a kind of aesthetic and spiritual recoil from the impropriety of discussing a successor while the Pope was making such a heroic effort to continue his service to the Church.

Speculation about a papal succession naturally intensified among journalists after the Great Jubilee of 2000. And if one were to survey the various lists of *papabili* that circulated in the media between 2001 and early 2005, perhaps as many as twenty names would be found to have been more or less regularly in play—in, of course, widely varying degrees of plausibility. For one of the striking things about *papabili* prognostications is that very few journalists seem to learn much from the past. In the latter years of Pope Paul VI, for example, a lot of the press openly speculated about Cardinal Sergio Pignedoli as Paul's successor; and by the time the first conclave of 1978 opened, Pignedoli was sometimes deemed the "front-runner." In fact, Cardinal Pignedoli

got precisely nowhere, and likely didn't receive more than a vote or two. What might be called the Pignedoli Principle was not, however, a lesson well-learned among the journalistic makers of lists of *papabili* in the quarter-century that followed.

Two years before the death of John Paul II, few of the lists being circulated had the name of Joseph Ratzinger on them, except as a kind of pro forma nod to his prominence in the Curia and his crucial role in John Paul's pontificate. Ratzinger was considered, variously, too old; too ill; too European; too intellectual; too "hardline"; too difficult to sell publicly, given the "hardline" reputation. In 2003, it was not easy to find anyone whose journalistic livelihood depended on Vatican-watching who was willing to put Joseph Ratzinger on their short list of *papabili*. And the journalists' settled skepticism about a Ratzinger candidacy was shared by many churchmen—including some who were great admirers of Cardinal Ratzinger and wished that, well, that things were different.

A few senior churchmen saw things differently. Monsignor Thomas Herron, who died in May 2004, was a pastor in the archdiocese of Philadelphia and a former staff member of the Congregation for the Doctrine of the Faith. In 2002, Msgr. Herron was telling friends, quietly, that he thought Cardinal Ratzinger would be the next pope; on Herron's analysis, Ratzinger was the best known and most widely respected of the cardinals and was, therefore, *molto papabile*. More than one of Msgr. Herron's friends, knowing the bonds of affection between the prefect of CDF and his former American staffer, listened politely but concluded that Msgr. Herron's wish was the father of his thought.

Then there was Cardinal George Pell, the archbishop of Sydney, Australia, a former Australian-rules football star with an Oxford doctorate in Church history. Created a cardinal in 2003, Pell brought one settled conviction to his thinking about the papal succession—clarity of teaching was the key to everything else in the Church. And if a sufficient number of cardinals could agree on that strategic point, Pell believed, they would naturally turn to Joseph Ratzinger, the man to whom they could with complete confidence entrust the highest teaching office in the Church. (Pell's tall and rugged frame—he towers above virtually everyone else in the College of Cardinals—masks a gentle soul and a wonderfully self-deprecating sense of humor. In the

2003 consistory, when he was exchanging the kiss of peace with his new brother-cardinals after receiving the red hat from John Paul II, Pell was greeted by Cardinal Pio Laghi with the salutation, "Ah, the greatest [of the new cardinals]." "No, Your Eminence," Pell replied, "only the largest.")

EARLY SIGNALS

In the weeks prior to the death of John Paul II, those keeping a careful watch on things in, around, and about the Vatican could see signs that the once-settled notion of Joseph Ratzinger's unelectability was fraying at the edges. On February 22, 2005, Monsignor Luigi Giussani, founder of the renewal movement *Comunione e Liberazione* [Communion and Liberation], died. John Paul had a great respect and affection for Don Luigi and sent Cardinal Ratzinger, as his personal representative, to celebrate the funeral Mass and preach the homily. Don Luigi was buried from the great cathedral of Milan, which was filled for the occasion. Milan's archbishop, Cardinal Dionigi Tettamanzi, who was not only on, but close to the top of, many lists of *papabili*, was also in attendance. Ratzinger preached a magnificent homily which began in these moving terms: "Father Giussani grew up in a home—as he himself said—poor as far as bread was concerned, but rich with music, and thus from the start he was touched, or better, wounded, by the desire for beauty. He was not satisfied with any beauty whatever, a banal beauty; he was looking for Beauty itself, infinite Beauty, and thus he found Christ, [and] in Christ true beauty, the path of life, the true joy." He continued in this vein for more than twenty minutes, recalling how Don Luigi's Christ-centered reading of the human condition had made him an acute analyst of the modern quest for freedom. Then he concluded with a request to the young members of the movement Luigi Giussani had nurtured for sixty years: "My dear faithful, dear young people above all, let us take this message to heart, let us not lose sight of Christ, and let us not forget that without God nothing good can be built—and that God remains enigmatic if he is not recognized in the face of Christ." Cardinal Ratzinger received a spontaneous and sus-

tained standing ovation after his homily. When the Mass had ended, Cardinal Tettamanzi rose to say some words of farewell; when he finished, there was silence in the cathedral. Tettamanzi, who did not discourage comparisons between his combination of roly-poly physique and bubbly personality with the late Pope John XXIII, had failed to move the congregation, composed of some of Italy's most intelligent and active Catholics. The supposedly dour and unpastoral Joseph Ratzinger had moved them deeply, and not by theatrics but by a solid catechesis, winsome and challenging at the same time. For those with eyes to see, it was a signal—about both men and their possible futures.

In early March, analysts tried to determine, mathematically, whether Ratzinger could be successfully blocked. Some began this exercise with the assumption that blocking Ratzinger was not only possible but likely—that there were thirty-nine or forty cardinals who simply could not be brought around to the idea of a Ratzinger papacy. But at least two of those analysts, both working on what might be called "worst case" assumptions (i.e., including as anti-Ratzinger votes men whose views weren't entirely clear or predictable), could not construct a blocking list larger than thirty or thirty-two cardinals. It was another signal, if along the *via negativa*, that a Ratzinger candidacy could become a serious possibility.

That Joseph Ratzinger was not blocked did not mean that he was elected, of course. Yet in the days immediately after the death of John Paul II, it quickly became clear to those prepared to ignore the regnant script about Ratzinger's unelectability that what one cardinal-elector called a "consensus of esteem" was rapidly forming around the dean of the College of Cardinals. Ratzinger himself seemed to sense this, and was, in fact, quietly trying to dampen any enthusiasm for his candidacy. As the cardinals were gathering in daily General Congregations while the vast crowds waited to pay their respects to John Paul II, lying in state in St. Peter's, Ratzinger was passing the word, "I'm not an administrator." After several days of this, some of his friends suggested that he simply leave matters in God's hands and not pre-judge the work of the Holy Spirit by running himself down.

As dean of the College of Cardinals, Ratzinger already had his hands full in the week between John Paul's death and the funeral Mass. In addition to preparing his funeral homily—knowing full well that he would

be addressing a world audience numbering in the billions—Joseph Ratzinger presided every day over the daily General Congregations of cardinals which were making funeral and conclave plans, listening to John Paul's spiritual testament, and digesting lengthy reports on the state of the world Church, the condition of the Holy See, Vatican finances, and so forth. Ratzinger led these sessions with what one cardinal-elector called "natural authority." Yes, he was the dean, and he had the legal right to preside and lead, but his authority came from his person far more than from the legal status of his office. Issues were vetted, and opinions exchanged; Ratzinger, recognizing a speaker, would respond in the European language used, or, if necessary, in a European language the speaker understood. After some days of attempting to make this process work without simultaneous translation, enough protests were raised by the cardinals not fluent in Italian (the predominant lingua franca of the College) that arrangements were made for translators to be present. If there were tensions in these early meetings, they had perhaps less to do with conclave politics than with the linguistic difficulties, the pressure from the immense crowds that the cardinals felt immediately on arriving in Rome, and what were evidently the sobering contents of some of the reports.

There was one media flap at this early stage of the interregnum: on April 7, it was announced that the cardinals in General Congregation had decided to impose a press blackout on themselves from the day of John Paul's funeral (April 8) until they were sealed in the conclave (April 18). Various commentators (including Father Andrew Greeley and a large portion of the Italian press) leaped to the conclusion that this was a Ratzinger maneuver, another exercise in anti-modern authoritarianism by the so-called *Panzerkardinal*. In fact, it was nothing of the sort. As Cardinal Godfried Danneels of Belgium told the *National Catholic Reporter*'s John Allen, Ratzinger had argued against any formal ban on interviews, saying that it was the cardinals' "human right" to speak their minds if they wished. But Ratzinger eventually bowed to the consensus of the cardinals, which was shaped by several considerations: concerns that, because of the global reach of their national media, European and American cardinals were dominating the world media (and thus the pre-conclave discussion about the future of the Church); concerns about the press setting one cardinal against another

either in ideological terms or in handicapping the papal "race" (and thus further complicating the conversations within the College itself); and concerns about the manipulation of the story by the state-controlled media in some countries. Whatever difficulties this blackout caused for reporters, it seems, in retrospect, to have been a decision made out of concern for the integrity of the process, not out of hostility toward the media or curial authoritarianism. And in any case, those in a position to know understood that Ratzinger, without defending himself publicly, had just calmly absorbed another unfair accusation.[13]

The self-imposed blackout was also the first signal that the cardinals were not going to be overly concerned about the scripts that had been pre-prepared for them by the world press. They were taking *Universi Dominici Gregis* seriously; they were going to do this on their own terms, not on terms dictated from outside the process. In a world in which many institutions and some of the world's most powerful personalities regularly bend to the prevailing journalistic narrative in their own particular circumstances, it was a refreshing declaration of independence, and quiet self-confidence, from the senior leadership of the Catholic Church.[14]

THE *PRATTICHE*

In conclave argot, the *prattiche*—literally, "exercises" in Italian—are those formal and informal meetings of cardinal-electors where the real politicking of a papal election takes place. The *prattiche* can take place anywhere: in the Vatican, in curial cardinals' apartments, in a national seminary, in walks in the Villa Borghese, in curial offices, and in hotels and restaurants. It was frequently said of Cardinal Giovanni Benelli, Great Elector of Conclave I in 1978, that he organized the election of Albino Luciani as John Paul I from his favorite table at the restaurant L'Eau Vive. One Latin American cardinal widely bruited as *papabile* in the early years of the decade took to hosting lengthy lunches during the 2001 Synod of Bishops; this was generally regarded as bad form, and likely did his candidacy no good. Yet there seemed less of this than one might have expected in the week immediately after John Paul II's

death. By a kind of tacit agreement, the *prattiche* only got going in earnest, as a full-time business, after John Paul's funeral Mass on April 8.

As these discussions unfolded all over Rome, the old criteria for choosing popes seemed to fall by the wayside. Age did not seem to be a prominent consideration; while concerns were expressed in some quarters about a twenty-six-year pontificate followed by a papacy of another quarter-century or more, the more widely expressed view was that, should agreement be reached that Cardinal X was, so to speak, God's choice, then it shouldn't matter if he were in his early sixties. By the same token, Joseph Ratzinger's age was never a factor in the *prattiche*, in any serious sense. Indeed, the two considerations mentioned here might well have worked together in some minds: electing a seventy-eight-year-old pope with a strong profile of his own would provide some time for the younger leadership of the Church to mature and demonstrate its capacities.

Nationality played a role only among the Italians, some of whom were determined to restore what they considered the right order of the Church (and the universe, for that matter) by electing one of their own. Their attitude had been neatly captured eight years earlier, when Cardinal Agostino Casaroli, John Paul II's longtime secretary of state and a man widely regarded as the most accomplished curialist of his generation, gave an address on the centenary of Pope Paul VI's birth. With John Paul II present in the Vatican's audience hall, and before an audience composed of every senior Vatican official and thousands of invited dignitaries, Casaroli unwound a lengthy encomium to Paul VI as the perfectly prepared pope—and then suggested, in so many words, that, while the past twenty years had been interesting, it would be time to return to that older, familiar, Italianate model when the current pontificate ended. It was an altogether astonishing performance, but it had the merit of honesty: that was how many of the traditional managers of popes felt in 1997, and there is no reason to think that they didn't feel that way in 2005. The difference was that very few of the cardinals agreed with them. The non-Italian members of the College were prepared to elect an Italian pope, but not because he was an Italian; indeed, the most serious Italian candidacy in 2005, that of Cardinal Camillo Ruini, John Paul II's vicar for Rome, was premised on the perception that he was a thoroughly un-Italian Italian in his management style and his views of the Curia.

If nationality was not an issue, except among Italian restorationists, race was, perhaps, more of a real factor. Americans talked easily of an African pope; some Europeans and some Latin Americans did not. At any moment when race becomes an issue in human affairs, the temptation is to think "racism." And it would be naive to think that none of that was involved when the candidacy of, say, Cardinal Francis Arinze (the Nigerian who had spent many years in the Roman Curia) was discussed. On the other hand, it seems more likely that at least some cardinals who held their African brother-cardinals in high esteem just thought it impossible, at this moment of history, to entrust the universal Church to the son of such a young Church as that in sub-Saharan Africa. On the other, other hand, it is certain that Cardinal Arinze, and perhaps other African possibilities, were also being measured by the same basic criteria that were being applied across the board: Is this *un uomo di Dio* [a man of God]? Can he do this particular job? Is this a man to whom we can entrust the Church? That the same criteria were being applied to everyone suggests that, whatever considerations of race were involved in the 2005 *prattiche*, they were of rather low voltage.

First World pope vs. Third World pope, or, more realistically, European pope vs. Latin American pope, was another non-starter in terms of actual criteria. As the *prattiche* unfolded, the cardinals seemed remarkably unconcerned about whether one could elect a pope from a part of the Church that was dying, or whether it was the turn of some other part of the world. In particular, it became clear very early in the *prattiche* that the Latin American cardinals were not functioning as a regional bloc determined to elect one of their own, on the theory that, as the demographic center of world Catholicism, their time had come.

"Administrator vs. pastor" was another traditional criterion that seems to have played little role in the 2005 *prattiche*. Of perhaps more concern than the number of years any given candidate had spent as a diocesan bishop (or curial administrator) was the question of public presence: Could this man communicate the Church's proposal to the world and to the Church in a compelling way, in public?

So the traditional criteria or sorting-out points were not decisively shaping the *prattiche*. Neither was the notion, widely bruited during John Paul's illnesses and in the pre-conclave press speculation, that the

cardinals would seek to impose a retirement age, or define a method for dealing with the circumstances of a comatose or otherwise incapacitated pope, before electing anyone in 2005. There seems to have been virtually no discussion about this—certainly not of imposing a pre-election agreement-to-retire on whoever was elected. The cardinals knew that, according to canon law and the provisions of *Universi Dominici Gregis*, they were forbidden from attempting to extract a promise of retirement—or indeed any other kind of promise—from a potential pope. No doubt there were concerns in the College that the question of an incapacitated pope be addressed in a more systematic way in the future. At the same time, the cardinals were, on this front, making another declaration of independence from regnant secular and media expectations. In the modern, bureaucratic world of the West, it is simply assumed that there must be a legal solution for every problem or contingency—in this case, a set of legal norms for determining when a pope is terminally incapacitated, thus rendering the Chair of Peter vacant. The College of Cardinals did not take that attitude in the *prattiche* of 2005. Perhaps some guidelines could and should be drawn up in the future. But as more than one cardinal had said during John Paul II's illness, the papacy and the Church are ultimately in the hands of God, and it would be foolish to try and provide a canonical-legal answer for every possible contingency. That might have struck some on the outside as an irresponsible deferral of a distasteful and difficult subject. To the cardinals themselves, it likely seemed more an act of faith in divine providence and in the Holy Spirit's guidance of the Church.

CONCLAVE DIARY

Universi Dominici Gregis laid down the rules of conclave confidentiality even more stringently than previous such apostolic constitutions: the cardinal-electors were enjoined to maintain absolute secrecy, not only about the balloting itself, but about any discussions they had had among themselves, or with the non-voting cardinals over eighty years old—who were also under oath to maintain complete confidentiality. There had been leaks about the balloting at the first conclave in

1978—the first in which the over-eighty cardinals were not permitted to vote. There was, understandably, resentment about this among the over-eighties and sympathy for their circumstances among their younger brethren; Paul VI's constitution had not explicitly forbidden the cardinal-electors from discussing the inner workings of the conclave with their over-eighty brother-cardinals; some talked; and some over-eighties, not believing themselves bound by the electors' oath (as they weren't electors), talked to the press. Cardinal Jean Villot, then the secretary of state, had reproved his fellow cardinals for their indiscretions at the beginning of Conclave II in October 1978; and there were fewer leaks. Still, in the provisions of *Universi Dominici Gregis*, John Paul II sought to plug any possibility of leaks legislatively—another example of his concern that the cardinals make as free a choice as possible, with each cardinal exercising unimpeded personal responsibility.

Because the Conclave of 2005 was short, and because the timing of the announcement of his election made it clear that Cardinal Joseph Ratzinger had been elected on the fourth ballot (held on the afternoon of April 19), the basic story line of the papal election of 2005 came quickly into focus: Cardinal Ratzinger entered the conclave with very strong support and received a large vote on the first ballot, held on Monday evening, April 18. His total increased with each succeeding ballot, such that he was elected by an overwhelming majority at the first afternoon ballot on April 19. There seems to be little if any disagreement that that is what happened inside the Sistine Chapel on April 18–19, 2005. Pope Benedict XVI essentially confirmed this basic outline of the electoral process in his remarks to a group of German pilgrims on April 25, when he described his own emotions during the balloting.

Yet the story of the conclave is not simply the story of what happened inside the Sistine Chapel. It is also the story of the *prattiche*; the story of the external media environment; the story of the attempt by the press and by various activist groups to shape the cardinal-electors' decision; the story of the cardinals' discussions with those non-cardinals in whom they reposed trust; and the story of the interaction among the cardinals themselves, prior to their being sealed into conclave. Above all, the story of the Conclave of 2005 is the story of Joseph Ratzinger's leadership of the College of Cardinals, and how that

leadership led to a very swift electoral conclusion. The human texture
of that more comprehensive conclave story can be conveyed by look-
ing at the period between April 11 and April 19, 2005, on a day-to-day
basis, and in the form of a diary.[15]

Monday, April 11

With today's announcement that Cardinal Adolfo Suárez
Rivera, the emeritus archbishop of Monterey, Mexico, is too ill
to come to Rome, the electorate has now been fixed at 115
(barring an eminent death before the balloting begins); Cardinal
Jaime Sin, the emeritus archbishop of Manila, had previously
informed the College that he could not participate because of
grave illness. Sin's absence means that only two cardinal-electors
will have had previous conclave experience: Cardinal Ratzinger
and Cardinal William Baum, former archbishop of Washington,
former prefect of the Congregation of Catholic Education, and
former head of the Vatican office dealing with questions of
conscience. Cardinal Baum, almost blind, will be allowed a
"conclavist," a young priest to assist him—his secretary, Father
Karl Bartholomew Smith, who will thus be one of the handful
of non-cardinals sealed into the conclave. Subtracting Suárez
Rivera from the electorate also gives the European cardinals—for
perhaps the last time in the foreseeable future?—an absolute
majority of electors: 58 to 57.

On this eighth day before balloting begins, three tiers of
candidates can be identified, sifting the media wheat from the
media chaff through conversations with cardinal-electors and
those in whom certain electors have decided to confide.

The first tier—those most likely to be elected—is composed
of Cardinal Joseph Ratzinger, the dean of the College; Cardinal
Camillo Ruini, the papal vicar for the Diocese of Rome; and
Cardinal Jorge Mario Bergoglio, S.J., the archbishop of Buenos
Aires. Within this first tier, Cardinal Ratzinger seems to be *primus
inter pares*, first among equals; Ruini and Bergoglio are in the first
tier because they are the two most likely alternatives should
Ratzinger not be elected or should he decline, which is at least a
theoretical possibility. Ruini's record in working with John Paul II

on the re-evangelization of Rome and Italy is respected, as are his administrative competence (which terrifies some Italian curialists) and his intelligence; like Ratzinger, he is a man with a clear analysis of the religious and cultural roots of Europe's current malaise. Bergoglio made a strong impression at the 2001 Synod as a man of deep piety and serious intelligence; a lot of Italians think of him as an Italian; and he has done well in Buenos Aires with a combination of theological sophistication, political savvy, and genuine humility (he takes public transportation to his engagements). The fact that he was persecuted in Argentina by his Jesuit brethren, who thought him too orthodox, might negate any concerns about electing the first Jesuit pope in history. Both Ruini and Bergoglio, like Ratzinger, have the requisite language skills; in the 1990s, Ruini spent time during the summer in an intensive English program in Portland, Oregon, expressing satisfaction during one sermon in the Rose City that he was now the owner of a Safeway card.

The second tier includes Cardinal Dionigi Tettamanzi of Milan, Cardinal Angelo Scola of Venice, and Cardinal Francis Arinze, the Nigerian head of the Curia's liturgy office. There seems little possibility of electing Cardinal Arinze, given European and Latin American nervousness about an African pope; but some of Ratzinger's supporters might move in his direction, should the Ratzinger, Ruini, and Bergoglio candidacies all fail. Cardinal Scola is a regular subject of conversation and, as one man who knows him well said, he "*could* make a great pope." But he is sixty-three, has only been patriarch of Venice since 2002, and for all that he attracts interest and esteem, the general impression is that this is not his moment. Were Scola to be elected, it would be as clear an indication as possible that, after the adventure of John Paul II, the cardinals are not looking for some sort of pause, but are in fact eager for another, and presumably lengthy, adventure. Cardinal Tettamanzi, as one Italian *Vaticanista* put it, is *il candidato della stampa*—the "press candidate," which likely means that he isn't going to be elected. But the maneuvering around Cardinal Tettamanzi may have a bit more to it than idle press chatter.

The third tier is composed of two Third World cardinals, both
of whom are widely respected by their peers: Cardinal Ivan Dias
of Bombay/Mumbai, and Cardinal Norberto Rivera Carrera of
Mexico City. Dias is a veteran Vatican diplomat with an
extraordinary gift for languages and a firm administrative hand;
he was also a vocal defender of *Dominus Iesus*, the 2000 declaration
on the unique salvific role of Jesus Christ, in his native India—at
which *Dominus Iesus* was (largely) aimed. A knowledgeable Vatican
official recently said of the Indian prelate, "He could do this [the
papacy] tomorrow." Rivera Carrera was appointed to Mexico City
(and thus became primate of Mexico) over the opposition of the
status quo elements of the Mexican hierarchy and their allies in
Rome; but those who supported him as a model "John Paul II
bishop" have been vindicated by his strong performance in the
world's largest diocese, where he has shown a marked ability
to use all the tools of modern communications technology as
instruments of evangelization. Those who have seen him in Rome
recently say he looks "concerned," which may indicate that he
wants to stay exactly where he is, but knows that he's being
appraised by his brother-cardinals.

The conventional wisdom, which in this case is probably
wiser than usual, has it that Cardinal Ratzinger has to be elected
quickly or not at all; and that is certainly the view of his
opponents. But one cardinal firmly committed to Ratzinger's
candidacy has said, privately, that "it's better to stay for two
weeks and get it right than to hold ourselves to some artificial
and external timeline." Whether other Ratzinger supporters take
that view—whether Ratzinger himself would take that view—is,
of course, another question.

Some cardinals, at least, are consulting broadly. The rules do
not forbid them discussing issues facing the next pontificate
outside the College; nor, under a generous interpretation of the
rules, are they forbidden from listening while others they respect
discuss both issues and candidates. The American cardinals, as a
group, seem to be an exception to this pattern of consultation
and conversation. Some of them may be discussing questions of
substance with non-cardinals, but in the main, the Americans—

including those most publicly committed to dialogue, consultation, "collegiality," and so forth—seem to be talking only among themselves, and among others in the College.

One other factor may be pointing to a quick election in favor of Joseph Ratzinger: the German Cardinal Walter Kasper, another distinguished theologian who has been on the opposite side of several debates with Cardinal Ratzinger in recent years, is said to have been deeply moved by Ratzinger's sermon at John Paul II's funeral. That, plus the pro-*Dominus Iesus* speech he gave to an ecumenical audience some months back, suggests that possibility that Kasper might not oppose a Ratzinger candidacy.

Tuesday, April 12

There was a lot of pre-conclave discussion of this being "Latin America's moment," and while the cardinals from Mexico, Central America, South America, and the Spanish-speaking Carribean are active, they do not seem to be following the prepared media script. There is, for example, no Latin American bloc, and certainly not a Latin American bloc determined to elect one of its own. On this sixth day before the voting begins, many of the Latin Americans, except the Brazilians and Cardinal Oscar Rodríguez Maradiaga of Honduras, seem to be inclining toward Cardinal Ratzinger as the next pope, with Cardinal Rivera Carrera as one of Ratzinger's chief supporters; some are still inclined toward Cardinal Bergoglio. There is reportedly broad agreement among the Latin Americans, including the Brazilians, on one point: that they don't want an Italian pope or a return to Italian "normality" in the Vatican—in the colorful phrase of one of their *consigliere*, they want to "break the 'Italian marmalade'" (presumably, the ordinary way of doing business in the Italianate Curia, in which Latin Americans tend to be treated as colonials). Thus another obstacle to an Italian restoration comes into focus: the contempt with which some curial Italians treat the Third World cardinals (or, perhaps better, the contempt with which many Third World cardinals feel they're treated by curial Italians) is leading Latin American cardinal-electors to be extremely shy of an Italian reclamation of the papacy—even by

Cardinal Ruini, the un-Italian Italian, who would likely take a very firm hand in overhauling curial personnel and practice.

This will create complications when the balloting starts for those looking to forestall Cardinal Ratzinger's election. Their current plan is, reportedly, a two-stage strategy: first, block Cardinal Ratzinger's election through next Wednesday (the third day of balloting); then, put Cardinal Tettamanzi forward as the acceptable compromise and get him elected on Thursday, before the first voting pause (for consultations and a prescribed sermon by the senior cardinal deacon) required by *Universi Dominici Gregis*. The Latin American complication here is that, whatever their views of Cardinal Ratzinger, virtually all the Latin American cardinal-electors would regard Cardinal Tettamanzi as the candidate of Italian restoration, which they seem determined to avoid. An exception might conceivably be made for Cardinal Ruini, but that would only be possible were Cardinal Ratzinger to point his supporters in that direction—firmly.

Cardinal Renato Martino, the voluble former president of the Pontifical Council for Justice and Peace, has reportedly e-mailed a seventeen-page-long summary of his life and accomplishments to numerous Italian journalists. It would be reasonable to assume that Cardinal Martino is unaware of the Latin Americans' views of a possible Italian restoration. The *curriculum vitae* of the former secretary of state, Cardinal Sodano, was reportedly e-mailed to Italian journalists before the late pope's funeral.

Wednesday, April 13
In what might be called the "external *prattiche*"—the discussions among journalists, Vatican "insiders" (of various degrees of inside-ness), and the confidants of cardinals, discussions which can sometimes reflect the thinking of the cardinals themselves—there has been a flurry of interest in the second- and third-tier *papabili* over the past few days. Cardinal Angelo Scola is perhaps most prominently mentioned as a possible pope by the great mentioners. Yet Scola, by most accounts, is one of those pressing the case for Cardinal Ratzinger. Then there is Cardinal Dias of Bombay, or Mumbai.

The fact that rumors are being spread about his health is a good sign that he's getting some serious attention—and that some people are worried that more attention may be paid.

Meanwhile, it seems that Luigi Accattoli, the veteran *Vaticanista* of the *Corriere della Sera*, Italy's newspaper of record, has a mole of some sort inside the General Congregations of cardinals: his daily reports in the *Corriere* usually include something that could only be known by someone present in the Synod Hall where the General Congregations are being held. This, of course, leads to another speculative game among journalists: who might be Accattoli's eminent mole? It might be more plausible to think that he's got a source among the translators, however; thus far, the cardinals seem to be taking the oath of confidentiality—and their media blackout—very seriously indeed.

More important than moles for the Milanese daily, however, are the changes that have taken place in the General Congregations themselves, in response to complaints from cardinals not comfortable with rapid-fire Italian. The translators are one obvious response to this concern. Perhaps, in addition to the translators, the cardinals themselves are taking more time to make their points understandable to all their brethren, and to understand what others are saying—and meaning. Whatever the causes, the tensions that were emanating from the General Congregations a week ago seem to have eased, according to several reliable reports. However, Cardinal Emmanuel Wamala of Uganda, and the Sudanese cardinal, Gabriel Zubeir Wako, are concerned that they and other Third World cardinals are not being cut into the *prattiche*, the discussions among cardinals being held "off campus" all over Rome. Their view may well be shared by other Africans and Asians, and that suggests an opportunity for those looking to rally support for a particular candidate.

As the day of decision draws closer, journalistic skeptics about a Ratzinger candidacy are beginning to reconsider. The bureau chief for an American newsweekly was much more impressed than he expected to be with Cardinal Ratzinger's conduct of John Paul's funeral: "He held the piazza," meaning he held the attention of the hundreds of thousands in St. Peter's Square

during the homily and indeed throughout the service. And if
previously skeptical journalists are picking up on the unexpected
public presence that Ratzinger displayed, it can be safely
assumed that the same thoughts have occurred to cardinal-
electors who may have been inclined toward Ratzinger but who
had doubts about his public persona.

A further sign of the vitality of the Ratzinger candidacy is that
some of his supporters are thinking about a longish conclave and
the possibility of electing Ratzinger under a simple-majority
vote if necessary; some of the pro-Ratzinger Latin American
cardinals are known to be willing to go down this road, if
necessary. Whether Cardinal Ratzinger would accept election
under those circumstances is, of course, an open question.

Thursday, April 14
With four days remaining until the conclave is sealed, the
Ratzinger coalition seems to be growing. In addition to strong
supporters in Europe (Ruini; Scola; Christoph Schönborn of
Vienna; Giacomo Biffi, emeritus of Bologna; Tarcisio Bertone of
Genoa, his former CDF deputy; Salvatore De Giorgi of Palermo;
Joachim Meisner of Cologne), Ratzinger's cause is being
promoted by the Australian Pell; the American head of the
Apostolic Penitentiary, J. Francis Stafford; the Canadian Marc
Ouellet; the Spanish canonist, Julian Herranz; and the
archbishop of Lima, Juan Luis Cipriani Thorne. The growing
end of the Ratzinger candidacy, though, is from the Third
World—Latin Americans, Africans, and some Asians, who
remember him as the senior curial figure who treated them as
adults and who listened best to their concerns. This sense of a
broadening Ratzinger coalition does not mean that the election
is settled; one veteran curialist, not ill-disposed toward a
Ratzinger papacy, has told friends that Ratzinger may have fifty
votes behind him, but can't get to seventy-seven—the number
necessary for election. One *Vaticanista* who has been right far
more than wrong in recent years says that Ratzinger is "very
strong" but that the outcome is "not certain"—before going on
to point out something that has not received much comment

before: one way or another, Cardinal Ratzinger will be the decisive figure in the conclave. Either he will be elected pope, or he will point to the eventual winner; either he will be the victor, or he will be the Great Elector of 2005.

As the pro-Ratzinger coalition broadens, the nature of the opposition to a Ratzinger papacy is coming into clearer focus today. It seems less a matter of an organized and disciplined coalition than of what one *Vaticanista* aptly calls different "strands." There is a strand whose primary concerns for the Church's immediate future are with globalization and other international political and economic issues; it is not difficult to imagine the Brazilian Franciscan, Claudio Hummes, and the Honduran Salesian, Oscar Rodríguez Maradiaga, as leading voices in this strand (in part because their own putative candidacies, widely discussed by the great mentioners, haven't gotten out of the starting gate). There is a curious Curia strand of opposition, curious in that its members have not been known to agree on very much in recent years (or even decades)— Sodano, Giovanni Battista Re (prefect of the Congregation for Bishops), Crescenzio Sepe (prefect of the Congregation for the Evangelization of Peoples), and Francesco Marchisano (vicar for Vatican City). Their allies are reported to include Severino Poletto of Turin, who is close to Cardinal Sodano, and two over-eighty curial cardinals who have been active in the past fortnight (and not simply in terms of leading the Church in prayer, as *Universi Dominici Gregis* prescribes): Pio Laghi, former nuncio to the United States, and Achille Silvestrini, the former Vatican "foreign minister." The truly knowledgeable Vatican insiders find this strand almost inconceivable, given the rivalries and animosities among its members. But the hope of an Italian restoration and a return to "the way we do things here" may, against all previous experience, be trumping every other tribal, sub-tribal, ideological, and personal consideration.

Then there is a strand that, for want of a better term than the journalistic conventions, can be called the "progressive" opposition to Ratzinger's election. Its membership is not hard to imagine: Cardinal Carlo Maria Martini, S.J., emeritus

archbishop of Milan; Cardinal Godfried Danneels of Belgium;
Cardinal Keith Patrick Michael O'Brien of St. Andrews and
Edinburgh; Cardinal Cormac Murphy-O'Connor of
Westminster; Cardinal Karl Lehmann of Mainz; Cardinal
Wilfred Fox Napier, the Franciscan from South Africa; and,
perhaps, at least two Americans, Roger Mahony of Los Angeles
and Theodore McCarrick of Washington.

The strategy of these opposition strands remains what it was
earlier in the week: to prevent a Ratzinger election on Monday
evening (when there will be one ballot only), Tuesday, and
Wednesday; then to put Cardinal Tettamanzi through quickly on
Thursday. The Tettamanzi project is being supported from
"outside" by two influential Italian groups, the Focolare
movement and the Sant'Egidio Community (who have excellent
media contacts and who reportedly hope that a Pope Tettamanzi
will appoint a new vicar for Rome, who will give Sant'Egidio a
considerable role in Roman diocesan affairs). There seems to be
a new tactical twist to this strategy, however: to encourage those
opposed to or nervous about a Ratzinger papacy to rally in
the early balloting behind Cardinal Martini as a placeholder.
There seems to be no intention of electing Martini (who suffers
from Parkinson's disease and has been living in retirement in
Jerusalem, pursuing the biblical studies that were his scholarly
specialty), but rather of using him as a magnet for anti-Ratzinger
votes until the Ratzinger candidacy collapses and the Tettamanzi
compromise can be proposed. How such placeholder voting
coheres with the elector's oath, repeated when casting each
ballot—"I call to witness Christ the Lord, who will be my judge,
that my vote is given to the one who, before God, I think should
be elected"—is not immediately clear.

Be that as it may, two outcomes now seem most likely: either
Cardinal Ratzinger will be elected on Tuesday (or late
Wednesday morning, at the latest); or the conclave will be a
very long one. There is no reason to think that the Tettamanzi
compromise will work on Thursday, given Latin American
concerns about an Italian restoration and the firm opposition to
Tettamanzi reputably attributed to Cardinal Ruini and Cardinal

Scola. And it seems unlikely that Ratzinger, moving into the role of Great Elector, could indicate a candidate and win the great majority of his supporters to that candidate in a day. So, absent Ratzinger's election on Tuesday or Wednesday morning, it seems inevitable that the conclave would have its first voting pause for consultations and reflection on Friday—and that the balloting on Saturday would begin with a reshuffled deck, so to speak.

Still, Ratzinger's supporters can take heart from the media campaign that is being intensified against him. *La Repubblica*, the principal Italian daily of the left, is, predictably, taking the lead on this front. Its *Vaticanista*, Marco Politi, has acknowledged that Ratzinger is the leading candidate, but has written that there is a workable German-American coalition in place to "veto" Ratzinger's election; what scorecard is Politi using? The *Corriere's* Accattoli has reported the Martini-as-placeholder strategy, and the *Sunday Times* of London, perhaps encouraged by some of the Italian anti-Ratzinger groups, has been seeking stories of Ratzinger-the-Hitler-Youth, apparently with a mind to contrasting Ratzinger's youth with the anti-Nazi resistance work of Karol Wojtyła—thus further driving a wedge between John Paul II and his closest theological advisor, which has been another tactic employed by Italian activists whose movements (like Focolare and Sant'Egidio) were supported by the late Pope. How these activists imagine their attempts at dividing Wojtyła and Ratzinger to be something of which John Paul would have approved is something else not altogether clear.

Friday, April 15

Some of Cardinal Ruini's strongest supporters report that Ruini continues to work hard on behalf of Ratzinger; and while Ruini was reportedly *preoccupato* [worried] earlier in the week, he now seems encouraged, if not completely certain of the outcome. The case for Ratzinger, as summarized today by one Roman intellectual, is coming down to three points on which there is broad agreement, even among his critics: he is a genuinely holy man; he is always interesting; and he is a man of substance. To which might be added a fourth qualification: he has shown

himself as someone whom the other cardinals can trust. Because, at some point, the question before the electors becomes a very simple one: whom do I *trust* with this awesome responsibility? The General Congregations have been a key here. One Ratzinger supporter says that he's "done everything right" in leading these sessions—he runs the meetings competently, listens well, is humble, and yet prods when necessary. Among the human dynamics shaping a conclave is the fact that the cardinals are electing a man whom many of them are likely to be dealing with for some time. Thus the question, "Is this a man I really want to work with?" is bound to occur. The General Congregations seem to have demonstrated that Cardinal Ratzinger is an eminently reasonable and decent man with whom to work. Beyond that, his funeral homily continues to be discussed and seems more impressive, not less, over time: it was a brilliant performance in which Ratzinger didn't draw attention to himself.

The mood seems calmer now. While the strands of opposition to Ratzinger continue to make the case for the Martini-as-placeholder strategy, the rather implausible nature of this exercise is also drawing comment—which is leading to another, and related, subject of discussion: where (to use the standard taxonomy) is the "progressive" candidate? The conventional wisdom, of course, is that there is no progressive candidate because John Paul II filled the College of Cardinals with a different sort of churchman. But this analysis collapses on riffling through pages 31 to 96 of the *Annuario Pontificio*, and noting the names of cardinal-electors like Danneels, Hamao, Hummes, Husar, Kasper, Lehmann, Mahony, Martini, Martino, McCarrick, Murphy-O'Connor, Napier, O'Brien, Poupard, Rodriguez, Schwery, and Williams—all of them created cardinals by John Paul II, and none of them likely to be labeled a "conservative." If "progressive" Catholicism has no serious candidate, it's not because candidates aren't available; it's more likely because the so-called progressive project, eager for the Catholic Church to make the same concessions to modernity that virtually every other non-fundamentalist western Christian community has made since World War II, is exhausted. And if it is exhausted, it may be because, ultimately, it's not all that interesting, this

business of deconstructing centuries of doctrine, liturgy, and moral teaching. That, in turn, may explain why the progressive project is infertile—increasingly unable to attract the brightest students in graduate schools of theology in the United States, for example.

Saturday, April 16

Today is Joseph Ratzinger's seventy-eighth birthday. His staff at the Congregation for the Doctrine of the Faith gave him a joint birthday/conclave bon voyage party (the cardinals go to live at the Domus Sanctae Marthae tomorrow night). Someone, likely just not thinking, bought an arrangement of white and yellow tulips to present to Ratzinger: the papal colors, a bit of an embarrassment, if an unintentional and innocent one. Archbishop Angelo Amato, the Salesian who is the congregation's second-ranking official, gave an *omaggio*, a speech in honor of the cardinal's birthday. Cardinal Ratzinger replied with thanks, but said that it was too emotional a moment for him to respond at length. There was more than one moist eye in the room when Ratzinger left to go to his apartment and pack his bags for the conclave.

Knowledgeable Italian churchmen confirm that one of the new dynamics of the Conclave of 2005 is the role that some of the renewal movements and new communities are trying to play in shaping the cardinals' deliberations—a role that is bringing to Rome some of the conflicts among these groups already under way in other parts of Italy (like Milan). All of which suggests that this is something the next pope, whoever he may be, is going to have to address. These movements and communities are intended to be the spearpoint of the Church's evangelization efforts, or, in the case of Europe, re-evangelization efforts. Their purpose is not to play intra-ecclesiastical games (of which they were highly and often rightly critical in the past), but to get on with the mission that the institutional element of the Church seems unable to perform as well as it should. If, as these Italian churchmen said, the renewal movements and new communities are "looking for a pope for themselves, not for the Church," then that has to be addressed in the next pontificate.

Sunday, April 17

The *Sunday Times* of London disgraced itself today with a
heavy-breathing front-page story about Joseph Ratzinger, Hitler
Youth; but after four paragraphs of hyperventilation, it turned
out that there was no news, no story—and it seemed clear to
reasonable readers that this was all planted with the intent of
raising serious questions in the electors' minds about the reception
a Ratzinger papacy might expect. If that was the intention, early
indications are that it backfired and that the only result was a
further diminution in the reputation of a once-great newspaper.

Ratzinger isn't the only leading candidate under nasty
personal attack. A book has just been published in Argentina
(with appropriate excerpts sent to the press) alleging that
Cardinal Bergoglio was complicit in the military junta's
persecution of two Jesuits in the 1970s. John Allen shot this one
down on CNN via well-placed phone calls to an Amnesty
International human rights activist and several Jesuits who are
not notably pro-Bergoglio; according to their testimony,
Bergoglio had, in fact, helped get the two men in question out of
the country and out of the junta's clutches. The source of this
calumny was not immediately clear, but Jesuits favorably
disposed toward Bergoglio openly speculated about their own
Jesuit brethren being involved. And, indeed, there has been talk
all week of the anti-Bergoglio signals coming out of the Jesuit
headquarters on the Borgo Santo Spirito—which, if true, would
seem to indicate that the current Jesuit leadership is not at all
interested in the election of a Jesuit pope whom they know to
have serious concerns about the Society's direction.

The cardinals are to have moved into the Domus Sanctae
Marthae by tonight, when they'll share their first meal together.
Some have expressed the wish that this move to the Vatican
guesthouse had taken place earlier in the week—that it would
have solved the problem of various cardinals, especially from the
Third World, being cut out of the *prattiche* and would have given
the entire College a better chance to get acquainted, to share
views, and to measure personalities. One sure sign of the John
Paul II difference in this conclave is that no one seems to be

complaining about being immured and no one is running out at the last minute for a final decent meal. The comfortable accommodations and the good kitchen at the Santa Marta (as everyone calls it, using the Italian form) have led to a situation where many of the cardinals are looking forward to being immured, which was certainly not the case in the past. One also gets the sense that the moment has come, that the discussions have gone about as far as they can go, and that everyone is eager to get down to business—and choose a pope.

Monday, April 18

The Mass *Pro Eligendo Romano Pontifice* [For the Election of the Roman Pontiff] was celebrated this morning in St. Peter's Basilica, with Cardinal Ratzinger presiding and preaching in his capacity as dean of the College of Cardinals. The homily was classic Ratzinger: richly biblical, emphasizing God's mercy and the importance of friendship with Christ; deftly drawing on theologians like Dietrich Bonhoeffer (German Lutheran martyr to the Nazis) and Hans Urs von Balthasar; calling his brother-cardinals to a "holy restlessness, a restlessness to bring everyone the gift of faith"; reminding them that the only thing that endures—"Money does not. Even buildings do not, nor books."—is "the human soul, the human person created by God for eternity." Thus the lasting imprint of a cardinal's work is "all that we have sown in human souls: love, knowledge, a gesture capable of touching hearts, words that open the soul to joy in the Lord." And so that should be their prayer: that the Lord will "help us to bear fruit that endures." For "only in this way will the earth be changed from a valley of tears to the garden of God."

It was also a noteworthy "un-campaign" speech.

One might imagine a candidate for the papacy, carrying the weight of a largely unfavorable public image, saying things like those just mentioned, if perhaps not quite so luminously. But it is impossible to imagine anyone who was actually campaigning for the papacy under the burden of a bad media reputation saying what Joseph Ratzinger also said:

Today, having a clear faith based on the Creed of the
Church is often labeled as fundamentalism. Whereas
relativism, that is, letting oneself be "tossed here and
there, carried about by every wind of doctrine" [Ephesians
4.14], seems the only attitude that can cope with modern
times. We are building a dictatorship of relativism that
does not recognize anything as definitive and whose
ultimate goal consists solely of one's ego and desires.

We, however, have a different goal: the Son of God,
the true man. He is the measure of true humanism. An
"adult" faith is not a faith that follows the trends of
fashion and the latest novelty; a mature, adult faith is
deeply rooted in friendship with Christ. It is this
friendship that opens us up to all that is good and gives
us a criterion by which to distinguish the true from the
false, and deceit from truth.

Cardinal Ratzinger is no fool. He knew that "dictatorship of
relativism" would be the sound-bite taken from his homily by
the world press. He must also have known that many of his
brother-cardinals were seriously thinking of casting their votes
for him, and he had a message for them, too—here is what I
think, unvarnished. He didn't use the phrase "dictatorship of
relativism" to be provocative; he used it because it seemed to
him the truth of the matter, and if others regarded it as
provocative, that was, so to speak, their problem. Prior to this
afternoon's entry into the conclave proper, Joseph Ratzinger let
everyone with a vote know precisely where he stood, and
precisely what kind of analysis he would bring to the Church's
task in the modern world.

Ratzinger knows that his public image is a caricature created
and sold by his critics and enemies to reporters who are only
capable of parsing the Catholic Church in good guy/bad guy,
"liberal"/"conservative" terms. He knows the image is false, and
he doesn't really care about it. The intensity with which his
brother-cardinals watched him at the *Pro Eligendo* Mass suggested
that a lot of them don't care about it, either.

Five and a half hours later, the cardinals gathered in the Hall

of Benedictions atop the atrium of St. Peter's Basilica for the impressive ceremony of the *Ingresso* [the Entry or Ingress] into the conclave. The Vatican had wisely decided to allow the entire procession to be televised, and even permitted cameras inside the Sistine Chapel so that the world could see each cardinal swearing his conclave oath on the Book of the Gospels, which had been enthroned in the middle of the chapel. Entering the *Sistina* to the chanted Litany of the Saints, the cardinals were entering what is arguably the greatest room in the world, a magnificent expression of human genius. Yet that genius pales before the figure dominating Michelangelo's fresco on the rear wall—the Risen Christ, returning as judge of the living and the dead. And it is before that Christ—Christ the judge—that each cardinal will cast his ballot.

After singing the *Veni, Creator Spiritus*, the ancient chanted invocation of the Holy Spirit, the cardinals were sworn into conclave by their dean, according to the formula prescribed by John Paul II in *Universi Dominici Gregis*:

> We, the cardinal-electors present in this election of
> the Supreme Pontiff, promise, pledge, and swear, as
> individuals and as a group, to observe faithfully and
> scrupulously the prescriptions contained in the apostolic
> constitution of the Supreme Pontiff John Paul II, *Universi
> Dominici Gregis*, published on 22 February 1996. We
> likewise promise, pledge, and swear that whichever of
> us by divine disposition is elected Roman Pontiff will
> commit himself faithfully to carrying out the *munus
> Petrinum* [Petrine ministry] of Pastor of the Universal
> Church and will not fail to affirm and defend strenuously
> the spiritual and temporal rights and liberty of the Holy
> See. In a particular way, we promise and swear to
> observe with the greatest fidelity and with all persons,
> clerical or lay, secrecy regarding everything that in any
> way relates to the election of the Roman Pontiff and
> regarding what occurs in this place of election, directly
> or indirectly related to the results of the voting; we
> promise and swear not to break this secret in any way,

either during or after the election of the new Pontiff, unless explicit authorization is granted by the same Pontiff; and never to lend support or favor to any interference, opposition, or any other form of intervention, whereby secular authorities of whatever order and degree or any group of people or individuals might wish to intervene in the election of the Roman Pontiff.

In order of precedence, each cardinal then went to the Book of the Gospels, where he completed being sworn into conclave by his personal affirmation of the oath:

> And I, N. Cardinal N., do so promise, pledge, and swear. So help me God and these Holy Gospels which I touch with my hand.

When the last cardinal had completed his oath, the door to the *Sistina* was closed by the ubiquitous master of pontifical liturgical ceremonies, Archbishop Piero Marini. Marini remained inside with Cardinal Tomáš Špidlik, an eighty-five-year-old Czech Jesuit and ecumenical specialist, who had been chosen to give the second prescribed pre-election sermon to the cardinals; the first had been given earlier in the week by the preacher of the papal household, the Italian Capuchin Raniero Cantalamessa. When Cardinal Špidlik finished, he and Archbishop Marini left the Sistine Chapel, and the cardinals were, at long last, on their own.

Given the size and diversity of the electorate, more than one observer has been suggesting that this might be a relatively long business, perhaps on the model of the Conclave of 1922, which elected Pius XI on the fifth day of voting and the fourteenth ballot. In 1903, the cardinals had taken four days and seven votes to elect Pius X; it took three days and ten votes to elect Benedict XV in 1914. The 1939 conclave was the shortest in modern times: two days and three votes to elect Pius XII. John XXIII lived through four days of voting and eleven ballots before he was elected in 1958, and it took three days and six votes to settle

on Paul VI in 1963. The "September papacy" of John Paul I began with a lightning election lasting only two days of voting and four ballots, while it took three days of voting and eight ballots to elect John Paul II. However one read the probabilities, though, no one expected a successful election on the first vote. Yet there was a real electricity in the air, as if it *might* happen.

The stove that has been re-erected in the back of the *Sistina* to send the famous *fumata*, or smoke signal, up the most famous smokestack in the world (which has also been re-assembled for the occasion) has been presumably strengthened by the addition of an air compressor rigged next to it. And to avoid the confusions of 1978, when the smoke came out a dingy gray and no one outside knew what was happening, the bells of St. Peter's are going to toll to confirm, along with the white smoke, a successful election. But, as usual, someone made something of a blunder in loading the ballots and the coloring chemicals into the stove, so, when the smoke went up at about eight p.m., it took a few minutes before it turned definitively, unmistakably black. That, plus the silence of the bells, told the city and the world that the See would remain vacant for at least one more night.

Tuesday, April 19

The cardinals got down to business again at eight-thirty this morning—and a lengthy business each ballot is. After each elector writes the name of his candidate on a small card, he folds it; the cardinals then form a procession in order of precedence (which is also the order in which they are seated in the *Sistina*). Each cardinal must then walk up to the altar, beneath the *Last Judgment*, and, before dropping his vote into an urn created for the occasion, say, "I call as my witness Christ the Lord, who will be my judge, that my vote is given to the one who before God I think should be elected." It takes a bit of time for 115 men, some of them quite elderly, to complete this basic casting of votes. Then comes a complex counting procedure, in which it must first be verified that the number of ballots in the urn is the same as the number of cardinals present and voting. Only after that has been done can the votes be counted—a process which is conducted by three cardinals, the Scrutineers, the last of whom

announces the name on a given ballot to the entire College. Their work, including their addition of the votes, is then reviewed by another group of three cardinals, the Revisers, to make sure that everything checks out properly. Under these provisions, it is hard to imagine a ballot being completed in anything less than an hour and fifteen minutes, and far more likely an hour and a half.

Thus, when the black smoke—this time, unmistakably black—came up at around noon, the cardinals had been at it for more than three hours. Three ballots had now been unsuccessful. But some observers had been predicting for days that Tuesday afternoon would be decisive. And it was.

At about five-forty p.m., the *fumata* appeared again—and, once again, its color was indeterminate. Yet to those familiar with conclave procedure, it could only be white: if there had been an unsuccessful first afternoon ballot, there would have been no smoke at this point, as the cardinals would immediately proceed to a second afternoon ballot—and it was impossible to imagine the cardinals completing two ballots in a little more than an hour. So the only smoke possible *at this moment* was white smoke, indicating that someone had been elected on the first afternoon ballot, the third of the day and the fourth overall. Yet there was another problem: the bells that were supposed to toll simultaneously with the white smoke weren't tolling. (As it turned out, the technician at the stove who was supposed to call the technician at the bells via cell phone forgot to do so and had to be reminded.) So, a strange, twelve-minute interlude ensued, in which it seemed that there *must* have been an election, but without the confirming, unmistakable white smoke accompanied by the pealing of bells. At last, the smoke began pouring out in a clear white; the bells finally started tolling at 6:04 p.m.

All that remained was the announcement. Crowds began pouring into the Square from all over the city by the tens of thousands. Some of those who imagined it might be Joseph Ratzinger had noted earlier in the day that April 19 was the liturgical commemoration of Pope St. Leo IX—the last great German pope. It seemed something of an augury. But no one knew for sure until the senior cardinal deacon, Cardinal Jorge

Arturo Medina Estévez, came out on the central loggia of St. Peter's.

Cardinal Medina had not previously displayed an effervescent public personality. And while "effervescence" would not quite describe his demeanor, he was enjoying himself, dragging out the suspense by saying "Dear brothers and sisters" in multiple languages before getting down to the prescribed Latin formula:

Annuntio vobis gaudium magnum [I bring you news of great joy];

Habemus Papam [We have a pope];

Eminentissimum ac Reverendissimum Dominum [The Most Eminent and Most Reverend Lord],

Dominum—(and a brief pause before revealing the Christian name)—*Iosephum* [Joseph],

Sanctae Romanae Ecclesiae Cardinalem [Cardinal of the Holy Roman Church] *Ratzinger*,

Qui sibi nomen imposuit Benedictum XVI [Who has taken the name Benedict XVI].

There was a great roar from the crowd when Cardinal Medina got to "Joseph," for everyone knew who "Joseph" was—and the tremendous applause for this second *straniero* in a row confirmed what one American curial official had said after taking a personal, unscientific poll of the Borgo district the week before: the neighborhood wanted Cardinal Ratzinger.

Pope Benedict XVI made his first appearance as the 265th Bishop of Rome a few minutes later, with his brother-cardinals coming out onto the balconies off the Hall of Benedictions to watch. Benedict's remarks were unadorned and to the point: a tribute to "the great John Paul II"; an introduction of himself as "a simple and humble laborer in the vineyard of the Lord"; a confession that he was comforted by the fact that "the Lord knows how to work and to act even with inadequate instruments"; and a request for prayer. After he gave his first papal blessing, his innate discomfort at being the center of attention reasserted itself, and he seemed to turn as if to go back inside. But the crowds simply would not let him. And, with the same broad smile with which he had come out onto the *loggia*, he waved and blessed them again and again.

The name, it was later reported, was something he had

discussed with a friend, the German journalist H. J. Fischer—*for someone else*. Joseph Ratzinger thought that "Benedict" was a great papal name, euphonic in many languages and the title of some wonderful liturgical music composed for the *Benedictus* of the Roman Mass; so, he told Fischer that he hoped the next pope, which he certainly didn't imagine to be himself, would take the name "Benedict." True to his instincts, his spiritual patrimony, and his ideas, that is exactly what the next pope did.

What was perhaps most striking about Pope Benedict's first public appearance was his radiance. He was, in a word, glowing. For all the burdens of the papacy, this was a man who had now been liberated to be himself, after subordinating his personality for more than two decades to the work another had given him to do. This was someone manifestly unafraid—and likely to challenge others to a similar, joyful fearlessness, rooted in a profound Christian faith.

One report had it that the cooks at the Santa Marta prepared schnitzel for dinner tonight. But perhaps that's only a pious story.[16]

WHAT HAPPENED, AND WHY

How was it that the College of Cardinals settled so quickly on Joseph Ratzinger as the 264th successor to St. Peter?

A portside effort at historical spin-control came from *La Repubblica* a week after the election; the Italian daily's April 26 issue featured a lengthy interview with Cardinal Carlo Maria Martini, in which the interviewer suggested that Cardinal Martini, far from being a mere placeholder, had in fact been the Great Elector of the Conclave of 2005, the man who signaled others that Joseph Ratzinger should be elected. It was spin admirable for its chutzpah—indeed, the idea of the Catholic "progressive" caucus claiming a victory for itself in the election of Joseph Ratzinger as pope gives new depth of meaning to chutzpah. But the *Repubblica* spin didn't bear very close analysis. In the three months following the conclave, there were no indications that Cardinal Mar-

tini, in fact, had drawn a significant number of votes on the first ballot on April 18, although he certainly drew some; moreover, there was no indication that these votes were Martini's to deploy, once his own strategic role as placeholder had evaporated.[17]

Rather, the more that bits and pieces of information emerged from the conclave's secrets, the more it seemed likely that Cardinal Ratzinger had made a very strong showing on the first ballot: perhaps fifty votes, perhaps even more, with Cardinals Ruini and Bergoglio also receiving some support, although neither Ruini's nor Bergoglio's votes were organized into a stable bloc. It can be reasonably assumed that Ruini and Bergoglio spent the evening of Monday night thanking their supporters but urging them to shift their votes to Ratzinger. So the Martini-as-placeholder strategy collapsed quickly, and the various strands of opposition to a Ratzinger papacy began to peel off. It is not unreasonable to speculate that the first to shift were the curialists, attentive as ever to their interests and accustomed to ecclesiastical Realpolitik. The less intransigent and more politically astute "progressives" were likely to have adjusted their thinking by late Tuesday morning, so that it is possible to imagine Cardinal Ratzinger's vote going from around fifty on Monday night to over sixty on the first ballot on Monday morning, to a bit over seventy, just short of election, on the second Monday-morning ballot—an analysis confirmed by the new pope's remarks to German pilgrims on April 25, when he spoke of feeling the "guillotine" falling on him:

As the voting process gradually showed me that the guillotine, so to speak, was to fall on me, my head began to spin. I was convinced that I had done my life's work and that I could hope to end my days in tranquillity. With profound conviction I said to the Lord: Do not do this to me! You have younger and more talented people who are able to face this great task with a completely different kind of approach and strength. Then I was deeply touched by a brief letter that had been written to me by one of my fellow members of the College of Cardinals. He reminded me that on the occasion of the Mass for John Paul II, I had centered the homily, using the Gospel as my point of departure, on what the Lord said to Peter at the lake of Gennesaret: follow me! I had ex-

plained how Karol Wojtyła had always received anew this call from the Lord, and how he had always needed to renounce much and simply say: Yes, I will follow you, even if you lead me where I would not have wished to go. This cardinal wrote to me: "If the Lord now says to you, 'Follow me,' remember what you preached. Do not refuse! Be obedient, just as you spoke of our great pope who has returned to the house of the Father." This moved me deeply. The ways of the Lord are not comfortable, but we are not created for comfort but for great things, for the sake of the good. So, in the end, I could do nothing other than say yes . . .[18]

"The end" was likely reached, de facto if not de iure, at the end of the third ballot, when it became clear that, given his ever-growing vote totals, Cardinal Ratzinger would be elected at the fourth ballot on Tuesday afternoon. The fourth vote—perhaps one hundred votes for Ratzinger, perhaps even more—then legally sealed the decision that had already been reached, and that in some respects seems to have been reached before the conclave was immured. Thus Joseph Ratzinger was elected pope in one of the three shortest conclaves in modern papal history, and Dionigi Tettamanzi was left in the unfortunate position of being the Sergio Pignedoli of 2005: the media candidate who never gets started.

Another post-conclave suggestion had it that John Paul II's simple-majority rule played a large role in April 2005—that once Ratzinger reached fifty-eight votes, it was all over, because it was clear to everyone that his supporters would hang on, if necessary, until the simple-majority provision was activated. Thus, on this analysis, those in the minority decided not to drag the affair out but to present the world with a united Church behind a quickly elected pope. The further suggestion was that, in creating the possibility of a simple-majority election, John Paul II had in fact lowered the bar from two-thirds to 50 percent +1.[19]

But this, too, seems a stretch. While some of his supporters were undoubtedly prepared to hold on for two weeks and thirty-four ballots—which is what it would have taken to reach the point at which the simple-majority provision of *Universi Dominici Gregis* could be invoked—no one knows whether Joseph Ratzinger would have been prepared to

accept election under those circumstances. Indeed, it is entirely plausible that, had things gotten to that point, he might well have used the occasion of the third voting pause on the eleventh day of balloting, at which he (the senior cardinal bishop) was to give a sermon urging his brethren to get on with the job, to withdraw his own candidacy so that the cardinals could proceed with a two-thirds majority election. Again, no one knows whether his supporters would have accepted that, but it is not easy to imagine them defying Ratzinger's wishes and forcing him to accept a simple-majority election. Had he not been elected before the first voting pause, it seems far more likely that Ratzinger would have transformed himself into the Great Elector of 2005, pointing to another candidate who could garner a two-thirds majority and thus not begin his pontificate under something of a shadow.

All of which is admittedly speculative. But it is speculation confirmed by the German cardinals' report that there was a "great collective sigh of relief" in the Sistine Chapel when Cardinal Ratzinger accepted his election. And that suggests that even some of his most ardent supporters were not entirely sure what Ratzinger would do.[20]

Why did events unfold this way? Catholics and other Christians will say, and rightly, that it was in part a work of the Holy Spirit, who helped the electors find the one whom the Lord had already chosen, as Cardinal Antonelli famously put it. The human instruments the Holy Spirit chose were readily on display. The atmosphere in Rome during the mourning for John Paul II and his funeral Mass certainly had an impact on the conclave—as did Cardinal Ratzinger's masterful funeral homily and comportment during the funeral Mass. Then there was Ratzinger's leadership of the General Congregations of cardinals, which by all accounts was impeccable. The Mass *Pro Eligendo* and the *Ingresso* doubtless concentrated minds, again in the direction of a Ratzinger papacy. And, in a sense, the rapid election of Ratzinger was a victory for the vision of what a conclave should be that John Paul had left the Church in *Universi Dominici Gregis* and in his *Roman Triptych*: in electing a pope, as in every other genuinely ecclesial act, it did turn out that there was only one standard, one criterion—and that was Jesus Christ. As John Paul had written in *Novo Millennio Ineunte* [Entering the Third Millennium], it wasn't, in the final analysis, a matter of defining or refining a program but of being conformed to Jesus Christ.[21] The

cardinals who dropped their ballots into the urn on the Sistine Chapel altar, calling "Christ the Lord" to be their judge, could not have failed to sense the truth of what the late, great John Paul II had written.

In purely human terms, there were other factors at work in Joseph Ratzinger's election as Benedict XVI.

Others who might also have been considered John Paul II's natural successors had either died (the Brazilian Dominican Lucas Moreira Neves), or were too old (Bernardin Gantin, who had resigned the deanship of the College of Cardinals and returned to his native Benin), or were too old and too ill (Jean-Marie Lustiger of Paris). Indeed, as John Allen points out, Cardinal Gantin, without intending to do so, helped clear the way for Ratzinger's election by resigning as dean of the College to return to Africa. Had Ratzinger not been the dean, his multiple talents would not have been on ready display at John Paul II's funeral Mass, in the General Congregations, and at the Mass *Pro Eligendo*.

Then there was the simple, even palpable, fact of Ratzinger's eminence. As one cardinal-elector put it afterwards, Ratzinger was the elder brother who was clearly head and shoulders above the rest, the one who knew everyone else and the one everyone else knew; moreover, he was the last living major figure of the Second Vatican Council. Although it was confirmed and deepened by the cardinals' experience of Ratzinger's performance during the interregnum, the esteem in which he had long been held had, in fact, been growing during the last years of John Paul II. As the Pope's authority waned, Ratzinger's waxed. Indeed, one reason why there was less concern than the world deemed appropriate over the possibility of a terminally incapacitated but still living pontiff was the widespread sense that, if things came to a difficult pass, Cardinal Ratzinger would know what to do, and how to do it. Thus Msgr. Thomas Herron had it right, in 2002: Ratzinger was the best known and most widely respected of the cardinals, and was thus *molto papabile*.

If Herron had it right about Ratzinger and his brother-cardinals' reactions to him, others had it wrong. Very wrong. The day of Ratzinger's election, columnist E. J. Dionne Jr. wrote in the *Washington Post* that, while Ratzinger "spoke for the conservative side of a culture-war argument that is of primary interest to Europe and North America" in his *Pro Eligendo* homily, "for the many cardinals here from the Third

World . . . the battle over relativism is far less important than the poverty that afflicts so many of their flock."[22] Which was to get things exactly backwards. The African cardinals, some of them first-genera-tion Christians, knew that the greatest poverty human beings can suffer is the lack of that hope and joy that come from conversion to Christ. These cardinals had a great pride in being Catholic—not out of arro-gance, but out of gratitude for what God had done in their own lives and in the lives of their people; and they were not about to take in-struction on whether "the battle over relativism" was important. They knew exactly what was most important, and they knew that electing Joseph Ratzinger was a sure guarantee of the Church's substance. The results of the Conclave of 2005 seem to make it clear that that convic-tion was shared beyond the ranks of the African cardinals—and that, in turn, suggests that the forty-year effort to compel the Catholic Church to bend its doctrine and moral teaching to the pressures of late moder-nity is over. Some will undoubtedly keep trying, from both outside the Church and from within. But they will increasingly be seen as the ec-clesiastical equivalent of those soldiers on remote Pacific islands who never got the word that Emperor Hirohito had surrendered in 1945.

Everything Joseph Ratzinger did from the death of John Paul II until his own election—including his capacity to name what others were feeling about those days: that they were a time of grace for the whole world—confirmed the cardinals' sense (which some had brought with them to Rome) that this was indeed the one the Lord had chosen. That Ratzinger was deemed "too Roman" or "too CDF" didn't matter. Na-tionality didn't matter. Age didn't matter. And, perhaps most important, neither did the external script that had been pre-prepared in some jour-nalistic quarters in the event of a Ratzinger papacy. The American car-dinal who told Cardinal Murphy-O'Connor of Great Britain, on their way out of the Sistine Chapel, that he didn't know how he was going to "sell this" back home, was rather alone—as he and those of his cast of mind had been for the previous two weeks. The overwhelming ma-jority of the College of Cardinals were prepared to do some of the Church's most important business on the Church's terms, by the Church's schedule, and according to the Church's criteria—a calm self-confidence that boded well for the future integrity of Catholic faith and practice.

The real questions about Joseph Ratzinger never had to do with his media image. The real questions, as Ratzinger himself had said in the early days when he was attempting to tamp down the beginnings of his candidacy, were always about his capacity for *governo*—his abilities as a man of governance. Some of the cardinals knew that; and they were evidently confident that, as pope, Joseph Ratzinger would know his own limitations well enough to get himself the help he needed.

Finally, the times themselves had something to do with the election of Pope Benedict XVI—who demonstrated that he understood that in his choice of a name. At a time of *homo homini lupus*—a time when "man [was] a wolf to man"—people had gathered around Benedict of Nursia because he embodied the principle of true human communion: Jesus Christ. In a new season of *homo homini lupus*, manifest in terrorism or in the "dictatorship of relativism," his brother-cardinals sensed in Joseph Ratzinger another Benedict, another man who had been given the grace of embodying the true principle of human solidarity, which is Jesus Christ. They could trust him to be a man of true communion, communion with God and communion within humanity. That is why they elected him pope.

SOME TELLING REACTIONS

Reactions to the election of Pope Benedict XVI were instructive. A Vatican official who was among those brought into the Sistine Chapel shortly after Cardinal Ratzinger accepted election thought that Cardinal Francis Arinze, obviously ecstatic with the outcome, might start dancing through the *Sistina*. Cardinal Joachim Meisner of Cologne was so choked with joy and emotion that, when he approached the newly enthroned Pope Benedict to offer his homage, he couldn't get the words "Cologne" and "World Youth Day" out of his mouth. Cardinal Norberto Rivera Carrera was another exuberant elector, drawing an acquaintance into a huge Mexican embrace on the street the next day and saying, "The cardinals have done great work, no?" The more restrained but nonetheless exultant Cardinal Christoph Schönborn said, with a tone of wonder in his voice, "Can you believe it? It took less

than twenty-four hours!" Even the American cardinals who could reasonably have been expected to have voted in other directions on the first ballot or two did a decent job with the press, urging American reporters not to indulge in stereotypes.

There were some vulgar headlines. The London *Daily Mirror's* tabloid front page screamed, "He was known as GOD'S ROTTWEILER. Now he is POPE BENEDICT XVI"; the headline inside wasn't any better: "Hitler Youth to Vatican: Journey of the Enforcer." Then there was the London *Sun*, perhaps the quintessence of tabloid vulgarity: its front page on April 20, 2005, read "From Hitler Youth to . . . PAPA RATZI." American newspapers were rather more restrained, but Joseph Ratzinger's old critics were not, in the main, finding it easy to be good sports. On April 19, Father Richard McBrien was quoted in the *Washington Post* on the impossibility of Ratzinger's election: the *Pro Eligendo* homily, McBrien opined, had shown that Ratzinger "realizes that he's not going to be elected. He's too much of a polarizing figure."[23] Several hours later, there was a brief but ominous silence when ABC's Charles Gibson asked McBrien, the network's Vatican analyst, what he thought of Ratzinger's election; when he had recovered himself, Father McBrien allowed that he was surprised. So was Father Patrick Howell, S.J., dean of the School of Theology and Ministry at Seattle University, a Jesuit institution. "I think most American Catholics were shocked by the selection of Cardinal Ratzinger," Father Howell told the Tacoma *News Tribune*. "What were they thinking?" Howell mused about the cardinals. "I don't have an answer."[24] Neither did one of Father Richard McBrien's favorite Catholic politicians. Former New York governor Mario Cuomo took to the op-ed page of the New York *Daily News* nine days after the election to discuss his depression: "Our new pope's record . . . offer[s] little hope for meaningful changes or even for a clear admission that its man-made rules are indeed alterable by the Church that made and enforces them"—which suggested that Mr. Cuomo had still not figured out that the Church's condemnation of abortion was not one of those "alterable rules made for us by the male descendants [sic] of Peter," but a matter of that first principle of justice which tells us never to take an innocent human life.[25]

Swiss theologian Hans Küng tried to be generous; while Benedict's election had been "an enormous disappointment for all those who had

hoped for a reformist and pastoral pope," the aging dissident did sug-
gest that both he and the rest of the Church should give the new pope
a "hundred days" before assessments were made.[26] But other Europeans
had already made up their minds. The editors of *The Independent* declared
Pope Benedict "a theologian of the past, not a pastor for the future," a
man likely to see to "the continuation of the Vatican's war on the mod-
ern world" by "preventing birth control, pursuing heretics and harass-
ing homosexuals." This latter part of the standard anti-Ratzinger
indictment, was, the editors conceded, "a little too easy . . . but such a
caricature is not entirely inaccurate."[27]

Near the new pope's old Roman apartment, the proprietors of two
Borgo district restaurants, Da Armando and Da Roberto, each said,
wistfully, "I've lost a customer." Closer to Joseph Ratzinger's older
home, the Hermann toy company in the German city of Coburg began
advertising a handmade "Benedict XVI Teddy Bear," in a 265-copy lim-
ited edition: 265 for the 265th pope. Amid the veritable hurricane of
commentary, analysis, celebration, and toy-making, an intriguing anal-
ysis came from what some might regard as an unexpected source: Pro-
fessor Timothy George, a prominent American evangelical theologian
and dean of the interdenominational Beeson Divinity School at Sam-
ford University, a Baptist institution in Alabama. Writing in the flagship
monthly of American evangelicalism, *Christianity Today*, Dr. George
suggested to his fellow Protestants that Benedict XVI could be the
"harbinger of a new reformation," and that, in any event, "his pontifi-
cate will be one of great moment for the Christian Church, not least
for evangelicals." Why? Timothy George proposed five reasons why:
because Benedict "takes truth seriously"; because "his theology is Bible-
focused"; because "his message is Christocentric"; because "he is Augus-
tinian in perspective"; and because "he champions the culture of life."
Unlike Pope Benedict's Catholic critics, it was the Baptist theologian
who picked up on the worldwide significance of the new pope's choice
of name. After noting that the first Benedictine monks had "carried the
Bible and the message of Christ to the most pagan corners of Europe,"
Dr. George concluded his essay in these sweeping terms: "These two
themes—the renewal of the Church through the worship of God, and
the evangelization of the world through the power of the Gospel—
may well mark the legacy of this present pontificate: a new Benedictine
moment in the history of the Church."[28]

GETTING STARTED

Pope Benedict XVI celebrated Mass with the College of Cardinals in the Sistine Chapel on the morning of April 20. Preaching in his fine scholar's Latin, he committed himself to the quest for Christian unity, the ongoing "purification of memory" which John Paul II had initiated in the Church, the pursuit of peace in the world, and a dialogue with the young, whom he described as "the privileged interlocutors of John Paul II." All of this, however, had to be built on the Church's experience of the Eucharist, "the heart of Christian life and the source of the evangelizing mission of the Church." The Eucharist, he told the cardinals who had seen God's hand upon his life, would be "the permanent center and the source of the Petrine service entrusted to me." He also asked the cardinals for their ongoing help.

Later that day, Pope Benedict returned to his former offices at the Congregation for the Doctrine of the Faith, where he had an emotional reunion with his erstwhile co-workers. He then went to his old apartment to fetch some books and other personal items, shaking hands among the crowds that instantly gathered when word got around that the Pope was out in public. One of Joseph Ratzinger's friends once described his extensive personal library as his "empire," and the new pope was not about to prepare the homily for his installation Mass without visiting his empire.

The installation Mass was held on Sunday, April 24, and began with Benedict and a few other senior churchmen gathered underneath the high altar of St. Peter's, where they prayed at Peter's tomb before gathering up the two signs of office with which Benedict would be presented during the Mass—and which had lain at Peter's tomb overnight: the wool pallium that would be placed over his shoulders, symbol of the yoke of Christ; and the Fisherman's Ring, which depicts the miraculous drought of fish in the Gospels and is used to seal the most important papal documents. The Pope and his attendants then processed through the basilica out onto the *sagrato*, where the Mass would be celebrated before hundreds of thousands in St. Peter's Square and a worldwide television audience.[29]

There were several striking changes from previous papal installations. The pallium with which Benedict was vested was a reversion to

the garment's first-millennium form; wider and longer than the pallium that John Paul II had used, it was decorated with five red crosses rather than the more familiar six black crosses. At the moment in the liturgy when, in the past, the entire College of Cardinals had formed a procession in order to offer their obedience individually to the new pope, the ceremony was broadened to include representatives of every state of Catholic life: three cardinals, one bishop, one priest, one deacon, two vowed religious, a married couple, and two confirmed young people, chosen from all over the world. Pope Benedict's homily spoke of the deserts of late modernity, those in arid human souls and those in the conflicted public world, proposing that faith in Christ, rather than denying us our freedom, waters the deserts of life and makes a truly human existence possible.

When the Mass was concluded, Pope Benedict XVI went back inside the basilica to receive the governmental delegations that had been sent to Rome for his installation. He sat on a small faldstool, or portable throne, which had been placed before the entrance to the *confessio*: the entrance to the grottoes beneath Bernini's high altar and thus the gateway to the tomb of Peter. The successor of Peter would receive the powerful, as the world understood power, above the bones of an illiterate fisherman from the far edges of the civilized world, whose life had been transformed by a power greater than any the world knew.

After which, Pope Benedict XVI, 264th successor to the fisherman, had lunch—and then played the piano.

The Making of a New Benedict

W HAT AN EXQUISITE PERSON"—that verbal snapshot of Pope Benedict XVI one week after his election, taken by a senior Vatican official and acute observer of the Catholic scene, would not have surprised many of those who had known Cardinal Joseph Ratzinger as prefect of the Congregation for the Doctrine of the Faith and dean of the College of Cardinals; or, before that, as Professor Dr. Joseph Ratzinger; or, before that, as Father Joseph Ratzinger. The new pope's courtesy, humility, and shy friendliness, like his remarkable intelligence, had long been obvious to those who knew him. However true the description, though, to characterize the 265th Bishop of Rome as an "exquisite person" barely scratches the surface of his personality— even if it usefully confounds some of the regnant stereotypes.

Who is he?

It may help to think of Pope Benedict as a man who showed his form early. In 1943, sixteen-year-old Joseph Ratzinger was a conscript member of a German anti-aircraft unit stationed at Obergrashof, near Munich. A "very reserved, fairly inconspicuous figure," as one of his fellow conscripts remembers him, he didn't leave much of an impression—except on one occasion. A high-ranking officer, who couldn't have been anything but intimidating, was inspecting the unit, and the boys were lined up at attention. Each was asked by the officer what he wanted to be as an adult. Several said that they wanted to be

pilots; others, presumably, said tank commanders, or engineers, or something else suitably manly, as the Wehrmacht understood manliness. When the inspecting officer came to thin, shy Joseph Ratzinger and asked him what he wanted to be, the response was unexpected: "I would like to become a parish priest." Many of the others burst out laughing. But as a fellow veteran remembered, "to give such an answer took courage."[1]

It took that, of course: it took a brave sixteen-year-old to confront a representative of armed totalitarian power—and, perhaps even more threateningly, his fellow teenagers—with a truth they didn't want to hear. It took more than courage, though. This wartime episode also suggests enormous self-possession, a quiet confidence created by a rock-solid faith. Joseph Ratzinger has never been one to make a spectacle of himself. But he is prepared to defy the conventions when doing so is what the truth requires—even when telling the truth means facing down the stares of his superiors and bearing the taunts of his peers.

It was a trait that would serve him well, and cause him no little pain, in the years after 1943.

SON OF CATHOLIC BAVARIA

Although he was frequently, and understandably, described as the first "German pope" in a very long time, Joseph Ratzinger is less a German than a Bavarian—if by "German" we mean someone formed by the culture that emerged from the German Reich that Bismarck welded together from several hundred states in the mid-19th century. Ratzinger's cultural roots run deeper than post-Bismarckian Germany—and, in some important instances, are in tension with the modern state that Bismarck wrought. The 265th Bishop of Rome is a man of the *Land Bayern*, the product of an intact and thriving Catholic culture from which he drew important lessons about the nature of faith, the Church, and worship. His Bavarian roots also mean that he is the second pope in succession who was formed in the intense Catholic ferment of *Mitteleuropa* in the first half of the 20th century—a ferment that did not take its intellectual and cultural cues from Berlin and the Prussian approach to life and learning.

Joseph Ratzinger was born on April 16, 1927, in Marktl am Inn, a village in Upper Bavaria on the north side of the river Inn, which eventually merges into the Danube at Passau; Marktl is a few miles from the Marian shrine of Altötting, a pilgrimage site for Bavarians and Austrians since the Middle Ages. April 16 was Holy Saturday in 1927, and in those days, before Pius XII's liturgical reform, the Easter Vigil service was celebrated in the morning. Thus Joseph Ratzinger was baptized late on the morning of his birth with newly blessed Easter water, a special privilege on which he would reflect seventy years later:

> I have always been filled with thanksgiving for having had my life immersed in this way in the Easter mystery . . . To be sure, it was not Easter Sunday but Holy Saturday, but, the more I reflect on it, the more this seems to be fitting for the nature of our human life: we are still awaiting Easter; we are not yet standing in the full light but are walking toward it full of trust.[2]

His parents' names were Joseph and Mary (which provoked innumerable jokes in his later life), and he was their third child, following his sister, Maria, born in 1921, and his brother, Georg, born in 1924. Maria would become her cardinal-brother's longtime housekeeper before her death in 1991. Georg would also be ordained a priest and go on to lead the Regensburg Cathedral Choir for many years, acquiring an international reputation in the process. Music and the intensity of his father's anti-Nazi views are two of Joseph Ratzinger's clearest memories from a childhood that was spent, in some respects, on the move.

The elder Joseph Ratzinger was a police constable, or commissioner; his duties and, later, the volatile politics of the period, required him to move his family frequently. Thus, in 1929, the Ratzingers left Marktl for Tittmoning, on the Salzach River (which forms the German-Austrian border). Tittmoning, the future pope would recall, was "my childhood's land of dreams," with a great town square surrounded by large houses; decorated shop windows during the Christmas season; an "unforgettable mighty fortress that towers over the town," at which the Ratzinger children would picnic with their mother; and an old monastic church, decorated in the Baroque style.[3] The childhood idyll didn't last, however. The elder Joseph Ratzinger's criticism of the Nazis made life there impossible, so, in 1932, the family moved to Aschau am Inn, a

village of farms, where the constable's family was quartered in a country house whose first floor doubled as police headquarters.

The Ratzingers arrived in Aschau in December 1932; a month later, President Paul Hindenburg named Adolf Hitler Reichschancellor. The future pope carried two indelible memories from the next four years: the brownshirts spying on the local priests and informing on these "enemies of the Reich"; and the mortification of his father, who was, at least formally, working "for a government whose representatives he considered to be criminals."[4] Young Joseph Ratzinger took his first steps in education at the village school in Aschau.

The family peregrinations stopped in 1937, when Joseph Ratzinger Sr. retired from police work (as he was required to do at age sixty) and moved to Traunstein, where he had bought an old farmhouse on the outskirts of the town in 1933. In the Traunstein *Gymnasium*, or secondary school, the younger Joseph Ratzinger began his studies in Latin, Greek, history, and literature—an education, Cardinal Ratzinger would later recall, which "created a mental attitude that resisted seduction by a totalitarian ideology."[5] In 1939, the year Hitler set Europe ablaze, Ratzinger, who must have been considering a priestly vocation for some time, entered the minor seminary in Traunstein at the urging of his pastor; his brother, Georg, was already studying there. The young seminarian found it hard to adjust to the rigidities of the study hall after having enjoyed reading on his own at home, but his real problems came on the athletic field; as he later put it, delicately, "I am not at all gifted in sports . . ." It was during this period that Ratzinger had his brief encounter with the Hitler Youth, membership in which was compulsory; a sympathetic teacher got him the certificate of attendance that Ratzinger simply didn't want to go get himself. "And so," as he later wrote, "I was able to stay free of it."[6] (An impertinent reporter, once probing these years in Ratzinger's adolescence, asked, at a German press conference held to present Cardinal Ratzinger's autobiography, why there weren't any references to girlfriends in the book. The legendarily formidable *Panzerkardinal* replied, with a twinkle in his eye, "I had to keep the manuscript to one hundred pages.")[7]

At the outbreak of World War II, the Traunstein seminary was designated as a military hospital, so the rector found a new location for the students in a convent school in the countryside outside the city.

Happily, from Ratzinger's point of view, "there was no place for sports," so for exercise the students hiked, fished, built dams: "It was the kind of happy life boys should have. I came to terms, then, with being in the seminary and experienced a wonderful time in my life. I had to learn how to fit into the group, how to come out of my solitary ways and start building a community with others by giving and receiving."[8]

It was not to last, however. In 1943, Ratzinger and other Traunstein seminarians were conscripted into the German anti-aircraft corps and sent to the Munich area, where they continued their *Gymnasium* education in their off-duty hours. Ratzinger found himself in the telecommunications section of the service, and never fired a gun. The Allied invasion of France in June 1944 came to Ratzinger and most of his fellow conscripts "as a sign of hope . . . there was a great trust in the Western powers and a hope that their sense of justice would also help Germany to begin a new and peaceful existence." At the same time, these teenagers wondered, as well they might, whether they would live to see that day—"None of us could be sure that he would live to return home from this inferno."[9]

In September 1944, having come of military age, Joseph Ratzinger was assigned to the infantry and, after basic training, was sent to a unit that was digging anti-tank fortifications on the Austrian-Hungarian border. After being reassigned to a post near his Bavarian home, he fell ill, but a sympathetic officer exempted him from military duties. The Third Reich was crumbling, but by late April 1945, the American liberators had still not arrived; so, as Ratzinger later wrote, "I decided to go home." Deserters were being shot on sight, but Ratzinger was fortunate to have suffered a minor injury, his arm was in a sling, and the two soldiers he encountered on his way home told him to move on. When the Americans finally arrived in Traunstein, they chose the Ratzinger home as headquarters, and young Joseph was easily identified as a soldier. So he "had to put back on the uniform I had already abandoned, had to raise my hands and join the steadily growing throng of war prisoners" who were being lined up in a meadow outside town. The POWs were marched to the military airport at Bad Aibling and then shipped to a large POW camp near Ulm, where fifty thousand were imprisoned. Ratzinger was there

for about six weeks and then released; he was trucked to Munich and left on the outskirts of the city, from whence he walked and hitch-hiked the 120 kilometers to Traunstein. He arrived on the evening of the Feast of the Sacred Heart of Jesus and went straight to his home. "In my whole life I have never again had so magnificent a meal as the simple one that Mother then prepared for me from the vegetables of her own garden."[10] The family reunion was completed in July, when Georg Ratzinger returned from military service in Italy. On his arrival home, the young musician sat down at the piano and played the hymn *Grosser Gott, wir loben dich* [Holy God, we praise thy name].

Joseph Ratzinger's published memoirs are rather more revealing about his family life, struggles, fears, and aspirations than those of other prelates. Those memoirs and other biographical interviews make it clear that his was a close-knit family. Like his predecessor as pope, Ratzinger was deeply influenced by the integrity and sturdy Catholic faith of his father, whose "simple power to convince came out of his inner honesty."[11] Ratzinger's love for his mother and her "warm and heartfelt piety," and for the brother and sister to whom he stayed close throughout his life, are also obvious from his autobiographical reflections.

Yet the more one reads Ratzinger's recollections of his early life, the more it becomes clear that, for the young Bavarian, the Catholic Church quickly became "home" in a special, even unique, way. In his conversations with the German journalist Peter Seewald, Cardinal Ratzinger spoke about his childhood excitement at receiving his first children's missal (a book containing the prayers of the Mass, in this case, in simplified form), and then "progressing to a more complete missal, [then] to the complete version. That was a kind of voyage of discovery."[12] At the same time, he was discovering the wonder of polyphony and other forms of Church music, the beauty of religious art, and the intellectual satisfaction to be had from understanding what all these things meant. Ratzinger never disdained the simple habits of piety he learned as a boy, although his spiritual life obviously deepened over time; yet some of those early habits would remain with him his entire life. Thus, every March 19, on the Solemnity of St. Joseph, the feast of his patron saint, Cardinal Ratzinger would invite other Josephs to celebrate Mass with him or to join him for a day trip and lunch out-

side Rome. The earthiness of Bavarian piety—the intertwining of the transcendent and the human—was deep in him.[13] From childhood on, Joseph Ratzinger experienced the Catholic Church as something wonderful, a divinely touched human community to be explored in all its richness, diversity, and complexity.

The war years taught him some important lessons that he would only later bring to intellectual expression. His father's anti-Nazi convictions and his own experience of the war suggested a truth that the French Jesuit Henri de Lubac had made the theme of his 1943 study, *The Drama of Atheistic Humanism*: "It is not true, as is sometimes said, that man cannot organize the world without God. What is true is that, without God, he can ultimately only organize it against man. Exclusive humanism is inhuman humanism."[14] That was a truth about the world. There was also a truth about Christianity to be learned from Germany's Nazi experience: the more robust and orthodox a community's faith, the better able it was to resist the siren songs of National Socialism. As his intellectual biographer, Aidan Nichols, put it, Ratzinger would later cite "the collapse of liberal theology before the advance of Nazi ideology . . . as one of the more instructive lessons provided by the history of his homeland."[15] While the National Socialist regime was obviously one factor in the heresy of the Nazified *Deutsche Christen*, these "German Christians" were, in another respect, a wretched by-product of the hollowing-out of Christian conviction from within. Ratzinger also learned from the Nazis his first lessons in the mortal danger of measuring human lives by their utility, or lack thereof. He had a cousin, just about his own age, who had Down's syndrome. When he was fourteen, the regime took his cousin away for what was described as "therapy," but was, in fact, euthanasia.[16]

Like many Bavarian Catholics, Joseph Ratzinger welcomed the defeat of the Third Reich and the restoration of democracy, the enthusiasm for which he once described as amounting to a kind of "religious fervor" in the post-war years.[17] Ratzinger always remembered, however, that Hitler had come to power by legal means, and that the Nazis' opportunity had come about because of the fatal flaws of the Weimar Republic, a beautifully constructed democratic system. It takes more than systems, though, to make democracies work; it takes virtues. That was another lesson Joseph Ratzinger learned early.

PRIEST, PROFESSOR, *PERITUS*

In November 1945, Joseph Ratzinger and his brother, Georg, entered the major seminary at Freising. (Freising, a town some twenty miles north of Munich, is joined to the much larger city in the name of the local archdiocese, which is "Munich and Freising." The diocese of Freising dates back to 739, while the double-named archdiocese into which the Freising diocese was incorporated only dates to 1818). In the seminary, which was also serving as a hospital for foreign POWs await-ing repatriation, older war veterans and youngsters like Joseph Ratzinger were united in a determination to serve the Church and, in doing so, to help rebuild a physically and morally shattered Germany. For a mind like Ratzinger's, the return to academic life was a long-awaited feast: "a hunger for knowledge had grown in the years of famine, in the years when we had been delivered up to the Moloch of power, so far from the realm of the spirit."[18] In addition to the pre-scribed courses in philosophy and other subjects, Ratzinger and his colleagues "devoured" novels, with Dostoevsky, Claudel, Bernanos, and Mauriac among the favorites. The seminary curriculum didn't neglect the hard sciences; as Ratzinger would later put it, "we thought that, with the breakthroughs made by Planck, Heisenberg, and Einstein, the sciences were once again on their way to God." Romano Guardini and Josef Pieper were favorites among the contemporary theologians and philosophers.[19]

The prefect of Ratzinger's study hall, Father Alfred Läpple, put him to work reading books that introduced him to Heidegger, Jaspers, Nietzsche, Buber, and Bergson, philosophers most certainly not on any Roman (or American) seminary reading list in those days; the young Ratzinger immediately made an intuitive connection between the per-sonalism of Buber and Jaspers and "the thought of St. Augustine, who in his *Confessions* had struck me with the power of all his human passion and depth."[20] Conversely, and concurrently, Ratzinger had an unhappy introduction to the philosophy and theology of Thomas Aquinas, which were presented in what he later termed a "rigid, neo-scholastic" form that was "simply too far afield from my own questions."[21] The young Bavarian scholar was beginning to range freely across centuries

of western and Christian thought, a lifelong process that would eventually give him an encyclopedic knowledge of theology. His seminary experience with neo-scholasticism would also mark him permanently, and would later make him the first non-Thomist in centuries to head the Catholic Church's principal doctrinal office.

In 1947, Ratzinger went to Munich for his theological studies, encountering there a host of renowned theologians and teachers who were breaking with the rigidities of neo-scholasticism and rethinking Catholic dogmatic theology through a return to the Bible, to the Fathers of the Church in the early centuries of Christianity, and to the liturgy, the Church's worship, which they believed was a *locus theologicus*, a "source" of theology. Preeminent among these teachers was Michael Schmaus, who had come to Munich from Münster after the war and was considered a theologian on the cutting edge of the renewal of Catholic thought. Ratzinger was also intrigued by the New Testament scholar Friedrich Wilhelm Maier, and while he could never accept aspects of Maier's method of biblical interpretation, he learned from him a passion for biblical studies which, as he later put it, "has always remained for me the center of my theology." Another influential teacher during these years was his Old Testament professor, Friedrich Stummer, who helped the neophyte theologian to understand that "the New Testament is not a different book of a different religion that, for some reason or other, had appropriated the Holy Scriptures of the Jews as a kind of preliminary structure." No, "the New Testament is nothing other than an interpretation of 'the Law, the Prophets, and the Writings' found from or contained in the story of Jesus."[22] In Munich, under the tutelage of Josef Pascher, Ratzinger began to explore the mid-century liturgical movement more deeply and to read in the mystical theology that had grown out of one center of that movement, the Benedictine monastery at Maria Laach. The Bible and the liturgy came together for Ratzinger, intellectually, in his Munich studies: "Just as I learned to understand the New Testament as being the soul of all theology, so too I came to see the liturgy as its living element, without which it would necessarily shrivel up."

In short, Joseph Ratzinger completed his initial theological course at a time of great ferment in German theology—a movement of intellectual and spiritual renewal that had begun in the 1920s. It was a move-

ment in search of a theology "that had the courage to ask new questions and a spirituality that was doing away with what was dusty and obsolete and leading to a new joy in the redemption."[23] At the same time, according to his friend, the German journalist H. J. Fischer, Ratzinger's introduction to the vitality of Catholic intellectual life convinced him that "that which is Catholic cannot be stupid, and that which is stupid cannot be Catholic."[24] Pre-conciliar Catholicism, in Ratzinger's experience, was anything but stale: it was bracing, vital, and intellectually vibrant. At the same time, theology was done as a self-consciously ecclesial discipline, a way of thinking with the Church. Ratzinger's memoirs of this period conclude with a telling episode:

In 1949 . . . Gottlieb Söhngen [a Catholic theologian] held forth passionately against the possibility of [the definition of the dogma of Mary's assumption] before the circle for ecumenical dialogue presided over by Archbishop Jäger of Paderborn and Lutheran Bishop Stählin . . . In response, Edmund Schlink, a Lutheran expert on systematic theology from Heidelberg, asked Söhngen point-blank: "But what will you do if the dogma is nevertheless defined? Won't you then have to turn your back on the Catholic Church?" After reflecting for a moment, Söhngen answered: "If the dogma comes, then I will remember that the Church is wiser than I and that I trust her more than my own erudition." I think that this small scene says everything about the spirit in which theology was done [in those days]—both critically and with faith.[25]

Joseph and Georg Ratzinger were ordained priests by Cardinal Michael Faulhaber on June 29, 1951, the Solemnity of Sts. Peter and Paul, in the cathedral of Freising. It was a splendid summer day that Ratzinger would always remember as "the high point of my life." When the Ratzinger brothers came to Traunstein for their first Masses, the town opened itself to them unreservedly; complete strangers invited the brothers into their homes to bestow the first priestly blessing. The point, Ratzinger later insisted, was not himself or his brother: "What could we two young men represent all by ourselves to the many people we were now meeting?" The point was that the people of Traunstein

recognized the change in them: "In us they saw persons who had been touched by Christ's mission and had been empowered to bring his nearness to men."[26]

After fifteen months of parish work in Munich, Father Joseph Ratzinger was assigned to the Freising seminary as a teacher, with adjunct work with young people and liturgical service at the cathedral. Above all, though, Ratzinger had to finish his doctorate, which he completed in July 1953 with a dissertation on "The People and the House of God in St. Augustine's Doctrine of the Church." Father Ratzinger was now Dr. Ratzinger. Before he could reach the highest levels of German scholarship, though, and in order to qualify as a university professor, he had to write a second doctoral dissertation, the *Habilitationsschrift*, or "habilitation." And here, for the first time in his academic career, Ratzinger got into serious trouble.

Under the influence of Gottlieb Söhngen, he decided to move from the Fathers to the Middle Ages in his habilitation thesis, and specifically from St. Augustine to St. Bonaventure. In the habilitation, Ratzinger, following Bonaventure, argued that revelation is "an act in which God shows himself"; revelation cannot be reduced to the propositions that result from God's self-disclosure, as certain forms of neo-scholasticism tended to do. Revelation, in other words, has a subjective or personal dimension, in that there is no "revelation" without someone to receive it. As Ratzinger would later put it, "where there is no one to perceive 'revelation,' no re-vel-ation has occurred, because no *veil* has been removed." Gottlieb Söhngen had no problem with this, and, as the first reader of Ratzinger's habilitation, accepted the thesis enthusiastically. But Michael Schmaus, the second reader, was not merely unpersuaded, he was adamantly opposed, and told Ratzinger in mid-1956 that he was rejecting the thesis—a stunning decision that, if upheld, would have denied Ratzinger the academic career he sought. Schmaus seems to have had serious difficulties with Ratzinger's conclusions about the nature of revelation. Offended pride may also have taken a hand, as it often does in academic life: the fact that Ratzinger had decided to do a dissertation on a medieval theologian, Bonaventure, under a director other than Schmaus, an acknowledged authority on the Middle Ages, may have had something to do with Schmaus's rejection. Four decades later, Ratzinger speculated that ecclesiastical politics

could have been at work, too, as Schmaus may have heard rumors of modernizing tendencies in Ratzinger's teaching.

After what can be imagined to have been a stormy meeting of the Munich theology faculty, Schmaus did not prevail entirely: the decision was made to allow Ratzinger to try and revise the thesis. He prudently decided to shift the focus of his habilitation to Bonaventure's theology of history—a section of the original thesis with which Schmaus had had no problems—and rewrote the entire work in two weeks. It was resubmitted and finally accepted by the faculty in February 1957. Before the habilitation process could be completed, however, Ratzinger had to give a public lecture—with both Söhngen and Schmaus, his two readers, as respondents. The atmosphere at the lecture was electric, and the subsequent discussion turned into a donnybrook between the two respondents. After the polemics were finished, the faculty met again, for what seemed to Ratzinger "a long time." Finally, the dean emerged from what was likely another stormy session to tell him "without ceremony" that he had passed and now held the habilitation degree. When things settled down, Dr. Hab. Joseph Ratzinger was named a lecturer (the lowest rung on the academic ladder) at the University of Munich. Then, in early January 1958, and "not without some sniper shots from certain disgruntled quarters," he was appointed a professor of theology at the college of Philosophy and Theology at Freising. Schmaus and Ratzinger were later reconciled and became friends in the 1970s.[27]

But Joseph Ratzinger was not to remain in his native Bavaria for long. With his brother's return from studies to Traunstein, where his assignment included a residence in which the aging Ratzinger parents could live with him, the path was open for the newly accredited theologian to accept an offer to take the chair of fundamental theology at Bonn, an assignment once sought by his mentor Söhngen. He began his work in Bonn on April 15, 1959, the day before his thirty-second birthday, one of the youngest theology professors in Germany and, despite the habilitation struggle, an obviously rising star.

Four months later, however, his father died of a stroke. The family was gathered around the deathbed; afterwards, Ratzinger sensed that "the world was emptier for me and that a portion of my home had been transferred to the other world."[28] Ratzinger's mother would die in 1963;

her son later paid tribute to his first educators in Christianity by writing that "I know of no more convincing proof for the faith than precisely the pure and unalloyed humanity that the faith allowed to mature in my parents . . ."[29]

Bonn is close to Cologne, and the young theologian soon came into regular contact with the cardinal archbishop of the city, Joseph Frings; Frings had heard Ratzinger lecture on the theology of the impending Second Vatican Council, which had been announced by Pope John XXIII three months before Ratzinger took up his new position. The relationship between the two developed to the point where, when Cardinal Frings left for Vatican II in September 1962, he took the thirty-five-year-old Ratzinger as his theological advisor and arranged to have Ratzinger appointed a *peritus*, an official theologian, of the Council. During those heady days, Ratzinger worked in tandem with some of the giants of 20th-century Catholic theology, including Henri de Lubac, Jean Daniélou, and his fellow German Karl Rahner. Ratzinger and Rahner had first met in 1956, just when Michael Schmaus was rejecting the younger man's habilitation thesis.

Ratzinger enthusiastically supported the idea that the Council should begin its work with the reform of the liturgy, for, as he later put it, the Eucharist is "the mystery where the Church, participating in the sacrifice of Jesus Christ, fulfills its innermost mission, the adoration of the true God." Divine worship, he wrote, is "a matter of life and death" for the Church: "If it is no longer possible to bring the faithful to worship God, and in such a way that they themselves perform this worship, then the Church has failed in its task and can no longer justify its existence."[30] Yet for all his enthusiasm about the Council's beginning with the reform of Catholic worship, Ratzinger would later come to the view that the reform as actually carried out was not the reform the Council fathers had intended.

Ratzinger's almost-aborted work on Bonaventure's theology of revelation bore fruit in the Council's seminal Dogmatic Constitution on Divine Revelation [*Dei Verbum*], which took essentially the same view that had gotten him into such trouble: God reveals *himself*, and that revelation is to be understood as the act in which God encounters human beings, rather than as merely propositions about God. At the same time, it was during his work on revelation at the Council that Ratzinger dis-

covered that he and Karl Rahner, the preeminent German dogmatic theologian and a figure of worldwide influence, "lived on two different theological planets." They agreed on issues like the reform of the liturgy, methods of biblical interpretation, and other contested questions, "but for entirely different reasons." According to Ratzinger's later recollection, Rahner's "was a speculative and philosophical theology in which Scripture and the Fathers in the end did not play an important role and in which the historical dimension was really of little significance. For my part, my whole intellectual formation had been shaped by Scripture and the Fathers and profoundly historical thinking."[31] The dramatic difference between these two theological methods—and the practical results to which it would lead—would have important consequences for the relations between the two men, and indeed for Catholic theology, in the post–Vatican II years.

In Vatican II lore, Joseph Ratzinger is often remembered for having helped draft a speech in which Cardinal Frings denounced the Holy Office for its modus operandi. The methods of the Holy Office, Frings charged in a sensational address in November 1963, "are out of harmony with modern times and are a cause of scandal to the world." There is little doubt that the charge had substance in those days, but it would be thrown back in Ratzinger's face more than once in his twenty-three years as prefect of the Congregation for the Doctrine of the Faith, the post-conciliar successor to the Holy Office. Ratzinger, it was frequently charged, had switched sides.

For his part, Ratzinger remembers that his concerns about the Council's direction—and the dynamics it was setting loose in the Church—began during Vatican II itself.[32] Halfway through the four sessions of Vatican II, the impression was being created that "nothing was now stable in the Church, that everything was open to revision." An anti-Roman bias, which went far beyond legitimate criticisms of curial stodginess, was in the air—and fouling it. Churchmen and journalists alike were describing the Council as if it were a parliamentary exercise in partisan politics rather than an effort at ecclesial and spiritual discernment. The new Pentecost imagined by John XXIII was being described as, and in some senses had devolved into, a scramble for power. Theologians, tasting power and liking the taste, were imagining themselves as a parallel teaching authority in the Church, a kind of magisterium of experts.[33] None of this, in Ratzinger's view,

had much to do with the kind of reform that he and others had en-
visioned in the 1950s.

Understanding both Ratzinger's role at Vatican II and his later criti-
cisms of the Council requires remembering that he was, in fact, a re-
former. As Aidan Nichols puts it, Ratzinger agreed with those who
thought that the Church of the past few centuries had shrunk itself,
theologically and spiritually, and that Vatican II's task was to "usher
Catholics into a larger room." The reform Ratzinger imagined would
have two dimensions, usually described in Council argot by a French
term and an Italian term. The reform required *ressourcement*—a "return to
the sources" of Catholic theology in the Bible and in the early Fathers
of the Church, where, as Nichols writes, "the Christian religion took
on its classic form" from men such as Ignatius of Antioch, Cyprian,
Ambrose, Augustine, Leo the Great, Gregory the Great, Athanasius, and
John Chrysostom. *Ressourcement*, it was believed, would free Catholic
theology from the cold logic and bloodless propositions of the neo-
scholastic system; and having been liberated in that way, theology
would revitalize Catholic life. That revitalization was the second di-
mension of the kind of reform Ratzinger imagined: the famous *aggiorna-
mento*, or "bringing up to date," of the Church's practices, structures, and
methods of encounter with modern culture and society. Yet here, too,
the living Christ had to be at the center of reform, for the "objective" of
aggiornamento, Ratzinger wrote immediately after the Council, "is pre-
cisely that Christ may become understood."[34] According to Ratzinger
and those of his cast of mind, the biblical and patristic *ressourcement*
would allow the *aggiornamento* of the Church in the modern world to be
a genuine, two-way dialogue, with the Church offering fresh insight to
modernity, its aspirations and its discontents.[35] For a truly reformed
Church would understand, once again, that it "does not exist for its
own sake"; rather, the Church is "the continuing history of God's rela-
tionship with man."[36]

Ratzinger was right: neo-scholasticism had gone stale, and fresh air
was needed in theology and in the Church. The problems came, in
Ratzinger's view, when *aggiornamento* lost its tether to *ressourcement*—when
the "updating" of the Church did not begin with a return to the sources
of Catholic intellectual and spiritual vitality. When *ressourcement* and *ag-
giornamento* came unglued, then Christian belief was simply another opin-
ion, and "believing" meant "having opinions."[37] Instead of building

Nichols's larger room in the Church, an *aggiornamento* unmoored from *ressourcement* stripped the room of a lot of its furniture. And in doing so, misguided forms of *aggiornamento* were unleasing what a later generation would have called Catholic "deconstruction": the new question became, "How little can I believe, and how little must I do, to remain a Catholic?" (Or, as Aidan Nichols put it, more elegantly, "Once *aggiornamento* had parted company from *ressourcement*, adaptation could degenerate into mere accommodation to habits of mind and behavior in secular culture.")[38] These were emphatically not the questions proposed by reformers like Joseph Ratzinger, for whom the whole point of the *ressourcement* was to empower a Catholic updating that put the people of the Church into steady contact with the vast riches of their tradition, which they would gradually make their own in order to serve the world in a distinctive way. *Aggiornamento* detached from *ressourcement*, Ratzinger came to see, was stupid. And as he had intuited in his first days as a student of theology, what is stupid cannot be authentically Catholic.

In other words, the real debate in post-conciliar Catholicism would not be between reformers, on the one hand, and ideologically hardened anti-moderns like the French archbishop Marcel Lefebvre (whose followers refused to use the reformed liturgy and thought the Council's Declaration on Religious Freedom heresy), on the other. Lefebvre's rejectionism was a sideshow. The real debate was between two tendencies among the reformers: a tendency that held to the crucial linkage of *aggiornamento* to *ressourcement*, and a tendency that was, over time, less and less interested in a return to the sources and more and more enthralled with modern culture. Ratzinger's fidelity to the first tendency would define the next forty years of his service to theology and the Church, as the widening fault line between the two tendencies spilled out from academic life to touch virtually every aspect of Catholic life and practice in the developed world.

BETWEEN THE COUNCIL
AND THE CONGREGATION

Prof. Dr. Hab. Joseph Ratzinger enjoyed teaching at the University of Münster, to which he had moved from Bonn in 1963; years later, he

would remember the venerable Westphalian city as a "beautiful and noble" one.[39] Yet he felt the tug of his native Bavaria and the south of Germany, so, when he was invited to take a chair in dogmatic theology at the University of Tübingen in 1966, he accepted. Interestingly enough, it was Hans Küng who pressed for Ratzinger's appointment within the Tübingen faculty (and reportedly short-circuited the usual procedures to ram it through). Tübingen's was among the most distinguished theological faculties in Germany, with strong Catholic and Lutheran scholars alike; the chance to be in contact with the latter was, for Ratzinger, one of the attractions of the move to Swabia.[40]

Life at Tübingen soon became contentious, though. For all its brilliance, the Catholic theological faculty was "much given to conflict," as Ratzinger, who didn't enjoy such goings-on, gently put it years later. But worse was to come. The existentialism that had been the dominant intellectual leitmotif at Tübingen was quickly displaced by various forms of Marxist analysis, which, as Ratzinger remembers, shook the university "to its very foundations." Marxism was a swindle of biblical faith, in Ratzinger's view: ". . . [It] took biblical hope as its basis but inverted it by keeping the religious ardor but eliminating God and replacing him with the political activity of man. Hope remains, but the party takes the place of God, and, along with the party a totalitarianism that practices an atheistic sort of adoration ready to sacrifice all humaneness to its false god."[41]

The situation became completely untenable, from Ratzinger's point of view, in the summer of 1969. Then, the students of the Protestant theologian union circulated a flyer asking, "So what is Jesus's cross but the expression of a sado-masochistic glorification of pain?" Two of Ratzinger's Protestant colleagues deplored this blasphemy, to no avail. The situation among the Catholic students never got "quite so bad," but "the basic current . . . was the same." So, the choice was sharply posed, and Ratzinger "knew what was at stake: anyone who wanted to remain a progressive in this context had to give up his integrity."[42] That he was not prepared to do, so he decamped from Tübingen and settled in late 1969 at the newly established University of Regensburg, where he would remain for the rest of his academic career. His critics later said that Ratzinger had left Tübingen because he couldn't handle student radicals. From his point of view, it wasn't the scruffiness of the student left that made things intolerable, but their *Marxisante* blasphemies. The-

ology simply couldn't be done in an atmosphere where basic Christian symbols were objects of loathing. So he left, for the sake of theology.

The Tübingen years did produce one lasting fruit. Hans Küng was responsible for the dogma lectures in the Catholic faculty of theology in 1967, which left Ratzinger free to take up a project he had been thinking about for a decade: a series of lectures for students from all the faculties, titled "Introduction to Christianity." Those lectures eventually led to the book of that title, which would become an international bestseller and a staple of introductory theology courses throughout the Catholic world.[43] Those with a sense of the divine irony will appreciate the fact that *Introduction to Christianity* was made possible by Hans Küng teaching the dogma course at Tübingen that year.

Ratzinger was happy at Regensburg, which was now home to his brother and sister as well. Between the Council and the Tübingen experience, the Sixties had been a decade of unremitting conflict for Ratzinger, and he was eager to get back to serious intellectual work. Pope Paul VI appointed Ratzinger to the International Theological Commission in 1969; during its meetings, he deepened his friendship with Henri de Lubac, S.J., and made new friends, including the Chilean theologian Jorge Medina and the French convert Louis Bouyer. These years also saw a ripening of Ratzinger's collaboration with the great Swiss theologian, Hans Urs von Balthasar, a pyrotechnic genius whose prolific theological, literary, and spiritual writings constitute one of the extraordinary Catholic intellectual achievements of recent centuries.[44]

With these and other colleagues, Ratzinger discussed the widening breach between the two schools of Vatican II theological reformers, and the way to achieve a genuinely Catholic reform of theology and the Church in light of contemporary culture, its problems and its promise. Balthasar's idea, which drew Ratzinger's support, was to bring together in a coherent intellectual movement "all those who did not want to do theology on the basis of the pre-set goals of ecclesial politics but who were intent on developing theology rigorously on the basis of its own proper sources and methods"—in brief, *aggiornamento* deeply rooted in *ressourcement*. The method Balthasar, Ratzinger, and their colleagues chose to launch this movement was a journal, which they decided to call *Communio* [Communion].

Those who had seemingly detached *aggiornamento* from *ressourcement* had previously founded the journal *Concilium* [Council], which appeared in the major European languages; they also ran *Concilium* within rather narrow ideological boundaries, according to a kind of theological party line. As one of the founders of the French edition of *Communio* later recalled, this was precisely what the *Concilium* people had rightly resented about pre-conciliar Roman theology—it enforced a party line. Yet here they were doing it themselves, in *Concilium*, if from the other end of the ideological spectrum. *Communio*, by contrast, was intended to be genuinely pluralistic, open to all sorts of theological methods and viewpoints, within the common bond of *sentire cum ecclesia* [thinking with the Church].

Supported by younger German theologians like Karl Lehmann, and with help from Don Luigi Giussani and members of his Communion and Liberation movement, *Communio* was first launched in Germany and Italy, but its ambitions were larger. Ratzinger described the broad sweep of the project and its internationalism in his memoirs: "Since the crisis in theology had emerged out of a crisis in culture and, indeed, out of a cultural revolution, the journal had to address the cultural domain, too, and had to be edited in collaboration with lay persons of high cultural competence. Since cultures are very different from country to country, the review had to take this into account and have something like a 'federalist' character."[45] Thus, *Communio* evolved over the years into a federation of allied, language-based journals. Thirty years after its founding, there were independent, federated editions of *Communio* published in German, Italian, Croatian, French, Flemish, Spanish (in distinct Spanish and Latin American editions), Polish, Portuguese (in distinct Portuguese and Brazilian editions), Slovenian, Hungarian, Czech, and English. Each edition was responsible for its own content; an annual meeting of senior editors helped keep the *Communio* network focused in parallel directions.

The *Concilium/Communio* split gave the Catholic Church an important set of new intellectual journals and a potent international network linking younger, older, clerical, and lay scholars. The split was not without costs for Joseph Ratzinger, though. The parting of the ways between *Concilium* and *Communio* marked the end of his friendships and collaboration with Hans Küng and Karl Rahner. Moreover, as the *Concilium*

group (which imagined itself the true heir of Vatican II) waned in influence, while Ratzinger rose in the Church hierarchy, he would be the frequent target of a form of ecclesiastical nastiness known as *odium theologicum* (which needs—and, in fact, has—no translation). It is not unlikely that the caricatures that dogged Ratzinger for twenty-five years (the *Panzerkardinal*, "God's Rottweiler") were at least inspired by members of the *Concilium* group with ready access to the media, which in Europe as well as North America was usually ready to pit good "progressives" against wicked "conservatives." These ideological cartoons were, of course, based on political categories that could not begin to parse seriously the real differences between the two estranged groups of reformers. They nevertheless made for great copy (or so it must have seemed to a lot of editors, given the ubiquity of their use).

During his Regensburg years, Joseph Ratzinger attracted impressive students who came to do their doctorates under his direction. Two of the most prominent were Christoph Schönborn, a young Dominican who would later become editor of the *Catechism of the Catholic Church* and cardinal archbishop of Vienna, and Joseph Fessio, an American Jesuit who would found Ignatius Press, a distinguished publishing house, and lead several important educational initiatives. Ratzinger did not confine his love for teaching to the classroom, however. From 1970 until 1977 he and the Catholic biblical scholar Heinrich Schlier led a week-long course at a country estate near Lake Constance for young people interested in deepening their understanding of the essentials of Catholic faith—a kind of theological and biblical summer camp, in which Ratzinger and Schlier shared the household duties with their students. In launching this initiative, Ratzinger was deliberately patterning himself after Romano Guardini, the great Munich theologian and one of the seminal figures of the Catholic revival in mid-20th-century *Mitteleuropa*, who had built a similar intellectual and spiritual center for young people in the 1920s and 1930s.[46] Guardini had written extensively about the Church "after modernity," which he believed had run its course and was out of gas, culturally and spiritually; it is not difficult to imagine Ratzinger and Schlier talking with their summer-school students along similar lines.[47]

Cardinal Julius Döpfner of Munich and Freising died, unexpectedly, on July 24, 1976. Precisely eight months later, on March 24, 1977, the

appointment of Joseph Ratzinger as the new archbishop of Bavaria's major see was announced. The rather lengthy interregnum suggests that there may have been some contention, in Rome and possibly in Germany, over the Munich succession. Ratzinger himself was not, evidently, in the conversation, and his first reaction to the idea of his becoming the new archbishop was that it was a very bad idea indeed:

> I did not think it was anything serious when [Archbishop Guido] Del Mestri, the apostolic nuncio, visited me in Regensburg on some pretext. We chatted about insignificant matters, and then finally he pressed a letter into my hand, telling me to read it and think it over at home. It contained my appointment as archbishop of Munich and Freising. I was allowed to consult my confessor on the matter. So I went to Professor Auer, who had a very realistic knowledge of my limitations, both theological and human. I surely expected him to advise me to decline. But to my great surprise he said without much reflection: "You must accept."[48]

Ratzinger still had his doubts, but, back at the nuncio's hotel, he wrote his letter of acceptance to Pope Paul VI on a piece of the hotel's stationery. His ordination as a bishop was celebrated in the Munich cathedral on May 28, 1977, the vigil of Pentecost. Ratzinger chose as his episcopal motto, *Cooperatores Veritatis* [Co-Workers of the Truth], a reference to 3 John 1.8, which linked his past life as a professor to his new ministry as a teacher-bishop, and which indicated how he thought about the bishop's and the Church's role in the late-modern world—the Church and her bishops ought to remind men and women that they are, indeed, capable of grasping the truth and being grasped by the Truth who is God.[49]

Less than a month later, on June 27, 1977, Archbishop Joseph Ratzinger was created a cardinal by Pope Paul VI, along with Giovanni Benelli of Florence, Bernardin Gantin of Benin, František Tomášek of Prague, and Luigi Ciappi, a curialist, in what was destined to be Paul's last consistory. Fourteen months after conferring his final red hats, Paul VI died. And Joseph Ratzinger, who had been a university professor in Regensburg a mere sixteen months before, was now called into conclave to help elect the successor of St. Peter.

Given the brevity of the first conclave of 1978, which elected Albino Luciani of Venice as John Paul I on the fourth ballot, it seems reasonable to assume that Cardinal Ratzinger was part of the Luciani coalition assembled by his cardinalatial classmate Giovanni Benelli. Luciani had gone out of his way to visit Ratzinger when the latter took his first vacation as a cardinal in Luciani's archdiocese in the summer of 1977; Ratzinger was touched and impressed by the courtesy to so junior a member of the College as he.[50] For the long-term future of the Catholic Church, however, the most important thing that happened to Joseph Ratzinger during the August conclave in 1978 was that he finally had a chance to talk seriously with Karol Wojtyła, the archbishop of Kraków.

Josef Pieper, the German philosopher whom Ratzinger had admired during his student days and who had become a friend, wrote Ratzinger after a 1974 philosophical congress in Italy, urging him to get in touch with Wojtyła, who had made a deep impression on Pieper. Ratzinger and Wojtyła began exchanging books; the Polish cardinal made use of Ratzinger's *Introduction to Christianity* in preparing the Lenten retreat he preached for Paul VI and the Curia in 1976, and they met briefly at the Synod of Bishops in 1977. The August 1978 conclave was, however, their first opportunity to speak at length. There was, Ratzinger later recalled, "this spontaneous sympathy between us, and we spoke . . . about what we should do, about the situation of the Church."[51]

When John Paul I died after a micro-pontificate of thirty-three days, Wojtyła and Ratzinger came once again to Rome to elect a pope—the German from Ecuador, where he had been on a pastoral visit. Ratzinger, like virtually everyone else in the electoral college, was stunned by Papa Luciani's sudden death:

For me it was a great shock, I have to say . . . we all hoped he could be, on the one hand, a pope of dialogue, very open for all people, with a pastoral capacity, and on the other hand, with a clear theological dimension. So it was really a shock when he died after one month, and for all of us, an examination of conscience: What is God's will for us at this moment? We were convinced that the election [of Luciani] was made in correspon-

dence with the will of God . . . and if one month after being elected in accordance with the will of God, he died, God had something to say to us . . . we had to reflect on what God's guidance was at this moment. I think the historical function of John Paul I was to open the door for a non-Italian pope, for a quite different decision.[52]

No one knows Joseph Ratzinger's position during the early phase of the October 1978 conclave, which eventually deadlocked between the two leading Italian candidates—Benelli, the pope-maker of August, and Cardinal Giuseppe Siri of Genoa, who had been thought *papabile* in three previous conclaves dating back to 1958. But when the shock of John Paul I's death and the Benelli/Siri deadlock "created the possibility of doing something new," as Ratzinger later put it, there can be little doubt that the archbishop of Munich and Freising was one of those enthusiastically supporting the previously unimaginable candidacy of the archbishop of Kraków.[53]

As Ratzinger recalled it, their friendship deepened in the first months of John Paul II's pontificate, and quickly led to a job offer:

He [John Paul II] often invited me to come to Rome for discussions and from the beginning of the pontificate there was a permanent relationship. When the apostolic palace was under restoration and he was [living] in the Torre Giovanni, I was with him. In 1979 he said, "We'll have to have you in Rome." And I said, "You'll have to give me some time, it's impossible now." His first intention was to make me prefect of the Congregation for Catholic Education but I said, "It's impossible after only two years to abandon Munich," so he named Cardinal [William] Baum [then the archbishop of Washington, D.C.] and that was a very good decision. But when a second prefecture was free, I could not resist this a second time.[54]

The "second prefecture" was, of course, the Congregation for the Doctrine of the Faith (CDF)—successor to the Holy Office and, as reporters never ceased to remind the public, an institution "formerly known as the Inquisition."

THE PREFECT

During his lengthy pontificate, Pope John Paul II was served by many outstanding churchmen, some of whom had very large personalities. None of them gave up more for John Paul II than Joseph Ratzinger, the man who couldn't say "No" twice—particularly when the second request to serve came after the attempt on John Paul's life in May 1981. Three times, Ratzinger tried to resign—in 1991, 1996, and 2001. Each time, John Paul asked him to stay, and he stayed. The man whom the crowds proclaimed "John Paul the Great" on April 8, 2005, simply could not imagine being pope without Joseph Ratzinger as his principal doctrinal advisor.

What did Ratzinger give up? To the eyes of the world (and to some of his critics), very little: he was one of the two or three most powerful men in the Catholic Church; he could travel the world; he was at the center of Vatican affairs, and not simply on matters involving his congregation. Ratzinger saw things differently. To leave Munich-Freising for Rome in 1981 meant abandoning any hope of writing his theological master work. As he put it to Peter Seewald, "For me, the cost was that I couldn't do full time what I had envisaged for myself, namely, really contributing my thinking and speaking to the great intellectual conversation of our time, by developing an opus of my own." Coming to CDF meant spending the bulk of his time on "the little and various things that pertain to factual conflicts and events." It also meant giving up the scholar-bishop's luxury of seizing intellectual opportunities; as Ratzinger put it, "I had to free myself from the idea that I absolutely have to write or read this or that." His primary responsibilities were at his desk on the second floor of the Palazzo Sant'Ufficio, the Palace of the Holy Office (as CDF's headquarters is still known).[55]

Ratzinger did not propose to give up his intellectual work entirely, a position with which John Paul II was naturally sympathetic. Having determined that previous prefects of the congregation had published theological works in their own names, the two men agreed that Ratzinger could do the same. And, in fact, his personal productivity during the CDF years was striking: some twenty books, largely composed of essays he had written during the CDF years, were published in English

while Joseph Ratzinger was prefect.[56] Add to that the volume of documents and studies CDF produced, plus the *Catechism of the Catholic Church* (for which Ratzinger had oversight responsibility), and the record is remarkable. Ratzinger never did get to write his theological magnum opus, and, now, never will. But there is no disputing the fact that he remained very much a partner in what he called "the great intellectual conversation of our time." That is why, in 1992, he was inducted into the Académie Française, founded by Cardinal Richelieu in 1635; Ratzinger took the seat previously held by the late Russian physicist and human rights activist Andrei Sakharov.

The Pope and the prefect

For those willing to look beyond caricatures and immediate controversies, Ratzinger's appointment as prefect of CDF disclosed several things about John Paul II's thinking on the state of Catholic theology and its importance in the Church. The first was that John Paul II took theology very seriously indeed. Rather than appointing an experienced Church bureaucrat to head the congregation, John Paul chose a man whom everyone, including his critics, regarded as a scholar of the first rank, one of the finest Catholic theological minds of the 20th century. The appointment also suggested that the Pope, far from wanting to drive theology back into the lecture hall, wanted it to engage the world—but in a distinctively *theological* way. Thus he chose Ratzinger, who had come to embody an updating of the Church based on a return to the sources of Catholic spiritual and intellectual vitality. And in the third place, the appointment underscored John Paul's commitment to a legitimate pluralism of methods in theology. Joseph Ratzinger was the first head of the Vatican's doctrinal office in centuries who did not take Thomas Aquinas as his theological lodestar. Both the Pope and his new prefect respected Thomas and Thomists. They also wanted a wide-ranging theological conversation to shape papal teaching.

By both men's accounts, they worked very well together. In addition to his weekly meeting with John Paul II on Friday evenings, where the two would review the work of CDF, Ratzinger was a regular part of John Paul's Tuesday lunches, which the Pope used as a sounding board

for his general audience addresses—the theology of the body, and the lengthy papal catecheses on the Trinity, the Church, and Mary, were first thrashed out around the dining-room table in the papal apartment, with Ratzinger an active part of the conversation. Their working lunches were also important in shaping major teaching documents, including the encyclical on moral theology, *Veritatis Splendor*, which Ratzinger once described as "the most theologically elaborated text of the pontificate."[57]

One aspect of Ratzinger's interaction with John Paul II bordered on the ironic: even as Ratzinger was the regular butt of animus from the self-styled "progressive" party in Catholic intellectual and leadership circles, those same critics (whose credulity was striking) also believed (and told the equally credulous press) that it was Ratzinger who was keeping the wild man John Paul II from acting on some of his more peculiar notions.[58] One notorious report had it that John Paul was prepared to declare that the Virgin Mary was present in the consecrated bread and wine of the Eucharist until Ratzinger talked him out of it. The "good Ratzinger" was also said to have prevented John Paul on several occasions from declaring this or that to be infallibly taught.

Ratzinger, who once laughed aloud at the "good Ratzinger/bad Ratzinger" characterization, had a different recollection of his discussions with John Paul II about how certain things should be done. It was widely reported, for example, that John Paul had wanted to invoke his papal authority to define infallibly the three principal teachings of the 1995 encyclical, *Evangelium Vitae* [The Gospel of Life]—that the direct and voluntary killing of the innocent, abortion, and euthanasia are always gravely immoral—and that Ratzinger somehow prevented this. The prefect denied that this is what had happened, and described the kind of consultations that had in fact taken place.

During the preliminary discussions leading up to the preparation of the encyclical, John Paul was "interested to have the suggestions of our congregation about what [was] possible," Ratzinger said. While *Evangelium Vitae* was being drafted, "the Holy Father was waiting for our response as to what was the [best] way to think about these problems; there was never an opposition, because the Holy Father wanted to be informed about the precise possibilities." Ratzinger understood that the Pope "wanted to give a very strong formulation" to the three teachings in question; the Pope "was always open to CDF's suggestions [about]

how this should be done." Through this process of consultation, it was decided that the best way to underscore the seriousness of what was being taught would be to footnote each declaration of grave immorality in *Evangelium Vitae* with a reference to paragraph 25 of *Lumen Gentium*, Vatican II's Dogmatic Constitution on the Church—where the Council had confirmed the infallibility of the "ordinary, universal magisterium" of the world's bishops in communion with the Bishop of Rome. The universality of the Church's teaching on these three questions, in other words, was the guarantee that these teachings were true, certain, and unchangeable. John Paul and Ratzinger had agreed that this was the way of formulating *Evangelium Vitae* that was "most corresponding to the tradition of the Church."[59]

The Pope's confidence in his prefect of CDF extended beyond a willingness to engage Ratzinger in conversation about numerous theological and doctrinal matters, including questions of the nature and exercise of John Paul's own papal authority. The Pope wanted Ratzinger involved in many other aspects of the Church's governance as well. Thus, at the time of John Paul II's death, Ratzinger was a member of five Vatican congregations (Oriental Churches, Divine Worship, Bishops, Evangelization of Peoples, and Catholic Education), one pontifical council (Christian Unity), and two pontifical commissions (for Latin America and for the reconciliation of the Lefebvrist schismatics); he was also a member of the advisory council of the Second Section of the Secretariat of State—the Vatican "foreign ministry."[60] In addition to ensuring, by these appointments, that Ratzinger's would be a regular presence in the most important deliberations of the most crucial offices in the Vatican, John Paul II honored his prefect as opportunities to do so became available, naming him to the highest rank of cardinal, "cardinal bishop," in 1993, and giving him the most important title a cardinal can receive—titular bishop of Ostia—in 2002, after his fellow cardinal bishops elected Ratzinger as dean of the College of Cardinals.

The lightning rod

The standard trope about the Congregation for the Doctrine of the Faith—"formerly known as the Inquisition"—tends to obscure the fact that, in the 1988 apostolic constitution, *Pastor Bonus* [The Good Shep-

herd], CDF was charged with the positive task of promoting theology in the Church as well as safeguarding the purity of Catholic doctrine. During Joseph Ratzinger's tenure as prefect of CDF, the congregation met that responsibility of promoting the development of theology through a number of important documents, preeminent among which was the 1990 *Instruction on the Ecclesial Vocation of the Theologian.*

Theology, the *Instruction* insists, is "something indispensable for the Church," and is "all the more important" in "times of great spiritual and cultural change." Theology has its own proper task—"to understand the meaning of revelation"—and so theology begins with revelation and is always accountable to revelation. At the same time, philosophy, history, and the other human sciences are crucial dialogue partners for theology. Theology must therefore be in conversation with culture: the theologian's task "is . . . to draw from the surrounding culture those elements which allow him better to illumine one or other aspect of the mysteries of faith." That is not an easy business and, as the instruction puts it, it is "an arduous task that has its risks." But the dialogue with culture "is legitimate in itself and should be encouraged."

Theology is also a distinctive intellectual enterprise in another way, the *Instruction* proposes. Doing theology as the Church understands it requires the theologian to "deepen his own life of faith" and make prayer an integral part of his or her work. Theology is not only done at one's desk, or in the library; theology is also done on one's knees, or in the chapel.

For all its intellectual importance, however, theology is an ecclesial discipline, according to the *Instruction*: if theology is theology and not religious studies, it has a necessary connection to the Church. And it is the Church's pastors, not the Church's intellectuals, who are ultimately responsible for maintaining the integrity of Catholic faith. The Church's teaching authority, or magisterium, lives in a collaborative relationship with the Church's theologians. But the bottom line, doctrinally, is defined by the magisterium of the Church's bishops in union with the Bishop of Rome. This relationship requires a communion of faith and charity between bishops and theologians. If serious problems occur, a theologian has not simply the right, but the responsibility, to make known to the authorities of the Church what he or she understands to be the difficulties of the teaching in question; theologians, if

they are acting in good faith and with charity, should not mount media campaigns to bring pressure to bear on the Church's pastors. The *Instruction* also reminds theologians that every doctrine of the Church is not somehow up for grabs unless it is infallibly defined; that the conversation between theology and the Church's teaching authority cannot be modeled on political protest; and that the truth of faith is not measured by opinion polls.[61]

In a cultural climate in which theologians are frequently tempted to think of their primary audience as the academy, the *Instruction* reminds theology that it exists in and for the Church—for strengthening the faith of the people who are the Church and for making the Church's proclamation of the Gospel more credible in the world. In that important sense, Cardinal Ratzinger was calling theology to a genuine reform—to look beyond its own academic bastions to a wider world of conversation, and to cultures in need of conversion. Thus, the *Instruction on the Ecclesial Vocation of the Theologian* reflected Ratzinger's long-held conviction that updating the Church—*aggiornamento*—must always be grounded in an intellectual and spiritual deepening of the theologian's appreciation for the riches of the Catholic tradition—*ressourcement*. The greatness of John Paul II's thinking, Ratzinger once observed, was that it began from the understanding "that Christianity is not an Idealism, outside of concrete historical reality," but rather a matter of "creating community, creating solidarity." Theology, like the rest of the Church, should learn from John Paul "the very different but very real power of truth in history."[62] The power of theology did not lie in its capacity to shape internal Church politics; the power of theology lay in its capacity, through the Church, to change history, to humanize the world. That was the kind of theology Joseph Ratzinger tried to promote through his work as prefect of CDF.

Yet there is, necessarily, the other side of CDF's work: its role as guardian of doctrinal integrity. That role, also spelled out in *Pastor Bonus*, made it inevitable that, under an energetic prefect like Ratzinger, CDF would become the last curial stop for many of the hot-button issues in the Church, including reviewing the work of theologians who may have strayed beyond the boundaries of orthodoxy, and disciplining them as necessary. That CDF could exercise this role, as a matter of last resort, was part of its canonical mandate; that it became the court

of last resort was, on several occasions, due in part to the pusillanimous behavior of local bishops or religious superiors, unwilling to weather the controversy and take the criticism that inevitably follows when the Church disciplines anyone.[63]

CDF's role, and the perception of its role, were also influenced by something new in post–Vatican II Catholic life: a phenomenon that might be called "virtual schism." Shortly after the Second Vatican Council, the English Catholic priest and theologian Charles Davis, editor of the British publication *Clergy Review*, left the Catholic Church, claiming that Pope Paul VI had been "dishonest" in describing the Catholic debate on contraception prior to the encyclical *Humanae Vitae*.[64] It was an honorable move on Davis's part, given his deep disagreement with the teaching authority of the Church; it also cost him his media audience. For while Charles Davis, dissident Catholic priest and theologian, was an interesting story (of the "man bites dog" sort), Charles Davis, non-Catholic theologian criticizing Rome ("dog bites man"), was not. Charles Davis's disappearance from the media radar screen after his abandonment of the Catholic Church was a lesson not lost on Catholic theologians of similar views. To stay in play, a theologian had to remain, formally, in communion with the Church, even if he or she was, de facto, in a kind of personal, intellectual, or psychological state of schism.[65] There were, of course, many other reasons, including deep conviction, why Catholic theologians who believed the Church was simply wrong about certain matters decided not to leave, but to stay and fight. It would be a mistake, however, to think that this new phenomenon of virtual schism, shaped as it was by the lessons learned from the Charles Davis affair, did not significantly shape the complex situation that CDF faced under Joseph Ratzinger's leadership.

Inevitably, Ratzinger and CDF became the lightning rod for charges that John Paul II was running an "authoritarian" Church and "crushing dissent." The fact that, by the end of John Paul's pontificate, his critics, including prominent theological dissenters, remained in firm control of many theological faculties throughout the world suggested, to those willing to look, that if this was authoritarianism, it was authoritarianism of a most inefficient sort. (So did the fact that, throughout the pontificate, stores within fifty yards of St. Peter's Square and one hundred yards of the "repressive" CDF were full of books and magazines by

prominent dissidents, dissenting from, indeed attacking, the magis-
terium of John Paul II.) But perhaps a brief review of some of the cru-
cial cases Ratzinger faced as prefect of CDF will suggest an alternative
view—that John Paul's was not an authoritarian pontificate at all, but
rather a pontificate determined to defend authoritative Catholic teach-
ing, in the firm conviction that that was important for both the Church
and the world.

The Boff Case. Leonardo Boff, a Brazilian Franciscan, had written his
doctoral dissertation in Germany in the late 1960s with Professor Joseph
Ratzinger as one of his readers. In his 1981 book, *Church: Charism and
Power*, Boff applied an analytic method inspired by Marxism to the na-
ture and structure of the Catholic Church, concluding that the ordained
hierarchy of bishops and priests was a "sinful social structure" of which
the Church should rid itself. As the Church's view was that its ordained
hierarchy was of the will of Christ and an integral part of Christ's con-
stitution of the Church, it was manifestly clear that Leonardo Boff did
not believe, and would not teach, what the Catholic Church believed to
be true about itself. Thus CDF issued a "notification" on Boff's book in
1985, stating the obvious—*Church: Charism and Power* was doctrinally de-
ficient. The prefect of the Congregation for Religious, Cardinal Jerome
Hamer, O.P., insisted that Boff maintain a year of silence on the subjects
CDF had found wanting in his book, presumably so that he might ex-
amine the questions at issue more deeply, and away from the media
spotlight; Cardinal Ratzinger finally agreed to this, but the original idea
was not his.[66] In any event, the Brazilian bishops, the Franciscans, and
members of other religious orders were upset at what journalists, un-
derstandably if luridly, described as the "silencing" of Leonardo Boff.
And it was Ratzinger, not Hamer, who was the object of most of the
criticism—despite the fact that Ratzinger retained a genuine affection
for his former student. Boff, for his part, eventually left the Church and
disappeared from global media attention, re-emerging briefly during the
interregnum after the death of John Paul II and after the election of one
of his "doctor-fathers" as pope.[67]

The Curran Case. Father Charles Curran, a Rochester native, had been
the chief symbol of Catholic theological dissent in the United States

since the days when the thirty-four-year-old junior professor at the Catholic University of America had helped accelerate a continuing controversy about the Church's teaching authority by his public dissent from Paul VI's 1968 teaching in the encyclical *Humanae Vitae* on the morally appropriate means of family planning. In the intervening decade and a half, Father Curran had published articles and books questioning virtually every aspect of the Church's sexual ethic; during that same period, he became a tenured faculty member of a Church-chartered institution. Something had to give.

The CDF process in the Curran case began with a document sent by the congregation to the priest; these "Observations" detailed the points at which Curran said, in effect, that the Catholic Church was teaching falsely, or at the very least non-authoritatively, about certain matters. After an exchange of letters, Curran declined to bring his teaching and writing into conformity with the settled teaching of the Church. CDF notified him again that the anomalous situation of a priest-theologian at a Catholic institution of higher education insisting that the Church's teaching was neither true nor binding could not be continued. After an "informal" CDF discussion with Curran in Rome, the theologian sent a final written response to the original "Observations," in which he stated plainly that he would not bring his teaching and writing into conformity with the teaching of the Church; he also proposed a compromise in which he would retain his tenure and continue to teach moral theology at Catholic University, but not sexual ethics. This was not acceptable, and in a letter dated July 25, 1986, Cardinal Ratzinger informed Cardinal James Hickey of Washington, chancellor of Catholic University, that Father Curran "was no longer . . . considered suitable [or] eligible to exercise the function of a Professor of Catholic Theology." Curran was suspended from the CUA faculty in January 1987 and sued the university for breach of contract in February. After negotiations failed to produce an out-of-court settlement, the case went to trial and Curran lost, on February 28, 1989. He then accepted a chair at Southern Methodist University in Dallas.

In assessing this case, it is important to note what didn't happen to Charles Curran: he wasn't suspended from the priesthood; he wasn't forbidden to publish; he wasn't barred from making public appearances or lecturing. In his response to CDF's observations (as in twenty-plus

years of writing), Father Curran had made two things abundantly clear: that he didn't believe to be true what the Catholic Church taught was true, and that he didn't intend to teach what the Catholic Church taught on tangled issues of sexual morality. Under the circumstances, it did not seem unreasonable for CDF and Cardinal Ratzinger (and John Paul II, who approved Ratzinger's letter to Cardinal Hickey) to conclude that Father Charles Curran should not hold the position of professor of Catholic theology at a pontifically chartered school like the Catholic University of America, or any other institution publicly identified as "Catholic."

Curran frequently said that his was "responsible" dissent, because it did not contradict Catholic teaching that had been infallibly defined. That was not the Second Vatican Council's understanding of what constituted authoritative teaching, however. As the *Instruction on the Ecclesial Vocation of the Theologian* would remind theologians a few years later, the Council had clearly taught that the Church doesn't live by infallible definitions alone. Articulated by the ordinary, universal magisterium of the Church's pastors, the authoritative tradition of the Church was binding on both the man and woman in the pews and on theologians; theologians did not constitute a parallel magisterium. It simply is not the case that Catholic teaching is either infallibly defined or, for all intents and purposes, non-existent. What the Curran case helped clarify was that Vatican II, John Paul II, and Cardinal Ratzinger all had a much more richly textured understanding of "Catholic teaching" than Father Curran and others of his cast of mind.

One other aspect of the Curran case touched the future of the Church, not just its immediate and contentious recent history. Charles Curran was, and is, a priest of genuine pastoral decency, who seems to have been convinced that lowering the Church's moral expectations by altering its moral teaching was the pastorally appropriate response to the difficulties in living lives of sexual integrity that most human beings had experienced since Adam and Eve. John Paul II had a different view, shaped by his own extensive pastoral experience; to define sin down was to take the dramatic tension out of life and to deny men and women the opportunity for moral heroism. That, to John Paul, was the truer pastoral sensitivity: to help human beings, troubled and prone to failure, to struggle toward the moral heroism of which, with God's

grace, they were capable. And that was the view John Paul II explored and defended in his theology of the body, which, perhaps ironically, he was bringing to a conclusion just as the Curran case was coming to a head.

The Instructions on Liberation Theology. In the wake of the collapse of communism as a world-shaping force in the Revolution of 1989 and the implosion of the Soviet Union in 1991, it may seem only of antiquarian interest to revisit CDF's two instructions on liberation theology—the effort to use Marxist analytical categories to rethink the Church's faith and practice. Yet these two CDF instructions, in which Cardinal Ratzinger played a large role, ought to be understood as part of John Paul II's effort to develop Christian humanism as the Church's proposal to the world, in light of the crisis of world civilization at the end of the 20th century and the beginning of the 21st. Marxism was, after all, more than a political project: it was a way of thinking about the human person, human communities, and human destiny. If it was a political and economic failure, which it manifestly was, the roots of that failure lay in its misunderstanding of the human. Yet by adopting, and then adapting, the biblical theme of liberation, Marxism—and the theologies of liberation—spoke to a deeply entrenched cultural memory in the western mind.

The tangled history of the various theologies of liberation (which was a pluralistic movement, with different tendencies and emphases) are of less interest today than what CDF had to say in response to these theologies, which had had a great impact on Latin America in particular. John Paul II had addressed the question of liberation theology in his meeting with the bishops of Latin America in January 1979, underscoring that liberation was an important part of the Church's message to the world. The two CDF instructions were meant to spell out precisely what that meant.

The first, the *Instruction on Certain Aspects of the Theology of Liberation*, was issued in 1984 and was the more critical of the two in character, in the sense of directly challenging core tenets of the theologies of liberation. It cautioned against reducing the biblical theme of liberation and the image of the Exodus to narrow political categories. Sin, according to the instruction, should not be located primarily in political, social, and economic structures (although those were certainly marked by human selfishness), but rather in the human heart: sin is

the product of human estrangement from God, which inevitably distorts the human. Class struggle, a preeminent Marxist category for analyzing history, is an inappropriate Christian way to think about the dynamics of history; further, using class struggle models to justify revolutionary violence was not an appropriate development of Catholic social doctrine. The instruction's cautions were well summarized toward the end of the document: the Church must not contribute to "the politicization of existence which, misunderstanding the meaning of the Kingdom of God and the transcendence of the person, begins to sacralize politics and betray the religion of the people in favor of the projects of the revolution."[68] The Church has a greater freedom to proclaim and advance—the freedom of the sons and daughters of God, who could live that freedom in any political circumstance.

What genuine Christian freedom means was the topic of the second CDF document, the *Instruction on Christian Freedom and Liberation*, issued in 1986. The deepest meaning of human liberation, it taught, was to be found in redemption, since by being redeemed, men and women were "freed from the most radical evil, namely, sin and the power of death." The true meaning of human freedom and liberation was to be found in our communion with God. That was why Marxist analysis and communist politics had to be resisted: they trampled on the radical freedom of the human person before the mystery of God, "who wishes to be adored by people who are free." Christian freedom found its historical expression in Christian solidarity with others and in work for the freedom of others; this was not the work of a partisan Church, but the work of a community that understood itself as the bride of Christ and the sacrament of the world's salvation.[69]

The two CDF instructions on liberation theology are not period pieces, perhaps of interest to those probing the tensions within the Catholic Church in the 1970s and 1980s, but of little long-term consequence. By clarifying the nature of true human liberation and the Church's distinctive role in the transformation of the world, the two instructions helped define a Catholic approach to the struggle for freedom that is sure to continue in the 21st century and far beyond. At the same time, they were a defense of the authentic meaning of the Church in the modern world, and thus another moment in the ongoing interpretation of the Second Vatican Council.[70]

Dominus Iesus *and the Case of Jacques Dupuis*. In September 2000, CDF issued a doctrinal declaration, *Dominus Iesus* [The Lord Jesus], which ignited a global controversy. As one U.S. newspaper put it, in headlines atop a photo of John Paul II with arms outstretched, "We're Number One!" A more sober, but no less inaccurate, headline read, "Vatican Declares Catholicism Sole Path to Salvation." It had done nothing of the sort; but perhaps the headline writer might be forgiven for reflecting the misunderstandings endemic in a culture where more than a few people are unsure whether anything is "true."

Dominus Iesus taught precisely what the Catholic Church had taught for centuries and had re-affirmed at the Second Vatican Council: namely, the Church's faith that Jesus Christ is what and who he said he was—"the way, the truth, and the life" [John 14.6]. He is not, as Father Richard John Neuhaus put it, "one way among other ways or one truth among other truths" amid a host of spiritual options.[71] *Dominus Iesus* also reiterated the implications of that basic, irreducible Christian confession that "Jesus is Lord." If there is one God who reveals himself in history, and if that history has come to a decisive point in Jesus of Nazareth, then there is only one story of salvation, one salvation history—and that history is centered on Christ.

It is also true, *Dominus Iesus* affirms, that God gives everyone the grace necessary to be saved, including men and women who have never heard of "Jesus Christ." Yet the salvation of those men and women, like the salvation of everyone else, has been made possible by what God did for the world and for humanity in Jesus Christ. The Catholic Church does not regard itself as "the sole path to salvation," if by that is meant that there is no salvation for anyone who is not a formal member of the Catholic Church—that has never been Catholic teaching. The Catholic Church does understand itself to be the most complete and rightly ordered expression of the will of Christ for the one Church that is his body in the world, so that everyone who is saved is, in some fashion or other (which the Church does not claim to understand fully), related to the Catholic Church and its mediation of God's saving grace in the world.

It would be tempting to say "What do you expect the Catholic Church to say about itself—that it's another brand-name product in the supermarket of spiritualities?" and leave the matter at that. That would

be a mistake, however, for the Church's defenders and critics alike. The *Dominus Iesus* controversy, and the related controversy over CDF's critique of the work of the Jesuit theologian Jacques Dupuis, touched some of the most important questions for the Catholic Church—and indeed for all Christian communities—in the 21st century.

As Christianity has become an ever more global phenomenon, the question of how the Church thinks about other world religions—and especially the religions of Asia—has become an urgent one for Catholics. How do these ancient, culture-forming religious traditions, some of whose roots go deep into the subsoil of human history, fit into the Church's understanding of the unique saving role of Jesus Christ in history? Is the Holy Spirit active in these religious traditions, and if so, how? Is the Church to regard these traditions as "pagan," or does the Church find hints and traces of God's hand at work in their doctrines, moral systems, and practices? When the Catholic Church engages Hindus or Buddhists or African animists, is it appropriate to think of adherents to these traditions as people whom the Church should call to conversion—or should they be regarded as people with whom Catholics are to be in an open-ended dialogue, on the principle that no one has a monopoly on religious truth?

These questions are of somewhat less urgency in Africa, where the extraordinary expansion of Christianity suggests that many Africans find the Gospel a liberation from traditional religions and the superstitions they foster. Asia, by contrast, is the continent that has seen the greatest failure of Christian mission in two millennia. Here, of course, the two great questions are China and India: almost one-third of humanity, perhaps 2 percent Christian, perhaps 1 percent Catholic. There are two dominant Asian issues, however.

China could be the greatest field of Christian mission in the 21st century, if it finally opens itself up to the world in the aftermath of a communist crack-up. Chinese communism has destroyed a great deal of traditional Chinese culture; the remains of Confucian ethics embedded in contemporary Chinese society and culture have interesting parallels with biblical ethics. So, it is not difficult to imagine China opening itself enthusiastically to Christianity, in order to fill the spiritual void deliberately created and ruthlessly enforced by Mao Zedong and his successors.

India is different. India, which may soon rival China as the preeminent Asian power, is a complex religious and spiritual tapestry thickly woven, even today, with Hindu (and some Buddhist) ideas. A militant form of Hinduism is now a major political force in India. How should the Catholic Church relate to this intensely religious culture? There, in a sentence, is one of the most urgent questions for the Church in the 21st century.

Jacques Dupuis, S.J., a native of Belgium, taught in India from 1958 until 1984. During that time, he became an immensely influential figure among those seeking to "inculturate" Christianity in Asia, and particularly in India. Here, the central question was the age-old one raised by Christ on the road to Caesarea Philippi: "Who do men say that the Son of Man is?" [Matthew 16.13]. Is Jesus the savior of all men and women, or the savior "for Christians"? Or, if Jesus is, as the Church had taught for two millennia, the unique savior of the world, how is his uniqueness to be understood in relation to other great world religious figures? Is there something in God's revelation in Jesus Christ that could be said to be completed by the Church's encounter with other world religions? That there were so many religious traditions in the world must mean *something* about God's dispensation of history: Could other world religions be fit into a Catholic understanding of salvation history such that they, too, became instruments or means of salvation, if of a different sort? Might the sacred texts of other world religions be regarded as revelatory, as the Church understood the Hebrew Bible as revelatory? The questions are, obviously, both complex and urgent, particularly in a shrinking world where religious convictions and passions shape history for good and for ill.

Jacques Dupuis's fame in wrestling with these and related issues was not largely a media creation, as the fame of some other theologians who had come under CDF scrutiny had been. Throughout the Church, even among his critics, he was regarded as a serious scholar who was probing the boundaries of orthodoxy while intending to stay inside those boundaries. As with other subtle and sophisticated thinkers and teachers, Dupuis was vulnerable to having his thought oversimplified and misapplied by less accomplished students, or by Catholic activists. Yet there were serious questions, even among Dupuis's admirers, about whether his theology worked, in the sense of both providing an ortho-

dox Christian account of the place of Christ in salvation history and understanding the role of other world religions in God's salvific work in the world. Thus, CDF decided to undertake a major examination of Dupuis's chief work, *Toward a Christian Theology of Religious Pluralism.*[72] Dupuis was then asked to respond to a series of questions about his work, which he did. Dupuis was also in conversation with the congregation and its consultors.

In a "notification" on Dupuis's book, signed by Cardinal Ratzinger on January 24, 2001, CDF recognized that Jacques Dupuis had tried "to remain within the limits of orthodoxy in his study of questions hitherto largely unexplored." The congregation also welcomed the fact that Dupuis had not obfuscated the gravity of the issues involved; in his book, the Belgian Jesuit did not "conceal the possibility" that his approach to "the meaning of the plurality of religions in God's plan for humanity" might "raise as many questions as it seeks to answer"—a polite if oblique Roman way of saying that these were indeed important and very difficult questions and that the author was courageous in taking them up. Nonetheless, according to the notification, Dupuis's book "contained notable ambiguities and difficulties on important doctrinal points," including the uniqueness of Christ as savior, the completeness of God's revelation in Christ, the saving work of the Holy Spirit throughout the world, and the meaning for salvation of other world religions. Jacques Dupuis accepted the notification, signed it, and thus committed himself, in his future theological work, to uphold the doctrinal truths that the notification wished to underscore. The notification was not, the document stated, "a judgment on the author's subjective thought"; rather, in listing certain truths about the unique salvific role of Christ and the role of the Church in mediating God's salvation to the world, it sought to identify the baseline from which future theological speculation on the Church's theological understanding of other world religions could proceed.[73]

At a press conference, Father Dupuis said that he accepted the points raised in the doctrinal portion of the notification. but insisted that CDF had misunderstood his proposals in *Toward a Christian Theology of Religious Pluralism.* He resigned his position at the Pontifical Gregorian University, where he had taught since his return from India in 1984, although he remained a consultor to the Pontifical Council for Interreli-

gious Dialogue and the editor of the theological journal *Gregorianum*. Jacques Dupuis died in 2004, at age eighty-one.

Dominus Iesus and the Dupuis case belong together in any account of Joseph Ratzinger's stewardship of CDF. Although it drew fire from some Christian ecumenical circles at its release in 2000, *Dominus Iesus* was not really about the Catholic Church's situation and self-understanding in Europe and North America. *Dominus Iesus* was, primarily, about India. By re-stating the Church's classic and unalterable faith in the unique, saving mission and person of Jesus Christ, *Dominus Iesus* was a response to what Jacques Dupuis insisted were "misunderstandings" of his thought and work—misunderstandings which were, however, deeply influential throughout Asian Catholic theological circles and among some Asian bishops, and which were buttressing a new religious relativism that downplayed the need for evangelization. At the same time, *Dominus Iesus*, and the doctrinal points in the CDF notification on Dupuis's book, clarified the boundaries within which Catholic theology could continue to explore some urgent questions for the 21st-century life of the Church—which ought to be an impetus toward such explorations, as well as toward the Church's evangelical mission in Asia.

Vatican II revisited

While these four cases represent some of the most memorable examples of the issues with which Joseph Ratzinger had to deal as prefect of CDF, they by no means exhaust the inventory of the congregation's work under his leadership. CDF took up other core issues in Catholic theology (for example, in examining the Christology of an influential Dominican theologian, Edward Schillebeeckx). It wrote letters to the bishops of the world on a variety of issues: the pastoral care of homosexual persons; the Church's understanding of itself as a "communion"; various questions raised by Catholic involvement in politics. In the 1987 instruction *Donum Vitae* [The Gift of Life], the congregation and Cardinal Ratzinger anticipated many of the most urgent questions that would be raised by the biotechnology revolution of the 21st century. In 2002, the congregation issued documents relating to the Marian apparitions in Fatima, including the so-called Third Secret. After the cri-

sis of sexual abuse and episcopal leadership failure in the United States exploded into the public eye, CDF's role as the court for determining whether men should be removed from the ministry expanded, as did Ratzinger's role in reviewing such cases. The list could be extended.[74]

In all this work, the congregation was supporting John Paul II's efforts to advance an authentic interpretation of the Second Vatican Council—the Council without keys. Cardinal Ratzinger played a central role in another moment in that project, the Extraordinary Synod of Bishops summoned by John Paul in 1985 to mark the twentieth anniversary of the Council's conclusion and to reflect on what the Council had, and hadn't, accomplished in its mission of igniting a new Pentecost in the life of the Catholic Church. Ratzinger's concerns about misunderstandings of the Council and the effects of those misunderstandings on Catholic theology and Catholic practice were brought to a fine point of concision in a book-length conversation with the Italian journalist Vittorio Messori, which was published in various languages just before the Synod met. Titled in English *The Ratzinger Report: An Exclusive Interview on the State of the Church*, the book created an international sensation—perhaps better, an international storm—to the point where Cardinal Godfried Danneels of Belgium felt compelled to say, at a press conference during the Synod, "This is not a synod about a book, it's a synod about the Council!"[75] From which it may be fairly concluded that *The Ratzinger Report* did set the context, or at least the informal agenda, for the Extraordinary Synod of 1985.

Joseph Ratzinger's critiques of the unbalancing of Vatican II were well known to anyone familiar with the *Concilium/Communio* split and what it represented. In *The Ratzinger Report*, however, and perhaps looking to sharpen questions to the point where they were unavoidable, he put matters bluntly indeed, saying at one juncture that "it is incontestable that the last ten years [i.e., 1975–85] have been decidedly unfavorable for the Catholic Church." As Paul VI had suggested, Catholic self-criticism had veered into Catholic self-destruction. Where was the joy that was supposed to be the hallmark of Christians?

The bill of particulars was specified further. The Church had lost a sense of the Cross as the center of human history, in part because of the decadence of the West, in which the idea of redemptive suffering found little resonance. Theological dissent was celebrated as a heroic

challenge of the conventions rather than understood for what it often was: a drastic concession to the spirit of the age. The Church's concept of herself had also been distorted, to the point where many seemed to think of the Church as a party or a club rather than as a distinctive community of faith and charity formed by the sacraments. Bishops and priests imagined themselves as coordinators of a consensus rather than as icons of the eternal priesthood of Christ, called to lead, shepherd, and, if necessary, challenge Christ's people. One result of this degradation of the ordained ministry could be seen in the severe decline in the practice of the sacrament of penance, or confession, which had too often devolved into another form of therapy. Another degradation was bureaucratic: bishops had let their proper episcopal authority drain away to local Catholic bureaucracies and national bishops' conferences. Bishops defaulting on the responsibilities that only they could meet affected the entire Church. Catholicism, Ratzinger insisted, was not a "federation of national churches." Rather, it was a universal communion, always balanced between community and person, in which the local bishop was the crucial link between the people of the Church and the universal communion of the Church. As ever, the Church needed saints more than it needed bureaucrats and functionaries; and, somehow, in Ratzinger's view, the Church wasn't fostering sanctity as it should.

All of this—not to mention Ratzinger's trenchant criticisms of theology and biblical studies in what everyone in Rome was calling *Il Rapporto*—did nothing to modify the German cardinal's already-established media reputation as a dour pessimist, out of sync with the modern world: a man yearning and pining for the secure Catholicism of his Bavarian boyhood. Ratzinger met the charge head-on in the *Report*: "If we look closely at the most recent secular culture, we see how the easy, naive optimism is turning into its opposite—radical pessimism and despairing nihilism. So it may be that the Christians who up to now were accused of being pessimists must help their brothers to escape from this despair by putting before them the radical optimism which does not deceive—whose name is Jesus Christ."[76]

From a distance of twenty years, it is perhaps difficult to understand just why *Il Rapporto* had the impact it did. It is, in some ways, an unattractive book, the list of failures piling so high that it can be diffi-

cult to see a path beyond them. Yet, in its time, the *Report* served a crucial purpose. It was a form of shock therapy, needed by bishops who, for twenty years, had imagined that there were no issues in Catholic life that couldn't be staffed-out and compromised. By insisting that some questions in the Church were beyond compromise because they involved the very constitution of the Church as willed by Christ, Ratzinger gave permission for the Synod fathers to discuss publicly two matters that had been only bruited privately before: the misinterpretation of the Council, and the drift toward turning Catholicism into a form of liberal Protestantism, which was the direction in which at least some of those misinterpretations led. Cardinal Ratzinger may well have bought himself two decades of further caricature by quite effectively masking the gentler, pastoral dimension of his personality and putting things as bluntly as he did in *Il Rapporto*. In doing so, however, he did something that was useful, even indispensable, for the Synod's deliberations: he put the crucial questions on the table, where no one could ignore them or wish them away.

The Synod's *Final Report* forthrightly affirmed Vatican II as "a grace of God and a gift of the Holy Spirit" while acknowledging that "partial and selective readings" of its documents had led to a 'superficial interpretation" of the Council's teaching. The Catholic Church hadn't begun with Vatican II; to draw from the Council's texts the fullness of the riches they contained, it was necessary to read the Council in light of two millennia of Christian tradition. The past twenty years had seen too much time wasted in internal ecclesiastical power struggles and too little time invested in evangelism. The problems of the Council's reception weren't entirely internal, however; the modern world had shown itself, in some respects, tone-deaf to the Church's appeal for a genuine dialogue. Such close-minded secularism, the *Final Report* forthrightly asserted, was an expression of the "mystery of iniquity" at work in the late 20th century. Thus, a Church preaching Christ crucified should expect friction in its encounter with modernity and whatever was coming after modernity. As always, the Church's greatest need was for saints, and the Synod vigorously re-affirmed Vatican II's teaching on the "universal call to holiness" as every Catholic's baptismal vocation.[77]

The Extraordinary Synod of 1985 did not end the divisions in the Church that had been a hallmark of the post–Vatican II period, nor did

it solve the problem of the bureaucratization of the Church; sixteen years after the Synod, Cardinal Ratzinger would describe the thick organizational grid of Catholicism in Germany as "a task force for old ideas."[78] It did, however, mark the end of a period in which certain skewed interpretations of the Council and its alleged "spirit" held the upper hand in the debate. The *Concilium* tendency, to take a symbolic reference point, was now the party of the status quo; as Father Francis X. Murphy, the liberal who had invented the liberal/conservative taxonomy for parsing contemporary Catholicism, put it during the 1985 Synod, "Why does there have to be a change? What's wrong with the way things have been going?"

The *Communio* tendency, to take the other symbolic reference point, was now the party of intellectual and spiritual energy. Perhaps even more significantly, the Synod, in part because of Ratzinger's *Report*, had begun to wrestle with the iron law of the Christian encounter with modernity: Christian communities that maintain a clear sense of their doctrinal and moral identity and boundaries prosper; Christian communities whose doctrinal and moral boundaries become porous wither and atrophy. The dialogue between the Church and the modern world had to be conducted along a two-way street—if the Church was to be true to itself, and if it was to offer the modern world an alternative to the stifling secularism that dominated high culture in the West.

Cardinal Ratzinger's role in the Extraordinary Synod of 1985 did not end when the Synod fathers dispersed. One of the Synod's recommendations was that the Holy See prepare a new universal catechism for the Church. The oversight responsibility for this massive project was given to Cardinal Ratzinger, as chairman of a commission of twelve cardinals and bishops. Ratzinger secured the services of his former student, Father Christoph Schönborn, O.P., as secretary of an editorial committee of seven diocesan bishops, who did the actual drafting with Schönborn editing and synthesizing the drafts into a coherent whole. Bishop James Malone of Youngstown, Ohio, then the president of the U.S. bishops' conference and a man distinctly unenthusiastic about the idea of a new catechism, nevertheless told a reporter not to worry about it, because "you won't live long enough to see it completed."[79] Bishop Malone was mistaken. After going through nine drafts, the *Catechism of the Catholic Church* was promulgated by Pope John Paul II with

the apostolic constitution *Fidei Depositum* [The Deposit of Faith], which the Pope signed on October 11, 1992—the thirtieth anniversary of the opening of the Second Vatican Council.

GOD'S DONKEY

Were one to choose a single connecting thread that ties together the half-century of Joseph Ratzinger's work as a theologian—the single theme that links his work in the academy and his work at the Congregation for the Doctrine of the Faith—one might well focus on Ratzinger's consistent emphasis on the uniqueness of the person and mission of Jesus Christ. For Cardinal Ratzinger, this is a claim with immense *human* consequences: as he put it once in an interview, "If Jesus is not the Son of God, then God really is at a great distance from us . . . If we see this Christ crucified for us, then we have a much more precise idea of God, who he is and what he does."[30] Without the revelation that finds its fulfillment in Jesus Christ, the path to the encounter with God is very difficult; without encountering God, men and women cannot encounter the depths of their humanity, where God's imprint may be found. Ratzinger's insistence that the Church re-center itself on Christ was a profoundly humanistic concern.

In the last decade of his service at CDF, Joseph Ratzinger let the world see both the range of his mind and the goodness of his heart in two book-length interviews with the German journalist Peter Seewald—who came back to an active practice of Catholic faith in the process. Here, Ratzinger's capacity to explain the most complex matters of doctrine in accessible, engaging terms was brilliantly displayed. So was the pastoral side of the man who had been regularly caricatured as the *Panzerkardinal*. Asked once by Seewald, "How many ways are there to God?" Ratzinger replied, "As many as there are people. For even within the same faith, each man's way is an entirely personal one."[81] When Seewald asked about the perception that Christianity is "sad and hard," Ratzinger replied that "faith gives joy. When God is not there, the world becomes desolate, and everything becomes boring, and everything is completely unsatisfactory. It's easy to see today how a

world empty of God . . . has . . . become a wholly joyless world. The great joy comes from the fact that there is a great love, and that is the essential message of faith. You are unswervingly loved."[82] And within that love, there is, Ratzinger insists, a "great sense of humor. Sometimes [God] gives you something like a nudge and says, Don't take yourself so seriously! Humor is in fact an essential element in the mirth of creation . . ."[83] (As if to illustrate the point, Seewald and Ratzinger engaged in some banter about organ donation. Seewald asked, "Can it be that you are an organ donor?" Ratzinger replied: "Yes, even though I assume that my old organs will not see much further use." Seewald: "An exciting prospect: an African Moslem in Paris with the heart of Cardinal Ratzinger . . ." Ratzinger: "It could happen.")[84]

Seewald also drew out of Ratzinger an intriguing speculation about the European, and perhaps First World, Catholicism of the future:

> The traditional Church can be very lovely, but this is not something necessary. The Church of the first three centuries was a small Church and nevertheless was not a sectarian community. On the contrary, she was not partitioned off; rather, she saw herself as responsible for the poor, for the sick, for everyone. All those who sought a faith in one God, who sought a promise, found their place in her.
>
> . . . The catechumenate of the early Church was very similar. Here people who didn't feel able to identify with Christianity completely could, as it were, attach themselves to the Church, so as to see whether they would take the step of joining her. This consciousness of not being a closed club, but of always being open to everyone and everything, is an inseparable part of the Church. And it is precisely with the shrinking of Christian congregations we are experiencing that we shall have to consider looking for openness along the lines of such types of affiliation, of being able to associate oneself.
>
> I have nothing against it, then, if people who all year long never visit a church go there at least on Christmas Night or New Year's Eve or on special occasions, because this is another way of belonging to the blessing of the sacred, to the light. There have to be various forms of participation and association; the Church has to be inwardly open.[85]

Throughout the two Seewald books, Joseph Ratzinger speaks in a rather different voice than the one heard in *The Ratzinger Report*. The two men agree with the French writer Georges Bernanos: "Holiness is an adventure, in fact the only one there is. Anyone who has understood that has penetrated to the heart of the Catholic faith." And then the allegedly fearsome *Panzerkardinal* concluded the conversation with an affirmation of the Catholic future. Asked by Seewald whether he could agree with John XXIII's confession that "I belong to a Church that is alive and young and that is carrying her work on fearlessly into the future," Ratzinger replied in unambiguous terms:

> Yes! I can say that with joy. I can indeed see many old and dying branches in the Church, which are slowly dropping off, sometimes quietly, sometimes loudly. But above all else I can see the young of the Church. I am able to meet so many young people, who come from every corner of the world; I am able to meet these new movements, meet with an enthusiasm of faith that is making its appearance here anew. And this enthusiasm cannot be shaken by any of the criticisms of the Church—which always have some basis—because their joy in Christ is just simply greater than that. In that sense I occupy a place where there are many troubles and yet still more encounters with the fact that the Church is young. And that we can move on into the future consoled by the fact that the Lord will quite obviously not abandon us.[86]

As he approached what he imagined would be his retirement years, his life at that intersection of troubles and hope remained remarkably the same as it had been for two decades, even after he had been elected dean of the College of Cardinals on November 30, 2002, succeeding Cardinal Bernardin Gantin. He lived near the Vatican, in an apartment on the Piazza della Città Leonina, and walked to the office every day, greeting friends and the curious along the way. Most Thursday mornings, at seven a.m., he celebrated Mass in the chapel of the Collegio Teutonico, inside the Vatican, for a mixed congregation of students, tourists, and pilgrims, often from the German-speaking world. After Mass, the cardinal prefect of CDF would meet-and-greet for as long as time permitted, before going upstairs for a breakfast of rolls and coffee

with the theological students in residence there; the open conversation suggested a man who missed the lecture hall and the seminar room, even after more than twenty-five years' absence. In the evening, Cardinal Ratzinger could be found walking through the streets of the Borgo district, looking in bookstore windows to see what was new or dining unobtrusively in local trattorias. He had remained a pastor, agreeing in 2004 to the request of an American couple, Marta and Antonio Valle, to celebrate and preach at their wedding Mass, inviting them to meet him beforehand to prepare themselves spiritually for their marriage.

His colleagues remember him as the most unflappable man at CDF. Once, when an agitated colleague finished a lengthy and emotional report about some problem or other, concluding that the whole business was "astonishing," Ratzinger calmly began the ensuing discussion by noting, "Here, we are beyond being astonished." Nor was the prefect of CDF and dean of the College of Cardinals above involving himself in lesser, but no less humanly urgent, affairs. When fussy bureaucrats tried to eject an elderly woman—whose father had been the porter at the Holy Office under Pius XI—from the small apartment she had long occupied in the Palazzo Sant'Ufficio, Cardinal Ratzinger personally intervened to save the apartment for her.

He had not sought his job as prefect of CDF; yet he had come to understand his Roman years as a curious confirmation of one symbol in the episcopal coat of arms he had chosen when appointed Archbishop of Munich and Freising: a bear with a pack strapped to its back. The image came from the legend of St. Corbinian, the first bishop of Freising, who, as the legend goes, was on his way to Rome when a bear attacked his horse and killed it. Corbinian scolded the bear and made it haul the pack the horse had been carrying all the way to Rome. The story reminded Ratzinger of Augustine's reflections on several psalms, in which the great patristic theologian speaks of having become a draft animal—a "good sturdy ox to pull God's cart in this world," as Ratzinger puts it. The paradox is that that was how the scholar, Augustine, who might have preferred not to be the bishop charged with pulling God's cart through history, came closer to God: "Just as the draft animal is closest to the farmer, doing his work for him, so is Augustine closest to God precisely through such humble service, completely within God's hand, completely his instrument." That was how

Ratzinger understood his own translation from scholar to bishop: "The laden bear that took the place of Saint Corbinian's horse, or rather donkey—the bear that became his donkey against its will: Is this not an image of what I should do and of what I am?" As St. Augustine had put it, "A beast of burden have I become for you, and this is just the way for me to remain wholly yours and always abide with you."

And that, in the end, was how Joseph Ratzinger had come to understand himself and his service to John Paul II:

> It is said of Corbinian that, once in Rome, he again released the bear to its freedom. The legend is not concerned about whether it went up into the Abruzzi or returned to the Alps. In the meantime I have carried my load to Rome and have now been wandering the streets of the Eternal City for a long time. I do not know when I will be released, but one thing I do know: "I have become your donkey, and in just this way am I with you."[87]

As things turned out, Joseph Ratzinger, the Lord's donkey, would have one more load to carry. He would carry it in Rome—and from Rome to the world.

Into the Future

SEVENTY-TWO HOURS before the Conclave of 2005 was sealed, the possible futures of Joseph Ratzinger came into focus. By September, the seventy-eight-year-old Ratzinger would be back home in Bavaria—living with his brother, Georg, surrounded by his beloved books, embarked on a retirement of writing and lecturing, doing the occasional puzzle with the grandchildren of his old friend Margaret Richardi. Or he would be marking his fifth month as pope. There is not the slightest doubt which future he would have preferred.

God, and his brother-cardinals, had had other ideas. The beast of burden was going to make his home alongside the Tiber for the rest of his days (as was St. Corbinian's bear, who soon appeared in the new papal coat of arms). There was one more task to complete. Pope Benedict XVI gave hints of how he understood the essentials of that task in the homily he preached at his installation Mass in St. Peter's Square, on April 24, 2005.[1]

LIFE BEYOND LONELINESS:
THE COMMUNION OF SAINTS

Every Sunday, Catholics profess their faith in the "communion of saints"—and likely don't give the notion much thought for another week. For Pope Benedict XVI, the "communion of saints" is at the heart

of the Church's message. In his settled view, the Catholic conviction that the community of the Church extends in, through, and beyond time and space—the Catholic belief that, to belong to "the Church" means to belong to a community that included those now living in the glory of God's Kingdom, those being purified for that destiny, and those still on pilgrimage in this world—is the Church's answer to the pervasive loneliness that characterizes the modern world. So, the Pope began his inaugural homily by reminding his fellow Catholics, his brother-cardinals, and himself that he, and they, were not alone.

Three times during these "days of great intensity," the Litany of the Saints had been chanted, Pope Benedict recalled. At John Paul II's funeral Mass, the Church was reminded by the litany that, while John Paul had "crossed the threshold of the next life . . . he did not take this step alone." The late Pope had been expected, even awaited. "Now we know that he is among his own and is truly at home." He had been welcomed among "his own"—the saints, those who, through the purifying grace of God, can live comfortably within the life and love of the Holy Trinity. John Paul II did not die alone; John Paul II was not alone now.

Nor were the Church's cardinals alone when they processed into the conclave "to elect the one whom the Lord had chosen." Then, too, they had sung the Litany of the Saints. For how could these 115 disparate personalities, gathered from about every corner of the globe, possibly "discover the one on whom the Lord wished to confer the mission of binding and loosing"? Only by recognizing that they, the cardinal-electors, were not alone. Only by remembering that they were "surrounded, led, and guided by the friends of God"—by the saints whose names they had invoked in song, and whose images they saw on Michelangelo's ceiling and in his *Last Judgment*.

And neither was the new Bishop of Rome alone. He had every reason to feel lonely. How could he "assume this enormous task, which truly exceeds all human capacity"? How could he do it? He could do it, he could take up this new burden, because of the communion of saints. As the procession carrying the pallium and the ring of Peter's office had moved from the tomb of Peter to the *sagrato*, outside the basilica, that morning, the Church had once again put itself and its new shepherd in the company of the blessed by singing the Litany of the Saints—

remembering "some of the great names in the history of God's dealings with mankind." That vast community of the friends of God would now come to the new Benedict's aid. And that is why he could say, with conviction, "I am not alone. I do not have to carry alone what in truth I could never carry alone. All the saints of God are there to protect me, to sustain me, and to carry me."

So did the prayers of those present at this Mass of installation, and the prayers of a billion Catholics throughout the world. For the communion of saints, Pope Benedict insisted, is here and now, not only in the past and the future: "All of us belong to the communion of saints, we who have been baptized in the name of the Father and of the Son and of the Holy Spirit, we who draw life from the gift of Christ's Body and Blood, through which he transforms us and makes us like himself." No one is ever alone in the Catholic Church, because no one is ever alone in the communion of saints. The Church is about sanctity, and sanctity is the greatest of human adventures—an adventure to be lived and embraced with others, living and dead.

This installation Mass, Benedict continued, was not the occasion to offer a plan for the first hundred days, or the first few months, or the first few years of the pontificate. Programs and plans had their place, but on this day, of all days, it was important to remember that the Bishop of Rome is the servant of a tradition, not its master. Thus his "real program of governance is not to do my own will, not to pursue my own ideas, but to listen together with the whole Church, to the word and the will of the Lord, to be guided by Him, so that He himself will lead the Church at this hour of our history." What needed saying now had to do, not with master plans but with symbols: the pallium and the Fisherman's Ring the new pope had just received.

Bishops of Rome had worn the wool pallium since the 4th century—"an image of the yoke of Christ, which the bishop of this city, the Servant of the Servants of God, takes upon his shoulders." Much of the modern world thought that to be yoked to the will of Christ, yoked by the will of God, was to live under oppression. That was not the truth of the matter, though. God shows us "where the path of life is found"; that was the joy of the People of Israel, and that is the joy of God's people who are the Church. Why? Because "God's will does not alienate us, it purifies us . . . and so it leads us to ourselves." The pallium is thus an

image of the Good Shepherd, who leads the flock to the truth about each sheep:

> The human race—every one of us—is the sheep lost in the desert which no longer knows the way. The Son of God will not let this happen: he cannot abandon humanity in so wretched a condition. He leaps to his feet and abandons the glory of heaven in order to go in search of the [lost] sheep and pursue it, all the way to the Cross. He takes it upon his shoulders and carries our humanity, he carries us all . . .

The pallium reminds us of the shepherd's office and the shepherd's mission. Like the Good Shepherd, the shepherds and pastors of the Church must seek what is lost; for the pastor of Christ's Church, "it is not a matter of indifference that so many people are living in the desert." And there are many kinds of deserts in the modern world: poverty, hunger, abandonment, loneliness. There is the desert of "destroyed love" and the "desert of God's darkness," which is a desert populated by souls "no longer aware of their dignity or of the goal of human life." The "external deserts" of the world—the world's problems—seemed to be growing. But that was because "the internal deserts have become so vast." It was the task of the Church's pastors, including the universal pastor of the Church, to lead the Master's sheep out of the deserts of the modern world in order "to build God's garden for all to live in."

The pallium's imaging of the shepherd and the sheep is also a reminder of the one whom John the Baptist called the "Lamb of God" [John 1.29]:

> In the Ancient Near East, it was customary for kings to style themselves shepherds of their people. This was an image of their power, a cynical image: to them their subjects were like sheep, which the shepherd could dispose of as he wished. When the shepherd of all humanity, the living God, himself became a lamb, he stood on the side of the lambs, with those who are downtrodden and killed. This is how he reveals himself to be the true shepherd: "I am the Good Shepherd . . . I lay down my life for the

sheep," Jesus says of himself (John 10.14). It is not power, but love that redeems us! This is God's sign: he himself is love.

How often we wish that God would show himself stronger, that he would strike decisively, defeating evil and creating a better world. All ideologies of power justify themselves in exactly this way: they justify the destruction of whatever would stand in the way of progress and the liberation of humanity. We suffer on account of God's patience. And yet we need his patience. God, who became a lamb, tells us that the world is saved by the Crucified One, not by those who crucified him. The world is redeemed by the patience of God. It is destroyed by the impatience of man.

The shepherds of the Church and their sheep are all, in some sense, wayward sheep before the eyes of the Good Shepherd. Thus pondering the pallium draws the people of the Church and their shepherds together in prayer: "Let us pray for one another, that the Lord will carry us and that we will learn to carry one another."

Then there is the Fisherman's Ring. It is a reminder that, at the beginning and toward the end of his public ministry, Jesus had told his disciples to let down their nets into the deep, in order to make a miraculous catch. Today, as John Paul II had so often reminded the Church, it was time again "to put out into the deep sea of history and to let down the nets, so as to win men and women over to the Gospel—to God, to Christ, to true life." The last century had talked much of "alienation." The true alienation, Benedict said, is "alienation in the salt waters of suffering and death, in a sea of darkness without light." To follow Christ and share in the mission of Christ's Church is to "bring men and women out of the sea that is salted with so many forms of alienation and onto the land of life, into the light of God." That is, in truth, "the purpose of our lives: to reveal God to men."

The modern world had come to think of itself as a kind of cosmic accident, something that had just happened. That was another form of alienation, and the Church had something to say to that, too: "We are not some casual and meaningless product of evolution. Each of us is the result of a thought of God. Each of us is willed, each of us is loved, each of us is necessary." It was sometimes difficult to preach that truth because the net, miraculously intact after the great drought of fish at

the Sea of Galilee, had been torn by the disunity of the Church. That was why, on this day, the Bishop of Rome must pray, and must ask all Christians to pray, "Lord, remember your promise. Grant that we may be one flock and one shepherd! Do not allow your net to be torn, help us to be servants of unity!"

Setting out into the deep waters of the late modern world took courage. But was that not what John Paul II had called the Church to, at his installation Mass? In addition to challenging the principalities and powers of this world to open the doors to Christ and stop persecuting a Church of which they were afraid, John Paul was also addressing each of the baptized: "Are we not perhaps all afraid in some way? If we let Christ enter fully into our lives, if we open ourselves totally to him, are we not afraid that He might take something away from us?" John Paul II's life had been a witness to the truth that there was nothing to be feared here. "If we let Christ into our lives, we lose nothing, nothing, absolutely nothing of what makes life free, beautiful, and great . . . Only in this friendship are the doors of life opened wide . . . Only in this friendship is the great potential of human existence truly revealed. Only in this friendship do we experience beauty and liberation." Christ was not to be feared: "He takes nothing away, and he gives you everything. When we give ourselves to him, we receive a hundredfold in return." In opening the door to Christ, we open the door to true life and to true freedom.

Pope Benedict's installation homily—a biblically centered reflection that raised two crucial points in the Catholic challenge to western high culture—was typical of the man, his catechetical style, and his analysis of the world's situation at the beginning of the 21st century. As he had done in his *Pro Eligendo* homily on the morning the conclave opened, Benedict reiterated his conviction, and the Catholic Church's, that without common truths to guide the public debate about public goods, what we call "society" becomes impossible. Life in the desert of radical relativism and skepticism is not a truly human life, for skepticism about the truth of anything, including the truths of how we ought to live together, can neither promote nor sustain genuine human communities. Neither, however, can a drastically diminished view of the human. If human beings come to think of themselves as mere accidents, chance by-products of cosmic chemistry, something is crushed in the human

soul. And a soulless humanity will either turn on itself in the kinds of self-destructive behavior that had marred the 20th century, or it will attempt to reinvent itself, perhaps not through politics—that had been tried, and had failed—but now, in the 21st century, through science untethered from any notion of the good.

Those were some of the lessons Benedict XVI had learned from a "long personal experience of life." And those were some of the lessons he now proposed to take to the world, as the supreme pastor of the Catholic Church.

GREAT EXPECTATIONS

Judging from the barely repressed hysterics that broke out in some quarters when his election was announced from the *loggia* of St. Peter's on April 19, 2005, it might have been thought that Pope Benedict XVI was about to order boxes of freshly polished thumbscrews to be brought from the basement of the Congregation for the Doctrine of the Faith to the papal apartment, while concurrently giving orders to haul out of storage the rusty guillotine that had served the 19th-century Papal States and reassemble it in the Cortile San Damaso of the apostolic palace. When those who fell prey to such fears managed to calm down, they noted with audible relief that the Pope had spoken eloquently in the days after his election of his commitment to Christian unity, to interreligious dialogue, and to the pursuit of peace in the world. Which, of course, he had. That this came as a surprise to some simply indicated, yet again, that more than a few of those who had created the cartoon character of Joseph Ratzinger—"God's Rottweiler"— actually believed their own invention.

Similarly overdrawn expectations were expressed, if from a very different angle of vision, by some of those Catholics who had been supportive of, but also disappointed by, the pontificate of John Paul II. Those offended by what they regarded as the vulgarities of modern liturgy seemed to think that all would now be put right, what with the man who had been a lucid critic of the implementation of Vatican II's liturgical teachings and a principal proponent of the "reform of the re-

form" now resident in the papal apartment. Catholics who had been deeply frustrated by the continuing theological dissent and the lifestyle libertinism evident on some Catholic campuses eagerly anticipated that the man whose "notifications" had removed Charles Curran from the faculty of the Catholic University of America, disciplined Leonardo Boff, and raised serious questions about the compatibility of Jacques Dupuis's theology of religions with Christian orthodoxy would quickly lead a thorough cleansing of what they regarded as the Augean stables of Catholic higher education, in the United States and elsewhere.

Some of those who immediately deplored Joseph Ratzinger's election as pope, but who found themselves vaguely consoled by his public commitments to ecumenism, interreligious dialogue, and peace, further comforted themselves with the thought that Benedict XVI's would likely be a brief, perhaps transitional, pontificate. He was, after all, the oldest man elected to the papacy in more than two centuries, and he had been in difficult health at several points in the 1990s. Yet there is nothing in Joseph Ratzinger's character to suggest that he would ever understand himself as a placeholder, a transitional figure bridging the gap between the papacy of John Paul the Great and someone else. His sense of vocational responsibility is too well developed for that. He had not sought the papacy; he had, in fact, tried, at one point, to deflect attention from himself as *papabile*. God had made a different choice. Now, in accordance with that choice, he would govern, he would lead, he would take the initiative—but he would do so as himself. As his striking deference to the memory and achievements of his predecessor during the interregnum and at his installation Mass suggested, he would not attempt to be John Paul III under a different name. He would be Benedict XVI.

And that, in turn, suggests that those who had looked forward with relish to a Ratzingerian Götterdämerung on matters of liturgy and theological dissent will likely be disappointed, at least in some degree. On the liturgy, for example, Pope Benedict XVI is not a man who believes in revolutionary upheavals. As a historically informed theologian who had argued for decades that the mistake of the late 1960s was to wrench the Roman Rite around 90 or even 180 degrees, the Pope is not likely to think that the solution to *that* error would be to wrench the liturgy 90 or 180 degrees in a different direction. Similarly, as prefect

of the Congregation for the Doctrine of the Faith, Joseph Ratzinger had insisted that proper intellectual and canonical procedures be employed in the case of dissenting theologians and activists. (Those who believe in their hearts that no such procedures should exist would likely deny that, but their complaints about CDF procedures are almost always complaints about the existence of CDF itself.) There is nothing in the history of Ratzinger's stewardship of CDF to suggest that, as pope, he would quickly and efficiently purge vast numbers of querulous theologians from Catholic faculties. Cases would be dealt with, as usual, in an orderly fashion. And, as had been the situation throughout the post-conciliar period, the immediate burden of ensuring the Catholic identity of Catholic institutions of higher education would fall on local bishops.

If the great expectations of both Joseph Ratzinger's harshest critics and at least some of his supporters were likely to be unmet, what, then, would the pontificate look like? Only Pope Benedict XVI knows for sure what he has in mind for his papacy, but a good place to begin reading his mind, so to speak, is with his papal name. For the name is, in some sense, the program, just as the name reflects the spiritual patrimony of the man.

St. Benedict was born in 480 in Nursia, an Umbrian village northeast of Rome. Forty-nine years later, in 529, just as a monastic town was being built for Benedict and his monks atop the brow of Monte Cassino, Plato's Academy in Athens closed its doors. One of the principal embodiments of classical culture shut down just as "the academy of Christianity" (as Joseph Ratzinger once called it) was getting firmly established—and not only on a craggy mountaintop in Italy, but wherever Benedict's spiritual sons could later be found throughout Europe.

The timing, one might say, was providential. Beset by wars, economic troubles, and social disorder, the western Roman Empire was breaking apart. And because of that, the civilizational achievement that Plato's Academy symbolized might have been lost; Athens might have gone the way of, say, the great Mayan civilization of the western hemisphere. That the classical world—the world of classical culture, ideas, and moral norms—was not lost had a lot to do with Benedict and the monastic movement he launched.[2] For the great achievement of the monks of those so-called Dark Ages was not simply to preserve

the cultural heritage of the classical world—although that would have been no mean feat. The monks also transformed what they saved in their libraries and scriptoria by infusing classical culture with a biblical understanding of the human person, human origins, human community, and human destiny.

The result of that fusion of Athens with Jerusalem and Rome was what we know, today, as "Europe"—or, more broadly speaking, 'the West." It was a tremendous achievement that profoundly shaped the subsequent course of world history—and the history of Christianity. Pope Benedict is fond of quoting a Benedictine motto: *Succisa virescit*—"Pruned, it grows." Thanks to Benedict of Nursia and his monastic offspring, what could have been more than mere pruning—what could have been the implosion and then disappearance of classical civilization—became the occasion for a new beginning and a new, nobler civilizational accomplishment.

In one of his interviews with Peter Seewald, Joseph Ratzinger described the character of this accomplishment through the greatest of Benedictine mottoes: *Ora et labora* [Pray and work]. As he put it to the German journalist, "Turning the earth into a garden and the service of God [were] fused together and became a whole . . . Worshiping God always takes priority . . . But at the same time, it's a matter of cultivating and renewing the earth in an ethos of worship. This also involves overcoming the ancient prejudice against manual labor . . . Manual labor now becomes something noble . . . an imitation of the Creator's work. [And] along with the new attitude toward work comes a change in our ideas about the dignity of man."[3] In preserving yet transcending classical civilization through the dual method of prayer and work, western monasticism secured the foundations of a true culture of freedom.

The new Benedict, like his namesake, sees the possibilities of a Dark Age on the horizon. The "dictatorship of relativism" Joseph Ratzinger deplored in his *Pro Eligendo* homily is one path into a new darkness. For if there is only "your truth" and "my truth" and nothing we can understand and share as *the* truth, then how are we to defend the civilizational accomplishment of the West, particularly in its public expressions: the rule of law and equality before the law; tolerance and civility; religious freedom and the legitimate rights of conscience; the method of persuasion

in politics and democratic self-governance? If we are the only measure
of ourselves, if *I* am the only measure of *me*, then the horizon of our as-
pirations has been drastically foreshortened, Pope Benedict is suggest-
ing. And the spiritual boredom that comes from self-absorption and
ultramundane aspirations can be lethal to a culture—no matter how ma-
terially wealthy it is.

Pope Benedict also senses that there is a possible Dark Age being
brewed in those laboratories where human begetting is being replaced
by human manufacture—where the "gift of life," as he styled CDF's
1986 instruction on biotechnology and human reproduction, is re-
placed by life as manufactured (or made to order) artifact. Benedict
knows that Aldous Huxley was remarkably prescient in *Brave New
World*. And he knows that time is running out on the possibility of
bringing the great accomplishments of the new genetics into a legal
and regulatory framework that will ensure that those accomplishments
lead to human flourishing, not to a race of stunted and soulless
creatures.

Benedict XVI took his name because he wants the Church to do for
the 21st century what Benedict of Nursia and his monastic communi-
ties did for another world in transition: preserve what is best of the
world's civilizational accomplishment while marrying it to a nobler,
truer understanding of who we are—to a humanism that sees in the
face of Christ the true meaning of our humanity. It seems unlikely that
the new Benedict will summon his followers into enclaves, though.
Rather, as he suggested at his installation homily, he will send them
forth into the lists of culture, precisely to convert culture. The days of
the one-way monologue between the Church and the modern world
are over, though. John Paul II created a two-way conversation. Bene-
dict XVI will, one suspects, build on his predecessor's achievement by
sharpening the argument while continually engaging those lost in the
deserts of modern loneliness, offering them the proposal of conversion
to Christ.

When Joseph Ratzinger stepped out onto the *loggia* of St. Peter's to
begin a work he never sought, more than one observer thought of the
closing section of *After Virtue*, philosopher Alasdair MacIntyre's pene-
trating study of the moral confusions of the West. After analyzing the
barbarism of a culture in which relativism had been married to willful-

ness, and emotion had replaced reason as the arbiter of judgment, Mac-Intyre ended on a striking comparison, defined by a contrast, between our own circumstances and what history knows as the Dark Ages. "This time," he wrote, "the barbarians are not waiting beyond the frontiers; they have already been governing us for quite some time. And it is our lack of consciousness of this that constitutes part of our predicament. We are waiting not for a Godot, but for another—doubtless very different—St. Benedict."[4]

The new Benedict has things to say to the world, and things to do in the Church. Opportunities and problems await him on both fronts.

THE CHURCH IN THE POST-MODERN WORLD

In the forty years that followed the Second Vatican Council, Joseph Ratzinger saw many of his concerns about the naive optimism that shaped certain readings of the Church's possibilities in the modern world vindicated by events. More presciently than others, Ratzinger saw that the "modern world," which some in the Church were so eager to embrace, was itself about to come apart at the seams. And while, at the end of the Council in 1965, Ratzinger did not anticipate the implosion in the West that followed three years later, he could and did look back on "1968" as the logical working out in history of the implausibilities that had been dominating western high culture for some time, especially in Europe. The new Benedict is a man thoroughly convinced that ideas have real-world consequences and that decent human societies cannot be built upon a foundation of falsehoods. The crisis of the post-modern world is only slightly different in that it is a world in which "true" and "false" have lost their meaning, except as verbal signals of personal preferences. Yet it seems to him just as unlikely that decent human communities can be built on foundations of determined ambiguity as on foundations of deliberate falsehood.

Any pope surveying the world-historical scene in the middle of the first decade of the Third Millennium could not help but notice certain things. Contrary to much 20th-century speculation (in which, to be sure, the wish was often the father of the thought), religious conviction

was not fading away as a culture-shaping force, and thus a history-defining force. This was not entirely good news, of course, because one of those forces, militant Islamism, had long seen the Christian West, and now saw the post-Christian West, as an enemy and a target. On the other hand, the global view from the window of the papal apartment would also espy vibrant and rapidly growing Christian communities in Africa; a thoroughly if increasingly diverse Christian continent in Latin America; the likelihood of a second majority-Christian country in east Asia (South Korea, in addition to the Philippines); and the possibility of an unprecedented evangelical opportunity opening up in China, at some point in the 21st century. From that same vantage point, a pope would notice that the most religiously arid parts of the world—the parts of the world where modernization had actually produced secularization—were in Catholicism's historic homeland, Europe, and one of its colonial expressions, Canada. The same world's eye view would note a confusedly vibrant Catholicism in the United States and the beginnings of a Catholic recovery in Australia. The view from the papal apartment would, in sum, be of a Catholicism that was becoming a predominantly southern phenomena, with the majority of its adherents living south of the equator—yet with opportunities waiting to be seized throughout the developed world of the global North.

These demographic realities, plus the experience of the 2005 conclave, might suggest to the new Benedict that he is likely to be the last European pope for a long time.[5] Be that as it may, Benedict XVI knows that his brother-cardinals elected him in part because of their profound concern for the state of Europe and the condition of the Catholic Church in its historic heartland. That knowledge, and his own convictions, suggest that the reconversion of Europe will be at or near the top of Benedict XVI's agenda for the Church in the post-modern world.

Europe: to go beyond "the silence"

In an essay published shortly after the new pope's election, philosopher and journalist Joseph Bottum identified the crux of the challenge Benedict XVI faces in Europe:

A failing civilization can't be argued out of its failing. It can be led, perhaps, or inspired, or converted and reformed. But argument requires the application of universal truths to the particular facts of the moment, and when a culture is tumbling downward, all its truths and facts—indeed, the whole *idea* of truth and fact and argument—are increasingly what its people increasingly disbelieve.[6]

That Europe is a failing civilization is hard to dispute, uncomfortable as the thought may be. The most telling evidence of its failure lies in its birthrates, which have been below replacement level for decades. Western Europe's failure to produce the human future in the most elemental sense, by producing successor generations, suggests that something ominous is afoot in what was once the indisputable center of world civilization. When that failure takes place at a moment in history when western Europe is richer, healthier, and more secure than ever before, it seems fair to conclude that the crisis at hand is not simply political, economic, or social (although politics, economics, and social mores all have something to do with it). Rather, what is happening is, at bottom, a crisis in the realm of the human spirit. Europe is suffering from a crisis of civilizational morale, and as a result, Europe, or its western half, is committing what looks alarmingly like demographic suicide.[7]

Pope Benedict XVI diagnosed the malady that has sapped Europe's spiritual energies and human strength a long time ago. It is a sickness in the order of ideas and values, a sickness caused by a profound forgetting. One can call that forgetting relativism in regard to morals; one can call it skepticism, bordering on irrationalism, about the human capacity to know the truth of things; one can think of it as a more generalized nihilism, in which the very mystery of being has soured. Whatever the nomenclature, however, the disease remains a matter of amnesia: a deliberate, willful forgetting of the truth that the human person "does not himself *invent* morality on the basis of calculations of expediency but rather *finds* it already present in the essence of things." Today's European crisis, Joseph Ratzinger once wrote, is the result of this great forgetting. As he put it in an essay published a year before the Berlin Wall fell (an essay that anticipated what would happen in a post-communist and post-modern Europe), Ratzinger summarized

what Europe had forgotten and what it must remember if there is to be any hope of reversing its civilizational death-spiral:

> We must again learn to understand that the great ethical insights of mankind are just as rational and just as true as—indeed, more true than—the experimental knowledge of the realm of the natural sciences and technology. They are more true, because they touch more deeply the essential character of Being and have a more decisive significance for the humanity of man.
>
> . . . Man's moral obligation is not man's prison, from which he must liberate himself in order finally to be able to do what he wants. It is moral obligation that constitutes his dignity, and he does not become more free if he discards it: on the contrary, he takes a step backwards, to the level of a machine, of a mere thing. *If there is no longer any obligation to which he can and must respond in freedom, then there is no longer any realm of freedom at all* . . . Morality is not man's prison but rather the divine element in him.[8]

Relativism, skepticism, and nihilism wedded to modern technology kill; that was the lesson of the first half of the 20th century. Relativism, skepticism, and nihilism can also render a culture sterile, and in the most literal sense: that is the drama of a 21st-century Europe in which Spain will lose almost one-quarter of its population by 2050 and Germany will lose the equivalent of the population of the former East Germany by the same date—at which point 60 percent of Italians will not know personally what a brother, a sister, an aunt, an uncle, or a cousin is.[9]

Joseph Ratzinger once said that the great public accomplishment of Pope John Paul II was that, in a season of flattened horizons, he had helped people to "recognize once again the spiritual dimension in history."[10] History, John Paul had reminded the world, and especially the European world, is not the result of the quest for power alone, nor is history the exhaust fumes of the means of economic production, as Marxism taught. History is shaped, ultimately, by "the spiritual dimension," by culture, by what men and women honor, cherish, and worship; history is the playing out of the truths, including the religious and moral truths, on which men and women are willing to stake their lives. The Revolution of 1989 should have reminded Europe of that, for here

was a nonviolent revolution built almost entirely on explicit and public claims about what was right and what was wrong—and it changed the course of history, in an indisputably more humane direction.

Yet that truth, which should have re-energized Europe spiritually and morally, was soon overrun, Ratzinger came to believe, by the false claim that freedom could be detached—indeed, *must* be detached—from any notion of moral truth, or at least any notion of moral truth with real traction in human affairs. That was what the argument over the so-called *invocatio Dei* in the preamble to the European constitutional treaty signed in October 2004 had been about. The argument was not so much about ceremonially invoking God, an exercise in civil religion in which Ratzinger would likely have had little interest. No, what the drafters of Europe's new constitution were determined to do was to declare secularism—and the skepticism and relativism that inform secularism— as the official creed, so to speak, of the newly expanded European Union. That was why the historic cultural contributions of Christianity to a Europe committed to freedom, human rights, and democracy could not be named in the preamble—because to do so would be to acknowl- edge that freedom and moral obligation, freedom and the spiritual di- mension of the human experience, had something to do with each other. And that is what Europe's constitution-makers were determined to avoid.

Joseph Ratzinger was not alone in his diagnosis of Europe's contem- porary malaise. Another German cardinal, Karl Lehmann, usually found on the other side of various issues in the Church, once offered a parallel analysis. Human beings, Lehmann said, "cannot live with the silence"—the silence of a world whose spiritual horizons have been razed. When men and women try to live "in silence," they forget how to give themselves, how to go beyond themselves. And that, Cardinal Lehmann suggested, was why Europe was depopulating itself.[11] If truths have consequences, then the conviction that there is no such thing as "the truth" also has consequences.

What can Pope Benedict XVI do to inspire and summon Europe be- yond "the silence"? One strategic clue can be found in the new pope's installation homily, in which he proclaimed, with genuine emotion, "The Church is young." The hundreds of thousands, perhaps millions, of young people who had flocked to Rome to say good-bye to John

Paul II—many of whom had stayed to greet John Paul's successor—
could form a potent network with which and through which Pope
Benedict XVI can work. Joseph Ratzinger's choice of the papal name
"Benedict" was interpreted by some as an indication that he intended to
foster a smaller, purer Church, a Church recognizing that it no longer
had serious culture-forming possibilities in Europe—a Church retreat-
ing into enclaves of intentional Christianity, a saving remnant preserv-
ing the truths that had once animated a now-dying civilization. It may
yet come to that. But it seems counterintuitive to suggest that any new
pope would imagine his task, even in Europe, to be one of fostering a
deliberate downsizing of the Church. Then there are the particulars
and peculiarities of Europe's own situation, which Pope Benedict knows
well. As Joseph Bottum pointed out, "Europe is [already] as dechristian-
ized as it's likely to get; everyone who's going to leave the Church al-
ready has." Moreover, as Bottum continued, "there are [still] millions of
believers scattered across the continent."[12] That some of the most com-
mitted of those believers are young adults is another reason to think
that Pope Benedict XVI is unlikely to adopt a kind of strategic hamlet
strategy in Europe, securing small, intact Christian communities in a
secularist sea. For, thanks to the revolution in communications technol-
ogy, those young adults can be linked in virtual communities, such that
World Youth Days and other (important) moments of the experience
of Catholic solidarity are not their only reminder that they are not
alone.

In the first weeks of his pontificate, Pope Benedict gave a very con-
crete indication that he did not propose to lead the European Church
into the catacombs. He strongly supported the efforts of his vicar for
Rome, Cardinal Camillo Ruini, and the Italian Bishops Conference, to
block passage by public referendum of several measures that would
have accelerated Italy's turn into the brave new world of technologized
human reproduction and embryo experimentation. Ruini's success—a
success the Italian journalist Sandro Magister rightly attributed to per-
suasion and argument, not to blind ecclesiastical obedience (an oxy-
moron in Italy, in any case)—suggests that the Catholic Church has
not completely lost its ability to shape the public moral discourse. And
while Italy is a distinctive case, Pope Benedict will not have missed the
implications for the rest of Europe: in Italy, the beginnings of success in
the re-evangelization of culture, in revitalizing Catholic practice, and

in deploying Catholic renewal movements as public actors, led, against the odds and the predictions, to a legislative success in defense of life.[13]

Pope Benedict's wide range of contacts with the bishops of the Church, as well as his long-standing concerns about the evangelical incapacities of Church bureaucracies, will likely have suggested something else to him: that the evangelical energy he wants to unleash in Europe will most probably come from renewal movements and new Catholic communities—from the charismatic element (broadly defined) in the European Church. Here, to return to Joseph Ratzinger's conversations with Peter Seewald, is where people can test out the possibilities of Christianity, in a new form of catechumenate; here is where the Christmas night and New Year's Eve Catholics can explore the possibility of taking a deeper plunge into the faith. Thus it was no accident that Pope Benedict, within two months of his election, should invite the members of these renewal movements and new communities to a mass meeting in Rome at Pentecost 2006.

On past form, Benedict XVI can also be expected to have some vigorous things to say about the high politics of European integration. He knows that the project of building "Europe" in its post–World War II phase was conceived, not by secularist technocrats or post-"1968" postmodernists, but by statesmen who were serious Catholics and who understood their statesmanship to be an expression of their Christian convictions about European solidarity: Konrad Adenauer, Alcide de Gasperi, Robert Schuman. Although he will not put the matter quite so bluntly, Pope Benedict knows that the project of defining and building Europe has been hijacked by secularists; and he will certainly try to remind all those committed to some form of European integration of that project's spiritual roots. Because Joseph Ratzinger is a widely respected pan-European intellectual—a member of the Academie Française, the Rhineland-Westphalia Academy of Sciences, and the Salzburg-based European Academy of Sciences and Arts; the man who publicly debated Europe's most influential philosopher, Jürgen Habermas, a few months before being elected pope—it is not unreasonable to hope that Pope Benedict might use the pause created by the failure to ratify the European constitutional treaty to invite his fellow shapers of Europe's high culture to think again, and to reconsider whether there is any genuine freedom without moral obligation and spiritual truth.

If Pope Benedict's proposals are to have a chance of being engaged

in the salons, seminar rooms, and editorial offices of Europe, he will have to ensure that his message is not obscured or blurred by signals from his own Vatican bureaucracy. The silence of the Holy See's Secretariat of State when a distinguished Catholic intellectual and public official, Rocco Buttiglione, was denied the post of minister of justice on the European Commission precisely because he was a committed Catholic was not helpful to the cause of reforming the high politics of Europe; nor was the subsequent denial by senior Vatican officials that Buttiglione's rejection had something to do with his Catholicism, which was clear to virtually everyone else. The Vatican's diplomats also seem reluctant to confront the attempt, via the European constitutional treaty, to establish secularism as the de facto house ideology of the European Union. Thus, in a May 17, 2005, address to the Council of Europe, the Vatican "foreign minister," Archbishop Giovanni Lajolo, noted that "the Holy See views with satisfaction the commitment expressed in the preamble [to the treaty] . . . 'to the universal values and principles which are rooted in Europe's cultural, religious, and humanistic heritage.'"[14] Why there should be any satisfaction taken from this was not clear, as this "religious . . . heritage" language was the shabby bone thrown in 2004 to those (like Pope John Paul II) who had lost the argument over an explicit reference to the Christian roots of European civilization in the constitutional treaty.

The problems Benedict faces in advancing an *aggiornamento* in Catholic bureaucratic thinking about Europe are not confined to the Vatican, however. The statement by the presidium of the Commission of the Bishops' Conferences of the European Community in the aftermath of the French and Dutch "No" votes in June 2005 on the constitution's ratification read as if it could have been drafted by the E.U. bureaucracy in Brussels; indeed, one paragraph could be read to suggest that the bishops of Europe were proposing a re-education campaign in European schools, to ensure that no such untoward outbreak of anti-E.U. sentiment as had just been registered in France and the Netherlands should happen in the future. And one could only wonder why the European bishops could not bring themselves to mention the word "Christianity" in their call to "engender a more authentic community of European values."[15]

Historians and sociologists often remark that the Roman Empire—

its roads, the order it brought to a large part of Europe, its teeming cities—helped make the success of Christianity possible. That is true enough, but Joseph Ratzinger sees more deeply into the historic relationship between Christianity and the late classical world. It was not accidental, he would likely argue, but providential that Christianity was first "inculturated" in that world. For here, in the encounter with Athens and Rome, Christianity found an environment in which its biblical ideas—for example, the claim that Jesus is "Son of God"— could be developed into doctrine in a comprehensive and philosophically coherent way. To take another, perhaps even more basic, example: it made a great deal of difference that Christianity was first inculturated in an intellectual environment in which the principle of non-contradiction was firmly established—the idea that something cannot "be" and "not be" at the same time. In a culture in which the principle of non-contradiction was not so secure (say, in India), the core Christian claim that "Jesus is Lord"—which means that no one else is Lord, including Caesar (or the Buddha)—would have had a more difficult time being articulated doctrinally, at least in a way that was true to the radical meaning of the claim. The philosophical environment of the late classical world was a crucial matrix in which Christianity worked out, intellectually, the meaning of its confession of faith. Christianity's first inculturation in Europe did not mean that the Christian encounter with Hellenic philosophy vitiated its biblical faith, as Adolf Harnack and other liberal Protestant historians claimed. If the God of the Bible really is the Lord of history, then those who read history as His-story will not think it merely a happy coincidence that the intellectual matrix of the late classical world was available to help shape the grammar and vocabulary of Christian doctrine when Christianity launched out into the deep of world evangelism. Rather, it all seems an example of divine oversight.[16]

Were Europe to be transformed demographically into what some scholars call "Eurabia," a cultural extension of the Arab Islamic world, or were Europe to collapse into the paralyzing social strife that would follow the fiscal meltdown of the European welfare state, that would be bad for Europe, for the larger project called "the West," and for all those countries that understand themselves as Europe transplanted. Despite the dramatic decline in Christian practice throughout the conti-

nent and Christianity's move to the south, the collapse of Europe
would also pose serious questions for the Catholic Church. True, the
intellectual and cultural roots that first nurtured Christian doctrine in
Europe have been successfully transplanted elsewhere (and arguably
enriched in the process). But it would surely mean something, and most
probably not something good, if the soil from which those roots first
grew turned barren and flinty.

Thus the new Benedict has his work cut out for him, precisely at
home.

Reconceiving Vatican diplomacy

Domenico Tardini was one of Pius XII's closest associates, with particu-
lar responsibilities for the Vatican's engagement with international pol-
itics. John XXIII made him a cardinal and his secretary of state. Once,
Cardinal Tardini was told by a gushing visitor that the Holy See's
diplomacy was the world's finest. "God help whoever's number two"
was the eminent reply.[17]

Even by the standards of mid-20th-century curialists, Domenico
Tardini was a famously crusty personality who seems to have enjoyed
shocking people from time to time. Yet this vignette, which has been
retailed around the Vatican for decades, contains two important truths.
It is true that the Church's diplomatic service is, in the main, staffed by
competent and skillful people; that the Vatican's diplomats are gener-
ally well regarded; and that the Vatican is often said to have the world's
best intelligence operation. It is also true that that reputation is some-
what overblown.

A few preliminary points of orientation, historic and bureaucratic,
will be helpful.

"Vatican" is shorthand here, for the "Holy See" and "the Vatican" are
not the same thing, in themselves or from the point of view of interna-
tional law. "The Vatican," technically speaking, is a concise way of
naming one of two things: the microstate called Vatican City State,
created by the Lateran Treaty in 1929; or the complex of buildings in-
side the Leonine Wall, composed of St. Peter's, the apostolic palace,
the Vatican library and museums, and so forth. According to interna-

tional law and long-standing diplomatic custom, however, it is the Holy See that counts diplomatically, for the Holy See is the juridical embodiment of the ministry of the Bishop of Rome as universal pastor of the Catholic Church. It is the Holy See that sends and receives diplomatic representatives, not Vatican City State; indeed, the Holy See was a recognized diplomatic entity when popes were self-styled "prisoners of the Vatican" and had no sovereign territory of their own, such as Vatican City State. "Vatican diplomacy" and "Vatican diplomats" are, however, less cumbersome phrases than "the diplomacy of the Holy See" or "the Holy See's diplomats," so the former will usually be used here—much as "Whitehall" and "Quai d'Orsay" are used to refer to the British and French foreign ministries—on the understanding that the true point of reference is not "the Vatican" in either of its meanings, but the Holy See.[18]

The Vatican's diplomacy was once overseen by a curial bureaucracy called the Congregation for Extraordinary Ecclesiastical Affairs. As a result of the 1967 and 1988 reconfigurations of the Curia, this congregation was transformed into what everyone in Rome calls the "Second Section" of the Secretariat of State (the "First Section," or "General Affairs," deals with the internal life of the Church). The Second Section, often referred to as the Vatican's "foreign ministry," is led by a secretary for relations with states, whose parallel in the First Section is the *sostituto*, the deputy secretary of state. Both the secretary for relations with states and the *sostituto* work under the secretary of state, although the *sostituto*, who functions as a kind of papal chief of staff, has traditionally had direct and regular access to the papal apartment, which the secretary for relations with states may or may not have, as a given pope wishes.

The Vatican's diplomats, who are all priests, are usually trained at the Pontifical Ecclesiastical Academy near the Pantheon. During their years at the *Accademia*, they earn doctoral degrees in theology or canon law at various Roman universities while honing their language skills and learning their trade through courses on the history of Vatican diplomacy, the writing of diplomatic reports, international law, and so forth. These diplomats are drawn from all over the world, representation from the Third World (where there is an abundance of clergy) is increasing significantly. Having completed their course at the *Accademia*

and finished their doctoral work, Vatican diplomats are usually sent immediately into the field, before being rotated back for service in the Secretariat of State, before returning to the field, before returning to Rome again, and so forth and so on. In the field, Vatican diplomats have two functions: they represent the Holy See in formal diplomatic relations with the host government, and they represent the pope to the local hierarchy. In countries where there are no serious Church-state issues or other political impediments to the Church's functioning, the latter responsibility is the crucial one, as the Vatican nuncio (the equivalent of an ambassador) is the principal contact point between the Curia and local situations; even more important, the nuncio is responsible for formulating lists of possible nominees for the office of bishop.

The latter function will be discussed later; for the moment, the focus will remain on Vatican diplomacy as the word "diplomacy" is usually understood—the Vatican's efforts to shape world politics according to certain convictions about the public goods of peace, justice, and freedom.

Vatican diplomacy under John Paul II scored some notable successes. In the early 1980s, the Vatican mediated a nasty conflict between Chile and Argentina over the Beagle Channel, which might well have broken out into a shooting war had Vatican diplomats not negotiated a border agreement between the two countries. Effective Vatican diplomacy got John Paul II to Nicaragua, where he began the unraveling of the Sandinista revolution. Several Vatican diplomats (including the man who would later design Benedict XVI's coat of arms, Archbishop Andrea Cordero Lanza di Montezemolo), played crucial roles in completing the 1992 Fundamental Agreement that led to full diplomatic relations between the Holy See and the State of Israel—a particular goal of Pope John Paul II. In 1994, as noted previously, Vatican diplomacy helped prevent a United Nations conference from declaring abortion on demand a fundamental human right. Vatican diplomacy also helped focus the 1995 U.N. world conference on the status of women on issues like health, nutrition, sanitation, and education—issues that would otherwise have not received much attention, but which were of far more importance to more women's lives than the agenda items being pressed by western feminists.

Vatican diplomacy also had some notable failures during John Paul's pontificate. It failed to convince Europe to do much of anything about

the slaughter in the Balkans after Yugoslavia cracked up, as it had previously failed to convince the splintering factions to find a loose federal solution to the problem of post-Tito Yugoslavia. In both 1991 and 2003, the Second Section seriously misread the likely reaction of the so-called Arab street to western attempts to enforce international legal agreements on the Saddam Hussein regime in Iraq. The Vatican's 2002–03 position on Iraq was coherent, if unpersuasive to some: no military action against Saddam Hussein should be taken without yet another, presumably final, authorization from the U.N. Security Council. Many found the Vatican's 1991 position simply incoherent, however. The Iraqi invasion of Kuwait was one of the clearest examples of cross-border armed aggression in post–World War II history, a situation for which the United Nations was designed to be the remedy; the Security Council had authorized military action to end the Iraqi occupation of Kuwait (a particularly nasty and brutal business); and still the Vatican—perhaps the world's preeminent defender of the U.N. system—resisted the use of armed force. Granted, it is not the business of either the pope or the Vatican to bless particular uses of armed force; but why did the Vatican continue to condemn. implicitly if not explicitly, a use of armed force that had the virtually unanimous approval of the world community as manifest by the will of the United Nations, which the Holy See typically regards as the embodiment of the world community? Both inside the Vatican and out, it was said in both 1991 and 2003 that the Holy See's refusal to countenance the use of armed force against Iraq had prevented these actions from being cast as a western crusade against the Arab Islamic world, with unpredictable but probably very bad consequences. Yet those disposed to think in those terms in the Arab Islamic world were likely to do so anyway.

Despite its long-standing investment in the United Nations, where the Holy See has Permanent Observer status, the Vatican has not been a stalwart proponent of U.N. reform, at least publicly. It was not notably vocal about the West African sex-for-food scandal in which U.N. peacekeepers were abusing children. As the Iraq oil-for-food program was revealed to be an oil-for-weapons program that was rearming Iraq while concurrently corrupting the Security Council process, little was heard publicly from Vatican diplomats about the imperatives of genuine, deep-reaching U.N. reform, beyond certain structural proposals.

Vatican diplomacy also seems to have learned little from the corruptions and failures of Third World development programs in the past forty years. In June 2005, when leading industrialized countries announced that they were writing off $40 billion in unpaid (and unpayable) Third World debt, the Vatican greeted this as a great triumph—rather than arguing that the only form of debt cancellation that might actually help poor people in the Third World was debt cancellation tied to radical reform of the corrupt governments that had squandered or looted the aid money in the first place. (Cardinal Renato Martino, president of the Pontifical Council for Justice and Peace, did suggest, quietly, that the money freed from debt servicing ought to be used for health and education infrastructure; a good idea, to be sure, but one unlikely to be realized unless the debt lever, and aid in general, are used to compel political change.)[19]

Despite John Paul II's passionate defense of the Christian roots of European civilization in the debate on the preamble to the European constitution, the Vatican's diplomats took a much more measured approach to the Euro-constitution debate, preferring, if necessary, to let the *invocatio Dei* (their term for an acknowledgment of the Christian sources of European civilization) slide if they could get the legal personality of religious bodies recognized in the actual text of the constitutional treaty. They accomplished that, but without seeming to recognize the price: that if secularism was, in fact, being "established" as the official ideology of the European Union, constitutional recognition of the legal personality of religious institutions might eventually come to mean very little, both de facto and de iure. The question of Turkey's possible accession to the E.U. was also muddled by the Vatican; the official Holy See position remained that, if Turkey satisfied the E.U.'s human rights criteria, especially on religious freedom, its application should go forward, while other senior Vatican officials (including then-Cardinal Joseph Ratzinger) were expressing doubts about Turkey's candidacy. This particular muddle might have been attributed to the lack of communications discipline that was an unhappy characteristic of the Holy See during the last years of John Paul II; when coupled with the Second Section's strategic approach to the Euro-constitution, however, it suggested a Vatican that really had not thought through what kind of Europe it supported, but was simply going along

with what seemed (prior to the French and Dutch referenda of June 2005) to be the irresistible political tide.

Thus several large and dubious ideas—dubious from the standpoint of Catholic international relations theory, not because they caused problems for the U.S. government or any other government—seemed to shape the Vatican's diplomacy and its diplomatic commentary in the last decade of John Paul II's papacy. The notion that collective security always and only means the United Nations was one such idea. So was the idea that international law could be enforced by diplomatic means alone. So were the notions that international terrorists might have legitimate goals, and that Islamist terrorism could be traced to resolvable root causes in poverty, disenfranchisement, etc. On several occasions, senior Vatican officials insisted that war never solved anything—a particularly shortsighted view from churchmen who had grown up in Mussolini's Italy. During the run-up to the 2003 Iraq War, Vatican officials embraced the European peace movement, seemingly unaware (or at least unconcerned) that it was primarily driven by anti-western and anti-globalization forces whose commitment to peace did not lead them to condemn Palestinian suicide bombing and other forms of Islamist terrorism. In Europe, as well as at the United Nations, the idea that vertical integration—the transfer of power to transnational or international institutions—was *necessarily* better in virtually all circumstances seemed to guide Vatican policy and commentary; but this was usually asserted, rarely argued.

Vatican diplomacy has been operating according to the same default positions for some forty years. The world has changed in that time, dramatically; so has the Catholic Church's role in world politics, and the papacy's; and so must the default positions in the Second Section. It is time for a rethinking of the Vatican's role in world politics and the fundamental strategic ideas that will shape how that role is played. No one may be better positioned to lead, or at least inspire, such a process of rethinking than a pope, like Benedict XVI, who takes his fundamental theological cues from St. Augustine.

For what seems to have become rather attenuated in the Vatican's diplomatic thinking in recent decades is Augustinian realism. Today, the Vatican's institutional voice in world politics is often indistinguishable from that of other international non-governmental organizations.

Yet the Catholic Church once had a distinctive, and distinctively Catholic, way of thinking about international relations. It began with Augustine and was subsequently developed by Thomas Aquinas and the Counter-Reformation theologians Francisco de Vitoria and Francisco Suárez, before being brought to a point of modern refinement by the popes of the mid-20th century. Throughout that process of development, from Augustine to John XXIII, this distinctively Catholic way of thinking about politics among nations was built on the foundation of three ideas, all of which could be traced, in one form or another, to Augustine's moral realism.

The first idea was that all politics, including international politics, is under moral scrutiny and judgment. Unlike the so-called realists who argue that world politics is amoral or necessarily immoral, Catholic international relations theory always held that there is no escape from making moral judgments, even in world politics, because politics is a human activity and the capacity to make moral judgments is a defining characteristic of human beings.

The second foundational idea the Church drew from Augustine was a classic understanding of power: power is to be understood, not as something vaguely distasteful, but as the capacity to achieve a corporate purpose for the common good; absent power there is anarchy. So the classic Catholic question never was, should power be exercised? The Catholic question was, how is power to be exercised—to what ends, by what means, by whose authority? Power, rightly understood, is a means to achieving justice and peace.

Which brings us to the third distinctive Catholic idea about world politics, in this case drawn explicitly from Augustine in *The City of God*: "peace" is *tranquillitas ordinis* [the tranquillity of order], the peace of a justly ordered and justly governed political community. Classic Catholic international relations theory did not believe it possible to build the peace of a world without conflict this side of the Kingdom of God. But something important could and should be built—the peace of order within and among states. In the 1963 encyclical *Pacem in Terris*, John XXIII proposed that the "universal common good" required the creation of an effective "universal public authority" to deal with those questions of international public life that could only be resolved on the international plane. In the late 20th century, John Paul II deepened

the analysis by arguing that the moral core of this universal common good is composed of basic human rights. including the first right, the right of religious freedom.

Yet, as the evidence above suggests, while these developments were under way at the level of papal teaching, the three core ideas of Catholic international relations theory were no longer shaping the default positions of Vatican diplomacy. The new realities of the post–Cold War world: the dominant position of the United States and the dramatic decline of Europe; the enduring realities of the nation-state system, which seems likely to be the basic framework of world politics for the foreseeable future; the troubled state of international organizations; the anti-democratic (and often anti-Catholic) bias frequently displayed in the E.U. and the U.N.; the dangers posed by international legal activism; the threat to a minimum of world order posed by international terrorist organizations and networks that marry distorted religious conviction to post-modern nihilism—none of these facts of contemporary international life seems to have prompted a rethinking of the Vatican's diplomatic strategy, as a sturdy, Augustinian realism might suggest they should. What, then, might that sturdy Augustinian, Pope Benedict XVI, put on the table for his diplomats' consideration?

He might begin by asking his diplomats to reconsider the assumption that the nonviolent collapse of communism in the Revolution of 1989 provides a universal template for thinking about conflict-resolution in the world—an assumption that is very close to becoming a default position in Vatican strategic reflection. The Revolution of 1989 was the result of the convergence of many forces, among which moral power— what Václav Havel called "the power of the powerless"—was most important.[20] Yet that form of soft power worked, and worked magnificently, within a political context set by hard power—including the western rearmament fiercely resisted throughout the 1980s by the European peace movement (and not a few Catholics). All of which suggests that the Vatican must rethink the relationship between hard power and soft power in world politics. The current tendency to juxtapose what Vatican diplomats call a "force of law" against a "law of force" simply does not stand up to serious analysis, not least because all law requires enforcement if "law" is to mean anything other than a vague expression of good intentions—and that certainly includes inter-

national law as well as domestic law. The force of law and the use of proportionate and discriminate armed force are not, according to classic Catholic understandings, antinomies or polar opposites, but rather two means of achieving Augustine's peace of order. That understanding needs to be recovered in the Vatican's thinking about world politics.

The Second Section and other Vatican offices concerned with problems of peace, order, freedom, and justice might also think again about the default assumption that the first use of armed force is always wrong, while the second use of armed force *may* be justifiable under certain circumstances. Given modern weapons technologies and the character of some regimes, classic Catholic realism would suggest that there are some occasions when the first use of armed force is indeed morally justifiable—to prevent an impending genocide, or the acquisition or use of weapons of mass destruction, for example. This is likely to be a crucial debate in the world politics of the 21st century. The Vatican will make its appropriate contribution to that debate only if it re-examines its current default position on the first use of armed force.

As suggested above, the French and Dutch refusals to ratify the European constitutional treaty might provide a pause in which Pope Benedict can encourage his fellow European intellectuals to think again about what kind of European integration, based on what understandings of the common good, they really want. At the same time, this pause should also be an opportunity for a similar process of rethinking in the Second Section and the Vatican diplomatic service. Vatican strategic thinking on the E.U. seems to have been something like this: an integrating Europe will be forced to ask the question of the sources of its unity; one possible answer to that question is Europe's Christian heritage; therefore, deep vertical integration of Europe will provide an opportunity for the re-evangelization of Europe. Thus the strategy: to ride the wave of European integration in the hope that Brussels, setting out to make the rest of Europe Belgium, in fact helps make the rest of Europe Poland. Needless to say, that hasn't happened. And the debate over acknowledging the Christian roots of European civilization suggests that Brussels has other, and very different, ideas of what it is about. A tough-minded strategic review of the Holy See's approach to the European project is in order—a review that would not begin by abandoning the hope of European integration, but that would raise

questions about precisely what form that integration takes and how it is compatible with Catholic thinking about political responsibility.

Then there is the United Nations. The suggestion from the Vatican that the world community has ceded all legitimate use of armed force to the U.N. doesn't tally with the record of recent history. Since 1945, by one estimate, 126 of the 189 U.N. member states have been involved in 291 armed conflicts in which some 22 million people have been killed.[21] This record does not lead easily to the conclusion that the world community (however one defines that notoriously slippery term) thinks about the U.N. the way the Vatican seems to. It is true that the Holy See is in a not-altogether-easy position at the United Nations, being the only Permanent Observer left (which effectively means having a voice but not a vote). On the other hand, a recent attempt by various *gauchiste* international non-governmental organizations to have the Vatican's observer status withdrawn was a failure. And it is, in fact, difficult to imagine the circumstances in which even an organization as given to self-inflicted wounds as the U.N. would see it in its interest to throw the Vatican overboard. Therefore, the Vatican's voice can and ought to be raised more vigorously in debates over U.N. reform than it has been to date. No other global institution is more likely to bring the skills of moral reasoning to bear on the task of international organizational reform than the Catholic Church. Vatican diplomacy ought to be part of that process of moral scrutiny and critique—which will require a Vatican diplomacy that sounds less and less, rather than more and more, like the World Council of Churches in its fulsome and uncritical embrace of the current U.N. system.

An Augustinian approach to the renovation of Vatican thinking about international relations would also involve a reconsideration and development of the just war tradition of moral reasoning within the Holy See, in the Roman universities, at the *Accademia*, and among the Church's diplomats. Such a reconsideration would in no way compromise or be in conflict with Benedict XVI's stated intention to foster peace among nations; on the contrary, such a reconsideration would be the expression of a classically Augustinian understanding that the peace of order must sometimes be defended, even promoted, by the proportionate and discriminate use of armed force. Some of the priority questions needing careful re-examination here include the question of how

one makes the moral judgment that aggression is under way—a question that touches two of the just war tradition's principal criteria for determining if the use of armed force is morally justified, "just cause" and "last resort." Just war thinking also includes thinking about the authority capable of legitimating the use of armed force: here, a revival of Catholic just war thinking would intersect with fresh thought about U.N. reform and other issues involving transnational and international organizations. Then there is the question left open by Pope John Paul II in his 1992 address to the U.N.'s Food and Agricultural Organization in Rome; there, John Paul spoke of a "duty" of humanitarian intervention in situations of impending or actual genocide, but without specifying how this duty was to be met, or on whom it fell. The gruesome situation in Sudan at the time Pope Benedict was elected suggests that the idea of "humanitarian intervention" raises a host of urgent questions that cannot be deferred by references to the appropriate regional or international institutions.

Finally, Pope Benedict XVI and his diplomats will have to contend with another new reality of the 21st-century world: the emergence of the pope, the occupant of the world's oldest institutional office, as a global moral witness. This intriguing phenomenon becomes even more interesting when we remember that, while John Paul II was taking moral arguments directly to the people of individual states and to the people of the world, going around or beyond their governments or the relevant international organizations, Vatican diplomacy continued to function through the normal grooves of bilateral relations and multilateral institutions. There is an obvious and built-in tension here, which deserves more serious reflection than it seems to have gotten to date in the Vatican.

John Paul II was a moral witness speaking truth to power in world politics; his diplomatic representatives, by definition, had to be players according to the established rules of the game. Sometimes those roles can get confused. Some would argue that that was the case prior to the 2003 Iraq War, when the prudential judgments of Vatican diplomats and agency heads were often reported (and perceived) as if they were decisive moral judgments by the man the world had come to recognize as its foremost moral authority—Pope John Paul II.

Then there is the question of how the Holy See, which is not a

state, is to function in international fora in which every other actor of consequence *is* a state. How is it possible for the Holy See to function *like* a state without being a state and without damaging the Catholic Church's moral witness? For example: Can the Holy See, without damaging the moral witness of the Catholic Church, form practical alliances for purposes of defending the family and the inalienable right to life with Muslim states whose policy and practice deny what the Catholic Church claims is the moral core of the universal common good—religious freedom? Then there is China. The Vatican has long sought regular, formal diplomatic relations with the People's Republic of China, which the PRC may be willing to consider in the future if the Vatican severs its existing diplomatic ties with Taiwan. What would it mean for the moral witness of the Catholic Church if the Vatican were to abandon the first Chinese democracy in history as the price for diplomatic relations with a regime that has been persecuting Catholics since 1949? How does the realism of getting a place at the table with the PRC government, precisely in order to safeguard the Church, square with the moral witness of the Church's commitment to the rule of law and democracy, both of which are embodied in Taiwan?

This tension between the moral witness of the papacy and the Church, on the one hand, and Vatican diplomacy, on the other, will not be resolved anytime soon—nor should it be prematurely resolved in either direction (i.e., by muting the moral witness of the Office of Peter, or by the Holy See's withdrawal from bilateral and multilateral diplomacy). At the present moment, when the Catholic Church is the world's premier institutional challenger to utilitarianism as the default position in international politics and in the understanding of the human person implicit in international organizations, the world needs the Church, working through Vatican diplomacy, to promote the dignity of the human person as the foundation of any worthy politics, including international politics. And if that means the Church must live with ambiguity and tension, then so be it. In the face of the Islamist threat (which, inter alia, intensifies the temptation in Europe and elsewhere to force religiously informed moral judgment out of public life), the world also needs a demonstration that publicly assertive religion is not necessarily violent or aggressive religion. The Catholic Church, acting through Vatican diplomacy, is the only available candidate for

making that demonstration at the global level. And, again, if that re-
sults in a certain tension and ambiguity, so be it.

Given these inevitable tensions and ambiguities, however, it is all
the more urgent for Pope Benedict XVI, theological disciple of Augus-
tine, to reconvene a conversation that has lapsed for almost forty
years—the conversation over the development of the Catholic interna-
tional relations theory that began with Augustine's thinking about the
nature of politics, the meaning of "peace," and the morally legitimate
use of armed force. That tradition's central insights remain true, and are
crucial in a global debate often dominated by less noble (and indeed
less true) conceptions of the human person, human community, human
origins, and human destiny. Moreover, Catholic international relations
theory, developed, would offer a dramatic alternative to what is now
the other prominent religiously grounded moral reading of world poli-
tics, namely, militant Islam or Islamism. Further, Catholic international
relations theory, developed, would represent an important challenge to
the Realpolitik that has corrupted western European thinking about
world politics and that is always a danger in the formulation of U.S.
foreign policy. Thus the moral witness pioneered by John Paul II might
well be complemented by a Benedictine intellectual activism in revital-
izing Catholic thinking about world politics—beginning with the
thinking in Benedict's own "foreign ministry."[22]

Strategic interreligious dialogue

Pope Benedict XVI will face another set of entrenched Vatican default
positions that need re-examination when he considers the Church's di-
alogue with Islam. That dialogue is of considerable consequence for
the human future, for it brings together representatives of the two most
culturally dynamic religious forces in the world of the 21st century.
One of those forces, the Catholic Church, is committed to the method
of persuasion in public life and to religious freedom as the first of
human rights. There is very little idea of a right of religious freedom in
Islam, and its most publicly assertive adherents have created elaborate
religious and moral justifications for the method of violence as a way to
achieve what they perceive as justice in human affairs.

There is an imbalance here, and the imbalance is exacerbated by an approach to the conversation in which the Catholic Church, operating through the Pontifical Council for Interreligious Dialogue, seems to be willing to talk with just about anyone in the Islamic world, about virtually anything. It is time to reconceive the dialogue in frankly strategic terms. If interreligious dialogue, especially at the highest levels, decays into another form of political correctness, the Catholic Church will be of little assistance to those courageous Islamic scholars and religious leaders who want to challenge Islamist radicals and extremists. If the Catholic Church, fearful of giving offense, gives its Islamic interlocutors a pass on the tough questions—like the necessity of a sustained, public, moral condemnation of suicide bombing and terrorism in the name of Islam—then the extremists will be strengthened and the forces of reason commensurately weakened.

A strategically conceived interreligious dialogue is not simply a matter of forcing the hard questions onto the table, however. It is also, and just as much, about creating a conversation that supports the work of those Islamic scholars, lawyers, and religious leaders who are trying to develop an explicitly Islamic case for religious toleration, social pluralism, and the method of persuasion in politics—an Islamic case for what the West has come to know as civil society. The great question for Islam as a culture-forming religion—a question whose resolution will shape a lot of 21st-century history—is whether Muslims can develop a genuinely Islamic case for civility amid diversity by drawing on their own sacred texts and legal codes. It is arrogant and foolish to expect a billion Muslims around the world to become good secular liberals—as some in western governments seem to expect. The goal in the Islamic world cannot be to create the kind of thoroughly secularized public space that those currently in charge of the European Union project seem to envisage for Europe. The question being pressed by Islamic reformers is whether Islam, within its own authoritative texts and its own history, can find the resources to support those Muslims who want to build modern societies around the conviction that it is God's will that we be tolerant of those who have different understandings of God's will.

The Catholic Church, thinking strategically, would bring some important assets to the interreligious dimension of that discussion. Specif-

ically, it would bring a part of its own recent history, with which Pope Benedict XVI is very familiar. The notion of rendering unto God what is God's and to Caesar what is Caesar's—which dramatically relativizes the claims of state power—is deeply embedded in the doctrinal structure of Christianity. Yet it took the Catholic Church until 1965, with the Second Vatican Council's Declaration on Religious Freedom, to articulate from within its own theological resources a Catholic theory of pluralism and tolerance. More than 150 years of robust (and often contentious) argument preceded the Declaration. The Catholic Church learned some important things from this experience, about the development of its social doctrine through the retrieval and reconsideration of perhaps-forgotten elements of its heritage. If a positive answer is found to the crucial question of whether Islam can, within its own deep theological structure, make a similar distinction between "God and Caesar," then perhaps what the Catholic Church learned in the course of its own development of doctrine on pluralism and religious freedom could be of use to Muslims trying to forge a development in the social and political vision of their own religion.

That is the strategic purpose that should guide all levels of the Catholic dialogue with Islam: the purpose is to help Muslims develop an Islamic case for the civil, tolerant society—a case that is sustainable by recognizably Islamic warrants. The success with which the Benedictine Church pursues that strategy could have a lot to do with the unfolding of a 21st century that otherwise seems headed for a long-running confrontation between civilizations. Successful development of this kind of dialogue would also help relieve pressure on those Catholic communities that find themselves living (and sometimes dying, violently) along the jagged fault line of Catholic-Islamic conflict that runs from the west coast of Africa all the way across the globe to East Timor.

ADVENTURES IN DYNAMIC ORTHODOXY

While Pope Benedict's activity on the world stage will draw considerable media attention, his work within the Church is not of less

consequence—indeed, it is of more consequence, for the degree to which Benedict XVI can advance the authentic interpretation of Vatican II offered by the magisterium of John Paul II will have everything to do with whether the Church of the 21st century has something distinctively and intelligently Catholic to say to the modern world. John Paul II's magisterium, which Joseph Ratzinger helped shape, demonstrated that the choice before the Church was not between a dynamism unmoored from two millennia of tradition and a traditionalism stuck in one moment of the past; there was a third alternative, the Vatican II alternative—dynamic orthodoxy, the world-engaging project of *aggiornamento* rooted in a *ressourcement*, a return to the deepest sources of Christian wisdom. Again, only Pope Benedict knows the priorities in advancing this project of dynamic orthodoxy that he brought to the Office of Peter, and only he knows how those priorities might have been refined in his first months as Bishop of Rome. Still, judging from the written record and recognizing that Joseph Ratzinger had an unparalleled view of the Church's internal situation as prefect of the Congregation for the Doctrine of the Faith for almost twenty-four years, it is not unreasonable to speculate on the issues of substance and process to which he might turn his hand.

The reform of the Roman Curia

Although Benedict XVI is a true scholar-pope rather than a man of management, he may well pay more attention to questions of the Vatican's internal structure and dynamics than his predecessor. There has not been a serious reconsideration of the structure of the Roman Curia for almost forty years, since Pope Paul VI re-configured the organization chart in 1967—a process John Paul II completed, essentially according to Pope Paul's plan, in 1988. Pope Benedict likely has a very clear idea, based on close experience, of what does and does not work in this system. It should surprise no one if he attempts significant changes in the structure of the Curia.

Paul VI's curial reform of 1967 made two crucial changes, one a reflection of Paul's own experience as a curial official under Pius XI and Pius XII, and the other in order to implement various aspects of the

Second Vatican Council. The first change was to erect the Secretariat of State into a curial super-bureaucracy, through which the work of every other "dicastery" (as the various congregations, tribunals, and councils of the Curia are known) would flow. Paul VI had been a Secretariat of State man for decades and this evidently seemed to him a way to rationalize the internal process of papal governance. At the same time, however, something changed when the first among the curial dicasteries ceased to be a theological agency—the old Holy Office (of which the reigning pope had traditionally been the prefect)—and became a bureaucracy: the Secretariat of State. Over time, the Secretariat of State evolved into a kind of mini-Curia of its own, with various of its desks supervising the work of virtually every other office in the Vatican, no matter how senior. This not only led to the obvious and predictable resentments; it also created impediments to governance in a cultural environment that, at the best of times, is less than Teutonic in its efficiency.

The second change Paul VI made was to create a bevy of new curial offices to oversee various parts of the Church's mission that Vatican II had highlighted. Thus were born dicasteries that eventually became known as "pontifical councils": the Pontifical Council for the Laity, the Pontifical Council for Justice and Peace, the Pontifical Council for Promoting Christian Unity, the Pontifical Council for the Family, the Pontifical Council for the Pastoral Care of Migrants and Itinerants, the Pontifical Council for Interreligious Dialogue, the Pontifical Council for Health Care Workers, the Pontifical Council for Culture, and so forth. These new dicasteries were usually located off the main Vatican campus, at a Vatican property in Trastevere, the Palazzo S. Calisto; there they were sometimes dubbed the "junior Curia," much to their annoyance. With the exception of a dicastery like the Pontifical Council for Promoting Christian Unity, which had an obvious agenda of managing the various bilateral theological dialogues Vatican II had mandated between the Catholic Church and its many dialogue partners in the worlds of Orthodoxy and Protestantism, the original idea for most of the rest of these new curial bodies seems to have been that they would function as in-house think tanks, taking up one or two subjects a year in depth, bringing in a range of expertise, and then making their studies available to the senior parts of the Curia and to the pope.[23]

The dynamics of modern bureaucracy soon took over, however, such that, by the turn of the millennium, many of the pontifical councils were functioning like international non-governmental organizations, hosting numerous conferences and releasing streams of documents, while their presidents, who were usually cardinals, were becoming alternative or parallel spokesmen for "the Vatican" on a range of issues—which further compounded the problem of the Holy See's voice.[24]

John Paul II's curial reform of 1988 rationalized the structure that Paul VI had built, creating three types of dicasteries: congregations (like Doctrine of the Faith, Clergy, and Catholic Education), which exercise jurisdiction over one or another aspect of Catholic life; tribunals (the Church's courts); and pontifical councils (like those named just above), which do not exercise jurisdiction but rather promote pastoral activity of one sort or another. Over it all remained the Secretariat of State, divided, as noted before, into a First Section which dealt with the internal affairs of the Church and a smaller Second Section (the "foreign ministry"). By the end of John Paul's pontificate, knowledgeable observers and some curialists of a more adventurous cast of mind were suggesting that the entire structure should be reconceived.

One proposal was to dismantle the Secretariat of State in its present form, making the Second Section a congregation (as it had been before) while transforming a vastly slimmed-down First Section into the executive office of the pope. The head of the executive office of the pope would function as the papal chief of staff, while the secretary of state would take a more direct role in coordinating the work of the various dicasteries, whose heads would have more regular access to the pope than under the present scheme. Another scheme (which could conceivably be merged with the first) would change the pontifical councils into commissions working under the appropriate congregations: a return to the original "think tank" model, and a way of forestalling the further transformation of these new bureaucracies into international non-governmental organizations—which has the effect of transforming the Catholic Church into simply another international non-governmental organization. Thus the Pontifical Council for Justice and Peace would become a commission or think tank for the new congregation looking after the Church's engagement with world politics (the old Second Section), while the Pontifical Council for Promoting

Christian Unity would become a commission of the Congregation for the Doctrine of the Faith, the Pontifical Council for Interreligious Dialogue would be a commission working under the Congregation for the Evangelization of Peoples, and so forth. Under this scheme, some pontifical councils would be suppressed, while another, the Pontifical Council for Social Communications, would be merged with the Holy See Press Office and the other communications offices of the Vatican into a single center, capable of articulating a coordinated "Vatican" message.

Whether Benedict XVI tries a massive reorganization of the Curia or not, he will likely want to do something on this last point— communications. During the months before the March 2003 invasion of Iraq, there was virtually no communications discipline in the Holy See; the "foreign minister" (the secretary for relations with states) had to compete with the president of the Pontifical Council for Justice and Peace, who was in turn making statements that might have better come from the papal spokesman in the name of John Paul II. The communications muddle of the Holy See was not limited to questions of world politics, however. The reception of the 2000 CDF document *Dominus Iesus* might well have been less difficult had different signals about its concrete implications not come from various dicasteries. Then there was the initial Vatican response to what many called the Long Lent of 2002 in the United States. A forty-five-minute press conference at the end of the U.S. cardinals meeting at the Vatican in April 2002 turned into a fiasco. The cardinals had been summoned by the Pope to discuss the sexual abuse scandals in the U.S. and had, in fact, made some important decisions—but that wasn't communicated, as no prepared statement of their conclusions was distributed beforehand. At the end of the press conference, which was televised live in the United States, concerned viewers had no more idea of what the cardinals had decided than they had had when they tuned in.

A strong secretary of state might be able to impose order on the often confusing and sometimes conflicting signals various heads of dicasteries give out to the press; but it stands to reason that his job, and everyone else's, would be easier if there were one bureaucratic point-of-reference for authoritative comment on the policy of the Holy See. Joaquín Navarro-Valls brought the Holy See Press Office into the 20th

century (admittedly, in the last two decades of the century), but there were limits to what he could accomplish; as a layman, he could not, for example, be the enforcer of a measure of discipline in Vatican communications. The pope and the Church might well be better served if a single authoritative reference point for Vatican commentary (especially during times of crisis) were established. That reform, to be successful, would also require enforcing communications discipline among senior members of the Curia, and by establishing a hard rule that no document intended for the world Church is ever publicly released by any office of the Holy See unless and until it is available in both of the world Church's principal languages—English and Spanish.

A better coordinated Vatican communications strategy would be one expression of a curial reform that numerous local bishops and some curial officials believe urgent—and that is better coordination within the Curia itself. On several occasions during the pontificate of John Paul II, an uncoordinated approach to a new initiative intensified what were already difficult problems—such as providing pastoral care for Catholics in Russia. When four Catholic dioceses were erected in Russia in 2002, the Secretariat of State's original plan was to inform the Russian government only, repeating the mistake that had been made in 1991, when the Secretariat of State's failure to inform the Russian Orthodox Church of a preliminary step (the creation of Catholic apostolic administrations in Russia) had led to a virtual breakdown of the Catholic–Russian Orthodox dialogue. On the latter occasion, the Pontifical Council for Promoting Christian Unity intervened with the papal apartment when it found out what was afoot, and helped prevent a difficult situation from becoming worse. Still, it is not easy to understand why the conversation between the Secretariat of State and the Christian Unity office—both of which were responsible for aspects of this complex decision—had not taken place long beforehand.[25] Quarterly meetings of the heads of dicasteries, amplified by regular (even monthly) meetings of a deputies committee composed of the second-ranking figure in each major dicastery (supplemented by other deputies as necessary) might be two ways to ensure that, within the relatively small world of Vatican decision-making, decisions are made with full recognition of their implications for all concerned. A pope insisting that inter-dicasterial jealousies and rivalries be muted for the common

good—and enforcing that dictum through personnel changes when necessary—might also help.

Moving boxes around on organization charts is not, perhaps, something that Pope Benedict XVI naturally relishes. Yet he knows, and in his pre-papal life has written, that misconceived bureaucracies can impede the evangelical and pastoral mission of the Church. He is also, surely, aware of the problem posed by the proliferation of pontifical councils determined to have their say publicly—a phenomenon that not only complicates the Vatican's communications problems, but, as indicated above, tends to make the Catholic Church and the Holy See seem to be something other than what they are. There are, in other words, serious theological issues involved in constructing organization charts, and if he, in fact, turns his mind to a significant reform of the structure of the Curia, it may be assumed that those issues will, under Benedict XVI, drive the discussion—and the resolution of questions.

Pope Benedict's extensive experience of the Curia will likely have taught him another lesson—that there is no substitute for genuine expertise. Thus it should not be surprising if Benedict alters the current personnel policy at the higher levels of the Curia, which is based, inter alia, on the assumption that experience as a papal nuncio qualifies a man for virtually any first- or second-tier position in the Curia. Benedict XVI knows that that is not true, and the surprise would be if he did not act on that knowledge in making senior appointments—and not simply at the top of the dicasteries, but at the immediately subordinate levels.[26]

Structure is important; it was not offended bureaucratic *amour propre* or personal pique but serious theological concerns that led some of Benedict's former associates at the Congregation for the Doctrine of the Faith, as well as some of the cardinals most supportive of his election, to raise questions during the papal interregnum about a Roman Curia in which a bureaucracy (the Secretariat of State) now trumps a doctrinal agency in the flow-chart. Pope Benedict may also feel that there are too many people in some parts of the Curia and not enough in others; he may have questions about the institutional culture of the Curia and the effects of a desire for promotion on both priestly spirituality and professional performance; he may think that there is too much paper-shuffling in the Curia, which eventually eats up a lot of a

pope's time. Still, in terms of Curia reform, the crucial question about Benedict XVI will be less one of his creativity in redesigning organizational flow-charts than of his skill and shrewdness as a judge of people. The best-designed structures will not work if they are not run by the right people—and here the premium must be on genuine expertise and demonstrated skill, not on various curial forms of the old school tie. That is, of course, a lot easier to propose than to do in a bureaucratic environment that still talks of "the way we do things here." John Paul II tried to change that by example. A more direct approach, in terms of both structure and personnel, might be considered.

Reforming the episcopate

Pope Benedict XVI may decide to invest significant papal time and energy in reconfiguring the Roman Curia; or he may designate an activist secretary of state to do that in his name; or he may leave things in the Vatican more or less the way they are, bureaucratically. The Pope will have no choice, however, but to spend significant time in appointing the Catholic Church's bishops. Indeed, the argument could be made that that is Benedict's most important task. For the Catholic Church is an episcopally ordered Church, and the Church's capacity to seize evangelical opportunities, respond to crises, and meet challenges and attacks has a lot to do with the quality of its bishops.

Benedict XVI knows the world episcopate better than anyone, having met virtually all of its members during their quinquennial *ad limina* visits to Rome and having attended the numerous Synods of bishops that John Paul II summoned during his pontificate—or endured them, as he might put it, with humor in his eye. He knows that the Vatican's *Directory for the Pastoral Ministry of Bishops* is an admirable document, but that its vision of the way a local bishop should function is often unfulfilled—and he may suspect that this has something to do with the process and criteria by which bishops are appointed. He knows that his predecessor's record in appointing bishops was mixed. As a man of the Second Vatican Council, Benedict has a clear idea of the bishop's primary roles as teacher, sanctifier, and governor of his local Church; he also knows, from his German and Roman experience, that many bish-

ops in the developed world think of themselves primarily as managers and consensus-builders, episcopal referees whose task is to keep everyone in the conversation and everyone reasonably happy with it. His most recent experience with a controversy within the U.S. hierarchy— the 2004 debate over whether bishops could deny holy communion to politicians who persistently voted in favor of abortion on demand— will have reminded him that more than a few bishops are not eager to be seen as disciplinarians, even if the integrity of the Church's sacraments is at stake. His further experience in reviewing sexual abuse cases from the United States will also have reminded him of the high costs of failed episcopal leadership, of which the financial costs, while massive, are certainly of less concern than the spiritual; Benedict XVI likely knows that a scandal became a crisis because numerous bishops failed to deal with the scandal as bishops should, but rather acted as managers (and not very effective managers at that).

A reform of the procedures for nominating bishops in the Catholic Church would involve a careful study of both the process and the criteria by which potential candidates are deemed worthy of consideration.[27] Pope Benedict may not wish to make radical adjustments in the basic structure of the current nomination process: a diocese falls vacant; the apostolic nuncio is charged with developing a *terna*, or list of three names, of possible nominees; the *terna* is considered by the Congregation for Bishops in Rome; a congregational *terna* (which may or may not be the same as the nuncio's *terna*, depending on the congregation's discussions and other informal inputs) is agreed upon and submitted to the pope by the congregation's prefect during their weekly meeting; and the pope agrees to one of the names—or sends the entire list back for reconsideration, at which point a new congregational *terna* is developed, with or without input from the nuncio. Many observers suggest that the way in which this process actually works could be significantly improved.

Nuncios, for example, could be instructed to consult far more widely than they do now when seeking possible nominees for the episcopate. In theory, the nuncio is charged with consulting a range of responsible and knowledgeable persons; in practice, this often means consulting the bishops, with minimal other input. Thus the process risks becoming one in which the existing members of a men's club are asked whom

they would like to see admitted to the club (or, to put it a slightly different way, the process risks being tilted toward the maintenance of the episcopal status quo). It does not always work that way, to be sure, but that this is one dynamic in more than a few episcopal appointments is not in serious doubt. Bishops may well have insight into the qualities necessary for the episcopate; but their view may also be skewed by various factors. A much wider consultation among knowledgeable priests and laity would likely produce a richer mix of candidates—some of whom might, indeed, make the existing members of the episcopal fraternity uncomfortable, but that is not necessarily a bad thing. (A classic example of a too-narrow consultation process involved the appointment of a new archbishop for Boston in the wake of the 2002 resignation of Cardinal Bernard Law. Not a single one of the priests or distinguished lay Catholics most knowledgeable about the crumbling situation in Boston, the reasons it had happened, and what kind of leadership was necessary to turn things around was consulted by either the nunciature in Washington or the Congregation for Bishops in Rome. As a result, neither the new archbishop nor the superiors in Rome had a clear idea of what was facing Cardinal Law's successor—which was fair neither to the successor nor to the archdiocese.)

Nuncios might also be instructed not to impose artificial age thresholds for episcopal nominations—say, that a man must be at least fifty years old before he can be considered for the episcopate. As a general rule, significant experience as a priest is essential in a bishop. Yet setting an arbitrary age threshold may eliminate as candidates men in their forties who are precisely the priests of the John Paul II generation that many local churches would welcome as bishops.

Experience in a chancery office or other administrative service is usually regarded, in countries like the United States, as good preparation for the episcopate. In some cases, it can be. Eighty years after Max Weber's intellectual dissection of the dynamics of bureaucracy, however, it also should be clear that the classic bureaucratic cast of mind, emphasizing efficiency and damage control (where necessary), and preferring amelioration to confrontation, can be in tension with the Catholic bishop's duty to teach, sanctify, and govern. No man should be blackballed as a possible candidate for the office of bishop simply because he has spent a lot of time at a chancery desk; neither should

that experience be thought necessarily superior to effective service as a pastor, educator, or seminary rector.

The reforms needed here touch precisely upon that question: What are the criteria by which the Church judges that a man is a suitable candidate for bishop? The questionnaire sent out now to those asked to comment on a potential nominee is unexceptionable, asking about a priest's character, fidelity to Catholic teaching, spiritual life, habits, and so forth. It is also inadequate, for these questions do not help the nuncio or the Congregation for Bishops (or the pope) assess whether a man has the intellectual, spiritual, and personal qualities to be an apostle—which is what the Church is looking for when it chooses bishops. The present process, for example, seems to place little if any emphasis on a man's skills as a communicator and his abilities to make use of mass media; yet surely that is a crucial qualification in circumstances where the bishop's ability to explain convincingly that freedom is not really personal license and that religious conviction opens a human being up to a true dialogue with others is going to be one serious public test of his apostolic effectiveness. In the wake of the U.S. Catholic crisis of 2002, an additional set of criteria to guide the selection process was proposed—questions that might be added to the standard list on inquiries now made about possible candidates for the episcopate. Replicated here, this amplified set of questions may suggest the kind of developed criteria that ought to be urged on the nuncios and on the Congregation for Bishops:

Radical discipleship: In his life and ministry, does this priest manifest a personal conversion to Jesus Christ and a deliberate choice to abandon everything to follow Christ?

Evangelical energy: Does this priest preach the Gospel with conviction and clarity? Can he make the Church's proposal to non-believers? With charity, can he instruct and, if necessary, admonish Catholics who have embraced teachings contrary to the Gospel and the teaching authority of the Church?

Pastoral effectiveness: Has this priest ever been a pastor? Did the parish grow under his leadership? If his primary work has been as a professor in a seminary, did his students flourish under his tutelage?

Liturgical presence: How does this priest celebrate Mass, in concrete and specific terms? Does his liturgical ministry lead his people into a deeper experience of the paschal mystery of Jesus Christ, crucified and risen?

Personal example: How many men have entered the seminary because of this priest's influence? How many women have entered consecrated religious life because of his influence? Does he encourage lay movements of Catholic renewal and the development of popular piety? In sum, is he a man who can call others to holiness of life because he manifests holiness in his own life?

The courage to be countercultural: Does this priest have the strength of character and personality to make decisions that will be unpopular with other priests and religious, because those decisions are faithful to the Church's teaching and liturgical practice?

Theological literacy: Is this priest well read theologically? Does he regard theology as an important part of his vocation? Can he "translate" the best of the Church's theology, ancient and contemporary, into an idiom accessible to his people?[28]

In any serious reform of the process of nominating bishops, a broader consultation process and a more evangelical set of criteria for assessing a man's fitness for the episcopate would be good starting points, at the local level. Those reforms will not come to fruition, however, unless the process in Rome is shaped by different understandings and different criteria than those that currently prevail. Thus any pope will want to think very carefully about the man on whom he must rely in exercising his own papal authority to appoint bishops: the prefect of the Congregation for Bishops. There is, arguably, no more important job in the Roman Curia than prefect of the Congregation for Bishops; not even the prefect of the Congregation for the Doctrine of the Faith has as much direct influence on the pastoral life of the Church throughout the world. That would seem to suggest certain qualifications for the prefect who, on a weekly basis, brings the pope the choices the pope must make about the world episcopate: deep conviction about the office of bishop as being a form of apostolic headship; broad experience of the world episcopate, including personal experi-

ence as a diocesan bishop; a capacity to listen, so as to understand situations before making choices on the leadership required in those situations; a healthy skepticism about clerical favoritism; and a very large capacity for work.

The prefect of the Congregation for Bishops must also, with the pope, consider what is to be done in situations where a grave mistake has been made—where a bishop has been appointed who is either incapable of the job humanly, or who has ceased to think with the Church doctrinally. That such bishops exist was demonstrated throughout the pontificate of John Paul II; yet John Paul was often reluctant to depose malfeasant, incompetent, or heterodox bishops. When things got completely out of hand in Evreux, France, John Paul did agree to the removal of Bishop Jacques Gaillot, whose teaching on sexual ethics was indisputably beyond the boundaries of Catholic orthodoxy (Gaillot eventually established a "virtual diocese" on the Internet). But others, perhaps not quite so flamboyant as Gaillot but equally beyond the boundaries, remained in office. So did most of the bishops in the United States who had done most to turn a scandal of clerical sexual abuse into a Church-wide crisis.

During those hard months in the United States, more than one priest of the John Paul II generation said that he would only be convinced that the Vatican was serious about reform when malfeasant bishops were deposed, even if by the gentle expedient of early retirement. Genuine reform, these young priests insisted, meant accountability; and if priests were going to be held accountable for their actions—as these young priests insisted they should be—then so should bishops. It is not an easy argument to refute. The suggestion here is not for an episcopal night of the long knives, in which Pope Benedict and the Congregation for Bishops depose bishops by the dozen. But when a bishop has manifestly lost the capacity to govern, or when a bishop is taking public positions contrary to Catholic teaching (on, for example, the issue of what constitutes euthanasia), then something must be done. The French bishops' conference finally requested that the Holy See remove Jacques Gaillot from Evreux; but bishops' conferences, as a general rule, have shown a marked incapacity to be self-correcting. Unfortunately, but perhaps inevitably, Rome will have to be the disciplinarian when circumstances require—which circumstances inevitably will.

Thus the Pope and the Congregation for Bishops could consider developing a set of criteria by which the Vatican would make the judgment that a bishop must be removed from office. What are the standards to be applied, so that the judgment to depose a bishop, when it comes, is not the result of a campaign mounted by a hostile local media or by disaffected Catholics, but is, rather, a genuine act of ecclesial discernment—a judgment that the man in question has lost the capacity to govern his diocese according to the mind of the Church? Respect for the office of bishop and for the prerogatives of local bishops and bishops' conferences has created, over the years, a deep reluctance in Rome to face the fact that some bishops must be removed, for the good of the Church (and, arguably, for their own spiritual good). That reluctance must be addressed. At the same time, the Roman authorities must come to recognize that, in some circumstances, the failure to remove malfeasant, incompetent, or heterodox bishops causes far more scandal than replacing them.

Over some twenty years, Cardinal Joseph Ratzinger did not hide his concerns about the way national conferences of bishops think of themselves and function. And it seems plausible to expect that, as Benedict XVI, he will bring those concerns to his work with the bishops' conferences. He stated his concerns in a particularly blunt form prior to the 1985 Extraordinary Synod, in *The Ratzinger Report*. There, he welcomed Vatican II's strengthening of the role and responsibility of the local bishop, but argued that the implementation of that teaching had gone awry:

> The decisive new emphasis on the role of bishops is in reality restrained or actually risks being smothered by the insertion of bishops into episcopal conferences that are ever more organized, often with burdensome bureaucratic structures. We must not forget that the episcopal conferences have no theological basis, they do not belong to the structure of the Church, as willed by Christ, that cannot be eliminated; they have only a concrete, practical function.[29]

The rhetorical emphasis here was on clotted bureaucracies, but the real issue was, and is, theological: nationalism, in Ratzinger's view, is

not a category through which one can understand the reality of Church. Or, as he put it in *Il Rapporto*, "the national level is not an ecclesial dimension."[30] The global structure of the Church's governance, willed by Christ, is episcopal—the college of bishops, successors of the apostles, with and under the headship of the pope, the successor of Peter. The college of bishops does not have national subdivisions, in anything other than a practical sense. There is the college with and under the pope; there is the local bishop, incorporated into the college by episcopal ordination and communion with the Bishop of Rome. Those are the theological and doctrinal realities; anything else is a matter of practicalities.

For Ratzinger, and indeed for anyone knowledgeable about Church history, these are not abstract doctrinal and theological points. In the 18th century, the Hapsburg emperor Joseph II, who believed that "the Church is a department of the police," radically subordinated the Catholic Church to state authority by, among other things, making episcopal appointments, running the Church's finances, and issuing decrees on the liturgy; "Josephinism" is, if not a living memory, then a lively memory in the cultural milieu in which Joseph Ratzinger grew up. Even more ominously (and more recently), the limits of a nationalistic conception of Christianity were demonstrated by the *Deutsche Christen*, the "German Christians," of the Nazi period—here was nationalism transformed into a true heresy, fracturing Lutheran and Reformed Christianity in the process. Conferences also have their weaknesses in the practical order, given the compromises inevitable in such structures. Thus Ratzinger remembered that, among German Catholics, "the really powerful documents against National Socialism were those that came from individual courageous bishops. The documents of the conference, on the contrary, were often rather wan and too weak with respect to what the tragedy called for."[31]

Pope Benedict XVI will not dismantle the national conferences of bishops throughout the world—in part because they are mandated by Vatican II and he is a man of the Council; and in part because he knows they serve useful practical functions. What might be expected from Benedict is that, in meeting with individual bishops and regional groups of bishops on their *ad limina* visits to Rome, he will remind them of the dignity of their own office; that they must have the courage to

challenge conference consensus when necessary; and that they must be forthright teachers of Catholic faith in their own dioceses, not referring all publicly controversial matters to the bishops' conference. Progress toward reducing the bureaucratic clutter in national bishops' conferences would also follow the appointment of new bishops who are committed to just that task—to making the conferences useful instruments for the pastoral work of the bishops, without the bishops' mortgaging their episcopal authority in the process. The episcopal conferences thus suggest one instance where the classic Ratzingerian emphasis on smaller and purer might well be applied—not by the Pope, directly, but through the kinds of bishops he appoints.

Pope Benedict XIV's creativity will be tested, as well, in what he makes of the Synod of Bishops, another mandate of the Second Vatican Council. Virtually no one, either in the Vatican or among the world's bishops, is happy with the way the Synod has functioned over the past fifteen years or so. The process subjects everyone involved to endless speeches, usually too time-constrained to be of much substance. There is little real intellectual exchange in the Synod hall. The process is laborious and lengthy. Pope Benedict sent two signals early in his pontificate when he shortened the length of the October 2005 Synod on the Eucharist and arranged for an hour of open discussion each day the Synod is in general session. Still, Benedict and those he chooses to manage the Synod of Bishops for him will likely have to devise other, imaginative changes in Synod practice so that this body can function, not as the deliberative parliament some envision, but as an instrument of true ecclesial discernment in which bishops, bringing their own distinctive local perspectives to bear on an issue or problem, are concurrently confirmed in their stewardship of the universal Church. No one has made this work yet. Benedict XVI will likely be more open to dramatic changes in synod process than his predecessor.

The Latin American Church

As prefect of CDF, Joseph Ratzinger spent a large amount of his time dealing with theological and catechetical problems in Latin America and India: liberation theology and its various effects in the Spanish- and

Portuguese-speaking western hemisphere; the "inculturation" debate in India and its effects on theology, catechetics, and Catholic missions throughout Asia. Latin America is now home to slightly more than half the world's Catholics; Indian Catholics remain a minuscule minority, but are positioned to have a considerable effect on India's social and political evolution because India's future leaders often begin their education in Catholic schools.

These two vast areas of the world may seem to have little to do with each other. India has built the largest middle class in world history and seems poised on the brink of becoming a 21st-century economic (and perhaps political) powerhouse; it has also, at least in recent years, sustained a robust democracy, despite unresolved caste issues and pressures from Hindu nationalists. In the 1990s, Latin America seemed to have turned the corner, trading caudillos for democracy and mercantilist arrangements for the market; yet while some parts of Latin America are making economic and social progress, others have not done so, as old patterns of corruption have blocked genuine economic and legal reform. At the same time, the Latin American Church has become deeply concerned about the widespread penetration of evangelical, fundamentalist, and pentecostalist Protestantism into what was once a thoroughly Catholic continent. And, as with others of its problems, Latin Americans, including Latin American churchmen, are frequently tempted to blame all, or at least most, of the challenge of "the sects" on El Norte—the United States.

While liberation theology in its more radical forms is no longer a significant factor in Latin America, it has left intellectual and attitudinal residues throughout the continent, and among senior churchmen. Latin American bishops at the 1997 Synod on America, and at the 2001 Synod on the office of bishop in the Church, frequently spoke a soft-liberationist language in which their countries' poverty was primarily blamed on exploitation by the developed world. Privately, Latin American bishops would freely concede that political corruption, corrupt legal systems, and personal corruption were the primary causes of their economic problems; publicly, they would lay the blame on international financial institutions and "globalization" (about which they had rather vague ideas). Privately, Latin American bishops would say that the structural corruptions of their societies were compounded by the attitude

that one was a fool if one actually obeyed the law; but they said little or nothing in the Synod about the responsibilities of the Church for a situation in which vast numbers of Catholics thought—and behaved—in these terms.[32] Some Latin American bishops inveighed at the Synod against the depredations of "unbridled capitalism," but they lived in state mercantilist systems, not free market systems.

The example of India—a subcontinent that arguably began its current climb to prosperity from a lower baseline than Latin America—ought to convince reasonable Latin Americans and other Third World Catholics that incorporation into the global economy is by far the most effective means of lifting poor people out of poverty. So is the rule of law. So is a relatively mild regulatory environment; when it takes the better part of a year to get a taxi cab license, as it does in some Latin American countries, one can conclude that the state regulatory apparatus is not encouraging entrepreneurship or protecting (much less encouraging) what Pope John Paul II called the "right of economic initiative."[33] Latin America, in other words, needs to stop acquiescing in its own marginalization by laying primary blame for its incapacities on others; Latin America must look to its own house—and particularly to its social and political culture—for both problems and solutions. The Latin American Church could play a crucial role in such a transformation of understanding—if its leadership understands that some bishops, intellectuals, and activists are impeding progress by laying blame everywhere but where it primarily belongs. In order to do that, however, Latin America's bishops are going to have to divest themselves of the intellectual remnants of "Marxist analysis" that they absorbed, if largely by osmosis, from the theologies of liberation. As Archbishop Estanislao Karlic of Argentina once put it, the Church in Latin America has to make the "common good" a "living category," not simply a term in Catholic social doctrine.[34]

Pope Benedict XVI could help facilitate that process in two ways. First, he might consider challenging Latin America's bishops to a more self-critical understanding of the success of evangelical, fundamentalist, and pentecostalist Christianity in Latin America. That success is, in part, a reflection of Catholic pastoral failure: the failure to provide sufficient priests for teeming Catholic populations; the failure to create extensive educational, health care, and social service networks; the failure

to challenge those aspects of Latin machismo culture that weaken family life and impede prosperity. Evangelical, fundamentalist, and pentecostalist Christianity's growth in Latin America is due in no small part to its ability to change lives spiritually and morally—and thus to create the behavioral conditions for the possibility of economic and social progress. Thus the challenge of the evangelicals in Latin America is a challenge to a more vigorous and evangelically assertive Catholicism in which genuine conversion to Christ leads to lifestyle changes— sobriety, marital fidelity, thrift—that strengthen family life and make social progress possible.[35]

Second, Pope Benedict might complete the critique of liberation theology he began in the 1980s by helping Latin America's Catholic leaders to understand that flogging "globalization" is not an effective way to lift the poor from their poverty—or, better, to empower the poor to lift themselves from their poverty. The analysis of John Paul II's groundbreaking 1991 social encyclical *Centesimus Annus*—in which the poor are conceived as people with potential, and which stresses incorporation into systems of productivity and exchange as the key to resolving the scandal of world poverty—has been vindicated in the economic success stories of east Asia and India. Benedict XVI need not craft an extensive social doctrine of his own to change what needs changing in the mind-set of the Latin American Church's leadership; he could simply encourage a close and unbiased reading of *Centesimus Annus*.

Pope Benedict XVI faces a very large challenge in the new demographic center of world Catholicism. He was elected pope with considerable Latin American support, which bespeaks a high level of trust. Whether he can use that deposit of trust to challenge Latin American Catholicism to a new maturity—one sign of which would be a Church no longer blaming others for Latin America's underdevelopment—may have a great deal to do with whether Latin America remains the demographic bulwark of world Catholicism in the 22nd century.

The pursuit of sanctity

The Catholic Church is not in the business of designing economies and polities, however. Its mission is to form the kind of men and

women who can, through an exercise of the virtues, build economies
and polities fit for human beings made in the image and likeness of
God. Joseph Ratzinger has long been convinced that the pursuit of
sanctity is the greatest of human adventures; he has often called that
sanctity a matter of deepening one's "friendship with Jesus." How will
Pope Benedict XVI foster the sanctity of the people of the Church?
Again, he knows his own mind and his own priorities, but his past
record suggests directions in which, as pope, he might naturally turn.

The Liturgy and the Church's Life. As suggested above, Pope Benedict
will almost certainly not undertake a drastic "reform of the reform" of
the liturgy, because it is precisely that kind of wrenching-around of
the Church's worship that he judged to be misguided after Vatican II.
He will likely permit a wider use of the Tridentine Rite—Mass cele-
brated according to the Missal of Pope St. Pius V—for those who prefer
this form of the Roman rite. He will support, and may be able to help
accelerate, the process by which better translations of the Latin originals
of the Church's liturgical books are made available; Pope Benedict is
well aware that this has been a particular problem with translations into
English, and his sympathies with those who have tried to restore sacral
language to these English translations through a more rigorous transla-
tion closer to the original texts cannot be doubted. In his own papal
liturgies, Benedict XVI can be expected to encourage a revival of Gre-
gorian chant and polyphony; he is not known to be overly fond of the
Andrew Lloyd Webber style of contemporary liturgical music, and in-
sofar as papal liturgies can set an example for others musically, it can be
expected that he will do so. As a man with a profound sense of liturgical
time, convinced that the Church must encourage its people to live in the
real world of *that* time rather than simply following the rhythms of
secular-calendrical time, Pope Benedict could consider a "reform of the
reform" of the Church calendar, restoring feasts like Epiphany, the
Ascension, and Corpus Christi to their proper places rather than con-
tinuing the practice of transferring them to the nearest Sunday (which,
in the United States and Italy—but not the Vatican!—has created the
biblical absurdity of Ascension Thursday Sunday).

More fundamentally, however, Benedict XVI will likely try to accel-
erate the "reform of the reform" conceptually, by reminding the
Church of truths about the liturgy that some seem to have forgotten.

Perhaps the most basic of those truths was expressed by the Second Vatican Council in these dramatic terms:

> In the earthly liturgy we share in a foretaste of that heavenly liturgy which is celebrated in the Holy City of Jerusalem toward which we journey as pilgrims, where Christ is sitting at the right hand of God, Minister of the sanctuary and of the true tabernacle. With all the warriors of the heavenly army we sing a hymn of glory to the Lord; venerating the memory of the saints, we hope for some part and fellowship with them; we eagerly await the Savior, our Lord Jesus Christ, until he, our life, shall appear and we too will appear with him in glory.[36]

The Church's liturgy, in other words, is God's work, not our own; or, perhaps more accurately, it is our privileged participation in God's work of sanctifying his people. In his major work on the subject, *The Spirit of the Liturgy*, Joseph Ratzinger made this point through a powerful analysis of the familiar biblical story of Israel's worship of the golden calf. He begins his analysis with an interesting observation often missed by those preaching on this text: "The cult conducted by the high priest Aaron is not meant to serve any of the false gods of the heathen . . . There is no obvious turning away from God to the false gods. Outwardly, the people remain completely attached to the same God. They want to glorify the God who led Israel out of Egypt and believe that they may very properly represent his mysterious power in the image of the bull calf."

But that is precisely the problem: "The people cannot cope with the invisible, remote, and mysterious God. They want to bring him down into their own world, into what they can see and understand. Worship is no longer going up to God, but drawing God down into one's world." And when worship becomes a matter of giving ourselves the kind of God we need, worship ceases to be worship. When "worship becomes a feast that the community gives itself, a festival of self-affirmation . . . it becomes a circle closed in on itself: eating, drinking, and making merry . . . [in] a kind of banal self-gratification." That is the warning to Catholic liturgy found in this familiar biblical story: when worship is something we do for ourselves, rather than something we do because God is to be worshiped, then liturgy deteriorates into a

matter of "giving oneself a nice little alternative world, manufactured from one's own resources." And then "liturgy really does become pointless, just fooling around." Even worse, it can become "an apostasy in sacral disguise" in which "there is no experience of the liberation which always takes place when man encounters the living God."[37]

The Church's worship, Ratzinger once wrote, exists to "make man capable of the mystery." Any by "the mystery," Cardinal Ratzinger meant the mystery of God. The liturgy exists so that we can be the kind of people God wants us to be—liturgy, and the worship of God, exist so that "we become loving persons, for then we are [God's] images. For he is, as St. John tells us, love itself, and he wants there to be creatures who are similar to him and who thus, out of the freedom of their loving, become like him and belong in his company and thus . . . spread the radiance that is his."[38] That is likely to be the principal theme that Pope Benedict XVI tries to teach the Church in questions of liturgy: that any "reform of the reform" must be based on an understanding that the Church's worship on earth is a participation in the worship of the angels and saints in heaven. When it is understood that way, and when the liturgy is celebrated according to that understanding, it indeed makes us capable of spreading "the radiance that is his."

This understanding of the liturgy, and the conviction that the liturgy is the center of the Church's life, will likely influence Pope Benedict's challenge to the various "states of life" in the Church. It may be expected that he will challenge priests to lead more eucharistically centered lives, with daily Mass as a sine qua non of priestly identity and ministry. The same challenge will be put to seminaries and religious houses of formation, as well as to those living lives consecrated by the vows of poverty, chastity, and obedience: make the Eucharist once again the center of your spiritual, pastoral, and intellectual lives. In laying out these challenges, Benedict XVI will strengthen those parishes that have taken the "reform of the reform" of the liturgy seriously, and that have rediscovered Eucharistic adoration—prayer before the exposed Blessed Sacrament outside of Mass—as a powerful means of spiritual and pastoral renewal.

The Movements and the Religious Orders. Like his papal predecessor, Pope Benedict XVI sees the explosion of renewal movements and new

Catholic communities as a gift of the Holy Spirit to the post–Vatican II Church—a fruit of Vatican II, and also an antidote to the bleak period that followed the Council. During a three-day meeting in Rome that preceded the great international meeting of these movements and communities with John Paul II on Pentecost, 1998, Cardinal Ratzinger gave the keynote address and described the emergence of these expressions of the charismatic element in the Church as a moment in which the Holy Spirit "once again asked for the floor, so to speak."[39] It seems unlikely that his view has changed materially since then.

In that Roman address, Ratzinger acknowledged the problems that new movements and communities always have in the Church: particularly a tendency to exclusivity, even pride, as if the movement or community in question were the only way of being authentically Catholic. These, he suggested, were growing pains, of which both renewal movements and new communities, on the one hand, and the Church's bishops and pastors, on the other, should be aware. With sufficient faith and goodwill on all sides, these growing pains could be overcome, such that the vigorous expression of the charismatic element in the Church's life becomes the occasion to renew the Church's necessary institutional dimension, which in turn helps the charismatic element from spinning off into its own orbit. Bishops and pastors are responsible for the unity of the Church, a point that renewal movements and new communities have to remember; pastors and bishops must keep in mind that being one Church—a point that Ratzinger stressed—means being open to the fact that the Holy Spirit is full of surprises, which should not be prematurely misjudged as threats to the Church's unity.

The balance between the institutional and the charismatic has never been easily achieved over two millennia of Catholic history, and there is no reason to think that the road ahead for the new communities and renewal movements will not have its potholes. On the other hand, Pope Benedict clearly signaled his intention to make the conversion (or re-conversion) of cultures a central focus of his pontificate by his choice of papal name; and in situations where the institutional Church often seems paralyzed by its own structures, renewal movements and new Catholic communities are the most likely candidates for deploying a culturally assertive Catholicism in the early 21st century. That is the view of senior churchmen in western Europe and Canada, and it is a

view likely to be shared by the new pope. The situation in the United States is somewhat different, because the ordinary structures of parish life are far more lively in the United States than in other parts of the developed world. The United States, then, may become the largest pastoral laboratory for testing how renewal movements and new Catholic communities will work together with the Church's parish and diocesan structures to foster both the unity of the Church and the new evangelization of culture, as Cardinal Ratzinger proposed in 1998.

John Allen suggests that some members of the established religious orders—Franciscans, Dominicans, Jesuits, and so forth—felt neglected by John Paul II, who they thought had given up on them in preference for the new renewal movements and Catholic communities; Allen goes on to propose that "Pope Benedict will see religious orders as precious laboratories in which life based on objective truth can be held up to a secular, relativized world, as a reminder of what the human spirit can accomplish when it is in alignment with God's plan."[40] That seems about right, especially given the new pope's high regard for the founder of western monasticism. By the same token, it is precisely that regard for the consecrated life as lived in traditional religious orders that may lead Pope Benedict to press for genuine reform within those communities, some of which still suffer from theological dissent and lifestyle aberrations of a severe sort. As a careful student of Church history, Benedict knows that there has never been a successful reform of the Church that did not include a thoroughgoing reform of consecrated life. And while he will likely remain open to the ways in which the consecrated life of the vows is being revitalized in the new communities and renewal movements, he may also believe that something more effective must be done to deal with the problems of intellectual and moral corruption in the established orders of consecrated life than has been done in the past forty years. One early indication of how Pope Benedict plans to address these problems will come when the Society of Jesus moves to elect a new General after, as is expected, Father Peter-Hans Kolvenbach, S.J., offers his resignation—a proposal John Paul II refused to consider in 2004.

The Young. As he indicated in his conversations with Peter Seewald, Benedict XVI is well aware of the phenomenon that the American writer

Colleen Carroll Campbell describes as the "new faithful": the return to a robust, self-consciously orthodox, morally rigorous, and liturgically centered Christianity by significant numbers of young adults, many of them accomplished professionals.[41] He is also, undoubtedly, aware of John Paul II's magnetism for young Catholics; but contrary to some speculations before and after his election, Pope Benedict is not likely to be overly concerned about his own reception by the John Paul II generation. He has no intention of competing with the late pontiff as a public personality. He has his own personality, which has proven attractive to students for decades. Moreover, Benedict likely understands that it is a mistake to interpret John Paul's capacity to draw and inspire young people as a matter of a celebrity cult; it was his personal integrity and his bracing challenge that drew young adults to him. Benedict XVI is a man of similar, granite-like integrity, and he is just as much a man of challenge. Further, the young people who were the most committed members of the John Paul II generation were, at least judged anecdotally, very, very happy with the election of Joseph Ratzinger as pope. They knew him to be one of John Paul's closest associates; many of them had read in Ratzinger's extensive writings; and they, like Anna Halpine with John Paul II, will be waiting for "orders."

Those "orders" will presumably be similar to those Benedict XVI may propose to the renewal movements and new Catholic communities—expanded and more intense efforts at the conversion of culture. At the same time, though, Pope Benedict will continue to remind the young, as he reminds the rest of the Church, that everything depends on friendship with Christ.

Catholic Universities. Benedict XVI's care for the young, his intense involvement for more than a half-century with the life of the mind, and his concern to promote sanctity in the Church all intersect in the Church's institutions of higher education—the largest network of which is in the United States. It is interesting to speculate as to what might have happened had Cardinal Joseph Ratzinger accepted Pope John Paul II's first invitation to come to Rome, in 1979, to become the prefect of the Congregation for Catholic Education. Would John Paul's 1990 apostolic letter on the Catholic identity of Catholic colleges and universities, *Ex Corde Ecclesiae* [From the Heart of the Church], have been more vig-

orously enforced—would the prefect of the Congregation for Catholic Education have taken the argument over Catholic identity right into the universities themselves—had Ratzinger been in charge of *Ex Corde's* implementation? Possibly.

Cardinal Joseph Ratzinger knew, and Pope Benedict XVI surely knows, that there are some circumstances in which Catholic schools get so hollowed out that it becomes ridiculous for the institutional Church to try and hold on to them. Here, as elsewhere, the experience of National Socialist Germany, where the bishops fought fiercely to maintain control of Catholic schools that, under Nazi influence, had ceased to be Catholic in anything but formal name, weighs on Ratzinger's judgment. In some instances, he has argued, the Church, in the sense of the hierarchical Church, simply has to let an educational institution go, recognizing that the situation cannot be retrieved.[42]

Surely, though, the hierarchical Church's responsibility in these instances does not end with the judgment, however reluctant, that the situation is not retrievable. If an institution still presents itself to the public—including parents of prospective students, alumni, and donors—as a "Catholic institution of higher education" when what is being taught on the campus in question is not the mind of the Church, and when the manner of life fostered on campus has little or nothing to do with a Catholic understanding of the virtues, then the hierarchical Church, it can be argued, has a responsibility to make known its judgment that this particular college or university is no longer considered a Catholic institution by the teaching authority of the Church. If that judgment is not made publicly visible, then parents and prospective students alike may be gravely disappointed—and, as experience shows, students may lose their faith; alumni and other donors will be deceived; and the false situation of pretending that such-and-so is a Catholic school, which Cardinal Ratzinger once deplored as "inane," will continue, to the detriment of virtually all concerned.

It is not the pope's job, in the first instance, to make the declaration that X College or Y University can no longer be considered a Catholic institution; the first responsibility here lies with the local bishop. But it can be argued that the pope's responsibility, in advancing the sanctification of the young, includes pressing local bishops to do their duty on this front, if they are not—and supporting them, if they are. Some

argue that the new pope will not waste time and energy on efforts to enforce *Ex Corde Ecclesiae*, because he knows that some Catholic colleges and universities, particularly in America, are beyond retrieving. There is a difference, however, between wasting energy on trying to retrieve the unretrievable, and making public the Church's judgment that the situation is irretrievable. Pope Benedict XVI cares a great deal about the integrity of Catholic intellectual life, and it should not come as a surprise if he takes at least some vigorous steps to defend that integrity by stopping the charade that allows institutions manifestly not Catholic to present themselves as if they were. Charges of a breach of academic freedom will surely follow. So should the response that this has nothing to do with academic freedom and everything to do with consumer protection: the protection of students, parents, alumni, and donors against an institution falsely advertising itself as Catholic.

MOZART AND THE CHAIR

In the rapid flurry of journalistic portraiture that followed Joseph Ratzinger's election as Pope Benedict XVI, his musical interests were frequently cited, and more than one reporter described him as a Beethoven aficionado. No doubt Pope Benedict respects Beethoven's achievement, but his own musical orientation is actually different. Growing up near the German-Austrian border, he and his family were drawn into the musical orbit of nearby Salzburg—and to be drawn into Salzburg means to be drawn into Mozart. There, Ratzinger told Peter Seewald, "Mozart thoroughly penetrated our souls, and his music still touches me very deeply, because it is so luminous and yet at the same time so deep. His music is by no means just entertainment; it contains the whole tragedy of human existence."[43]

Which is certainly true enough, as anyone familiar with Mozart's unfinished *Requiem* will readily testify. Still, it would seem to be an established law of human personality that, while a Beethoven man may have a lot of dark, brooding corners in his soul, a Mozart man is someone who is, fundamentally, a happy person—even if that happiness is a happiness on the far side of tragedy. Musically inclined theologians

sometimes say that, while Bach is what the angels play in heaven on high days and holy days, they turn to Mozart when they're playing for the sheer pleasure and joy of it. Joseph Ratzinger never discussed this in his theological reflections on angels, but he may well agree.

And that, in a sense, brings his understanding of the papacy into focus one last time: for Benedict XVI, the Office of Peter is charged with promoting and defending the integrity of the faith through which human beings may enter the joy that is on the far side of the tragic—the Easter that follows Good Friday. Pope Benedict made precisely this, and related, points in his sermon at the Basilica of St. John Lateran, his cathedral church as Bishop of Rome, on May 7, 2005.

It is only within the mystery of Christ, he began, that the mystery of the chair, symbol of the bishop's teaching authority, can be understood. During that Ascension weekend, the Pope said, the Church should reflect on the fact that, in the Ascension, the Risen Christ takes our humanity into the very life of God himself: "And given that God embraces and sustains the whole cosmos, the Lord's Ascension means that Christ has not gone far away from us, but now, thanks to the fact that he is with the Father, he is close to each one of us forever." We may turn our backs on him (as so much of Europe and other parts of the developed world have done); but "he always awaits us and is always close to us."

Christ told his disciples, before his Ascension, to be his "witnesses." Another word for "witness," Benedict XVI reminded his congregation, is "saint." A saint is someone who is a "shining light capable of leading [others] to Christ." Once again, Benedict was proposing, the Church must learn to think of itself as a "communion of saints." Yet that communion of saints has a structure, also willed by Christ—it is the responsibility of the Church's bishops, the successors of the apostles, "to make this network of witnesses endure with the passing of time." That is why the first task of every bishop, and most especially the bishop who is the successor of Peter, must be the proclamation of the truth that "Jesus is Lord." Like Peter, Peter's successor must "strengthen the brethren" in their confession of that absolutely basic, three-word Christian creed. And that is what any bishop's chair, and certainly the Chair of Peter, is for: its teaching authority exists, not to flatter him who sits there, but "to give testimony of Christ," to articulate the "living voice of the Church" which teaches the truths for which human beings have lived and died.

He was not, Benedict XVI insisted, "an absolute monarch." The pope, too, was subordinate—subordinate "to Christ and his word." Thus "the pope must not proclaim his own ideas, but bind himself constantly and bind the Church to obedience to the Word of God, in [the] face of attempts to adapt and water down, in the face, as well, of all opportunism." The awesome responsibility of the Bishop of Rome is to ensure that the Word of God "continues to be present in its grandeur and resonating in its purity." The Chair of Peter exists so that the one who speaks from the Chair bears witness to the fact that "the Word of God—his truth!—may shine among us, indicating the way to us."

And the way, ultimately, is the way of love. St. Ignatius of Antioch described the see of Rome as that see "which presides in love." This is no vague sentimentality. The love here is the love of the crucified and risen Christ, "always made tangible among us" in the Eucharist, over which the Bishop of Rome also presides. So the two go together: teaching from the Chair and presiding at the Eucharistic table. "To preside in doctrine and love, in the end, must be only one thing: all the doctrine of the Church, in the end, leads to love." Doctrine is not an impediment on the Christian journey, as so many have misunderstood it. Doctrine is the vehicle that permits the journey in the first place—and that keeps the journey pointed in the right direction.

That was what it meant to be the father of this "great family of God, that family in which there are no strangers." It means to preside in truth and in love, knowing that truth and love are both of God.

And that, in the final analysis, is what Pope Benedict XVI proposes to do: to be a servant of truth and love, in the conviction that "in the end, the world is not redeemed by machinery, but by love."[44] The commitment he has made, before God, the Church, and the world, is to show the way toward truth and love. It promises to be a most interesting journey indeed.

Acknowledgments

I HAVE ACCUMULATED A large number of author's debts in the course of preparing this book, and it is a pleasure to acknowledge them.

Carrie Gress not only kept my office going while I was in Rome for John Paul II's funeral and Benedict XVI's election; she did invaluable research throughout the writing and was also instrumental in preparing the briefing book that guided NBC News through these epic events. Katie Lenczowski and Mary Katherine Sheena did excellent work as interns. Adam Keiper and Brother Tomasz Grabowski, O.P., were gracious and efficient with technical assistance. My best thanks, too, to the president of the Ethics and Public Policy Center, M. Edward Whelan III, and to all those who make EPPC's Catholic Studies work possible, for their stalwart support.

My brother, Dr. John H. Weigel, was a steady source of medical insight during the last illness of John Paul II.

Todd and Jane Flanders, and Father Jacek Buda, O.P., saved me when I thought I was lost—or, perhaps better, the book's outline had been lost, and my spirits with it. Father Jay Scott Newman was, as always, a helpful friend. Robert Louis Wilken makes German seem a reasonable language. Erica and Scott Walter directed me to materials about and by Joseph Ratzinger that I would not otherwise have encountered. As he has done for years, Anthony Sivers was most helpful in keeping me informed of the goings-on in the British press.

As viewers of MSNBC now know, Elizabeth Lev is the best English-language art and architecture guide in Rome, period. She is also a great friend and a patient provider of the telling artistic or architectural detail.

My first thanks for help in Rome in April 2005 must go to Sister Mary Christine, R.S.M., and her associates Sister Mary Joanna, R.S.M., Sister Mary Christa, R.S.M., and Sister Elizabeth Mary, R.S.M. Best thanks, too, to Mother Mary Quentin Sheridan, R.S.M., for her generosity, good sense, and good humor.

Rome during that remarkable month was truly a gathering of the great Catholic family, among whom I must mention some friends whose presence in my life during the drama of April 2005 was much appreciated: Cardinal William Baum, Rocco Buttiglione, Michael Cassabon, Father Raymond de Souza, Father Joseph Augustine DiNoia, O.P., Jean Duchesne, Father James Farnan, Father Kevin Flannery, S.J., Archbishop John P. Foley, Msgr. Thomas Fucinaro, Father Richard Gill, L.C., Mary Ann Glendon, Archbishop James M. Harvey, Kishore Jayabalan, Father Paul Mankowski, S.J., Krzysztof Mięsożerny, Father Christopher Nalty, Father Richard John Neuhaus, Michael Novak, Robert and John Paul Odle, Cardinal George Pell, Roberto Presilla, Cardinal Christoph Schönborn, O.P., Father Robert Sirico, Father K. Bartholomew Smith, Vittorio Sozzi, Msgr. Daniel Thomas, Father Thomas Williams, L.C., and Msgr. Alfred Xuereb.

Several Polish friends shared stories of the death of John Paul II and the election of Benedict XVI: Teresa Malecka, Paweł Malecki, Piotr Malecki, Maria Rybicka, Hanna Suchocka, Karol Tarnowski, and Father Maciej Zięba, O.P.

Among the scribes and broadcast journalists, I owe special thanks to John L. Allen Jr., Raymond Arroyo, Alejandro Bermudez, Jeff Israely, Sandro Magister, Jon Meacham, Philip Pulella, David Quinn, Tunku Varadarayan, and the members of the Borgo Pio Sanhedrin. Austen Ivereigh, who has traded in his journalist's notebook (temporarily, I hope), remained a helpful friend.

I'm grateful, and the reader should be, for close readings of the manuscript by Carrie Gress, Father Richard John Neuhaus, Michael Novak, and Joan Weigel.

It has been my privilege to work with NBC News since 1999. Professionalism combined with calm amid the storm of events is always impressive, and I salute all those NBC and MSNBC colleagues to whom I have dedicated this book—most certainly including the engineers and technicians whom viewers never see but who make every-

thing possible and seemingly effortless. Of those with whom I worked most directly, I owe special thanks to the following: Chris Airens, Joe Alicastro, Philip Alongi, Gene Choo, Katie Couric, Subrata De, Clare Duffy, M. L. Flynn, Jean Harper, Lester Holt, Chris Jansing, Margie Lehrman, Mark Lukasiewicz, Jim Maceda, Keith Miller, Frieda Morris, Mimi Mouakad, Elena Nachmanoff, Michele Neubert, Beth O'Connell, Michael Sonnessa, Marjorie Weeke, Stephen Weeke, Brian Williams, and John Zito.

Diane Reverand commissioned this book while at HarperCollins, and I remain grateful for her friendship, which was so important in creating *Witness to Hope*—to which this is a kind of sequel, if of a different genre. Tim Duggan's succession as my editor at HarperCollins was a blessing. Thanks, as always, to my agent, Loretta Barrett.

It should go without saying, but probably should be said, that none of these friends and colleagues bears any responsibility for the analysis here—that responsibility is mine alone.

<div align="right">

G.W.

July 29, 2005

Memorial of St. Martha

</div>

Notes

1. THE DEATH OF A PRIEST

1. Cited in George Weigel, *Witness to Hope: The Biography of Pope John Paul II*, revised paperback edition (New York: HarperCollins, 2005), p. 395.
2. *L'Osservatore Romano* [English Weekly Edition], 2 February 2005, p. 1.
3. John L. Allen Jr., *The Rise of Benedict XVI: The Inside Story of How the Pope Was Elected and Where He Will Take the Catholic Church* (New York: Doubleday, 2005), p. 23.
4. *L'Osservatore Romano* [English Weekly Edition], 9 February 2005, p. 1.
5. *L'Osservatore Romano* [English Weekly Edition], 16 February 2005, p. 3.
6. *L'Osservatore Romano* [English Weekly Edition], 23 February 2005, p. 1.
7. Canon 332 of the *Code of Canon Law* governs the possibility of a papal abdication: "If it should happen that the Roman Pontiff resigns his office, it is required for validity that he makes the resignation freely and that it be duly manifested, but not that it be accepted by anyone." In the section of the Code dealing with the resignation of ecclesiastical offices in general, Canon 188 proscribes resignation under coercion: "A resignation submitted out of grave fear, which has been unjustly inflicted, or because of fraud, substantial error or simony is invalid by the law itself."
8. See Allen, *The Rise of Benedict XVI*, pp. 28, 31. The notion of an "elective tracheotomy" was foreign to some American physicians, who took the view that one didn't perform a tracheotomy on a patient with numerous other problems unless the patient was in danger of choking to death.
9. See Allen, *The Rise of Benedict XVI*, p. 31.
10. *L'Osservatore Romano* [English Weekly Edition], 16 March 2005, p. 1.
11. *L'Osservatore Romano* [English Weekly Edition], 23 March 2005, p. 1.
12. *L'Osservatore Romano* [English Weekly Edition], 30 March 2005, p. 7.
13. *L'Osservatore Romano* [English Weekly Edition], 30 March 2005, p. 1.
14. Cited in Allen, *The Rise of Benedict XVI*, p. 39.
15. Further details of the last two days of John Paul II's life may be found in Allen, *The Rise of Benedict XVI*, pp. 37–42.
16. Cited in Matthew Bunson, *We Have a Pope! Benedict XVI* (Huntington, Ind.: Our Sunday Visitor Publishing Division, 2005), p. 36.

2. THE CHURCH THAT JOHN PAUL II LEFT BEHIND

1. Apostolic constitutions and encyclicals are particularly weighty papal documents, legally and/or doctrinally. An apostolic letter carries less, but not insignificant, magisterial weight, often addressing a subject thought not quite appropriate for an encyclical. John Paul II used the form of an apostolic exhortation, which falls on the scales of magisterial weight somewhere between an encyclical and an apostolic letter, but below an apostolic constitution, to complete the work of Synods of Bishops.

2. For reasons explained in the author's *Witness to Hope, Person and Act* is the more accurate translation of Karol Wojtyła's principal philosophical work, *Osoba y czyn* (Lublin: KUL Press, 1994). The presently available English-language edition, *The Acting Person*, is a less than fully accurate rendering of Wojtyła's thought, a problem reflected in the inadequate and somewhat distorting English title. For details, see Weigel, *Witness to Hope*, pp. 172–76.

3. See *Origins* 8:20 (November 2, 1978); translation revised by the author.

4. John Paul II, *Redemptoris Missio*, 39.

5. See, for example, Avery Cardinal Dulles, S.J., "John Paul II and the Mystery of the Human Person," *America*, February 2, 2004, pp. 10–22.

6. Pope Paul VI thought this problem of keys sufficiently serious that, on his instruction, a *Nota praevia explicativa* [Prefatory note of explanation] on certain questions of papal and episcopal authority, and on the relationship of papal primacy to episcopal collegiality, was appended at the last minute to the Dogmatic Constitution on the Church [*Lumen Gentium*], to guide subsequent interpretations of this crucial text.

7. Benedict XV was elected on September 3, 1914, just weeks after the "guns of August" began World War I. Benedict was an experienced diplomat who understood exactly what was at stake in this intra-civilizational death struggle. Yet his efforts at mediation were of so little consequence that few of the standard histories of the war even mention them, except to note that the Treaty of London, which bound Italy to the Allied side, contained (at Italy's insistence) a secret provision that the Holy See would have no role at the post-war peace conference—as it had had at the 19th-century Congress of Vienna.

8. On John Paul II's role in the collapse of European communism, see George Weigel, *The Final Revolution: The Resistance Church and the Collapse of Communism* (New York: Oxford University Press, 1992; paperback edition, 2003), and the relevant sections of Weigel, *Witness to Hope*, which also contains an extensive bibliography of other works on the Pope and the communist crack-up. The Pope's role in the democratic transitions in east Asia and Latin America is also discussed in detail in *Witness to Hope*.

9. John XXIII had, of course, discussed human rights in the 1963 encyclical *Pacem in Terris* [Peace on Earth], as the Second Vatican Council had done in its Pastoral Constitution on the Church in the Modern World [*Gaudium et Spes*, Joy and Hope]. John Paul II's extension of that discussion, his demonstration in Poland in June 1979 that such ideas could have real effect, and his articulation of those ideas in a humanistic vocabulary that could be engaged by all took the Catholic discussion (and Vatican diplomatic practice) to an entirely new level.

10. John Paul II, "Address to the Fiftieth General Assembly of the United Nations Organization," 18; emphasis in original.

11. Technically speaking, Opus Dei is not a renewal movement, but a kind of world-wide diocese, led by a bishop. Nonetheless, as its outreach and modus operandi tend to reflect the charismatic element of the Church, it can be located here without too much distortion.

12. For a more detailed discussion of John Paul II's understanding of the quest for Christian unity, see George Weigel, *The Truth of Catholicism* (New York: Harper-Collins, 2001; Harper Perennial paperback, 2002), pp. 131–37.

13. For the full text of *Dabru Emet* and a more thorough discussion of Catholic-Jewish relations, see Weigel, *The Truth of Catholicism*, pp. 137–43.

14. Author's interview with Archbishop John Onaiyekan, November 30, 2001.

15. *"Murzyn"* [The Negro] from *Kościół* [The Church], in Karol Wojtyła, *Poezje i dramaty*, second revised edition (Kraków: Znak, 1998), p. 73; translated by the author, Sister Emilia Ehrlich, O.S.U., and Marek Skwarnicki.

16. See Philip Jenkins, *The Next Christendom: The Coming of Global Christianity* (New York: Oxford University Press, 2002), p. 58.

17. Catholic growth in Africa is one facet of the larger phenomenon of rapid Christian growth south of the Sahara. Philip Jenkins illustrates the comparative significance of this at one juncture by noting that, by the mid-21st century, Uganda alone will have more Christians than several of the largest European countries—together (see Jenkins, *The Next Christendom*, p. 91). In a broader Third World/First World perspective, Jenkins notes that metropolitan Manila today has as many Catholics as the Netherlands (see Jenkins, *The Next Christendom*, pp. 91, 98).

18. Author's interview with Archbishop John Onaiyekan, November 30, 2001.

19. John Paul II's firm stance against the claim by various western governments and the U.N. health bureaucracy that condoms were the only answer to the African AIDS crisis brought him a lot of abuse during his lifetime; one member of the committee that awards the Nobel Peace Prize publicly announced his determination to block John Paul's receipt of the prize precisely because of this stance. The abuse continued post-mortem: Johann Hari, writing on the op-ed page of *The Independent*, informed British readers on the day of the Pope's funeral that, because of John Paul's stance on AIDS prevention, "one day, the fatuous tributes of the past week will rot, and his name will be cursed here on earth" (Johann Hari, "History will judge the Pope far more harshly than the adoring crowds in Rome," *The Independent*, April 8, 2005).

 Africa's bishops had a different view. As Archbishop Onaiyekan once put it, the key to coping with AIDS is behavior change; and that was why he and other bishops were talking to young people in these terms: "What is somebody telling you when they hand you a box of condoms? They're telling you that you're an animal who can't control itself. They're killing you. You don't have to have sex, like they say" (author's interview with Archbishop John Onaiyekan, November 30, 2001). The Ugandan ABC program, the only large-scale success story in African AIDS prevention, bears out empirically what John Paul II and bishops like John Onaiyekan were arguing and teaching morally.

20. Author's interview with Archbishop John Onaiyekan, November 30, 2001.

21. Nuns were sometimes the targets of predatory clergy, a point admitted by Vatican spokesman Joaquín Navarro-Valls in 2001, who nonetheless insisted that the problems were "circumscribed to a limited geographic area" (see "Abused nuns: the evidence," *The Tablet*, March 31, 2001, pp. 467–68).

22. How Africa's "New Testament Christianity" might shape the world Church is another theme explored in Jenkins, *The Next Christendom.*

23. See "A Report on the Crisis in the Catholic Church in the United States," prepared by the National Review Board for the Protection of Children and Young People, established by the United States Conference of Catholic Bishops, February 27, 2004; the numbers behind the Review Board's analysis may be found in "The Nature and Scope of Sexual Abuse of Minors by Catholic Priests and Deacons in the United States 1950–2002," a research study conducted by the John Jay College of Criminal Justice, City University of New York, February 2004. See also George Weigel, *The Courage To Be Catholic: Crisis, Reform, and the Future of the Church* (New York: Basic Books, 2002; revised paperback edition, 2004).

24. Letter to the author from Archbishop Edwin F. O'Brien, June 10, 1997.

25. Pierre Manent, "Current Problems of European Democracy," *Modern Age,* Winter 2003, p. 15.

26. See John Paul II, *Ecclesia in Europa,* pp. 4, 7–8, 25. For more on Europe's crisis of civilizational morale, and John Paul II's attempt to address it, see George Weigel, *The Cube and the Cathedral: Europe, America, and Politics Without God* (New York: Basic Books, 2005).

27. The full text of this important address may be found at http://www.geocities.com/ trvalentine/orthodox/bartholomew_phos.html.

28. These three points were highlighted in the author's interview with Cardinal Francis George, O.M.I., on October 20, 2001.

29. Author's interview with Cardinal Walter Kasper, February 19, 2002.

30. Author's conversation with Archbishop Ioan Robu, September 5, 2001.

31. On these and other aspects of the episcopal role in turning scandal into crisis, see Weigel, *The Courage To Be Catholic,* chapter 4.

32. For a more detailed portrait of the attempt to reform the Jesuits, see Weigel, *Witness to Hope,* pp. 425–30, 468–70.

33. According to official statistics for 2004, released by the Society of Jesus, 4,003 (20.2 percent) of the world's 19,850 Jesuits live in what is called the "South Asia Assistancy," which, for all practical purposes, means India. The impending influence of Indian Jesuits in the Society is a matter of age as well as numbers; while there are 6,639 Jesuits in Europe, they are, as a group, considerably older than the Indians.

34. See Raymond Arroyo, *Mother Angelica: The Remarkable Story of a Nun, Her Nerve, and a Network of Miracles* (New York: Doubleday, 2005).

3. THE TEARS OF ROME

1. See Allen, *The Rise of Benedict XVI,* p. 42.

2. See Weigel, *Witness to Hope,* pp. 225, 405. When he called the Pope on December 7, 1980, to brief him on U.S. intelligence about a possible Soviet invasion of Poland and what the Carter administration and its U.S. labor movement allies proposed to do to prevent it, Brzezinski asked the Pope for his private phone number, in case circumstances required him to call Rome again. There was a pause, and then the national security advisor heard the Pope asking Msgr. Dziwisz, in a loud whisper, "What's my phone number?"

3. Timothy Garton Ash, "The first world leader," *Guardian,* April 4, 2005.

4. Cited in Mark Steyn, "Why progressive Westerners never understood John Paul II," *Daily Telegraph*, April 5, 2005.

5. Charles Krauthammer, "Pope John Paul II," *Washington Post*, April 3, 2005.

6. Robert D. McFadden, "All-Embracing Man of Action for a New Era of Papacy," *New York Times*, April 3, 2005.

7. "Pope John Paul II, Keeper of the Flock for a Quarter of a Century," *New York Times*, April 3, 2005.

 The *Times*'s inability to understand John Paul II was long-standing. On June 5, 1979, the fourth day of the Pope's epic first pilgrimage to Poland, the *Times* editorialized, "As much as the visit of Pope John Paul II to Poland must reinvigorate and inspire the Roman Catholic Church in Poland, it does not threaten the political order of the nation or of Eastern Europe." The *Times*'s view was not shared by Leonid Brezhnev and Yuri Andropov.

8. Cited in Mark Steyn, "The Pope's Divisions," at www.steynonline.com.

9. "Pope John Paul II," *Washington Post*, April 3, 2005.

10. *Daily Telegraph*, April 4, 2005.

11. Graham in *Newsweek*, April 11, 2005; Gibbs in *Time* online edition, posted April 3, 2005.

12. Quoted in Michael Paulson and Diego Ribadeneira, "A life for history," *Boston Globe*, April 3, 2005.

13. Cited in Virginia Heffernan, "Pope John Paul Appraised as Pope, Not Rock Star," *New York Times*, April 5, 2005.

14. Marco Politi, "A man ill at ease in his own century," *The Tablet*, April 9, 2005, p. 25.

15. Thomas Cahill, "The Price of Infallibility," *New York Times*, April 5, 2005.

16. Clifford Longley, "The best and worst of times," *Guardian*, April 2, 2005.

17. "French secular politicians criticize flag tribute to pope," *Wall Street Journal*, April 4, 2005; "Ireland argues over day off for pope's funeral," *Wall Street Journal*, April 4, 2005.

18. John Paul II, "Address to the Fiftieth General Assembly of the United Nations Organization," p. 2.

19. Cited in Timothy Garton Ash, *The Polish Revolution: Solidarity* (Sevenoaks, UK: Hodder and Stoughton, 1985), p. 280.

20. The only officials of the highest rank who retain their positions on the death of a pope are the *camerlengo* (or "chamberlain," who must look after the temporal affairs of the Church during the interregnum and who has certain important ceremonial functions in conducting the papal obsequies); the head of the Apostolic Penitentiary (who must be able to respond to urgent questions of conscience during the interregnum, for the mercy of Christ, manifest through the ministry of the Church, cannot be put on hold); the papal vicar for Rome (because the pastoral life of the Roman diocese must continue); and the papal vicar for Vatican City and the archpriest of St. Peter's (for the same reason). The second-ranking official in each curial office, usually styled the "secretary," keeps the basic machinery of the office running during a papal interregnum, but can make no policy decisions.

21. During John Paul II's funeral, BBC television ran a subtitle that mentioned "Karma Light" nuns; see Libby Purves, "The BBC's subtitle service produced a troop of Karma Light nuns," *The Tablet*, May 7, 2005, p. 15.

22. Allen, *The Rise of Benedict XVI*, p. 58.

23. In June, Archbishop Dziwisz would announce that he had not burned the late Pope's notes, on the grounds that they were of importance to history and scholarship.

24. The Italian translation of the Pope's testament, released by the Vatican, completely missed the fact that, for John Paul II, the Polish noun *środowisko* was personal, not impersonal: the translators in the Secretariat of State didn't recognize the name the Pope used for the network of those students he had met in the late 1940s and the 1950s, men and women who remained his closest lay friends throughout his life. The Italian translation of "milieu" (which carried no explanatory note) was picked up by others, with the net result being that one of the most personal elements in the testament was almost entirely ignored—except, of course, by the members of John Paul II's *Środowisko*.

25. Among the guests who managed to get invited by the Pontifical Council was the Rev. Jesse Jackson, hitherto not known for his prominence in the ecumenical theological dialogue.

26. The full text of the *rogito* can be found in Bunson, *We Have a Pope!*, pp. 44–46.

27. The "orders" of cardinals, while honorific today, find their origin in the College of Cardinals as a college of the Roman clergy: the bishops from the six immediately surrounding areas (the "cardinal bishops" of the so-called suburbicarian sees around Rome), local pastors ("cardinal priests"), and Roman deacons (the "cardinal deacons"). In contemporary practice, "cardinal priests" are typically residential archbishops or bishops from around the world, while "cardinal deacons" are usually curial officials in Rome; the six "cardinal bishops" are senior members of the College whom a pope wishes to honor in a special way. The six cardinal bishops choose the dean and vice dean of the College, with their choice ratified by the pope. Precedence in the other two orders of cardinals is determined by longevity in the College, with an order of precedence established for each new "class" of cardinals at the consistory in which they receive the red hat.

28. The *Annuario Pontificio* accords the title to Pope St. Nicholas I (858–867), but the title is virtually never used in Catholic practice or in histories of the papacy.

29. The Apostolic Camera is the office of the *camerlengo*; the Prefecture of the Papal Household is responsible for the public schedule of the pontiff; the Chapter of St. Peter's is a body of senior priests under the leadership of the archpriest of the basilica. The addition of the seal to the Office of Pontifical Liturgical Ceremonies to the traditional three seals of the Apostolic Camera, the Prefecture of the Papal Household, and the Chapter of St. Peter's was an innovation by the papal master of ceremonies, Archbishop Marini, whose otherwise admirable planning of the papal obsequies, the ritual of the conclave, and the papal installation Mass gave a noticeable (and unprecedented) prominence and public visibility to . . . the papal master of ceremonies and his assistants.

4. GOD'S CHOICE—THE CONCLAVE OF 2005

1. Pope John Paul II, *Roman Triptych: Meditations*, translated by Jerzy Pieterkiewicz (Washington, D.C.: USCCB Publishing, 2003), pp. 24–25.

　　　Interestingly enough, Cardinal Joseph Ratzinger had a different, if not ultimately contradictory, view of the Holy Spirit's function in a conclave. In an interview on German television in 1997, he was asked about the Holy Spirit's responsibility for the outcome of an election. His answer was striking: "I would

say that the [Holy] Spirit does not exactly take control of the affair, but rather like a good educator, as it were, leaves us much space, much freedom, without entirely abandoning us. Thus the Spirit's role should be understood in a much more elastic sense, not that he dictates the candidate for whom one must vote. Probably the only assurance he offers is that the thing cannot be totally ruined." [Cited in Allen, *The Rise of Benedict XVI*, p. 6.]

2. See Werner Goez, "Election, Papal," in *Dictionary of Popes and the Papacy*, Bruno Steimer and Michael G. Parker, eds., translated by Brian McNeil and Peter Heinigg (New York: Herder and Herder/Crossroad, 2001), and J. N. D. Kelly, *The Oxford Dictionary of Popes* (New York: Oxford University Press, 1986).

3. According to one well-recycled conclave story, when Cardinal Merry del Val approached the now-enthroned Benedict XV to kiss his foot, knee, and hand, as ritual then provided, the new pope looked at him and frostily quoted Psalm 118.22: "The stone that the builders rejected has become the cornerstone." To which the unabashed Merry del Val replied with the psalm's next verse: "This is the Lord's doing; it is marvelous in our eyes." One addendum to this tale has it that Merry del Val was subsequently ordered to move out of the Vatican within forty-eight hours.

4. These and a host of other fascinating details are available in an invaluable resource now, alas, out of print: Matthew Bunson, *The Pope Encyclopedia: An A to Z of the Holy See* (New York: Crown Trade Paperbacks, 1995).

5. Once cardinals began to be created in the New World, the rule which then specified that the conclave had to begin ten days after a pope died made it almost impossible for cardinals from the western hemisphere to arrive in time to vote. Gibbons took part in 1903 only because he happened to be in Europe when Leo XIII died. In 1914, Gibbons, William O'Connell of Boston, and Louis-Nazaire Bégin of Québec all arrived after the cardinals had elected Benedict XV. In 1922, O'Connell and Bégin were late again, as was Denis Dougherty of Philadelphia; thus in 1922 there were no cardinal-electors from the New World. Pius XI changed the ten-day rule to make participation by cardinals distant from Rome more possible. O'Connell and Dougherty finally made it in time in 1939, where they were joined by George Mundelein of Chicago and the unfortunate Bégin's successor in Québec, Jean-Marie-Rodrigue Villeneuve, O.M.I. Two Latin American electors also helped choose Pius XII in 1939: Santiago Luis Copello of Buenos Aires and Sebastião Leme de Silveira Cintra of Rio de Janeiro.

6. John Paul II, *Universi Dominici Gregis*, introduction; the legislative suppression of these two methods of election is at #62.

7. John Paul II, *Universi Dominici Gregis*, introduction.

8. John Paul II was not unaware of the concern that the comforts of the Santa Marta (as everyone quickly started calling it, using the Italian form) might stretch things out in a conclave. When a visitor once jokingly put this to him, suggesting that the Santa Marta might be a bit too nice for quick work, the Pope immediately returned service and said (in a neat reference to the goings-on at Viterbo in 1241), "After two weeks, retractable roof!"

9. John Paul II, *Universi Dominici Gregis*, 55.

10. John Paul II, *Universi Dominici Gregis*, 75.

 For some reason, various commentators suggested in April 2005 that the move to a simple-majority election could come after only a week. There is no plain reading of *Universi Dominici Gregis* 74–75 that supports that claim.

11. This concern was often raised by (to use the conventional imagery) Catholic "progressives," including the prominent U.S. commentator, Father Thomas Reese, S.J. Yet it was from the other end of the spectrum of ecclesiastical opinion that formal protests about the simple-majority provision were made to the Pope. In early 2001, Cardinal Jorge Arturo Medina Estévez wrote John Paul II and some forty other cardinals, expressing his grave concerns about the possibility of a simple-majority papal election; his worries seem to have been triggered in part by the controversial nomination of the German Karl Lehmann to the College of Cardinals. Some evidently expected Cardinal Lehmann to rally the progressive opposition and organize a conclave that would, in effect, repudiate the pontificate of John Paul II. Medina was still sufficiently concerned about a simple-majority election that, in October 2001, he pressed one of the Spanish-language working groups at that year's Synod to recommend to John Paul II a recision of the simple-majority provision.

12. See Laurie Goodstein and Ian Fisher, "The Transition in the Vatican: The Contenders," *New York Times*, April 17, 2005.

13. John Allen's telling of this particular facet of the conclave is especially well done, although his conclusion (that it materially strengthened Ratzinger's candidacy) is perhaps, as a Scottish judge would say, "not proven." See Allen, *The Rise of Benedict XVI*, pp. 71–72.

14. American cardinals were among those who seemed most concerned about the external script. As one of them told John Allen a year before the conclave, Ratzinger might be the best man for the papacy, "but my concern is how I would sell this back home." Even granting a legitimate concern about the reception of a particular pope, that formulation bespeaks a certain lack of self-confidence—or, perhaps more likely, a certain unwillingness to challenge certain media shibboleths. (The quote is in Allen, *The Rise of Benedict XVI*, p. 89).

15. The "diary" that follows is based on the author's diary and other memoranda and notes written during the period in question, amplified by interviews and conversations in April 2005 with cardinal-electors (none of whom violated his oath of confidentiality in the process), Vatican officials, close observers of the Vatican scene, and distinguished journalists, many of whom the author had worked with for years (and, in some instances, for more than a decade). Given the cardinals' oath of confidentiality, any such reconstruction of events is bound to be impressionistic at points. Still, the sequence of events in the actual voting validated the author's confidence in those of his sources who called it precisely right as to date, time, and candidate—and thus may be assumed to have gotten a lot more than that right in the run-up to the actual voting.

16. The story of the name "Benedict" is in H. J. Fischer, *Pope Benedict XVI: A Personal Portrait* (New York: Crossroad, 2005), pp. 106–107.

17. According to a more likely scenario, Cardinal Ruini persuaded Cardinal Martini and Martini's voters to move quickly to Cardinal Ratzinger.

18. Quoted in Sandro Magister, "What Really Happened at the Conclave," www.chiesa.espressonline.it, May 2, 2005.

19. John Allen unwinds this analysis in *The Rise of Benedict XVI*, p. 126.

20. See Fischer, *Pope Benedict XVI*, p. 100.

21. See John Paul II, *Novo Millennio Ineunte*, 29.

22. E. J. Dionne Jr., "Cardinal Ratzinger's Challenge," *Washington Post*, April 19, 2005, p. A19.
23. Daniel Williams and Alan Cooperman, "Conclave Begins with Day of Ritual," *Washington Post*, April 19, 2005.
24. Steve Maynard, "Faithful sing hallelujah, though some wait and see," Tacoma *News Tribune*, April 20, 2005.
25. Mario Cuomo, "Infallibility has its limits," New York *Daily News*, April 28, 2005.
26. Cited in Hugh Williamson and Tony Barber, 'Servant of a changing Church," *Financial Times*, April 23, 2005.
27. "Pope Benedict XVI: A theologian of the past, not a pastor for the future," *The Independent*, April 20, 2005.
28. Timothy George, "The Promise of Benedict XVI," *Christianity Today*, June 2005.
29. It was reliably reported that Pope Benedict had at first proposed holding his installation Mass inside St. Peter's. There, he believed, the focus would be more on Christ than on the new pope. He was evidently persuaded that, because of the size of the crowds who wanted to participate, the ceremony should be held outdoors.

5. THE MAKING OF A NEW BENEDICT

1. This story was told in *Der Spiegel*'s online edition of April 22, 2005, by seventy-eight-year-old Walter Fried, who had served with Joseph Ratzinger in Obergrashof. See Dominik Baur, "Ratzingers Jugend," *Der Spiegel Druckversion*, April 22, 2005. Father Paul Mankowski, S.J., kindly provided the reference and a translation.
2. Joseph Ratzinger, *Milestones: Memoirs 1927–1977* (San Francisco: Ignatius Press, 1998), p. 8.
3. Ratzinger, *Milestones*, p. 11.
4. Ratzinger, *Milestones*, p. 14.
5. Ratzinger, *Milestones*, p. 23.
6. Joseph Ratzinger, *Salt of the Earth: The Church at the End of the Millennium—An Interview with Peter Seewald* (San Francisco: Ignatius Press, 1997), p. 52.

 A distinguished German historian, Hans-Ulrich Wehler, told the *Financial Times* that any concerns about Ratzinger and the Hitler Youth were ill-informed. "Children were forced by law to join; those who did not were rounded up by the police. Ratzinger's experiences are normal for his generation." (Cited in Williamson and Barber, "Servant of a changing Church.")
7. As related in Allen, *The Rise of Benedict XVI*, p. 146.
8. Ratzinger, *Milestones*, pp. 25–27.
9. Ratzinger, *Milestones*, p. 32.
10. Ratzinger, *Milestones*, p. 46.
11. Ratzinger, *Salt of the Earth*, p. 51.
12. Ratzinger, *Salt of the Earth*, p. 49.
13. On these points, see Fischer, *Pope Benedict XVI*, pp. 23–24.
14. Henri de Lubac, *The Drama of Atheist Humanism* (San Francisco: Ignatius Press, 1995), p. 14.
15. Aidan Nichols, O.P., *The Theology of Joseph Ratzinger: An Introductory Study* (Edinburgh: T&T Clark, 1988), p. 16.
16. See Allen, *The Rise of Benedict XVI*, p. 148.

17. Nichols, *The Theology of Joseph Ratzinger*, p. 19.
18. Ratzinger, *Milestones*, p. 42.
19. Ratzinger, *Milestones*, pp. 42–43.
20. Ratzinger, *Milestones*, pp. 43–44.
21. Ratzinger, *Milestones*, p. 44.
22. Ratzinger, *Milestones*, p. 53.
23. Ratzinger, *Milestones*, p. 57.
24. Fischer, *Pope Benedict XVI*, p. 42.
25. Ratzinger, *Milestones*, p. 59.
26. Ratzinger, *Milestones*, p. 100.
27. Ratzinger's habilitation adventures are described in detail in his *Milestones*, pp. 104–13, from which the account here, and the quotations, are drawn.
28. Ratzinger, *Milestones*, p. 119.
29. Ratzinger, *Milestones*, p. 131.
30. Joseph Ratzinger, *Theological Highlights of Vatican II* (New York: Paulist Press Deus Books, 1966), pp. 14, 84.
31. Ratzinger, *Milestones*, pp. 128–29.
32. This point is borne out by a close reading of Ratzinger's *Theological Highlights of Vatican II*, which is now, unfortunately, out of print.
33. On these points, see Ratzinger, *Milestones*, pp. 132–33.
34. Ratzinger, *Theological Highlights of Vatican II*, p. 2.
35. See Nichols, *The Theology of Joseph Ratzinger*, pp. 294–96.
36. Ratzinger, *Theological Highlights of Vatican II*, pp. 48, 46.
37. Ratzinger, *Milestones*, p. 126.
38. Nichols, *The Theology of Joseph Ratzinger*, p. 296.
39. Ratzinger, *Milestones*, p. 134.
40. See Ratzinger, *Milestones*, p. 135.
41. Ratzinger, *Milestones*, p. 139.
42. Ratzinger, *Salt of the Earth*, pp. 77–78.
43. See Ratzinger, *Milestones*, p. 139.
44. For an accessible and reliable introduction to Balthasar's thought, see Edward T. Oakes, S.J., *Pattern of Redemption: The Theology of Hans Urs von Balthasar* (New York: Continuum, 1994).
45. Ratzinger, *Milestones*, pp. 144–45.
46. Ratzinger, *Milestones*, pp. 145–46.
47. See Romano Guardini, *The End of the Modern World* (Wilmington, Del.: ISI Books, 1998).
48. Ratzinger, *Milestones*, p. 152.
49. See Ratzinger, *Milestones*, p. 153.
50. Author's interview with Cardinal Joseph Ratzinger, September 12, 1996.
51. Author's interview with Cardinal Joseph Ratzinger, September 12, 1996.
52. Author's interview with Cardinal Joseph Ratzinger, September 12, 1996.
53. Author's interview with Cardinal Joseph Ratzinger, September 12, 1996.
54. Author's interview with Cardinal Joseph Ratzinger, September 12, 1996.
55. Ratzinger, *Salt of the Earth*, pp. 116–17.
56. An eighty-page bibliography of Joseph Ratzinger's theological work from 1954 to 2002 may be found in Joseph Ratzinger, *Pilgrim Fellowship of Faith: The Church as Communion* (San Francisco: Ignatius Press, 2005), pp. 299–379.

57. Author's interview with Cardinal Joseph Ratzinger, December 18, 1997.
58. This myth maintained itself to the very end. In an otherwise critical editorial the day after Benedict XVI's election (in which it lamented the "overwhelming sense of an opportunity missed"), the British *Guardian* took mild comfort in reporting that "defenders insist that he [Ratzinger] moderated some of the last Pope's wilder conservative instincts." That was mistaken in itself. And it wasn't Ratzinger's defenders who said such things during the pontificate of John Paul II, but Ratzinger's critics. ("Smoke signals," *The Guardian*, April 20, 2005.)
59. Author's interview with Cardinal Joseph Ratzinger, September 20, 1997.
60. The Congregation for Oriental Churches has oversight responsibility for Catholic communities that use liturgical rites similar to those of Orthodoxy, but which are in communion with Rome—such as the Greek Catholic Church in Ukraine, or the Melkite churches. The Congregation for Divine Worship is responsible for ensuring the integrity of the Mass and the celebration of other sacraments, and oversees such knotty issues as liturgical translations into vernacular languages. The Congregation for Bishops recommends nominations to the episcopate for about two-thirds of the dioceses in the world; the other one-third are under the supervision of the Congregation for the Evangelization of Peoples (which everyone in Rome calls by its pre-1967 name, *Propaganda Fidei* [Propagation of the Faith], or simply "Prop"). The Congregation for Catholic Education supervises Catholic institutions of higher education, including seminaries and theological institutes. The Pontifical Council for Promoting Christian Unity is the Vatican's chief ecumenical agency, and is also responsible for the world Catholic-Jewish dialogue. The Pontifical Commission for Latin America is a filtration point between the Vatican and CELAM, the council of Latin American bishops' conferences. The *Ecclesia Dei* [Church of God] Commission receives back into full communion with the Church those Lefebvrists who want to be reconciled with Rome.
61. See Congregation for the Doctrine of the Faith, *Instruction on the Ecclesial Vocation of the Theologian*, 6, 8–10, 14, 21, 30, 33, 35.
62. Author's interview with Cardinal Joseph Ratzinger, September 12, 1996.
63. During the October 2001 Synod on the bishop's role in the 21st-century Church, Ratzinger got the biggest ovation during the first week of deliberations for a strong defense of the bishop as teacher of truth. The CDF prefect told his brother-bishops that, if the bishops were doing what they were supposed to be doing, i.e, exercising the charism of headship and teaching orthodox doctrine, the problem of "decentralization" (of which there had been much chatter in the press, much of it critical of CDF) would take care of itself. That this was applauded suggests that the bishops recognized and admired courage, even if some of them were not prepared to exercise it very often.
64. Davis's comment is cited in Peter Hebblethwaite, *Paul VI: The First Modern Pope* (New York: Paulist Press, 1993), p. 474.
65. Rosemary Ruether essentially concedes this point in an essay on Charles Davis written after his death; see Rosemary Radford Ruether, "He sought the truest meaning of faith," *National Catholic Reporter*, February 12, 1999.
66. See Fischer, *Pope Benedict XVI*, p. 37.
67. Ratzinger described the Boff affair to Peter Seewald in these terms:

 "The phrase 'penitential silence' was invented in Germany. We had simply said that for a year he shouldn't speak about this subject but should reflect on it and

not travel around the world. Well, you can always discuss whether something like that is right or not, but, objectively considered, it wasn't bad to invite someone to reflect longer on a difficult question. Perhaps it would do us all some good were someone to tell us, you should stop talking about that for a while, you shouldn't keep publishing frenetically, but give things a chance to mature . . . Boff, in any case, was supposed to have been able to keep teaching. However he didn't do so that year. It was only this particular subject that he was not supposed to pursue further in lectures and books but was to let alone for a year . . ." (Ratzinger, *Salt of the Earth*, pp. 94–95.)

68. Congregation for the Doctrine of the Faith, *Instruction on Certain Aspects of the Theology of Liberation*, XI, 17.

69. Congregation for the Doctrine of the Faith, *Instruction on Christian Freedom and Liberation*, 3, 14, 44.

70. Critics of the first instruction frequently claimed that the second instruction was ordered by John Paul II as a corrective to the harsh tone of the first. Cardinal Ratzinger insisted that this was never the case in a series of interviews with the author, the key points of which are summarized in Weigel, *Witness to Hope*, pp. 458–59.

71. Richard John Neuhaus, "To Say Jesus is Lord," *First Things* 107 (November 2000), p. 69.

72. Maryknoll, New York: Orbis Books, 1997.

73. Congregation for the Doctrine of the Faith, "Notification on the book *Toward a Christian Theology of Religious Pluralism* by Father Jacques Dupuis, S.J."

74. During these years, Cardinal Ratzinger also played an important role in John Paul II's attempts to reconcile Archbishop Marcel Lefebvre and his followers with the Church. Those efforts collapsed in 1988 when the Frenchman illicitly ordained three bishops after ignoring a passionate telegram from Ratzinger pleading with him to desist. Lefebvre, Ratzinger sadly concluded, was "a very difficult man." See Weigel, *Witness to Hope*, pp. 562–64.

75. *The Ratzinger Report: An Exclusive Interview on the State of the Church* (San Francisco: Ignatius Press, 1985).

76. Richard John Neuhaus offers a penetrating commentary on *The Ratzinger Report* in *The Catholic Moment: The Paradox of the Church in the Postmodern World* (San Francisco: Harper & Row, 1987), pp. 105–10.

77. The call to sanctity was a consistent theme in Cardinal Ratzinger's thought for decades. His thinking about what it means to be a saint is illuminated by the following answer, which he gave to the question of why St. Thérèse of Lisieux (1873–1897), the "Little Flower," should have been given the title "Doctor of the Church," which is usually reserved for the Church's greatest theologians:

"We have distinct forms of doctors of the Church, even before Anthony of Padua. We have on the one hand the great scholastic doctors, Bonaventure and Thomas Aquinas, who were professors and academicians and great doctors in the scientific sense; in the patristic period we have great predicators who developed doctrine not in theological discussion but in predication, in homilies; we also have Ephraim who developed his theology essentially in hymns and music. Now in these times we have new forms of doctors and it's important to lift up the richness of the different means of teaching in the Church. We have Teresa of Avila with her mystical experiences and her in-

terpretations of the presence of God in mystical experience. We have Catherine of Siena with an experiential theology. And now we have Thérèse of Lisieux, who is also a different way of a theology of experience.

"It is important, in our scientific society, to have the message of a simple and deep experience of God, and a teaching about the simplicity of being a saint: in this time, with all its extremely action-oriented approach, to teach that to be a saint is not necessarily a matter of great actions, but is letting the Lord work in us.

"This is also interesting for the ecumenical dialogue. Luther's doctrine of justification was provoked by his difficulty in understanding himself justified and redeemed through the complex structures of the medieval Church. Grace did not arrive in his soul and we have to understand the explosion of *sola fide* [justification by faith alone] in this context: that he discovered finally that he had only to give *fiducia*, confidence, to the Lord, to give myself into the hands of the Lord—and I am redeemed. I think in a very Catholic way this returned in Thérèse of Lisieux; you don't have to make great things. I am poor, spiritually and materially; and to give myself into the hands of Jesus is sufficient. This is a real interpretation of what it means to be redeemed; we don't have to do great things, we have to be confident, and in the freedom of that confidence we can also follow Jesus and realize a Christian life. This is not only an important contribution to the ecumenical dialogue but to our common question—how can I be redeemed, how am I justified? The 'little way' is a very deep rediscovering of the center of Christian life.

"The other concept is that from the cloister, far from the world, one can do much for the world. Communion with Christ is presence to Christians all over the world. Everybody can be 'efficient' for the universal Church this way. This is also a new definition of 'efficiency' in the Church. We have so many actions, and we have to discover that 'efficiency' begins with communion with the Lord. This idea, that the heart of the Church is present in all the parts of the body, is a good correction to a merely pragmatic Church, an 'efficient' Church in the external sense. It's a rediscovery of the roots of all Christian activity.

"She also had a new idea of heaven, of the relationship between eternity and time. To be present on earth and to do good on earth *is my heaven*. We have a new relationship between eternity and time: heaven is not absent from the earth, but a new and stronger presence. Eternity is present in time, and living for eternity is living in and for the time at hand. By living a Christian life we are more present to earth, we are charging the earth . . ."

[Author's interview with Cardinal Joseph Ratzinger, September 20, 1997.]

78. Author's interview with Cardinal Joseph Ratzinger, October 29, 2001.
79. Cited in Neuhaus, *The Catholic Moment*, p. 123.
80. Author's interview with Cardinal Joseph Ratzinger, October 29, 2001.
81. Ratzinger, *Salt of the Earth*, p. 32.
82. Ratzinger, *Salt of the Earth*, p. 27.
83. Joseph Ratzinger, *God and the World: A Conversation with Peter Seewald* (San Francisco: Ignatius Press, 2002), p. 19.
84. Ratzinger, *God and the World*, pp. 438–39.
85. Ratzinger, *God and the World*, p. 442.

86. Ratzinger, *God and the World*, pp. 459–60.
87. Ratzinger, *Milestones*, pp. 155–56.

6. INTO THE FUTURE

1. From both a theological and a canonical point of view, popes are neither inaugurated nor installed, as there is no official of parallel authority to inaugurate a new pope (as the chief justice inaugurates the president of the United States by administering the oath of office); the full powers of the papacy belong to the new pope from the moment he says "I accept" in the Sistine Chapel. "Installation Mass" is perhaps the least clumsy and misleading translation of this ritual, which was titled in Italian as *Santa Messa, Imposizione del Pallio, e Consegna dell'Anello del Pescatore per L'Inizio del Ministero Petrino del Vescovo di Roma, Benedetto XVI* [Holy Mass, Imposition of the Pallium, and Consignment of the Fisherman's Ring for the Beginning of the Petrine Ministry of the Bishop of Rome, Benedict XVI].
2. Lord Clark makes this point in the first chapter ("The Skin of Our Teeth") of his study of western civilization, concentrating on the achievements of the Celtic monks. See Kenneth Clark: *Civilisation: A Personal View* (New York: Harper & Row, 1969).
3. Ratzinger, *God and the World*, pp. 389–91.
4. Alasdair MacIntyre, *After Virtue: A Study in Moral Theory* (Notre Dame, Ind.: University of Notre Dame Press, 1981), p. 245.
5. See Joseph Bottum, "The Last European Pope?" *Weekly Standard*, May 2, 2005, pp. 19–23.
6. Bottum, "The Last European Pope?" p. 19.
7. This argument is unwound at greater length in Weigel, *The Cube and the Cathedral.*
8. Joseph Ratzinger, "Breaking Down and Starting Out Afresh: Faith's Answer to the Crisis of Values," in Ratzinger, *A Turning Point for Europe? The Church in the Modern World—Assessment and Forecast* (San Francisco: Ignatius Press, 1994), pp. 35–36; emphasis added.
9. For these and other startling numbers, see Philip Longman, "The Global Baby Bust," *Foreign Affairs*, May–June 2004, and Philip Longman, *The Empty Cradle: How Falling Birthrates Threaten World Prosperity and What to Do About It* (New York: Basic Books, 2004).
10. Author's interview with Cardinal Joseph Ratzinger, December 18, 1997.
11. Author's interview with Cardinal Karl Lehmann, October 24, 2001.
12. Bottum, "The Last European Pope?" p. 19.
13. See Sandro Magister, "Embryos Welcome: Ruini Wins the Referendum, and Sets an Example," June 16, 2005, at www.chiesa.espressonline.it.

 A week after the Italian referendum, some half-million Spanish Catholics demonstrated in Madrid in defense of marriage, with strong support from several leading Spanish bishops.
14. "Vatican Address to Council of Europe," ZENIT news service, May 17, 2005.
15. See "Statement by the COMECE Presidium on the current situation in the European Union, 14 June 2005," available at www.comece.org.
16. For an example of Joseph Ratzinger's mind at work on these and related issues, see "Christ, Faith, and the Challenge of Cultures," in *L'Osservatore Romano* [English Weekly Edition], April 26, 1995, pp. 5–8.

17. John Allen, among many others, relishes this story in Allen, *All the Pope's Men: The Inside Story of How the Vatican Really Thinks* (New York: Doubleday, 2004), p. 31.

18. The standard introduction to these questions remains Robert A. Graham. S.J., *Vatican Diplomacy: A Study of Church and State on the International Plane* (Princeton, N.J.: Princeton University Press, 1959).

19. See John Allen, "The Word from Rome," www.nationalcatholicreporter.org, June 17, 2005, p. 16.

20. See Weigel, *The Final Revolution.*

21. See David Rivkin and Lee Casey, "Leashing the Dogs of War," *The National Interest* 73 (Fall 2003), p. 59.

22. For a more detailed analysis of these issues. see George Weigel, "World Order—What Catholics Forgot," *First Things* 143 (May 2004), pp. 31–38.

23. The Catholic Church's inter-religious dialogue with Judaism falls within the responsibility of the Pontifical Council for Promoting Christian Unity, which has an affiliated commission responsible for the Catholic-Jewish dialogue. This arrangement was made at the request of Jewish leaders, in part because the pontifical council's predecessor, the Vatican II Secretariat for Christian Unity, had been their interlocutor during the Council, and in part because Jewish leaders feared that bundling the Catholic-Jewish dialogue into the Church's dialogue with "world religions" would lead to a diminishment of the sense of the theological priority of the Church's dialogue with its parent.

24. This promiscuous document-making also cheapens the Holy See's voice—and the Catholic Church's. What conceivable evangelical point was being made in July 2005 when the Pontifical Council for the Pastoral Care of Migrants and Itinerant Peoples, celebrating a "13th World Day of Tourism" built around the theme "Travel and Transport: From the Imaginary World of Jules Verne to the Reality of the 21st Century," released a letter from Cardinal Sodano, the secretary of state, to Cardinal Hamao, the pontifical council's president, noting the occasion—and trying rather desperately, it seemed, to find some significance in it?

25. Author's interview with Cardinal Edward Cassidy, March 1, 2002.

26. John Paul II seemed to take the position that his job was to appoint the heads of dicasteries, while others (the Secretariat of State, the prefect or president of the dicastery in question, and/or the curial "network") could find nominees for the number two and number three positions—which are, in fact, very important, because much of the daily work flows through those officials. The result was that heads of dicasteries were sometimes saddled with deputies whom they didn't want and who became impediments to a congregation's or council's work. Any serious reform of the Curia will recognize that the three senior positions in any dicastery ("the superiors," as they're known in curial argot) must form a team that agrees on goals and methods. Experience suggests that any such rationalization of the curial culture is not going to be easy, but the effort is certainly worth making.

27. What follows describes the procedure for appointments to the episcopate in the Latin-rite Catholic Church in the developed world; in the Third World, nominations for the episcopate go through the Congregation for the Evangelization of Peoples. Eastern-rite Catholic Churches have their own synodal methods of nominating bishops; these nominations are then confirmed by the pope.

28. See Weigel, *The Courage To Be Catholic*, pp. 205–06.

29. Ratzinger, *The Ratzinger Report*, p. 59.
30. Ratzinger, *The Ratzinger Report*, p. 60.
31. Ratzinger, *The Ratzinger Report*, p. 61.
32. According to Archbishop Héctor Cabrejos Vidarte, O.F.M., of Trujillo, Peru, the Peruvian bishops have been addressing these problems of contempt for the law publicly, as have some other Latin American episcopates (notably, Argentina). But the problem has never been sufficiently addressed in the Synod of Bishops. (Author's interview with Archbishop Héctor Cabrejos Vidarte, October 22, 2001.)
33. John Paul II, *Sollicitudo Rei Socialis*, 15. For more on a path to Latin American progress, see Alvaro Vargas Llosa, *Liberty for Latin America: How to Undo Five Hundred Years of State Oppression* (New York: Farrar, Straus and Giroux, 2005).
34. Author's interview with Archbishop Estanislao Karlic, March 2, 2002.
35. On evangelicalism's capacity to generate social change out of behavioral change, see Amy L. Sherman, *The Soul of Development: Biblical Christianity and Economic Transformation in Guatemala* (New York: Oxford University Press, 1997).
36. Constitution on the Sacred Liturgy [*Sacrosanctum Concilium*], 8.
37. Joseph Ratzinger, *The Spirit of the Liturgy* (San Francisco: Ignatius Press, 2000), pp. 22–23.
38. Ratzinger, *Salt of the Earth*, p. 283.
39. Cited in Bunson, *We Have a Pope!*, p. 202.
40. Allen, *The Rise of Benedict XVI*, p. 187.
41. See Colleen Carroll, *The New Faithful: Why Young Adults Are Embracing Christian Orthodoxy* (Chicago: Loyola Press, 2002).
42. John Allen discusses this aspect of Pope Benedict's thinking in *The Rise of Benedict XVI*, pp. 219–20, drawing a different conclusion than mine.
43. Ratzinger, *Salt of the Earth*, p. 47.
44. Ratzinger, *Theological Highlights of Vatican II*, p. 159.

Index